AEQVOREA VENS
PORTV RESIDEO
HIC NEPTVNVS

VENICE

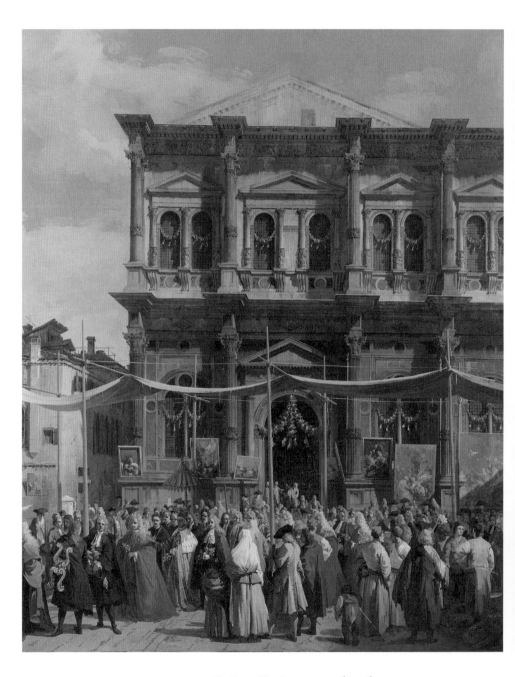

CANALETTO *The Feast of San Rocco, c.* 1735 (detail)

Martin Gayford

VENICE

CITY OF PICTURES

To David Hockney, from whom I have learned
so much about the history of pictures

First published in the United Kingdom in 2023 by
Thames & Hudson Ltd, 181A High Holborn, London WC1V 7QX

First published in the United States of America in 2023 by
Thames & Hudson Inc., 500 Fifth Avenue, New York, New York 10110

Reprinted 2024

British Library Cataloguing-in-Publication Data
A catalogue record for this book is available from the British Library

Library of Congress Control Number 2022945661

ISBN 978-0-500-02266-5

Printed in China by Reliance Printing (Shenzhen) Co. Ltd

Be the first to know about our new releases,
exclusive content and author events by visiting
thamesandhudson.com
thamesandhudsonusa.com
thamesandhudson.com.au

CONTENTS

INTRODUCTION

O ne evening a few years ago, as I was walking along the Calle del Magazen during the opening week of the Venice Biennale, I paused for a moment and had a thought just as I passed the entrance of the Scuola Grande di San Giovanni Evangelista. This little structure is like a fifteenth-century stage set. Designed in the late 1470s by the sculptor and architect Pietro Lombardo, it consists of a screen of marble and limestone, with windows and a doorway. But the latter opens on to an empty space. It is a beguiling composition but – since the doors that it once held have been removed – serves no useful purpose except to form a frame for the small courtyard beyond.

Such theatrical transformations of urban space are characteristic of Venice. But that was not the idea that came into my mind at that instant. Perhaps it was the soft light of the setting sun that made the portal seem like this, but at that moment, the stone from which it was made appeared not to be a hard mineral thing as it would elsewhere. Instead, the delicately veined panels of marble looked as if they had been dappled by the strokes of a paintbrush. An eagle, emblem of Saint John, emerges from a semi-circular pediment above the doorway as if from a cloudy sky. The praying angels who flank the bird are not so much three-dimensional figures as silhouettes. Around the doorway itself, the decoration is richly carved with leaves and flowers. In soft shadowy twilight, its texture seemed like embroidery.

The entrance of the Scuola Grande di San Giovanni Evangelista

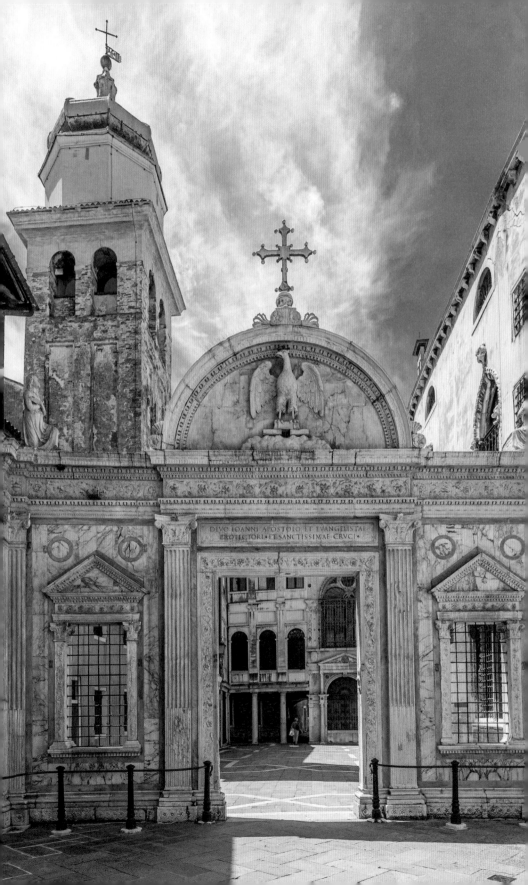

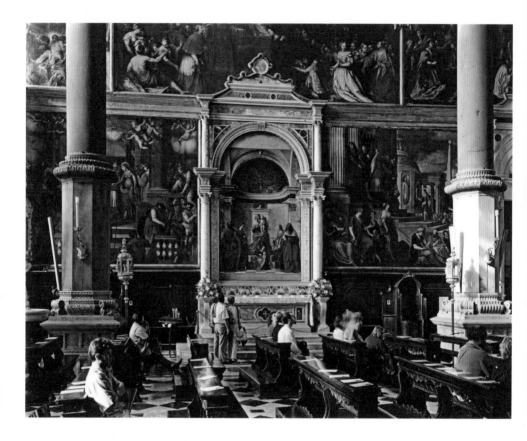

THOMAS STRUTH *San Zaccaria, Venice,* 1995

My thought was that here one kind of thing is apt to blend into something else. And everything, even sculpture and architecture, turns into a picture. That is what you find in Venice: images on top of images, views of the town itself, sometimes pictures of pictures. This is a city of pictures.

<center>*</center>

The nave of the church of San Zaccaria is covered with seventeenth- and eighteenth-century paintings, arranged side by side. Amidst these there is an altarpiece by Giovanni Bellini in an elaborate frame, looking as if it has been stuck on top of the others. From the point of view of a curator or

collector, this is as mad a way of hanging a masterpiece as could be imagined. But it works because few if any people ever look at the other paintings.

These layers of images are deposits in time, similar to the strata in a rock face – although, as with geology, the process has been complicated. Like an outcrop of older stone on a cliff, the Bellini is surrounded by works that are actually later than it is itself. And Bellini's painting includes a depiction of a different, older type of picture: the Byzantine-looking mosaic in the half dome above the Madonna's throne, with luxuriant, curling leaves and paradise-dwelling birds.

These layers of time are still accumulating. In 1995, the German artist Thomas Struth made this collage-like patchwork of paintings the backdrop of a late-twentieth-century picture. This is a study of individuals gathered in the church: a few looking at the great Bellini, the rest just sitting in the pews as if they were at a service. In Struth's photograph, some of the people are reduced to ghostly blurs by the length of the exposure; others, presumably because they were more attentive or perhaps just stiller, are not. So this image of an image surrounded by other images contains different quantities of time: the seconds or fractions of a second of the exposure itself; the minutes for which modern visitors pause in front of the altarpiece; the weeks and months it took the artist to paint it; the centuries during which it has existed.

*

One of the best books ever written about Venice is the 1972 novel *Invisible Cities* (in Italian, *Le città invisibili*) by Italo Calvino, even though ostensibly it is not about Venice at all. It consists of a long series of descriptions of towns provided by the medieval explorer Marco Polo to entertain his employer, the emperor of China, Kublai Khan. They are all different, all fantastic, and simultaneously reminiscent of the actual accounts of numerous Asian urban centres given in Polo's famous book of travels. Eventually, the emperor asks him why he has never mentioned his wonderful birthplace, somewhere Kublai would obviously like to hear about. Polo replies: 'Every time I describe a city, I am saying something about Venice.' In other words, it is the archetypal metropolis.

I feel something similar. Of course, this is a bizarre and unique place; none of the replicas and lookalikes scattered around the globe – Little Venice in London, Venice Beach in California – are truly anything like it. I still remember the surprise of recognition when I first stepped out of the booking hall of Stazione Santa Lucia in 1975, and onto the wide terrace beside the Grand Canal. Astonishingly, Venice really looked just the way that it was supposed to look; apart from the motor-boat taxis and water buses, it was very much like a Canaletto.

Since then, I have been back repeatedly, for days, weeks, and months, on family holidays and overnight hops. My stays have been short and long, for pleasure and also for work. I have reviewed exhibitions, attended openings, and, at a steady two-yearly rhythm, visited and reported on the Venice Biennale. T. S. Eliot's J. Alfred Prufrock measured out his life with coffee spoons. I have done the same with Biennales: hot ones, wet ones, sociable ones, hectic ones, boring ones, memorable ones, others that have left so little impression that I have had to read my own review to remember what I saw.

I do not think that I have ever arrived, even in the depressing bus station at Piazzale Roma after a Ryanair flight and journey on a crowded coach, without a feeling of excitement – and also a sensation of coming home. Venice has been interwoven into my life for decades. But I realized, as I wrote and researched the pages that follow, that the same has been true for many others over the centuries, including a startling number of those who devised art and literature as we know them. So, like Calvino's Marco Polo, you may find that when discussing something else – oil painting, for example, or British country-house architecture – you are talking about Venice.

This book is an unusual kind of history. It is not a chronicle of battles, rulers, sieges, and revolutions – though such events sometimes come into the story. It is written in the belief that the most interesting things that have happened in this place were not military, political, or economic. Many of them were not even verbal, but sensory experiences that were heard and – in particular – seen.

Neither is this a standard type of art history. It considers works in the context of the time in which they were created, but also what happened to them afterwards. It is my contention that George Eliot's response to

a Veronese – or Lord Byron's to a Giorgione, or Richard Wagner's to a Titian – is part of the history of that picture. David Hockney has noted that a work of art remains contemporary if we are still interested in it, even if it was created many centuries ago, and that certainly applies to many pictures made in Venice.

There are two venerable opinions about the place, repeated for centuries by generations of visitors. One, which was expressed even before the fall of the Venetian Republic in 1797, is that the city is moribund or even already deceased. This was almost the first verdict that I ever heard about it: Kenneth Clark declared with patrician dolefulness on the television more than fifty years ago that the city would sink beneath the waves and, like all human creations, cease to be. No doubt that last prognostication is correct. Yet Lord Clark himself departed from life many years ago now, and Venice itself is still there and – despite all its problems, environmental and economic – in some respects, it is in better shape than it was when he made his prediction. In 2020, the movable flood barriers in the mouths of the lagoon that go by the acronym MOSE (Modulo Sperimentale Elettromeccanico, or Experimental Electromechanical Module) were activated and proved successful. So now, for the time being at least, Venice is fairly safe from the menace of *acqua alta*, or high water. Subsequently, a long-overdue decision was taken to ban cruise liners from docking in the city itself – thus perhaps mitigating the threat of inundation by immense crowds of human beings eager to see this astonishing place. In the aftermath of the terrible *acqua alta* of November 2019, during which the water reached 1.87 metres above its normal level and more than eighty per cent of the city was flooded, I sent a message of commiseration to a friend who lives on the Grand Canal. His reply was bold: 'Venice is a great city and will still be here in 500 years' time.' This seems just as plausible as the pessimistic opposite.

*

In the opening week of the Biennale in May 2019, a picture appeared on an area of dank, crumbling plaster just above the water of a canal near to the church of San Pantalon. It was a mural by the mysterious British artist Banksy, who was in town. Among other stunts, he had set up a stall selling

pictures of a huge cruise liner looming menacingly over the ancient city-scape. The artist sat (or employed an accomplice to sit) beside it, reading a newspaper. He explained the meaning of his picture in a statement, reusing one that he had originally written for another work on a wall in Calais four years previously: 'We're often led to believe migration is a drain on the country's resources, but Steve Jobs was the son of a Syrian migrant – Apple is the world's most profitable company.' The child carrying a torch of liberty in Banksy's mural hints at a deep truth about Venice, and everywhere: ultimately, we are all migrants.

Ever since the Middle Ages, there have been comments on the number of different languages spoken in Venetian streets: the place, it has been remarked for hundreds of years, is full of foreigners. The city has always been populated by refugees and migrants – it was allegedly founded by people escaping the invasions and chaos of the imploding Western Roman Empire. At regular intervals, these have been succeeded by others fleeing one danger or another: Christians on the run from the Ottoman invasions of the eastern Mediterranean; writers, artists, and others escaping the Sack of Rome in 1527 by other Christians; Jews trying to get away from perse-cution and settling amidst somewhat milder Venetian oppression. Many of the architects and builders who made the city came from elsewhere: Pietro Lombardo from – as his name implies – Lombardy, Andrea Palladio from Vicenza, the Florentine Jacopo Sansovino. The names of many painters give away the fact that they did not quite belong: Cima da Conegliano, Giorgione da Castelfranco, Andrea Schiavone (that is, Andrew the Slav, because he was born in what is now Croatia), Paolo Veronese, Jacopo Bassano.

The physical nature of Banksy's mural is evocative too. In the past, Venice was covered in paintings on damp, crumbling plaster, some by the greatest of painters: Giorgione, Titian, Tintoretto. Just about all of them are gone, although, as we shall see, a few battered and faded fragments still more or less survive. It will be interesting to see how long the Banksy lasts.

Another frequent observation is that there is nothing new to say about this remarkable city. This thought is far from novel. On Monday, 1 November 1610, the nineteen-year-old William Cecil, Viscount Cranborne – one of the first English noblemen to make a grand tour – arrived. But, he wrote,

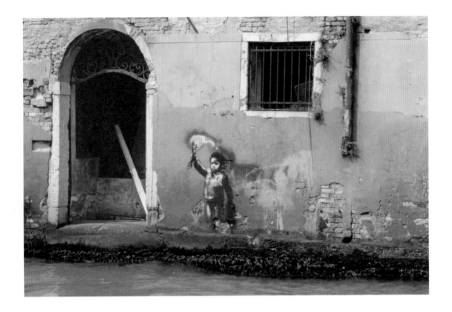

BANKSY *Untitled mural, Venice,* 2019

it was not his intention 'to say something of the wonderful location of this town, [nor] of the beauty of its churches, of their riches, of the construction of so many beautiful buildings both public and private; it would be a great fault to say too little and there are entire books on the subject.' This verdict has been repeated often ever since, most memorably by Henry James in 1882, who began a long essay entitled 'Venice' with the words, 'It is a great pleasure to write the word; but I am not sure there is not a certain impudence in pretending to add anything to it.' There is, James continued, 'notoriously nothing more to be said on the subject. Every one has been there, and every one has brought back a collection of photographs.'

That was nicely put, and correct about the photographs, which in these days of camera phones are taken in uncountable millions. But the rest, like the belief that Venice is expired or expiring, is mistaken. On the contrary, important events took place after Cranborne made his visit and James wrote his reflections. Plenty has happened and continues to occur in the city, including while this book was being written in the third decade of

the twenty-first century – which means there are always new and different things to say.

Venice continues to affect the lives of many people who come to stay for days, weeks, or years, and artists continue to make works that add to the huge accumulation that is already there. Its story did not end with the fall of the Republic in 1797 because it was not solely a political affair. The city found a new role in the nineteenth, twentieth, and twenty-first centuries. Many of the people who contributed to its reinvention were not Venetian by birth, but then, as we have just seen, neither was Giorgione, Palladio, or Veronese, nor even Titian, who came from Cadore up in the Dolomites.

This book argues that there is an enormous amount still to be said about Venice, in part precisely because it is not dead. Its life continues to unfold, and the works created in the past remain a reference point for artists in the present. However, the rapport flows in both directions. Titian and Tintoretto affected later painters, as we shall see – not just Rubens, Velázquez, and Van Dyck, but also Jackson Pollock and Lucian Freud; and in turn, those more recent works make us look anew at their predecessors from a fresh perspective.

So it goes on. A twenty-first-century video artist echoes Tiepolo and so alters our response to his paintings – and thus, you might say, the present influences the past (as well as vice versa). This is a history of a particular town over five hundred years, viewed in terms of its most important creation: pictures. And the story is still continuing.

A PICTURE OF VENICE

On a clear day, the final minutes of a flight into Venice's Aeroporto Marco Polo are a lesson in geography – assuming that you have a window seat. The aircraft steadily loses height, until you sweep in over the lagoon and there is the city itself. It looks, as innumerable observers have said before, just like a sea creature – or perhaps two crustaceans intertwined, the twisting line of the Grand Canal between them. All around is the water of the lagoon, punctuated by low banks of sea marsh – and, if you are sitting on the correct side of the plane, maybe a glimpse of the Alps in the distance. Even today this is an astonishing sight, but consider how much more astounding it would have been to see such a picture more than five centuries ago at the dawn of the sixteenth century.

*

In the autumn of 1500, the Venetian doge and the Signoria, the supreme body of government of the Republic of Venice, received an unusual request. It was from a book dealer and print-seller named Anton Kolb, who explained that he had underwritten an extraordinary venture – one, he continued enticingly, that added 'to the fame of this most excellent city of Venice'. Kolb had created – or more accurately commissioned – nothing less than a portrait of the city from above in the form of six large woodcut prints.

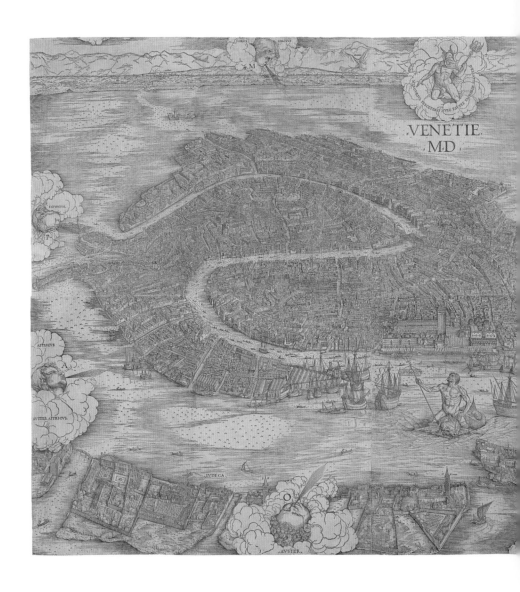

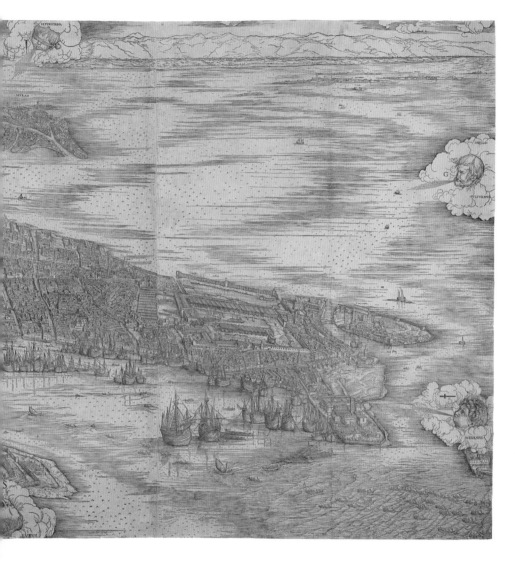

JACOPO DE' BARBARI *View of Venice*, 1500

This was a picture more than a map. Although many streets and canals are visible, it would not be much use as a means of finding one's way around (especially as the whole thing is nearly three metres across). It is a topographically precise view of the place as it might be seen by an exceptionally high-flying bird. Many places – such as the Piazza San Marco – are easily recognizable, as are buildings such as the Doge's Palace or the church of the Frari, not much altered over the intervening five hundred years. The question that immediately comes to mind – in the twenty-first century as much as the sixteenth – is, 'How on earth was it done?'

When addressing the doge and the government, Kolb did not go into details. Instead, he stressed the 'almost unattainable and incredible skill' required to carry out this enterprise. It had been a collaborative effort. Kolb himself was a businessman from Nuremberg who was resident in the city, as were many merchants from the German-speaking lands north of the mountains. He had funded, and also probably instigated and overseen, the project. It was an international affair: a product of the Venice–Nuremberg nexus. Its immediate predecessors were the city views by Michael Wolgemut in the lavishly illustrated *Weltchronik*, published in 1493. Copies of this luxurious publication were part of Kolb's trading stock, and perhaps prompted his scheme to make a giant view of Venice in the first place.

The techniques involved in making woodcuts, such as the finely detailed carving of the wooden blocks with which they were made, were northern specialities. So a task such as this probably required skilled technicians to be imported from Germany. But not all the team were northerners, since at least one of the artists who worked on the view of the city was a local man named Jacopo de' Barbari. Probably, the Venetian government had a hand in the process too. At this date, sheets of paper this large – each of the six is almost seventy by one hundred centimetres – were not being manufactured. Therefore, the basic material, and the equipment necessary to produce it, would have had to be made especially for this project.

For similar reasons, the view would have had to be printed on supersized presses built for the purpose. Just finding six suitably large, fine-grained pear-wood blocks must have been difficult. In all, this suggests state support, or at least approval for an enterprise intimately connected with

both political prestige and – maps being vital in war – military security. Most formidable of all the problems was what Kolb called 'the difficulty of the overall composition'. The only way this could have been done, as the scholar Juergen Schulz argued, was by making a series of separate aerial views from the highest points available, which were the campaniles of the city and perhaps the roofs of a few high buildings. The methods of surveying available in 1500 simply were not adequate to map a place as bewilderingly complex, as full of twists, turns, and curvilinear geometry as Venice. There remains, then, only one other possibility. It must have been pieced together from lots of overhead prospects at various heights. Then the whole thing would have had to be adjusted, so as to appear to be seen consistently from the south – and from much higher than any actual campanile. Angles of view would have had to be altered and reconciled. This process would have required amazing levels of what Kolb calls 'mental subtlety'.

This method is reminiscent of the way David Hockney made his photographic collages in the 1980s, such as *Pearblossom Hwy*, which is composed of 850 smaller images, each taken from a distinct angle and distance from the object that it represents. One of the most testing aspects of this, the artist discovered, was fitting one segment of the jigsaw onto the next. Close examination of Kolb's great map reveals awkward junctions between separate sightings, analogous to the intersections between Hockney's photographs. Similarly, Schulz found the joins between the different prospectives, gaps into which more than one building or campo has disappeared.

Schulz declared that this view was a work of art – implying that there must have been one single figure in charge of it all: the artist. He believed this person to have been de' Barbari (1460/70–before 1516), a local painter who subsequently moved to Germany. He was well known to Kolb and his friend Albrecht Dürer (whom we shall soon be meeting again). The god Mercury in the sky above and Neptune seated on a dolphin in the lagoon below and the winds puffing out their cheeks are certainly in de' Barbari's style. But there was another form of production of art: the workshop. In the workshop model, for certain paintings, the master would execute the main figures, senior assistants would create the background, and more junior helpers would prepare the panel or the canvas. Similarly, the *View* of Venice

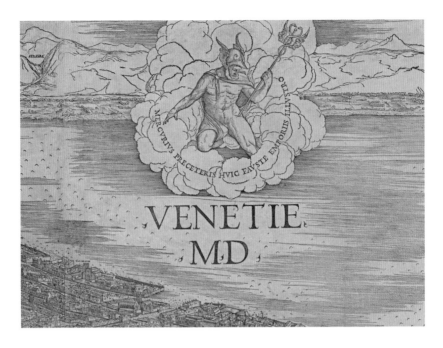

JACOPO DE' BARBARI *View of Venice*, 1500 (detail)

may well have been the achievement of a team. De' Barbari would have been responsible for the classical staffage, but someone else would have been tasked with the 'mental subtlety' of piecing the whole civic vista together (skills of which the Venetian showed no sign in any of his other works).

As Hockney has observed, there is no such thing as a neutral picture: every depiction of anything in the world is seen from a particular angle, or angles, with certain interests in mind. In the case of the *View*, fantastically detailed and accurate in many respects though it is, there are revealing biases. The western quarters of the city have been oddly scrunched, while the great naval dockyard of the Arsenale is given ample attention, as are the boats bringing goods from the Adriatic and the east. The central axis passes from Neptune's trident to Mercury's right arm – straight through the Piazzetta and the Piazza San Marco, up the main commercial thoroughfare – the Merceria – to the Rialto and the headquarters of the German merchant

community, the Fondaco dei Tedeschi. Just behind Mercury and to his left is the Brenner Pass, the main route over the mountains to the north. This picture was not only made by Kolb; it also represents his point of view as a businessman from Nuremberg. This is a picture that is essentially about trade – and especially goods coming by sea from the east and south and travelling north. In between is the labyrinthine city itself: a permeable filter through which things, people, ideas, and information are constantly passing – and, as they travel through, leaving a residue in the place behind. Hovering in the air above, Mercury declares that this is his most favoured marketplace. 'I Mercury shine favourably on this above all other emporia'. In the lagoon below, Neptune's trident bears a placard reading, 'I Neptune reside here, smoothing the waters at this port'. This, in other words, is the greatest, most perfectly located bazaar in the Western world.

<p style="text-align:center">*</p>

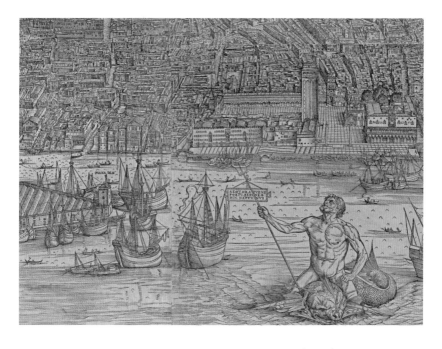

<p style="text-align:center">JACOPO DE' BARBARI View of Venice, 1500 (detail)</p>

Venice is also, of course, a wonder – a city so unusual that it caused amazement (and sometimes repulsion) long before Kolb, de' Barbari, and company got to work. This was part of the point of making such an elaborate depiction of it, using what was then cutting-edge technology. In 1500, Johannes Gutenberg's printing press was some sixty years old, but Kolb's scheme pushed its potential further than ever before. The resulting product was indeed unusual: a huge image of this centre of commerce that could be multiplied indefinitely and traded itself (it seems to have hung on the walls of many Venetian houses).

The uniqueness of Venice's position was its fortune. A description of the city sounds like a riddle. What is in the sea, but not in the sea? Answer, a lagoon, which is navigable by boat but only if you know the routes through the watery labyrinth, so safe from attack. What is natural yet artificial? Venice itself, since it was constructed on marshy islets in the waters of a naturally occurring phenomenon: the shallow body of water that forms when the flow of rivers is dammed by a barrier such as the sandbanks of the Lido. But those silty, sandy outcrops in the lagoon have been shaped, extended, and raised by generations after land reclamation. And the lagoon would have silted up long ago if the Venetians had not taken careful steps to prevent it from doing so. The city is a delicately balanced joint product of natural forces and human intervention. The latter's management was generally wise until the twentieth century; thereafter, often catastrophic.

The Venetians of the Renaissance had a good idea of the conditions in which their ancestors had lived in much earlier times. A painting by Domenico Tintoretto, son of the great Jacopo, represents Saint Mark blessing the islands of Venice (a legendary event that would have happened, if it had really occurred, in the first century). Behind the saint, ancient Venetians can be seen living in reed huts a foot or two above water level. If you take a boat into the northern areas of the lagoon to an island such as Sant'Erasmo, you can still see a landscape much as it would have been a thousand or two years ago. Small sandbanks known as *barene*, covered with hardy, salt-resistant grasses, rise above the surface. Between them, there is a network of channels; elsewhere – in what seems to be open water – the navigable routes between sunken banks and shoals are just as complex.

DOMENICO TINTORETTO *Saint Mark Blessing*
the Islands of Venice, 1587–90

In her series of crime novels, the American author Donna Leon often describes how her Venetian detective Commissario Guido Brunetti has internalized the entire route map of the city. He may be thinking over some mystifying series of events, but while he is doing so his legs and feet take him unerringly to his destination. A native, born and bred, he has the entire place in his head. This is an impressive feat because the plan of Venice is utterly irrational: the opposite of a town built, like Manhattan, on a geometric grid. The original settlements were randomly distributed on the *barene*, small islands and mudflats sticking up out of the lagoon. The first thoroughfares were the natural water courses that wound between them. Next came paths between spots where people happened to want to go, and – eventually – bridges, although for a long time those who wanted to move from one islet to another used a boat or maybe just waded across. In 1581, in a pioneering guidebook entitled *Venetia, città nobilissima, et singolare* (Venice, most noble and unique city), Francesco Sansovino observed that, despite the title, this is in reality 'not one but many separate cities, all conjoined together'. In terms of its early evolution, this was correct.

The city coalesced slowly, planned by no one in particular. According to legend, the traditional date of its origin was noon on Friday, 25 March 421, when the city's first church, San Giacomo, was dedicated. But archaeological evidence suggests that there were people living in the lagoon in Roman times. It had probably been inhabited much earlier; wetlands were often favourite sites for human occupation. But at that time, the area was marginal. In the unsettled period after the collapse of Roman power in the west, however, this place became increasingly valuable as a secure maritime point of interchange between east and west.

One piece of solid ground was named *Rivoaltus* – Rivo Alto in Italian, Rialto to Venetians (and, consequently, to everybody else). This is variously translated as 'high bank', 'high shore', and 'high channel'. Through it (or past it) flowed a particularly deep waterway, which perhaps was originally the course of the river Brenta before too much silt accumulated and the lagoon formed. A river, T. S. Eliot declared, is a sort of god: a 'strong brown one'. Early on, the poet wrote, it forms a frontier; later, it is useful, though untrustworthy, as 'a conveyor of commerce'. Finally, it is 'only a problem

confronting the builder of bridges'. This list more or less encapsulates the role of the Rialto. Here more than anywhere else was the point of interchange, where east, west, north, and south met (and not coincidentally where the German merchants had their headquarters). From early on, this was the site of an important crossing – by ferry, pontoon bridge, and then a permanent structure.

In medieval Venice (and afterwards), weighty buildings were typically constructed on a wooden platform, or *zatterone*, made up of two or three layers of planks. This in turn rested on a dense mass of wooden piles, typically one and a half to three metres long, driven into the alluvial silt and mud beneath. In other words, you might say the walls, bridges, and towers of Venice are floating. Beneath them are so many rafts, held up by a dense thicket of poles, which in turn lie on top of the waterlogged subsoil beneath, where the process of rotting is arrested by the lack of air. Twenty-first-century dendrochronologists have drilled down into the ground beneath the southern end of the current Rialto Bridge and removed core samples from the wooden piles that support the massive masonry above. The earliest dated to the year AD 960 (plus or minus 59). Venice rests on ancient foundations.

*

While the area now known as the Rialto was the commercial heart of this community suspended on tree-trunks driven into mud, the political nerve centre was a short distance away, in the administrative complex that John Ruskin boldly described as 'the central building of the world': the Doge's (or Ducal) Palace. Ruskin did not mean this claim politically or geographically. His reasons were architectural. He argued that this structure contained the three basic styles of building that he had identified – 'the Roman, Lombard, and Arab' – blended 'in exactly equal proportions'. His vocabulary was eccentric – by 'Lombard', he meant European medieval styles, and by 'Arab', what we might call 'Middle Eastern' or 'Islamic'. But his essential point was correct. In her study of the architectural relations between Venice and the Islamic world, Deborah Howard traced the origins of the most startling, beautiful, and unusual feature of the medieval walls of the Doge's Palace: the crisscross lozenges of oblong red-and-white stone on its upper levels.

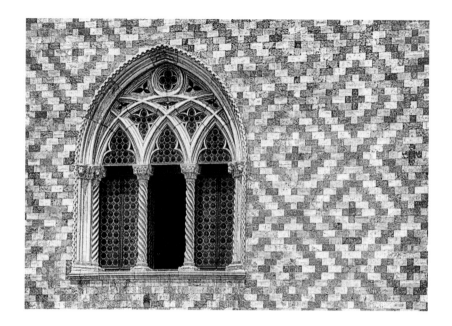

The crisscross pattern and one of the large windows on the upper level of the Doge's Palace

It seems that this pattern was derived from Iran. The huge dome of the Great Mosque at Yazd, Howard writes, 'is decorated in a very similar diaper design in glazed tiles, shimmering like a mirage in the desert sun'.

Venice was not only a nodal point at which physical objects were exchanged, ideas – including visual ones – also passed through it. One of the few widely read books by a Venetian is *The Travels of Marco Polo*, first published around 1300. It was a collaboration between Polo (*c.* 1254–1324) – a well-travelled merchant – and Rustichello da Pisa, a writer of chivalric romances, while they were in prison together in Genoa. Analysis suggests that the latter contributed the more imaginative and improbable details, while Polo provided a dry account of the commercial potential of each exotic place: its population, principal products, and their quality. This soberly practical attitude explains why he famously failed to mention the Great Wall of China: it was of no interest to a businessman.

Polo was by no means the only medieval Venetian who travelled to distant lands; he was just the only one who happened to get his notes written

up (by Rustichello). Others went to Iran, even apparently as far as China. Merchants from the city spent years in eastern Mediterranean places such as Istanbul, Alexandria, and Acre, where they maintained permanent premises, just as the Germans did in Venice at the Fondaco dei Tedeschi (the name comes from the Arabic *funduq*, a form of hostel for travelling merchants).

There was a yet more exotic ingredient in the cross-cultural fusion of the palace: astonishingly, the Venetian master masons may have derived some elements from distant England. Eduardo Arslan, an authority on Venetian Gothic, quotes Nikolaus Pevsner's observation that in the early fourteenth century, 'the architecture of England was, although the English do not know it, the most forward, the most important and the most inspired in Europe'. This is the style, labelled 'Decorated', that can be seen, for example, in Wells Cathedral and the Angel Choir of Lincoln Cathedral. Arslan points out that the four large windows of the palace – two on the eastern end of the facade facing the water, and two more around the corner on the Rio di Palazzo – look very much like English 'Decorated'.

*

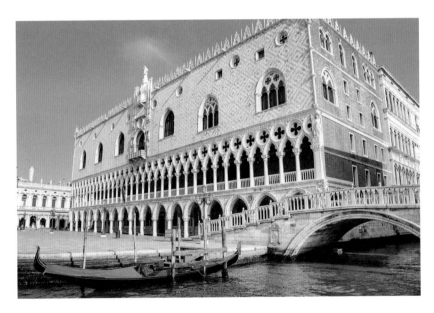

The eastern front of the Doge's Palace facing the lagoon, with the Rio di Palazzo on the right

Followers of Critical Theory are fond of using the word 'construct' to describe the formation of an idea. But the visual identity of Venice was quite literally constructed out of physical bits and pieces: broken stones, carvings, exotic patterns. The fabric of the city is like a three-dimensional collage or, to be more exact, an *assemblage*: a work of art made of sundry items stuck together. Some of these were looted, some just removed from ruins or derelict structures; possibly a few were even purchased.

At the end of the Piazzetta are two pink-grey granite columns, filched from Alexandria. On one stands the so-called Lion of Venice, symbolizing Saint Mark the Evangelist and thus the Venetian state. Nobody is entirely sure where this bronze sculpture comes from: over the years, different scholarly authorities pronounced that in origin it was medieval, Chinese, Assyrian, Sasanian, or archaic Greek from the sixth or seventh century BC. This was the confused state of play up until 1990, when the Lion was taken down and subjected to exhaustive technical examination. After analysis of the composition of the various bronze alloys, Bianca Maria Scarfi concluded that the sculpture was a metallurgical jigsaw, resulting from five phases of 'restoration and reconstruction', the latest in 1892 and the first around the fifth century AD.

Originally, Scarfi wrote, it might have been 'an early oriental Hellenistic lion-griffin executed by a Greek or Ionian Greek artist between the close of the fourth and beginning of the third centuries BC'. However, only a few parts of the beast as it currently exists are original: just the head, neck, breast, and some portions of the legs. The rest has been added at different points since it arrived in Venice, probably beginning long before 1293, when it makes its first documented appearance in history. Since then it has been through many vicissitudes, including being taken to Paris in 1797 by Napoleon's forces, in the process of which it was broken up and lost its paws and tail, before being put on a plinth in the Place des Invalides, dropped when it was being taken down to be repatriated, and returned to Venice as a mass of fragments. And that is just the Lion: the city, especially the area around San Marco, is peppered with such objects. The Horses of San Marco, looted from Constantinople in the thirteenth century, are only the best-known example.

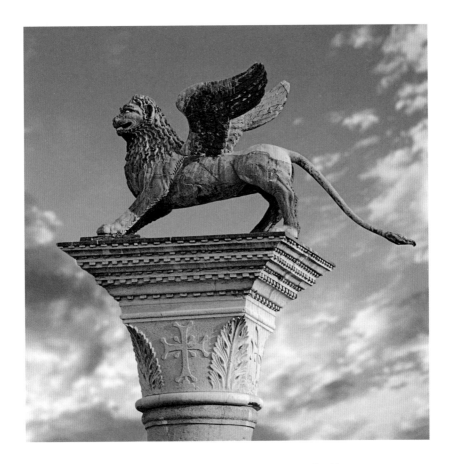

The Lion of Venice atop a granite column in Piazzetta San Marco

Those most celebrated of Venice's stolen treasures can be seen in another, equally radical view of the city made four years before Kolb's vista. This is a painting by Gentile Bellini, who signed and dated it some time around 1496: 'GENTILIS BELLINI VENETI EQUITIS•CRUCIS / AMORE INCENSUS•OPUS'. Thus he pithily conveyed that he had been ennobled by the Holy Roman Emperor, that he fervently revered the Holy Cross, and that this sensational picture was his work. At its centre, the Horses of San Marco gleam on the facade of the basilica, the spot they occupied – with a brief sojourn in Paris – from the fourteenth century until the 1970s.

This picture is known as *A Procession in the Piazza San Marco*, which is a reasonable description of what it represents (see pages 32–3). However, at least nominally, its subject was a miraculous cure that had taken place in 1444. It was intended to adorn the Sala dell'Albergo, or boardroom, of the Scuola Grande di San Giovanni Evangelista. The true subject of the painting was perhaps something closer to 'the glory, piety, wealth and patriotism' of this organization. The *scuole* were Venetian institutions that we shall come across a lot. Originally, they had evolved from medieval orders of voluntary flagellants, who would process the city in penitence, whipping themselves and bleeding. Occasionally this still occurred, the self-flagellation generally being carried out by less wealthy and senior members. But over the years, they had developed into a combination of lay religious confraternity, a cooperative devoted to mutual assistance, and a club. The *scuole* were part of the social glue that held Venice together. Rich and poor alike belonged to them, and they allowed those who were barred from any role in actual politics to find an honourable niche in the hierarchy. But there was a degree of rivalry between the major confraternities that verged on the unseemly. They vied with each other over the magnificence of their premises, and also the holiness of their saintly relics. More than one *scuola* owned a piece of the true cross – but the Scuola Grande di San Giovanni Evangelista, dedicated to John the Baptist, naturally believed their splinter was more miraculous than the others.

As mentioned above, the ostensible subject of Bellini's picture is an event that had taken place on 25 April 1444. One Jacopo de' Salis, a merchant from Brescia, had travelled to Venice for the annual feast day of Saint Mark. While he was there, he got word from home that his son had had a fall, fractured his skull, and was dangerously ill. As the contingent from the Scuola Grande di San Giovanni Evangelista passed by holding aloft their precious reliquary, de' Salis knelt before it, imploring divine aid. When he got back to Brescia, he discovered that the boy had recovered at that very moment. The difficulty about this event, from the artist's point of view, was that it had taken place in two separate places simultaneously, and the most crucial aspects of the narrative were effectively invisible. To the modern observer, finding de' Salis among the hundreds of figures is

rather like searching *Where's Wally?* puzzles. He, and his significance, may have been easier to spot in 1496, but nonetheless the principal interest of the picture must always have been its astonishingly, lovingly detailed depiction of this place, so familiar to all Venetians. When you see it, you believe that this is just what the Piazza San Marco looked like when the artist painted it, and you are right to do so. Some of the vanished features of the piazza so carefully depicted by Bellini can be checked. Traces of gilt paint, for example, have been found on the stonework of the basilica just as they appear in the picture. Therefore, through the painting we know exactly what the thirteenth-century buildings of the Procurators of San Marco, to be seen on the right, and the Procuratie Vecchie, on the left, looked like, although both were rebuilt centuries ago. The painter would not have had to move far to study his subject. This was not just the most important place in Venice, it was the backdrop to his life – the setting with which he had grown up and saw every day. His father Jacopo Bellini's lodging and workshop, which Gentile had inherited, was on the piazza opposite San Marco. So when we contemplate the picture, we are looking, near enough, at the view from the workshop window.

Gentile Bellini was proud of his achievements and was admired for them. A discourse written around 1497 on the proper behaviour of young Venetian aristocrats presented both him and his brother Giovanni as examples of selfless labour for the good of the state. Not only did they embellish the Doge's Palace 'with most beautiful paintings', they also 'decorate almost the whole city'. Urban views were not a novelty in European art of the day. They can be seen in the backgrounds of Flemish paintings, which were admired and collected in Venice. Florentine artists such as Domenico Ghirlandaio sometimes tucked them into the background. But such a work on this scale, and with such a meticulous degree of topographical accuracy, was unprecedented and extraordinary. The *Procession in the Piazza San Marco* is a picture of the past so faithful that looking at it comes close to time travel. What Gentile accomplished was made possible in part by the medium of oil, which allowed him to work slowly and meticulously, correcting errors, adding nuances of texture. As with many Venetian things, the ingredients were imported but the blend was novel.

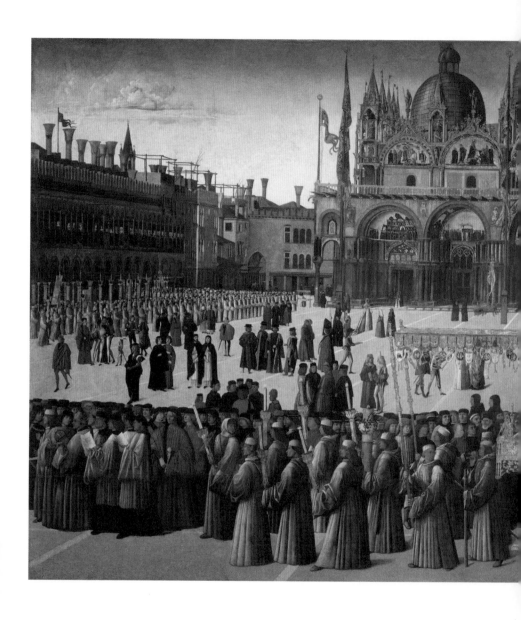

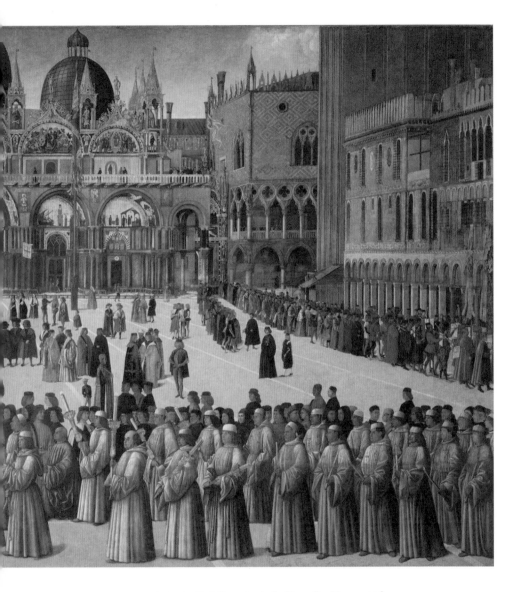

GENTILE BELLINI *A Procession in the Piazza San Marco*, 1496

CHAPTER TWO

THE BROTHERS BELLINI

The main rivals of the Bellini clan of artists in Venice were the Vivarini family, a group of talented, innovative individuals headed by Antonio Vivarini, who collaborated with his brother Bartolomeo, son Alvise, and brother-in-law Giovanni d'Alemagna. The splendid altarpiece of the Coronation of the Virgin painted by Antonio and d'Alemagna in 1444 for the church of San Pantalon reveals the pictorial tradition from which Venetian paintings were then emerging: a medieval, spiritual space symbolized by a field of gleaming gold. Unlike previous paintings, however, this golden world is inhabited by chunkily three-dimensional figures, some seated on a celestial throne painted in almost – but not quite – 'correct' linear perspective, with angels derived from the cupids of classical sculpture added around its base. This picture is the work of painters tentatively experimenting with the innovations of the avant-garde in distant Florence.

Jacopo Bellini did the same, but with more enthusiasm and inventiveness. His surviving paintings are rare (and disappointing), but two surviving sketchbooks – one in the British Museum, one in the Louvre – reveal that he was an ambitious, learned, and thoughtful artist. He was the founder of the Bellini family painting business – which also included Gentile and Giovanni, and was allied through marriage with Andrea Mantegna, one of the most brilliant artists in northern Italy. Apart from these sketches, the most impressive surviving work attributed to Jacopo is in the Cappella dei Mascoli, a small space opening off the north transept of the basilica of San Marco. In the mid-fifteenth century, this was decorated with a series of mosaics on the curved surface of the vault. Two of these were apparently

34

ANTONIO VIVARINI AND GIOVANNI D'ALEMAGNA
Coronation of the Virgin, 1444

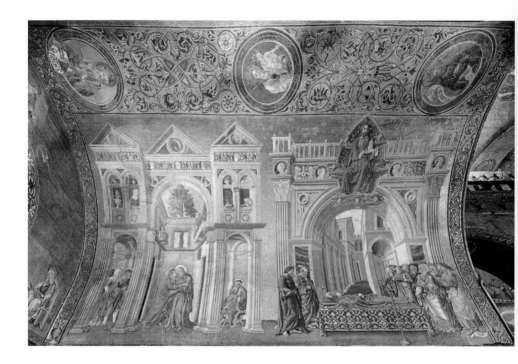

JACOPO BELLINI AND ANDREA DEL CASTAGNO *'The Visitation' and
'Dormition of the Virgin', Cappella dei Mascoli, Basilica of San Marco, c.* 1448

designed by Michele Giambono, a leading Venetian painter of the time, set
amongst Gothic architecture. On the opposite side, there are two scenes,
one of which is partly attributed to Andrea del Castagno, a painter in the
most up-to-date Florentine manner who worked in Venice in the 1440s.
He is thought to have conceived the architecture of the 'Dormition of
the Virgin', on the right. This consists of a triumphal arch depicted in the
rationally ordered manner of Filippo Brunelleschi's novel linear perspective.
Behind it, a distinctly Florentine-looking street opens out. The figures in
this scene and the one to the left, 'The Visitation', are attributed to Jacopo
Bellini. So in this patch of wall you can simultaneously see him learning
from cutting-edge Tuscan art and, slightly timidly, following suit. The effect
is of the Renaissance suddenly breaking into a setting that is otherwise
entirely Byzantine.

The Vivarini were eventually overshadowed by the Bellini brothers, both of whom were brilliant, and one of whom – Giovanni – matured into the first truly great artist in the Venetian tradition. Gentile – probably the older brother – was named after a famous artist, Gentile da Fabriano, who had trained Jacopo. From his christening, he had been destined to become a painter. In 1474, Gentile, then perhaps in his mid-forties, was asked to replace the cycle of paintings in the council hall of the Doge's Palace, the Sala del Maggior Consiglio. This huge room was the parliament chamber of the Republic of Venice. It had been decorated with a cycle of pictures representing an episode in 1177 when the Venetian state had acted as intermediary between the Holy Roman Emperor Frederick I and Pope Alessandro III. This incident was crucial to the Venetians' political sense of themselves, suggesting that the Republic was a third force, separate from and equal to the empire and the papacy. Gentile Bellini was asked to replace the existing cycle since it had deteriorated, no doubt because it had been done in fresco. The commission was an honour, and one probably earned by the efforts of the Bellini family over decades. The motion passed by the Senate was effusive, describing Gentile as 'outstanding painter and excellent master'.

He won considerable prestige with this ambitious project in the Sala del Maggior Consiglio. Gentile's works did not remain in place very long, however: they went up in flames during a fire on 20 December 1577. But they had impressed many people, including Giorgio Vasari, whose descriptions make clear that they were similar to the *Procession in the Piazza San Marco* that we saw in the last chapter. They also featured detailed depictions of the city, especially the Doge's Palace, the Piazza San Marco, and the facade of the church. Vasari also mentions 'innumerable portraits from the life', and the latter seem to have caught the eye of an unexpected connoisseur, an Ottoman envoy. For centuries, Venice was intermittently on the losing side of a bitter war with the Ottoman Turks. But they were curiously intimate enemies. Their mutual borders were porous and shifting, the product of a long tussle for control of the eastern Mediterranean and profound religious difference – each regarding the other as infidels – but Venice and the Ottomans knew each other well. Each was fascinated by their foe.

In 1479, a peace treaty with the Turks was concluded by a senior Venetian emissary, Giovanni Dario. An Ottoman ambassador came to Venice in April and was received in the Sala del Maggior Consiglio, by now adorned with several new paintings by Gentile Bellini. Whether coincidentally or not, a few months later, in August, the Venetian government received an unexpected request: Mehmed the Conqueror, the Ottoman sultan, asked them to send 'a good painter' to work for him in his new capital Constantinople or, as it became, Istanbul. The Signoria responded by dispatching Gentile.

A few years later, a chronicler named Jacopo Filippo Foresti da Bergamo updated his account of history from ancient times onwards to include a note on Gentile, 'a very famous painter of this time'. This passage was added only a few years after Bellini's return – in fifteenth-century terms, almost breaking news – and detailed enough to suggest that Jacopo had been briefed by the artist himself. Gentile was, Jacopo enthused, not only shedding glory on Venice, but 'on all of Italy with his unheard-of and admirable style of painting. … His talent one day reached the ears of Mehmed, Prince of the Turks, who, burning with desire of seeing him, wrote humbly to the Venetian Senate with a request that it should as a great favour send [Gentile] to him in Istanbul as a gift.' The word 'humbly' was perhaps not strictly accurate: humility was not a quality to be expected from Mehmed the Conqueror. But the rest of Jacopo's report seems circumstantial. When Gentile arrived, to 'test his skill', Mehmed made him 'paint a great many marvellous and extraordinary paintings of himself and almost countless other subjects'. At least one of these portrait studies seems to have survived. In Istanbul, Bellini would presumably have lived in the Topkapi Palace, and – the art historian Alan Chong suggests – probably spent time in the Third Court, where the Sultan had his own quarters, and which also contained a school for the young men and boys destined to run the Ottoman Empire. These pages were described as being of 'signal physical beauty and nobility and talent of soul'. This tallies with another detail mentioned by Giovanni Maria Angiolello, a Venetian subject from Vicenza who was in Mehmed's service at exactly the time Gentile was working for the Sultan. He related that, 'when the Sultan wanted to see someone noted for being a handsome man, he had him portrayed by the said Gentile Bellini'. A watercolour

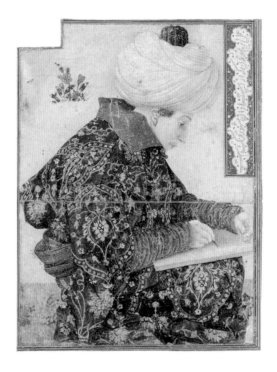

GENTILE BELLINI *Seated Scribe*, 1479–81

drawing of a young man seated and writing is at once a delicately accurate portrayal of the subject's features and hands – one clasping a pen, the other resting on a block of paper – while also depicting his sumptuous robe with a connoisseur's eye for pattern and texture (qualities of special interest to textile-trading Venetians in general and Venetian painters in particular). The attribution has been doubted, but if this really is by Gentile, he managed to find a point of balance between the traditions of East and West. It is a beautiful, but also a brilliantly diplomatic work.

*

None of the births in the Bellini family is documented. A reasonable guess, though no more than that, is that Gentile was born in the first half of the 1430s and Giovanni, a few years afterwards in 1435 or later. Nor do we

know their exact relationship. Contemporary documents, including Gentile's will, describe them as brothers. Some, however, believe that Giovanni was illegitimate since he was not mentioned at all in the will of Jacopo's wife. An alternative theory proposes that he was actually a very late bastard fathered by Gentile's grandfather, and that – technically – the two painters were not brothers at all, but uncle and nephew. What is clear is that their relationship was close. Gentile describes Giovanni as his 'dear brother'; Vasari wrote that the latter was 'bereft' when the former died, whom 'he had ever loved most tenderly'.

But from early on, Giovanni took a distinct path – or so we deduce from his pictures, and also from a change of address. The first surviving mention of Giovanni was in 1459, when he was witness to a will. At this point, he was perhaps in his mid-twenties and living in the parish of San Lio. This implies that he was living apart from his father, mother, and Gentile. There must have been a good reason to split up Bellini and sons. One possibility is that the move was the result of a business decision on the part of the clan, presumably with the backing of Jacopo, who was still firmly in charge. According to this theory, the Bellini elected to diversify. One branch would continue to specialize in the large, official paintings for *scuole* and the Doge's Palace, which Gentile would supply. The new work headed by Giovanni would explore other possibilities such as altarpieces and the emerging market for pictures to hang on the walls of private houses.

When Albrecht Dürer of Nuremberg was living in Venice in 1506, he quickly got on friendly terms with the older Giovanni Bellini (the former was in his mid-thirties at this point, Bellini perhaps seventy). On 7 February 1506, when Dürer had been established in the city for only two or three months, he reported proudly to his friend Willibald Pirckheimer that Bellini:

> has praised me highly to many gentlemen. He would willingly
> have something of mine, and came himself to me and asked
> me to do something for him, and said that he would pay well
> for it and everyone tells me what an upright man he is so that
> I am really friendly with him. He is very old and yet he is the
> best painter of all.

Joachim Camerarius (1500–74), a German humanist who knew Dürer later in his life, gave some more details of this interchange between two celebrated artists from different generations and traditions. He recounted a discussion between the two:

> Bellini also candidly expressed his admiration of various features of Albrecht's skill and particularly the fineness and delicacy with which he drew hairs. It chanced one day that they were talking about art, and when their conversation was done Bellini said: 'Will you be so kind, Albrecht, as to gratify a friend in a small matter?' 'You shall soon see', says Albrecht, 'if you will ask anything of me I can do for you.' Then says Bellini: 'I want you to make me a present of one of the brushes with which you draw hairs.'
> Dürer at once produced several, just like other brushes, and, in fact, of the kind Bellini himself used, and told him to choose those he liked best, or to take them all if he would. But Bellini, thinking he was misunderstood, said: 'No, I don't mean these but the ones with which you draw several hairs with one stroke; they must be rather spread out and more divided, otherwise on a long sweep such regularity of curvature and distance could not be preserved.' 'I use no other than these,' says Albrecht, 'and to prove it, you may watch me.'
> Then, taking up one of the same brushes, he drew some very long wavy tresses) such as women generally wear, in the most regular order and symmetry. Bellini looked on wondering and afterwards confessed to many that no human being could have convinced him, by report, of the truth which he had seen with his own eyes.

In the quarter century between 1506 and 1532, when Camerarius published his translation, the incident might well have been improved and embellished in the writer's classically stocked mind. But essentially it is highly plausible: this is just the kind of question – about tools and techniques, not theory – that Dürer and Bellini might have talked about. The problem of how to depict long, wavy hair was a challenge that fascinated fifteenth- and early sixteenth-century artists (Leonardo devoted many drawings to it). Bellini had already done so superbly, as one can see from the softly curling

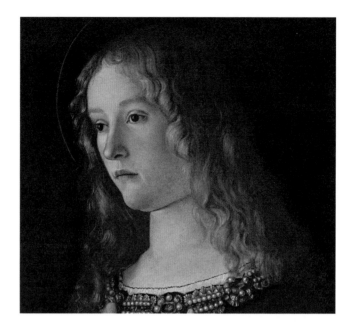

GIOVANNI BELLINI *Madonna and Child with Two Saints*, c. 1490 (detail)

tresses of Mary Magdalene from a picture of the Madonna and Child and two saints done around a decade and a half before. But perhaps he felt he could still do better; that there was more to learn.

It would not be surprising if he had thought that. He had been absorbing such lessons throughout his career. Naturally, he studied the paintings of his father, his brother, and his brother-in-law Andrea Mantegna. He was powerfully affected by the works of the last of those, a formidably talented artist who was, perhaps, a little older and far more precocious. Giovanni Bellini actually used a tracing of Mantegna's *Presentation in the Temple* as a basis for his own picture of the same subject.

He did not follow his brother-in-law's *Agony in the Garden* quite so closely – even so, he recycled Mantegna's composition and tried, less successfully, a similarly audacious foreshortening of the sleeping disciples. The intriguing thing, however, is how dissimilar Bellini's picture (see page 44) is in other ways. Mantegna's landscape is hard and rocky, and even his figures look

as if they have been chiselled out of stone. In contrast, Bellini's figures are more softly modelled, and his scenery is full of light and air. In the distance breaks one of the earliest and most beautiful dawns of the Renaissance.

A technical examination carried out by the National Gallery in London, which owns both paintings, revealed a fundamental difference between Bellini and Mantegna. Both had begun by making a carefully detailed drawing on the panel that they were going to paint. But whereas the face of Mantegna's Christ is clearly defined, Bellini's is shaded. So, from the very beginning he imagined the head of his main figure silhouetted, dark against the luminous sky behind. His *Agony of the Garden* is illuminated by naturalistic light at a particular moment during the day. The dawn and the landscape that it is slowly revealing – with winding paths, shadowy olive-coloured hills, and walls of buildings just being caught by the rays of the rising sun – is an integral part of the drama. Indeed, it is the point of

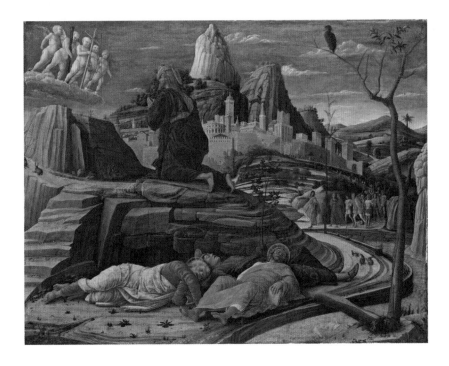

ANDREA MANTEGNA *Agony in the Garden, c.* 1455–6

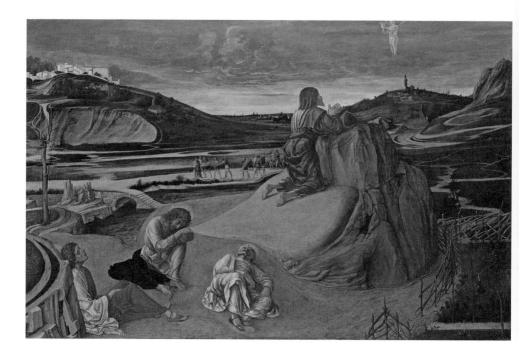

GIOVANNI BELLINI *Agony in the Garden, c.* 1458–60

the picture. This one small work done close to the start of Bellini's career demonstrates his originality. He was an *atmospheric* painter, one of the first in Italy. Instead of every item in the picture being sharply delineated as in, say, a Botticelli, Bellini's forms blend, one into another. This process has only just begun in the *Agony in the Garden*; Christ's robes do not have soft edges. But the grey tops of the cumulus clouds in his sky, and the shadowy slopes of the hills below definitely, beautifully do.

We can make a guess at an additional model that Giovanni must have studied. It was a multi-scene altarpiece by Dieric Bouts, a painter from Haarlem who later settled in Louvain. This work seems to have arrived in Venice soon after it was finished, in the 1450s. According to tradition, it belonged to the Foscari family, perhaps bought by Doge Francesco Foscari, who was in power from 1423 to 1457. But the reason we can be sure that it was in Venice is that we can still see the effect it had on the youthful

Giovanni. Everything about these pictures would have been fascinating to him, but most of all the landscapes, like that in the Bouts's *Resurrection*: the winding paths, dark hills, and leafy trees outlined against the luminous dawn. Reimagined and reconfigured, improved and extended, these reappear in the *Agony in the Garden*, and many other pictures.

Later, Giovanni adopted the oil medium that was favoured by northern painters and the Sicilian Antonello da Messina, who worked in Venice around 1475–6. But to their naturalism he added other ingredients such as the expertise in architectural perspective that had been a particular enthusiasm of Jacopo Bellini's. He also had a sense of the structure and proportions of the human body that came from a study of ancient sculpture, which the Bellini family collected. Gentile inherited Jacopo's drawings and 'other things pertaining to the art of painting'. One of these was a sculpture, 'the Venus of Paphos'. An obscene poem by Bartolomeo Fuscus described Giovanni in bed with a beautiful apprentice, 'an ideal model with limbs better proportioned than a Greek statue'. Whether this is a joke, a libel, or an accurate report of the great painter's sexual habits is hard to say. But the naked bodies of male saints were certainly a subject that – like landscape and locks of wavy hair – he excelled at painting.

*

From the moment that it was finished, around 1487 or 1488, Giovanni's altarpiece in the friary of San Giobbe (Saint Job) was renowned. It was noted in a pioneering description of Venice by Marcantonio Coccio Sabellico – published around 1495 – one of only two works of art mentioned: 'A noticeable panel by Giovanni Bellini, which shows us the main principles of his art'. By the mid-fifteenth century, rather than paint the sacred figures of an altarpiece, more advanced artists and patrons preferred to depict them altogether as if they had met in some celestial conference room. This is an arrangement dubbed by art historians a *sacra conversazione*, or sacred conversation. As interpreted by Bellini, however, '*sacra meditazione*' would be more apt. Each of his figures seems lost in contemplation. Writing some satirical verses about painting, a scurrilous Venetian poet named Andrea Michieli, known as Squarzola or Strazzola, described a badly painted figure

of Christ lamenting that if only he had been painted by Bellini, 'I would have been much more human and more divine.' It was an acute remark. The figures manage to be exactly both of those: human and divine.

At San Giobbe, Bellini created an illusionary extension of the actual church, which is not a symmetrical structure. The left side of the nave is divided by the arched entries of three chapels, but the opposite side is blank. Bellini's altarpiece was for the central place on this wall, and the painting that he produced was a trompe l'oeil chapel, perfectly melded in its design not only with its frame but also with the chancel, which had recently been refurbished in an up-to-date classical style by the architect Pietro Lombardo. The painter must have collaborated closely with Lombardo, whose workshop made the stone frame that blends precisely with the painted architecture. Bellini was always concerned about such things; one of his placatory offers to Isabella d'Este, Marchioness of Mantua, was to 'have a most beautiful frame made' for her very late-delivered *Nativity*.

The painted chapel would have melded with the frame, but also with the space of the actual church (sadly the painting was long ago removed to the Accademia). You seem to be looking up into a sort of heavenly annex, in which the revered, succouring divine beings look extraordinarily real, yet also remote. As we have seen, Jacopo Bellini designed a mosaic in San Marco representing up-to-the-minute Florentine perspective and classical architecture. At San Giobbe, Giovanni reversed the process. He painted not only the figures and the architecture, including a receding barrel vault but also a glittering mosaic in the apse. In the niche of the apse there were seraphim, holding the inscription, 'Ave [Maria] Gratia Plena' (Hail [Mary] full of grace), with marble panelling that rippled like water beneath. Contained within this sumptuous painted structure was an empty, light-filled space; a shadowy vat of air. Even that void seems to have its own special quality, filled with the silent yet visible music of the angels, the atmosphere still and slightly golden. Bellini had painted an altarpiece that was both a zone of virtual reality and a glimpse into the audience chamber of heaven.

GIOVANNI BELLINI *San Giobbe Altarpiece, c.* 1487 (photomontage showing the painting in its original frame in the church of San Giobbe)

By the end of his long life, everyone, at least in Venice, acknowledged Giovanni's extraordinary abilities. When Gentile died in 1507, Marin Sanudo (1466–1536) recorded the fact in his diary, then added, 'there remains his brother Giovanni Bellini, who is the most excellent painter in Italy'. When, a decade later, the Republic presented the sister of the king of France with a painting of the Madonna, as the Venetian ambassador handed it over, he echoed Sanudo's verdict, but added a reassurance that by then meant something to connoisseurs in Venice: Giovanni's numerous assistants had done none of this painting. The picture was, he informed her, 'entirely by the hand of the first painter in Italy'. This made such a work of particular value in the eyes of a new category of person who was just emerging: the collector.

One such individual we know a great deal about, because so much of her correspondence survives, is Isabella d'Este. As she herself admitted, Isabella was greedy for art, and had an 'insatiable desire' for Greek and Roman antiquities. Not surprisingly, given the strength of these acquisitive urges, she was impatient – she threatened one painter and the team of parquetry-makers assisting him with a spell in the dungeons if they did not get a move on with her commission. On the other hand, as befitted a follower of fashion, she was impressed by stardom and consequently prepared to put up with delays and even an outright brush-off from a celebrated artist such as Leonardo da Vinci. Part of her interest in Bellini was a persisting desire among those interested in art: she wanted to compare and contrast his work with that of other masters. This is an exercise still carried out by innumerable exhibitions, books, and blogs. In the fifteenth century, the only way to do this was to put original works side by side. In April 1498, Isabella wrote to the Milanese noblewoman and poetess Cecilia Gallerani, asking to borrow Leonardo's portrait of Cecilia – the masterpiece now known as *Lady with an Ermine* – so that she could look at it beside 'certain beautiful portraits by Giovanni Bellini'. She explained that she had been looking at these, 'and we began to discuss the works of Leonardo and wished we could see some of them to compare with the paintings we have here'.

Isabella also wanted to own more pictures by Bellini herself. In 1496, she had begun to negotiate for him to paint a work for her small study, or *studiolo*. This was a pet project of hers, a room intended to express both her

taste and her ideas. It would contain pictures by the contemporary masters of painting with the greatest reputations – ideally including Leonardo and also Bellini. She took up the matter again in March 1501, her intermediary being a Venetian collector named Michele Vianello. He extracted a cautious agreement from the artist to execute a painting for Isabella, for the sake of his friendship with Vianello. This was despite the fact that Bellini was so busy doing pictures for the Sala del Maggior Consiglio that, 'he could never leave it from early morning until after dinner'. There followed a brisk haggle over the fee. Bellini asked for 150 ducats, and Vianello got the price down to 100, Isabella being on a tight allowance from her husband, and warned 'this is all that can be done'.

It was the start of a very long process. Bellini clearly had misgivings. He would have heard from his brother-in-law Mantegna – who was the Mantuan court artist – how tiresomely demanding Isabella could be. She wanted this painting to fit into a set of complicated compositions featuring allegorical figures and classical gods that she had concocted with her court poet. With another artist, Pietro Perugino, who was unwise enough to agree to this proposition, she proved a stickler for exact adherence to her script. Bellini – whose stipend as painter to the Venetian government arrived more dependably than Mantegna's from the Marquis of Mantua, and who had plenty of other work anyway – was not cornered so easily. When Vianello next caught up with him, Bellini announced he did not 'like the idea of the *Storia* [the narrative for the picture] that you propose'. He was 'unwilling' partly because the work would have hung alongside Mantegna's picture – and he was wary about risking the comparison, especially with a type of picture that was his speciality. Bellini must have expressed himself strongly. He seemed 'so reluctant' that Vianello advised that, 'it would, I think, be better to let him do as he pleases'. Unexpectedly, Isabella agreed, implying that she just wanted a picture by the artist; it did not matter what so long as it demonstrated the power of his brush and imagination. But her surrender did no good. Months went by. A new intermediary was called in: Lorenzo da Pavia, a famous maker of musical instruments and a connoisseur who knew the painter well. To him, Bellini promised to paint 'a beautiful *fantasia*' for the marchioness, but he had not yet set to work. 'He is a slow

man', Lorenzo noted gloomily. By and by, Isabella asked for her payment of twenty-five ducats to be returned.

That made no difference either. Neither the ducats nor the picture appeared. Bellini was evidently absolutely confident that he had the whip hand, even when dealing with a powerful – though distant – aristocratic patron. Eventually, Isabella gave up on her first idea. She just wanted something – anything – by Bellini. So she offered to put the twenty-five ducats towards the price of a Nativity, a speciality of Bellini's. Into such pictures, he was able to introduce extraordinary nuances of tenderness, grief, and sorrow: emotional atmospheres to match the subtleties of his landscapes (in an inscription on a Pietà, he claimed the painting itself was weeping). There was further haggling about the price: she thought fifty ducats was enough for a Nativity; he wanted one hundred. But he agreed to paint it 'with a distant landscape and other inventions, if this is agreeable to Your Highness'.

Even this painting – absolutely up Bellini's street – was not quickly forthcoming. Further ideas of hers were crushed. Could the master insert an infant Saint John? No, came back the answer: such a figure did not fit into a Nativity. She then suggested a Saint Jerome instead, to no avail. 'Apparently,' she wrote on 25 November 1502, 'Bellini will not hear of St Jerome being introduced in my Nativity.' She sighed, 'Let him do as he pleases.'

It took almost two years, and a complaint from the Mantuan ambassador to Venice, before the *Nativity* was finally delivered. Lorenzo da Pavia was less than entirely enthusiastic. But Isabella was delighted. The painting, she declared, was 'as dear to us as any picture we possess'. So pleased was she that, after an interval, she began a new campaign for Bellini to paint a mythological subject for her study. This time she enlisted the help of a young Venetian aristocrat and writer and friend of the artist, Pietro Bembo. Ultimately, this commission failed too. But on 11 January 1506, about the time that the elderly master encountered Dürer, Bembo produced a memorable description of Bellini's attitude to his art: 'He does not like to be given many written details that cramp his style; his way of working, as he says, is always to wander at will in his pictures, so that they can give satisfaction to himself as well as to the beholder.' Here was as succinct a statement of imaginative independence as pithy as any later painter has uttered, from then to now.

AT THE RIALTO BAZAAR: DÜRER AND GIORGIONE

few days earlier, on 6 January 1506, Dürer wrote from Venice to his friend Willibald Pirckheimer back home in Nuremberg. Like many people who visit the city, he had already spent a good deal of time shopping. Pirckheimer had asked Dürer to buy some jewelry for him, 'a few pearls and precious stones', and the artist had been looking for something suitable. However, there were difficulties. For one thing, Dürer explained, 'I can find nothing good enough or worth the money; everything is snapped up by the Germans.' For another, there were a lot of swindlers around. These sharp operators 'always expect four times the value for anything, for they are the falsest knaves'. His Venetian friends had warned him against such traders, telling him that 'they cheat both man and beast'. Nonetheless, Dürer persisted. There were many items on Pirckheimer's wish list: feathers for his hats, Middle Eastern carpets – but he wanted wide ones, not narrow – 'glass things' made by the craftsmen on Murano, and paper, although Dürer felt that what was available was no better than in Germany. Meanwhile, the artist was shopping on his own account, including for clothes.

A running gag in this bantering correspondence is that the artist's possessions are sending their regards. On 8 September, 'My French mantle greets you, and so does my Italian coat'; on another occasion, it was his

doublet and brown coat that spoke ('while your humble servant, Albrecht Dürer, wishes Herr Pirckheimer all health, great and worthy honour, with the devil as much of such nonsense as you like').

<p style="text-align:center">*</p>

Dürer was living close to the greatest marketplace in the Western world. All around the Rialto Bridge – and especially in the area south of San Giacomo di Rialto, reputedly the oldest church in the city – there were arcades lined with shops and wholesale emporiums. Radiating from the Campo San Giacomo, on both sides of the Grand Canal, were numerous alleys and thoroughfares packed with shops owned by goldsmiths, jewellers, textile merchants, and specialists in all manner of goods. This, wrote Marin Sanudo, was 'the most important and richest spot in Venice'. We can see the bridge that Dürer crossed and the bustle of the neighbourhood in *The Miracle of the Cross at the Ponte di Rialto* by Vittore Carpaccio (*c.* 1465–1525/6). This was a work from the same series, commissioned for the Scuola Grande di San Giovanni Evangelista, as Gentile Bellini's *Procession in the Piazza San Marco*. It had been painted about a decade before Dürer arrived for this, his second visit. In Carpaccio's painting, the canal is choked with gondola traffic (several boatmen being Africans, probably servants or slaves, another important component in the ethnic kaleidoscope of Venice). The bridge itself and the quays are packed with people, some on the left witnessing another wonder wrought by the fragment of the cross, while others go about their business.

Isabella d'Este was an even more voracious long-distance shopper than Pirckheimer. Lorenzo da Pavia, who negotiated with Giovanni Bellini on her behalf, also bought drinking goblets, crystal flowers, ostrich feathers, and chess pieces for her. Art was another product on sale, including Dürer's prints. According to Vasari, Marcantonio Raimondi (*c.* 1470/82–*c.* 1534), a printmaker from Bologna, saw some of these on sale in Piazza San Marco – where art was often sold – and promptly spent all his money on the woodcuts. Equally rapidly, he began copying them, complete with the trademark 'AD' monogram. Apparently, one of Dürer's objectives in coming to Venice was to get a 'privilege' or copyright on the use of this personal device. Naturally,

VITTORE CARPACCIO *The Miracle of the Cross at the Ponte di Rialto, c.* 1496 (detail)

53

the German artist traded his own works, as he told Pirckheimer: 'I have sold all my pictures [presumably woodcuts or engravings] except one. For two I got 24 ducats, and the other three I gave for these three rings, which were valued in the exchange as worth 24 ducats, but I have shown them to some good friends and they say they are worth only 22.'

*

In *Triumph of the City*, Edward Glaeser describes fifth-century BC Athens, or twenty-first-century Bangalore or Silicon Valley, as places where, 'One smart person met another and sparked a new idea.' The same applied to sixteenth-century Venice. Intangible items – ideas, skills, and fashions – were exchanged there as well as objects. The question posed in *The Merchant of Venice*, 'What news on the Rialto?', was no dramatic fiction. Sanudo spent a great deal of his time asking exactly that. Every day, he moved from San Marco to the Rialto, picking up information all the time. Then he would return to his palazzo, not far away at San Giacomo dell'Orio, and record a daily, densely factual, precisely described stream of events that eventually amounted to fifty-eight volumes. Some of the news swirling around concerned pictures. Art-world gossip would have spread as quickly as political and economic events. On 13 March 1500, Lorenzo da Pavia informed Isabella d'Este that, 'Leonardo Vinci, who is here in Venice, has shown me a portrait of Your Ladyship that is very lifelike.'

Inevitably, when word got around that Dürer had arrived, intellectuals and art lovers were keen to meet him: 'There are so many good fellows among the Italians who seek my company more and more every day which is very gratifying to me, these were connoisseurs of art and music – men of sense, and scholarly, good lute-players, and pipers, men of much noble sentiment and honest virtue.' No doubt all the painters in Venice would have heard that this famous man was in town. But his arrival was not welcome to his professional rivals. Dürer's new Venetian acquaintances advised him to be careful. 'I have many good friends among the Italians who warn me not to eat and drink with their painters, for many of them are my enemies and copy my work in the churches and wherever they can find it.'

In January 1506, Dürer also reported, 'I have to paint a picture for the Germans.' This was an altarpiece for the Confraternity of the Rosary, which met at the church of San Bartolomeo, a couple of minutes' walk from the Fondaco dei Tedeschi. The painting was clearly intended to make an impression. It was almost two metres wide and more than one and a half metres high. So he would have needed a substantial, if temporary, studio just for this work (as well as for other pictures that he did in Venice). It created a sensation when it was eventually installed in the church. Dürer wrote that, 'The Doge and the Patriarch have seen my picture.' He exulted in the success: 'I have shut up all the painters, who used to say that I was good at engraving, but that in painting I didn't know how to handle my colours.' Dürer was a celebrity. On 28 February, he suggested that Pirckheimer should join him: 'The time would pass quickly, for there are so many nice men here, real artists. And I have such a crowd of foreigners (Italians) about me that I am forced sometimes to shut myself up and the gentlemen all wish me well, but few of the painters.'

As we have seen, the venerable Giovanni Bellini wanted to learn what he could from Dürer. More youthful artists, while perhaps regarding the German as a dangerous rival, probably felt the same. Among this crowd of disruptive visitors may have been Sebastiano Luciani (known much later as Sebastiano del Piombo), an enthusiastic teenager named Tiziano Vecellio, and – the leader of this trio of Venetian avant-gardists – Giorgione (that is, 'Big George') from Castelfranco.

Giorgione's sheer elusiveness has had the power to drive scholars mad, as Enrico Maria Dal Pozzolo has noted. This derangement takes two forms: wild conjecture or an ecstasy of scepticism. Some of the few precisely fixed facts about him are noted on the back of a panel in the Kunsthistorisches Museum, Vienna. There someone – possibly the artist – wrote the words, 'On 1 June 1506 this was made by the hand of master Giorgio from Castelfranco, the colleague of master Vincenzo Catena, at the instigation of misser Giacomo.' That is, the picture was painted in the middle of Dürer's sojourn in town. The woman seems enveloped in slightly hazy air, an effect that was created by the subtle softening of brushstrokes in her flesh, the fur lining of the coat that she has slipped over her naked shoulders, and the texture of its

GIORGIONE *Laura,* 1506

rich, red material. This slight blurring and melting shadows are contrasted with the crisp, crinkly laurel leaves behind her.

Many explanations have been suggested for the branches of foliage that give the woman in this picture her name. It has been argued that she is intended to be a courtesan, a bride, a poetic muse, or a depiction of Petrarch's Laura. But whatever and whomever she is supposed to represent, the face and body have been observed from reality. This young woman is a specific person.

Her partial nudity might owe something to Dürer. The female nude came to be such a speciality of Venetian art that it is a surprise to discover that there are few if any studies from naked women's bodies in Italian art before Dürer set up his temporary studio in Venice. Florentines such as Michelangelo and Donatello drew male models in the nude, but if undressed female figures were required, they invented them on the basis of classical statues. Dürer, on the other hand, made many studies of female bodies. Some are dated 1506, and therefore done in Venice, clearly from real naked women. Working from bare bodies, male and female, came to be a standard practice in the city. Years later, Lorenzo Lotto noted in his account book, 'For undressing a woman only to look ... 12 soldi.'

*

ALBRECHT DÜRER *Nude,* 1506 GIORGIONE *Nuda, from the Fondaco dei Tedeschi,* 1508–9

In late autumn 1508, Giovanni Bellini – as head of the local painting profession – was asked to nominate three colleagues to assess a fair price for the frescoes that Giorgio from Castelfranco had painted on the facade of the Fondaco dei Tedeschi. Bellini chose Carpaccio, Lazaro Bastiani, and Vittore di Matio, who priced the work at 150 ducats. Then for some reason the government officials in charge decided that he was due only 130 ducats. Perhaps this reduction was connected with cuts to the state budget. A league against the Republic had just been agreed at Cambrai in northern France: Venice was in the alarming position of being at war simultaneously with all the major European powers. In any case, Giorgione said that he was happy with the fee on offer.

With the frescoes for the Fondaco, it seems that Giorgione became famous. There was little or no previous mention of him, but within a couple of years Isabella d'Este, admirer of Bellini and Leonardo, was hunting for a work of his. Later in the century, these frescoes were mentioned in guidebooks among the sights of the city. In Baldassare Castiglione's *Book of the Courtier* (published in 1528), Giorgione himself is listed alongside Mantegna, Raphael, Leonardo, and Michelangelo as the 'most outstanding in painting': these were the greatest artists of the age.

Despite the reduced fee, Giorgione's frescoes could hardly have been more prominent. The Fondaco is a large, plain building (which has now, appropriately, been transformed into a shopping mall). It had burnt to the ground in 1504 and been rebuilt at top speed since the German merchants it housed were a crucial source of trade and revenue. It provided warehouse space, offices, and lodging for the 'Germans' that Dürer mentioned, who were largely from the modern areas of Bavaria and Baden-Württemberg. The urgency of the rebuilding explains the lack of sculptural or architectural ornament. The resulting big, featureless facade functioned as a huge hoarding in the centre of Venice. Everybody who travelled down the Grand Canal or over the Rialto Bridge would inevitably see it. Giorgione covered this with an effective advertisement for himself: heads and figures that Vasari described as naturalistic and in a new style.

As Giorgione doubtless knew, a couple of years previously in Florence, Michelangelo had produced a cartoon for a battle scene full of naked figures

that had astounded his fellow artists. Depictions of the nude body were an area of intense competition among cutting-edge artists. So, too, was an ability to emulate the art of antiquity (which is why local painters told Dürer that his work was 'no good because it wasn't antique'). In both departments, these frescoes were Giorgione's bid to compete. What they represented is a mystery. Vasari admitted that he did not understand them, nor did anyone he asked. Probably even when he first saw them in the early 1540s, the frescoes had already begun to deteriorate (nothing is worse for painting on plaster, Vasari thought, than moist, salt-laden winds like those of Venice). Five hundred years later, almost nothing remains: just the upper half of one rose-pink female nude (see page 57). Two of the rest were copied in the eighteenth century in an effort to preserve a record of the last remnants of this famous work. But for Giorgione they had served their purpose.

As the art historian Paul Joannides notes, Giorgione seems to have been a maverick who did not follow a normal career path. In 1506, it appears that he was sharing a studio with another artist, the gentleman amateur Vincenzo Catena. It may well be that he never had premises of his own or a formal workshop. If Vasari is to be believed – and on this point he probably is, since he was in contact with several people who must have known Giorgione well – he was almost as celebrated as a musician as he was as a painter. From his youth, Vasari relates, he 'took unceasing delight in the joys of love; and the sound of the lute gave him marvellous pleasure, so that in his day he played and sang so divinely that he was often employed for that purpose at various musical assemblies and gatherings of noble persons'. Dürer was struck by the emotional impact of Venetian lutenists: 'They play so beautifully that they weep over their own music.' Giorgione was perhaps as sensitive to the emotional nuances expressed by a certain harmony or vocal timbre as he was to the subtle language of the brushstroke.

His double life as a musician might help to explain why Giorgione painted his self-portrait in the role of the young harp-playing David. Of course, David was also the hero who slew Goliath, and before the picture was cut down by a later owner, the painter was clasping the severed head of the giant. Tom Nichols has suggested that this self-identification was perhaps 'a symbol of his defeat of older rivals' (coincidentally or not, in a

GIORGIONE *Self-portrait as David, c.* 1510

seventeenth-century print, the long-haired, bearded Goliath, later cut from the painting, has a resemblance to Dürer). This self-portrait is a picture of a dandy, in terms of the first decade of the sixteenth century, with flowing, abundant hair in a style known as *zazzera* – which the fashion-conscious Dürer also favoured. It was a remarkably original way to present himself: poetic, romantic. Although we scarcely ever hear his words, this picture gives a strong sense of his presence: big, good-looking, with a gaze both intense and gentle. It is easy to believe that, as Vasari claimed, he took,

'took unceasing delight in the joys of love'. He seems to have lived a raffish, Bohemian sort of life. Vasari also relates that the painter, 'became enamoured of a lady' – the word he used implied that she was a courtesan. 'She became infected with plague, without, however, knowing anything about it.' The artist 'visiting her as usual' caught it too.

Early in his career, Giorgione appears to have specialized in frescoes on the outsides of buildings, which – perhaps because they were destined to fade and peel off the walls – were not a high-status genre (Tintoretto also painted these when he was starting out, but not after he was established). It seems also that he turned out little pictures to decorate furniture. His *Judith with the Head of Holofernes* was probably a cupboard door – the panel once had hinges and a lock or keyhole in it. As Dal Pozzolo has argued, he collaborated a great deal with other painters. Of two early pictures in the Uffizi, *The Trial of Moses* and *The Judgment of Solomon* (also apparently cupboard doors), one appears to be largely by Giorgione himself, the other mostly by someone else. In the sixteenth century, several works by Giorgione were listed as partly by another artist. The landscape and cupid in his *Sleeping Venus* (see page 65) were reportedly 'finished' by Titian, who was also responsible for parts of a lost picture of the dead Christ. The *Three Philosophers* was said to have been completed by Sebastiano Luciani. These statements are still controversial. But the fact that they interested collectors and commentators within a decade or two of his death is revealing. Who painted which bit of a certain work is the kind of question that intrigues connoisseurs – and aficionados of art were precisely Giorgione's customers.

By the end of his life, Giorgione concentrated on producing pictures for lovers of painting, rather than for churches or public buildings. He is perhaps the first major artist to make this choice. His pictures seem to have been valued as much – or more – as displays of his own manner than for what they represented. *The Book of the Courtier* explained that great artists are all different, but 'each knows how to produce perfect work in his own style'. What was Giorgione's? Jaynie Anderson has pointed out that one of the first authors to mention Giorgione, Pietro Pino, describes him as having an idiom of 'poetic brevity'. Both terms are accurate. In the artist's celebrated *Tempesta* (see page 329), two figures are revealed in a landscape by a flash of

lightning, with so little extraneous detail that no one has ever convincingly explained what the picture is about. It does not matter, however, because it is like a line of poetry: condensed but packed with evocative associations. His brushwork, too, does not itemize a person in every detail. It evokes surfaces and textures: the softness of Laura's skin in comparison with the quite different sensual fluffiness of her fur and the knifelike contours of the laurel leaves around her. This kind of painting could be savoured like a sonnet. It was no accident that he was working at the moment that the modern world of books – and readers – was coming into being.

*

Dürer's copy of Euclid's *Elements* translated into Latin is inscribed, 'This book I bought for a ducat at Venice in 1507'. Venice was not only a marketplace for book dealers such Anton Kolb, by 1500 it was the greatest centre in Europe for a new industry. Just as the city attracted merchants, writers, and artists, intellectuals such as Aldus Manutius (*c.* 1449–1515) also gravitated to Venice, drawn by its prosperity and (relative) political freedom. Originally from Bassiano near Rome, Manutius set up the Aldine Press in Venice around 1494. He has a good claim to be the first publisher. Among other innovations, he was the first to use italic type, in 1500, and the following year he introduced small, cheap editions of classic texts – '*libelli portatiles*' – cheap enough for students and poor scholars to buy, light enough to carry in a pocket. These allowed a new pastime: reading for pleasure.

In 2019, an inscription was discovered in a copy of Dante's *Divine Comedy* in an Australian library. It read, 'On the day of 17 September, Giorgione of Castelfranco, a very excellent artist died of the plague in Venice at the age of 36 and he rests in peace.' This was an edition from 1497, which may have been owned by Giorgione himself since it contains a drawing attributed to him. If so, this confirms the painter was a reader of poetry in his leisure.

In 1501, Manutius published an edition of Petrarch's poems, followed in 1502 with one of Dante. The editor of these was Pietro Bembo, the learned young patrician whom we have already met as an intermediary between Bellini and Isabella d'Este. Bembo was a bridge between the worlds of literature

and painting in more than one way. His sympathetic response to Bellini suggests that he was a friend. He was certainly close to Titian, and also knew Vincenzo Catena (therefore probably Giorgione, Catena's 'colleague', as well). Bembo understood the way that artists thought, but also – more extraordinary – his literary work affected what painters painted. His edition of Petrarch turned the fourteenth-century poet into a best-seller (in various editions, 100,000 copies of Petrarch were sold). Bembo's *Gli Asolani*, dialogues on the nature of love published by Manutius in 1505, also help to create a mood and a fashion that led to a new kind of painting: a picture that was, like the *libelli portatiles*, intended for private, poetic pleasure.

Another of Manutius's projects was anything but cheap or pocket sized. The *Hypnerotomachia Poliphili* (Poliphilo's strife of love in a dream) has often been described as the most beautiful illustrated book ever published. It appeared in 1499, but had been written long before by, of all people (given that its contents are both antiquarian and erotic), a Dominican friar. His identity was concealed by a simple cipher. The initial letters of the first word of each chapter spell out the words 'POLIAM FRATER FRANCISCVS COLVMNA PERAMAVIT ('Brother Francesco Colonna greatly loved Polia'). This code was pointed out in a note written in a copy of the book in 1512. The writer added that this Francesco Colonna 'now lives in Venice at SS. Giovanni e Paolo'. Indeed, Colonna (1433–1527) had been prior of this monastery, the Dominican headquarters in the city. His career, admittedly, was eccentric – at one point, he walked out of the monastery because of the election of a sub-prior appointed to improve its morals. But the fact that a celibate member of a religious order can have written such a book says something about the atmosphere of Venice around the turn of the sixteenth century.

Admittedly, it can never have been easy reading, since Colonna wrote in a mixture of Italian syntax with a largely Latin vocabulary ('the more recondite the better' in the words of his translator) with some Greek thrown in. Looking at it, however, has always been a pleasure since it is illustrated with 172 woodcuts. These were probably the work of Benedetto Bordon, a Paduan miniaturist. They allow anyone with eyes to bypass the difficult prose and enter the world of the book – which is a mixture of enthusiastic

'Satyr with Sleeping Nymph', from Hypnerotomachia Poliphili, 1499

archaeology and medieval romance, full of dancing nymphs, ancient ruins, inscriptions in Latin and Greek, passionate lovers, leafy glades, fountains, and naked gods. This dreamy fusion of poetry, romance, and antiquarianism is exactly what you find in pictures such as Giorgione's *Tempesta* or the *Concert Champêtre* (generally thought to be by Titian; see page 71). Giorgione's *Sleeping Venus* (apparently completed by Titian, as we have seen) seems to have borrowed the slumbering, naked nymph from one of those woodcuts. This gave Venetian, and European, painting a new subject: the reclining nude.

*

In Castiglione's *The Book of the Courtier*, a book in the form of dialogues, the speakers (one of whom, unsurprisingly, is Bembo) debate the differing merits of painting and sculpture. This was a favourite topic in the Renaissance, known as the *paragone* or the comparison of the arts. In the book, it is argued that the painter is superior since the sculptor is unable to 'show the

colour of auburn hair, nor the glow of armour, nor a dark night or a storm at sea – no thunder or lightning nor the burning of a city, nor the pink glow of early dawn with those rays of gold and purple; in fact he cannot depict sky, sea, earth, crowds, woods, meadows, gardens, rivers, cities nor houses'.

As it happens, Giorgione actually did depict many of these items (the dawn in the *Three Philosophers*, his own auburn hair, the lightning strike in the *Tempesta*). And a later writer, Pietro Pino, claimed that he made a work specifically to show that anything a sculptor could do, he could do too – and more. Apparently, Giorgione 'painted a picture of an armed Saint George, standing and leaning on the shaft of a spear, with his feet at the very edge of a limpid and clear pool'. This reflected the saint from the opposite direction, 'foreshortened as far as the crown of the head'. So Giorgione had shown the same figure from two opposite points of view. In addition, a mirror leaning against a tree reflected 'the entire figure' from the back and one side, and

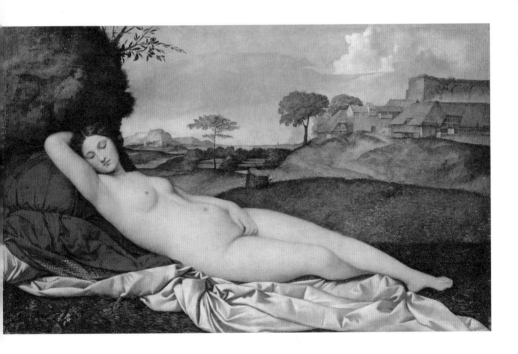

GIORGIONE *Sleeping Venus*, 1510

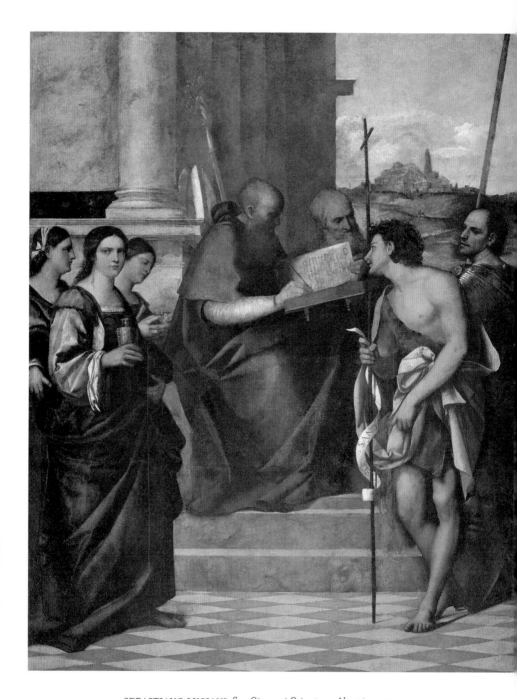

SEBASTIANO LUCIANI *San Giovanni Crisostomo Altarpiece*, 1510–11

a second mirror reflected his other profile. So this picture did everything a statue could – plus, of course, the deliciously naturalistic colours and surfaces of flesh, glinting armour, foliage, and looking-glass smooth water that oil paint could mimic so well. Vasari described a similar picture with a nude man instead of George. Whether either really existed is unknown. But there is evidence that these were exactly the kind of subjects Giorgione and his associates thought about. Around 1510, Sebastiano Luciani painted an altarpiece for the church of San Giovanni Crisostomo just off a busy street near the Rialto. It is a marvellous work, which Vasari attributed to Giorgione in the first edition of his *Lives of the Artists*, altering this passage in the second edition to say that it was so like Giorgione that it was 'sometimes held by people without much knowledge of the matters of art to be by the hand of Giorgione himself'. In fact, it is more monumentally classical and lucidly composed than anything surviving by Giorgione himself. But it does show clear rivalry with another earlier altarpiece in the same church, a marble relief by the sculptor Tullio Lombardo (1455–1532). The trio of female saints on the left – Mary Magdalene, Catherine, and Lucy – look very much like the same young woman. But she has been shown from three differing points of view: full-face, profile, and three-quarter view. This looks very much like a challenge to a sculptor: anything you can do I can do too, but I can also paint a distant city, glowing sky, and flowing hair.

As we have seen, Giorgione died suddenly of the plague in the autumn of 1510. The inscription in the copy of Dante gives the date, 17 September, and his age, thirty-six (which makes him a late developer as an artist). Just over a month later, on 25 October, Isabella d'Este wrote to her agent in Venice, Taddeo Albano. She had heard that 'in the effects and the estate [*heredià*] of Zorzo da Castelfrancho the painter, there exists a painting of a night scene ['*una nocte*'], very beautiful and unusual'. 'If this were to be the case,' Isabella went on, she was 'extremely desirous of owning it'. But as it turned out she was out of luck. Albano reported back that Giorgione had indeed died recently. But he had been told by friends, 'who had had a lot of dealings with the artist', that there was no such night piece among the works that he had left in his estate. He had painted two such pictures, but their owners had no intention of parting with them. 'Neither one nor the

other is willing to sell at any price, for the reason that they wish to keep them for their own enjoyment.'

Another recently discovered document suggests what might have happened to Giorgione. It is an inventory of his goods made after his death. This gives his surname as Gasparini, but as soon as it was published in 2011, the scholar Lionello Puppi forcefully argued that this was in fact a patronymic, and that – as rumoured since the seventeenth century – his family name was in fact Barbarelli. Thus a haze of obscurity persists in veiling Giorgione.

At any rate, this inventory gives the location of his demise: the Lazzaretto Novo, and from this a little more can be deduced. There were two quarantine hospitals in Venice; the first, the Lazzaretto Vecchio, was situated on a small island in the lagoon, Santa Maria di Nazareth (from which last word the name 'Lazzaretto' was derived). This was for patients suffering from the disease, and at times of peak epidemic was a place of horror, with victims packed three to a bed. The second, the Lazzaretto Novo, was intended for those suspected of having been in contact with the plague, rather than those who had actually come down with it. This suggests that Giorgione had been identified by the rather efficient Venetian tracing system as a member of the same household as a known case, or a close associate. Perhaps this was, as Vasari related, the woman whom he loved.

The inventory, made many months after Giorgione's death, suggests that his effects had already been thoroughly rifled. There are no paintings noted, nor expensive musical instruments, just a pitiful list of clothes, bedding, and bits of furniture. Only one item seems linked with his art: an expensive red gown lined with fox fur, valued at twelve ducats. This sounds like the cape that Laura is wrapping around herself.

In the summer of 1511, the year after Giorgione's death, Sebastiano Luciani accepted an invitation to work in Rome and stayed there, except for visits to his home town, for the rest of his life. So Carpaccio, well established and painting important works for the government in the Doge's Palace, might well have thought that he was the obvious heir to the aging Giovanni Bellini as the principal painter in Venice. If so, he had a nasty surprise coming from yet another young artist associated with Giorgione: Tiziano Vecellio.

CHAPTER FOUR

'YOUR SERVANT FROM CADORE'

O n 31 May 1513, the doge and the Council of Ten, one of the governing bodies of the Republic, received a petition. It began with a declaration of self-belief: 'Since childhood, Most Serene Prince and Most Excellent Lords, I TICIAN, your servant from Cadore, have devoted myself to learning the art of painting, not so much from the desire for profit as to acquire some little bit of fame, and to be counted among those who at the present time practise this art as a profession.' It is likely that the actual prose was composed by a literary friend, probably Andrea Navagero (1483–1529), a patrician poet, orator, and scholar known for his eloquence as a writer. But the sentiments must have been Titian's, even if the claim that he wanted to earn glory as a painter more than simply money was disingenuous. His whole career shows how well he knew the two of those things go together. But clearly he already sensed his own enormous gifts – and he saw an opportunity.

Titian, generally reckoned to have been born around 1488–90, would have been twenty-five at most. He came from Pieve di Cadore, a little town high in the Dolomites; a frontier zone close to the point where the Italian language dwindles away to be replaced by German and an Alpine tongue, Ladin. Titian's family, the Vecellio, were neither rich nor poor. The house where he grew up still exists; it is a sturdy wooden structure – not a hovel but far from being a palace. His father, Gregorio, was a soldier who was in

charge of the local castle and managed mines in the area. Over the years, many of the family had been notaries or invested their money in timber, but none had ever been a painter – so why Titian and also his (probably younger) brother Francesco went to Venice to train as artists is a mystery. Somehow, his tremendous talent must have manifested itself. According to Ludovico Dolce's *Dialogo della pittura*, written by a man who knew Titian well and published in the artist's lifetime, 'his father having perceived in him, even at that tender age, strong marks of genius toward the art', he was sent to Venice to stay with an uncle who arranged for him to be apprenticed to the mosaicist and painter Sebastiano Zuccato. From there, he moved on to the workshop of Gentile Bellini, whose 'dry and laboured manner' he could not stand, preferring to work 'with boldness and expedition'. It seems that from early on he had an urge to be *painterly*, loose and free with the brush.

Having had a row with Gentile, who told him that he would not get far painting like that, he transferred to Giovanni Bellini's studio – but that did not suit him either. These stays in the Bellini workshops were probably brief, since technical examination suggests that Titian did not learn much from either of them, but had instead been trained by a fresco painter such as Zuccato. Certainly the three frescoes he painted for the Scuola del Santo in Padua in 1511 (his first documented and firmly datable works) display a confident technique. Then – according to Dolce, who must have been relying on what the artist himself related – Titian began 'designing and painting' with Giorgione, which implies that he was more of an informal 'colleague' than an apprentice. An anonymous seventeenth-century life of Titian, though not a reliable source, tells a plausible story. The young man, attracted by the 'more grave and delicate' style of Giorgione, took to gazing at the older master's works as they dried in a courtyard (an essential part of the process of producing oil paintings). Giorgione, noticing his interest, 'affectionately' took him under his wing. Rapidly he absorbed Giorgione's lessons, especially his way of using oil on canvas to mimic textures and surfaces and poetically evocative subject matter. Then, apparently, Titian pulled ahead. When Giorgione was commissioned to fresco the Grand Canal facade of the Fondaco dei Tedeschi, Titian was allocated the less prominent side wall.

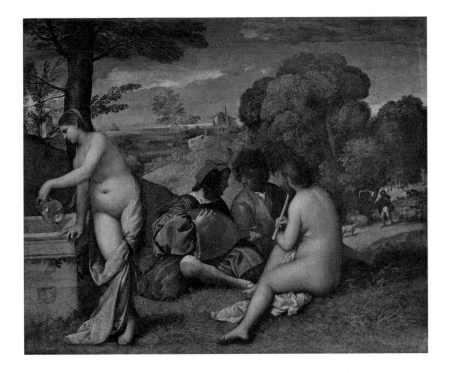

TITIAN *Concert Champêtre, c.* 1509

These frescoes are now only fragmentary, but not as wrecked as those on the main facade. Everyone who saw them before they flaked and peeled agreed that Titian's paintings were even better than Giorgione's. Dolce claims that Giorgione was mortified by this humiliation, but the anonymous life recounted that he accepted the defeat without jealousy. Perhaps both were true, in sequence. One of Dolce's speakers remarks, 'I have heard that Giorgione said that Titian was a painter in his mother's womb.'

Titian's work on the side of the Fondaco was probably done in the summer – the warm, outdoor frescoing months – of 1509. If he was, as Dolce says, 'not quite yet twenty years of age', this would suggest a birthdate around autumn 1489. At that time, and over the next few years, he quickly produced a series of masterpieces. Some of these, such as the so-called *Concert Champêtre*, were so close to Giorgione in style as to cause endless

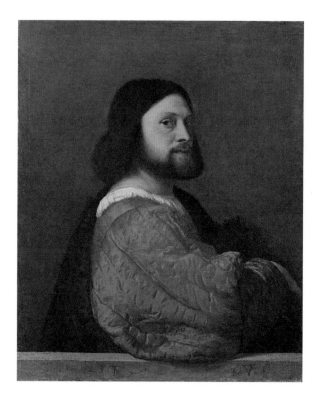

TITIAN *Portrait of Gerolamo Barbarigo, c.* 1510

disagreement among scholars. Others, such as the portrait of a man in the National Gallery in London, with its astonishing violet sleeve, could be by no one else. This is created with brilliant flickering brushstrokes that turn into silvery, quilted satin in front of your eyes, without ever quite ceasing to be marks made in paint. And it is not just the visual sense that it activates. By looking at it, you can feel this garment, its cushiony softness.

This might be dubbed 'the Titian effect': an almost hallucinatory evocation of the sensuous feel and lustrous surfaces of things – and also of people. Vasari, who greatly admired this picture, was struck by the way the sitter's beard was rendered as well as his clothes, 'the hairs were so well distinguished one from the other that they might have been counted'. He says that the subject was a member of the Barbarigo family, and that this man helped

Titian get the commission for the Fondaco. This morsel of information may have come from the artist himself (who else would have remembered, decades later?). Recently, the name of the sitter has been convincingly pinpointed. It seems that he was Gerolamo Barbarigo (*c.* 1479–1531). He was a high-flying young patrician: grandson of a doge, praised by Pietro Bembo, an arts graduate from Padua University, and a member of that circle of youthful aristocrats who were enthusiasts for poetry and new forms of art. He might well have been able to put in a word for Titian in influential circles (although the portrait may have been painted a few years later). In 1509, the year that Titian probably painted his frescoes at the Fondaco dei Tedeschi, Gerolamo began his climb up the Venetian political hierarchy. That same year, another friend of Bembo's, Niccolò Aurelio, became the secretary to the Council of Ten, which controlled the commission. As we shall see, he too was very probably an admirer of the young artist's work.

In addition to being an astonishingly gifted painter, Titian must also have had a way with words. Dolce claimed that he was 'an eloquent conversationalist', with 'a most perfect intellect and judgment in all things; of a gentle and placid temper; affable; of the most delicate manners; insomuch that whoever once speaks to him must always love him'. Although the sketch of Titian in Dolce's *Dialogo* is biased, in that the entire text is an extended paean in the painter's praise, other more independent sources agree that he had a pleasant, easy manner (which, given his success with the most socially exalted of patrons, must have been true). Perhaps his family's long service as agents for richer and more powerful people gave him inner social confidence. But concealed beneath this smooth exterior there must have been tremendous drive – and also what often goes with energy and ambition: a temper. There are glimpses of this in his later correspondence, such as his furious response to rebellion by his eldest son, Pomponio.

By 1513, Titian had earned a reputation among connoisseurs. Not only had he been 'insistently requested' to work for the pope, as the petition to the doge and Council of Ten stated, but also 'other lords' had tried to recruit him. A new pope, Leo X, had been crowned in March 1513. A member of the Medici family, Leo intended to spend lavishly on the arts (and did). His newly appointed secretary was none other than Bembo, who as a friend of

Venetian painters such as Bellini must have known Titian and been well aware of his gifts. It is more than likely that Bembo suggested that the brilliant young painter should try his luck at the papal court.

Many years later, Dolce, again probably relaying Titian's own account, wrote that Navagero, 'believing that in losing him Venice would be despoiled of one of her greatest ornaments', persuaded Titian not to go. It is not hard to see how the arguments for and against would have been balanced in the young painter's mind. The prospects in Rome were enticing, but there he would have been in direct rivalry with two older and formidably talented artists: Michelangelo and Raphael. The Venetian Sebastiano Luciani had departed for the eternal city two years earlier and was having some success, but he was far from displacing Raphael as the leading painter in the city. In Venice, conversely, Bellini would soon be gone, and the middle-aged Carpaccio was too old-fashioned to present much competition. Titian could rapidly become the leading artist of La Serenissima. He presented his proposal to the doge and Council of Ten with a flourish:

> I have resolved, if it seems feasible, to paint in the Great Council Hall
> and to put into that task all my intellect and spirit for as long as I live,
> beginning, if it please Your Sublimity, with the canvas of the battle
> for the side facing the Piazza, which is the most difficult and which
> no man until now has had the courage to attempt.

This battle scene was demanding because of its position, between two windows, but even more because of its subject. The complexities of intertwined bodies in furious combat would have been beyond Bellini or Carpaccio. Moreover, as Titian would have been well aware, very similar military subjects had been commissioned in the Council Chamber of Florence a few years before from two of the greatest artists in Italy: Michelangelo and Leonardo. Although neither picture was eventually completed, this was the grandest of artistic contests. By choosing his subject – a battle – Titian was effectively adding himself to the competition as a Venetian contender.

He went on to name his own fee – although he began by declaring that he wanted 'whatever payment is judged proper'. Then he smoothly went

on to request the 'same terms, conditions, obligations, and exemptions' as Bellini. Namely a sinecure for life in the form of a *sanseria* at the Fondaco dei Tedeschi – that is, to be the nominal Venetian proxy for one of the German merchants there, taking a cut of the profits for doing nothing. He also modestly requested a free studio, wages for two assistants, and the cost of materials. Navagero, who was a senator, probably advised that he could get this deal accepted. And so it was, for a while. But then in March 1514, the agreement was cancelled.

Various things had gone wrong. The Republic had suffered a military reverse in a real battle. Secondly, Carpaccio was fighting back. Presumably he was the person whom Titian had in mind when he referred to 'the skill and cunning of some who do not want to see me as their rival'. This dispute may be connected with one of the young Titian's greatest masterpieces; not the battle scene, which he did not deliver for decades, but a picture of two beautiful women, one nude, one sumptuously clothed, plus a naked child, sitting at a fountain in a landscape. This painting (following pages), known as *Sacred and Profane Love*, has long been the subject of scholarly debate. But it is difficult to resist the idea that it was painted to celebrate and/or commemorate the wedding, on 17 May 1514, of Niccolò Aurelio to a young widow from Padua named Laura Bagarotto. As the secretary to the Council of Ten, Aurelio would have been ideally placed to help Titian in this career crisis. It was noticed long ago that the Aurelio family *stemma*, or coat of arms, is painted above the waterspout that gushes from the relief on the front of the fountain. After that, it gets complicated. Numerous interpretations of its subject have been advanced. The only evidence that it is connected with Aurelio is this coat of arms. Laura's own family *stemma* was once thought to be visible in the silver dish on the edge of the fountain, but this turned out on closer examination not to be there at all.

Yet a connection with Aurelio's marriage remains likely. As we have seen, he was a member of the circle of cultivated humanists that included Navagero and Bembo. In 1523, when Aurelio was appointed grand chancellor of Venice, Bembo wrote him a warm letter of congratulation, remarking that, 'as we were friends and brothers in our early youth, so we are in old age'. Politically, however, Aurelio's marriage was extremely unwise – which suggests that it

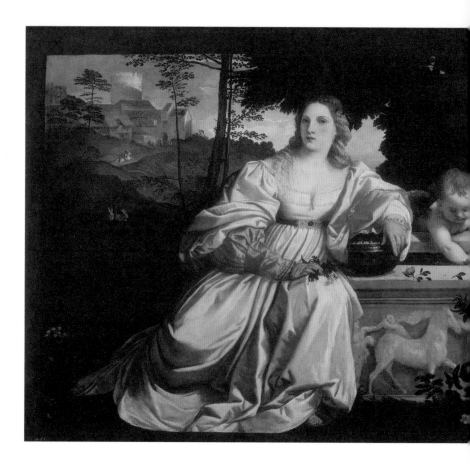

may have been a love match. His bride's family and first husband had been condemned as traitors by the Venetian Republic because they had supported the imperial forces during the siege of Padua in 1509. Her father, Bertuccio Bagarotto, still protesting his innocence, was hanged in the Piazzetta in front of his wife and children. Apparently, her first husband was executed for the same reason. In 1524, Aurelio himself was arrested, threatened with torture, dismissed, fined, and exiled. The reason was probably because the new doge, Andrea Gritti – the commander who recaptured Padua – was suspicious of his link to the treacherous Bagarotto clan.

TITIAN *Sacred and Profane Love*, 1514

Titian's painting – in contrast to this tragic and horrifying saga – is concerned with peaceful, fertilizing love. The goddess Venus sits to the right holding up a lamp in blessing; in the centre, her son Cupid, the god of love, stirs the waters in the basin of the fountain. Lower down, beneath the Aurelio *stemma*, a spout juts from its side and water gushes out. Although parts of this image are hard to decode, the symbolism of the polished pipe is plain enough. Rona Goffen was surely right to suggest that it graphically expresses the middle-aged Aurelio's desire to father children. The fertile countryside all around conveys the same message.

77

If Venus and Cupid represent divine beauty and love, the spout stands for a much earthier variety. The woman on the left, who looks like Venus and is dressed as a bride, perhaps represents married love. And the whole composition is arranged around a sculpted sarcophagus – that is, a stone coffin – on which the figures sit or lean. So the message is that out of death, through love, comes new life. There is a similar fountain illustrated in the *Hypnerotomachia Poliphili*.

This is a private painting; the fact it is loaded with personal meaning explains why scholars find it hard to analyse. Titian painted a black border around it, suggesting that it was intended to fit into a piece of furniture – a chest perhaps or a bedhead. There is something more that this picture reveals about Aurelio – and perhaps Laura too, whose unfortunate father had been a professor of law at Padua, moving in learned and literary circles. Titian did not just assemble suitable imagery, he performed miracles of art. The skin of the naked goddess is soft and warm; the bowls on the fountain, metallic

'Sarcophagus fountain', from Hypnerotomachia Poliphili, 1499

and shiny; a soft dawn light illuminates the blue hills in the distance. This is a painting for people who loved painting for its own sake. There were increasing numbers of such connoisseur-collectors in Venice, and Titian was not the only artist who made pictures to fit their tastes – and houses.

A few years after Titian delivered *Sacred and Profane Love*, a noble named Marcantonio Michiel (1484–1552) began making lists of what other Venetian collectors owned. Michiel himself had at least one painting by Giorgione – a male nude – and likely more (*Il Tramonto* in the National Gallery of London belonged to his heirs). It is highly probable that he knew Giorgione, Titian, and Sebastiano Luciani (that is, Sebastiano del Piombo) personally. If he had thought them interesting, he could no doubt have jotted down vivid anecdotes and biographical details about them, but that was not the Venetian way. In Florence, lives of artists began to appear from the fifteenth century onwards, and vignettes and revealing memories were being collected by an anonymous Florentine at the time Michiel was making his notes. Individual personality was of less importance in the more collective culture of Venice, but nevertheless the origins of the European art market can be traced to the consumerist city in the lagoon.

Above all, Michiel was interested in what is called attribution: who had painted and carved what. He was also keen to know where a work of art was and by whom it was owned – the preoccupations of dealers and collectors of art through the ages. The identity of the painter interested Michiel much more than what he had depicted. Noting Giorgione's *Tempesta* in the house of Gabriele Vendramin, he merely described it as a 'little landscape on canvas, representing stormy weather and a gipsy woman with a soldier' – thus leaving generations of scholars to argue about its real subject.

Attribution remains crucial both to scholarship and to the art trade. A work by Giorgione is worth astronomically more than one that is merely 'after' or 'circle of'. This goes back to a moment around 1500 when certain people – Isabella d'Este, Michiel, Vendramin, Bembo – became fascinated by what brilliant artists could achieve. For them, no imitation would do. They were interested in *quality* and believed it went hand in hand with authenticity. At Antonio Pasqualino's house in 1529, Michiel saw a portrait: 'the head of the young man holding an arrow in his hand is by Giorgio

GIORGIONE *Young Boy with an Arrow*, 1505

da Castelfranco, and was obtained from Messer Giovanni Ram, who possesses a copy of it, which he believes to be the original'. In other words, in Michiel's opinion, Ram had got it wrong. But it is possible that Ram, a merchant from Spain, had been correct (or indeed that Giorgione might have produced two versions of the picture). Either he or Pasqualino owned a genuine Giorgione known as *Young Boy with an Arrow*. Today it is one of the treasures of the Kunsthistorisches Museum in Vienna.

When Michiel visited Ram's own house in the parish of Santo Stefano two years later, he found a miniature museum of masterpieces, among them a portrait of Ram by Vincenzo Catena, a painting attributed to Rogier van der Weyden, and an early picture by Titian depicting the Baptism of Christ with Ram himself inserted into the corner, peering over the bank of the Jordan to witness the scene.

On the walls of private homes in Venice hung many pictures that eventually found their way into the museums of the world – how they got there is part of the subject of this book. Their earliest owners were not necessarily grand. Most of the collectors visited by Michiel were noble and / or wealthy gentlemen – Vendramin, Taddeo Contarini, Cardinal Domenico

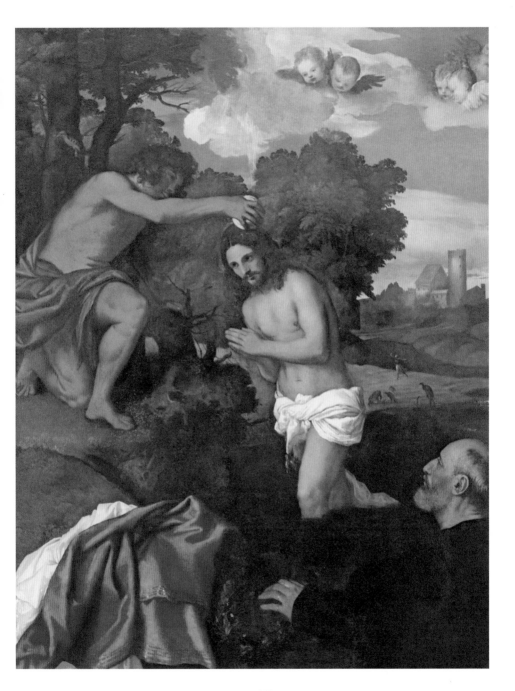

TITIAN *Baptism of Christ*, 1512

Grimani. But some masterpieces had humbler owners. Giorgione's prices were probably not high; Lorenzo Lotto's certainly were not. Many people could afford a marvellous painting.

Venetians were enthusiastic consumers. In 1512, the Senate legislated against various luxurious furnishings, including gilded chests, mirrors, and embroidered bedlinen. To no avail; the government lamented that, 'The fickleness of unbridled appetites of men as well as women, continues to grow so much that few care about spending.' In 1538, an inventory was made of a woman called Elisabetta Condulmer. She could be called a courtesan (perhaps like the lady whom Giorgione loved), but equally one might say that she was successfully practising polyandry. Elisabetta had a husband, but he does not feature in her will. In this, she declared that she had seven children by three other men, two described as 'my lord'. Elisabetta was the illegitimate daughter of an impoverished aristocrat, but her unorthodox domestic arrangements meant that she could live much more comfortably than her sister, who became a nun.

Among the possessions in her lavishly furnished apartment were eight drawings and ten paintings. Some of the subjects of these had a classical, poetic flavour: Pyramis and Thisbe, a nude woman tied to a tree (possibly Andromeda), an old man with a cage (perhaps Diogenes), and a picture of 'a woman and a nude man'. The notary did not bother to note the painters of these pictures. But the subjects – and the ambiance – suggest the world of Titian and Giorgione. So do Elisabetta's furnishings and accessories. As Patricia Fortini Brown noted, that bed sounds like the one on which Titian's *Venus of Urbino* reclines. In another room, Elisabetta kept no fewer than four lutes. This was of course the instrument on which Giorgione and Sebastiano excelled, and by which Titian's Venuses were sometimes entertained. Unsurprisingly, the social lives of painters and women such as Elisabetta overlapped. Many years later, the writer Pietro Aretino – whom we shall see meet again – sent Titian an invitation: 'A brace of pheasants, and I know not what else, await you at dinner, with Signora Angela Zaffetta and myself'. Angela del Moro (nicknamed 'La Zaffetta') was the most celebrated courtesan of the time. It has been claimed that she was the model for the *Venus of Urbino* and several more of Titian's paintings.

*

Having regained his commission to paint a battle scene for the Doge's Palace, Titian switched priorities. Instead, he now threw himself into the project for a prominent painting in another important Venetian building. This was for the high altar of Santa Maria Gloriosa dei Frari and was to depict the Assumption of the Virgin (in Italian, the *Assunta*). Dolce says that it was executed 'very quickly', and it must have taken at most a little over two years, perhaps no more than eighteen months. Sanudo recorded that it was unveiled on 19 May 1518. According to an inscription on the frame, the picture was commissioned in 1516 by the prior of the monastery, Fra Germano da Casale. This does not say at what point in the year the commission was given, but perhaps it was after the death of Giovanni Bellini on 29 November. At any rate, it was a commission that the older master might have expected when he was younger and fitter.

Titian had already painted a couple of notable altarpieces. In an early one, *Saint Mark Enthroned with Saints* for the church of Santo Spirito in Isola, he began updating the Bellini formula, with an asymmetrical composition and a cloud crossing the sky and casting a shadow over the Evangelist. Another, of Tobias and the Archangel Raphael, was dominated by the dynamic figure of the Archangel, twisting like a dancer. But neither of these were anything like as large or prominent as the high altar of the Frari. Here was Titian's opportunity to demonstrate very publicly how he could reimagine a type of painting that Bellini had made his own. However, there were probably other competitors, still alive and formidable, that he had in mind when he tackled this work. At the end of 1516, an artistic competition began in Rome. Cardinal Giulio de' Medici, the cousin and right-hand man of Pope Leo X, commissioned two altarpieces, one from Raphael and another from Sebastiano Luciani, who was to be assisted by Michelangelo with drawings. These were for the cathedral of Narbonne in southern France, of which Cardinal Giulio was the bishop. Implicitly, and probably deliberately, this set up a competition between the greatest artists in central Italy.

Titian must have known about this grudge match between artistic champions (Michelangelo and Luciani were deeply resentful of Raphael). In all likelihood, Titian and the artistic community in Venice were given

updates from Luciani by post – quite possibly with drawings of his own composition included. Dolce's praise of Titian's picture – perhaps derived from conversations with the artist – strongly suggested that he had those rivals in mind: 'this one picture contains at once the grandeur and sublimity [*terribilità*] of Michelangelo, the pleasing grace and perfect beauty of Raphael, together with the proper colouring of Nature'.

It was a commonplace of Renaissance art criticism that Michelangelo, like the hedgehog in Aesop's fable, knew one big thing. He was supreme in what the Florentines called '*disegno*'. In sixteenth-century art parlance, this meant 'drawing', but it signified more than what the English word suggests. It implied an internalized sense of form, especially human anatomy. Michelangelo was unrivalled in his understanding of the male nude. In contrast, as Vasari explained, Raphael was almost as accomplished at *disegno* but could also do things that Michelangelo ignored or disdained. His works were 'pleasing in colour, beautiful in invention, and charming'. Titian intended to take them both on, equalling Michelangelo's *disegno* and Raphael's elegance, while adding the Venetian speciality, '*colorito*' or '*colore*'. Just as *disegno* was not simply 'drawing', '*colore*' meant more than just colour. Robert Echols and Frederick Ilchman have suggested that 'paint handling' would be a better paraphrase. By '*colore*', Titian meant not vivid pigments, but everything that oil paint could do to evoke surfaces, textures, and atmosphere. Luciani later told Vasari that if Titian had gone to Rome as a young man and studied the works of Michelangelo and Raphael, he would have achieved stupendous things (a view of which Titian himself was probably well aware).

If he wanted to be an unofficial extra competitor in this artistic tournament, it would explain the urgency with which he set to work. He would have been aware that Luciani was forging ahead with his entry and probably did not know that Raphael was cannily holding back, waiting to see what his antagonist would do. Titian had one advantage over the others. He knew the building in which his work would be placed intimately. According to the seventeenth-century writer Carlo Ridolfi, he was given a workshop in

The interior of Santa Maria Gloriosa dei Frari, with Titian's Assunta behind the high altar

85

the Frari to paint the altarpiece. This enabled him to do something unprecedented and highly creative. His painting interacted with its architectural surroundings. And it did so *dynamically*. As we have seen, in earlier works such as the San Giobbe altarpiece, Bellini had depicted virtual annexes to the structure around them, with pilasters, domes, and mosaic created by paint (see page 47). But his figures were relatively static. They sit and stand, scarcely moving. This is true even when the subject was a dramatic scene, such as the Baptism of Christ. In contrast, Titian's picture responds to its environment: the Gothic tracery surrounding the east end of the church. The curve of the angelic throng around the Virgin echoes the arched vault above. So do her upraised arms. But the painting also has a barley-sugar twist. A swirling movement runs from the prominent apostle on the lower right, who turns upward and to his left, to the Virgin, who also gestures and gazes above but sways to her right. Beneath, the waving arms, jutting beards, and inclined heads and bodies of the apostles create a complex zigzag rhythm. The painting energizes the whole huge space that it occupies.

You notice the *Assunta* as soon as you step inside the entrance of the church. It is the visual climax of the structure, animating the whole interior. From closer, however, you are conscious of how Titian has depicted 'the proper colouring of Nature'. The apostles are silhouetted against the bright sky, their faces in soft, half-shadow. The *Assunta* has a strongly outdoor feel. Everything in the picture is immersed in real light and air. Like Bellini's altarpieces, this is a truly atmospheric painting.

This spiralling, almost levitating masterpiece, with others by Titian that followed, did much to endow Venice with its magnetic attraction for painters and lovers of painting. Over the centuries to come, uncountable numbers of such people – from Rubens and Van Dyck to George Eliot and Wagner – stood gazing at the *Assunta*. I have often lingered there too, just contemplating it.

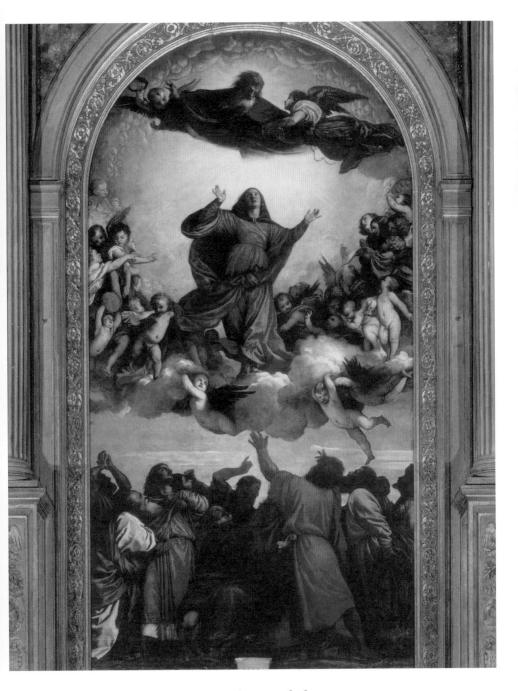

TITIAN *Assunta*, 1516–18

'NIGHT AND DAY
WITH BRUSH IN HAND':
TITIAN IN THE 1520s

The unveiling of Titian's *Assunta* in May 1518 must have been an important event, otherwise Marin Sanudo would not have mentioned it in his diary. It was also a controversial one. According to Dolce, again probably relying on the artist's own account, 'ignorant painters, and the blind vulgar ... said all the ill they could of this very picture'. It is not hard to guess who the 'ignorant painters' might have been – followers of the Bellini brothers, with Carpaccio perhaps in the lead. In other words, the painting was denounced by Titian's professional rivals and also by Venetians whose tastes had not kept up with the avant-garde ('the blind vulgar'). If they did so, it would scarcely have been surprising.

In so far as an altarpiece can be revolutionary, this one was. According to Ridolfi, some friars wandered into Titian's workshop while he was painting the *Assunta*, making unhelpful and critical remarks. Perhaps they did; this newfangled painting might have struck them as irreverent. Others might have been repelled by its alien idiom, which would have seemed advanced even in Rome and Florence; and by the handling of paint, which would have seemed shockingly broad and loose when seen from close up. But enough of Titian's supporters must have acclaimed it to attain his objective. The *Assunta* established him as a rising star in the minds of those who cared about modern art. In particular, as Titian must have hoped, praise of this

astonishing masterpiece reached the ears (and eyes?) of Alfonso d'Este, Duke of Ferrara.

Alfonso d'Este (1476–1534), younger brother of Isabella, was an eccentric and in some ways unpleasant man. In his youth, he was known to stroll around the streets of the city state that he ruled stark naked. He had two of his brothers, accused of rebelling against him, imprisoned for life in a tower of his palace. More engagingly, he was an enthusiastic amateur craftsman specializing in woodwork and decorating pottery. Also, just like his sister, he was an enthusiastic and pertinacious patron of the visual arts. He had already employed Titian in the early spring of 1516, when the painter and two assistants had spent a month living in the castle at Ferrara. There he painted the *Tribute Money* on wood, as the door of a cabinet of medals. Titian clearly tried very hard with this extremely highly finished work. Giorgio Vasari praised it fulsomely; the Emperor Charles V – interestingly – thought it was very close to Albrecht Dürer's idiom, by which he probably meant that it was full of close-focus detail, including the contrasting surfaces of the different figures' skin – Christ's smooth and milky, the Pharisee's swarthy and wrinkled. Even the hair of their two beards, which almost touch each other, is carefully distinguished.

However, the commission revealed how Alfonso categorized the young painter. This type of picture, a drama acted out by two bust-length figures, was one for which Giorgione was noted. Titian was a suitable replacement. But Alfonso did not yet consider him a candidate to take part in his most cherished project: an apartment in which he wanted to display pictures by leading painters. It was an idea very similar to Isabella's project of comparing and contrasting great living masters in her *studiolo*. The result would be a *paragone* not in words but in works. There would be a comparison not only between the powers of painting and sculpture (Alfonso owned remarkable sculptures by Antonio Lombardo, which gave his rooms the name of 'Camerini d'alabastro'), but also between different painterly styles. His initial choice of star contemporary artists consisted of Raphael, Michelangelo, Fra Bartolomeo, and Giovanni Bellini (plus some contributions by his court artist, Dosso Dossi). But of these, only Bellini delivered his picture, in November 1514. Raphael had won a tremendous reputation for his frescoes

in the pope's private rooms in the Vatican, but he was too busy to take much interest in Alfonso's project. Fra Bartolomeo did not get very far before he died late in 1517, leaving Alfonso with a much diminished *paragone*. Therefore, Alfonso was casting around for a substitute when he heard of the acclaim that Titian had gained for the *Assunta*, whereupon it seems that he promoted Titian to the first division and commissioned him to paint Fra Bartolomeo's subject, *The Worship of Venus*. Here was Titian's chance.

Alfonso's plan was that the pictures for this suite of rooms would follow the descriptions in a classical text, the *Imagines* of Philostratus, of which Isabella had supplied a handy translation. The subject that Titian was given, and followed closely, consisted largely of a crowd of cupids gathering apples ('if there are many of them, do not be surprised'). Since the *Assunta* contained a similar throng of chubby cherubim ringed around the ascending Virgin, it is not difficult to see why Titian seemed a natural person to take this on. And, indeed, he eventually made a good job of this unpromising theme: a meadow densely packed with naked toddlers. The completed picture has a joyful sense of abundant young life (suggesting that Titian observed small children closely and affectionately).

But Alfonso, whose eagerness to get hold of new works of art matched his sister's, was becoming impatient. In late September 1519, the Ferrarese ambassador to Venice, Jacopo Tebaldi, was ordered to tell the artist to hurry up (Alfonso's ambassador to Rome delivered similar messages to Raphael, with no effect). Apparently, Titian had promised to begin this work 'that very morning' a year and a half previously – around the time the *Assunta* was completed. *The Worship of Venus* obviously still had a way to go, because – under pressure – Titian travelled to Ferrara with two assistants and worked on it for nearly three months before it was finally finished. One of the artist's reasons for delay was both valid and revealing. As he told Tebaldi in October 1519, he did not want to finalize the picture before he had examined exactly where it was going to hang. That is, he wanted to be sure that it related to the space it was in and the fall of light within it, just as the *Assunta* did in the Frari.

Titian's other difficulty about delivery, a good one for an ambitious artist to have, was sheer volume of work. Alfonso was by no means the

only patron whose estimation of the artist had ascended steeply since the *Assunta* was unveiled. Titian had been busy before, but mainly on smaller works such as portraits. In the two years following the completion of the *Assunta*, more orders poured in for large, ambitious works. Among these were no fewer than five altarpieces, for churches in Ancona, Treviso, and Brescia, plus one for the nave of the Frari and another for a little church nearby, San Nicolò ai Frari (also known as San Nicolò della Lattuga, 'of the lettuce', because of a miraculous cure involving salad). He had inveigled this last task away from a youthful ex-pupil of his named Paris Bordone, who was still bitter decades later when he told Vasari that Titian 'so went to work with various means and favours' that he was given the job. Bordone darkly suggested that he did this either to prevent his potential rival 'from being able to display his ability so soon', or perhaps alternatively through greed – 'his desire of gain'.

On 6 April 1520, a few months after Titian got back to Venice, Raphael died aged only thirty-seven, having (just about) finished his altarpiece in the competition with Sebastiano Luciani for Cardinal Giulio de' Medici and not begun his picture for Alfonso d'Este, although he had produced a design for it. This commission also went to Titian.

Obviously with so much work piling up, Titian had to prioritize. He was also plagued with errands for Alfonso, who – just as Pirckheimer had done with Dürer – asked him to shop on his behalf in the great bazaar of Venice. His unfortunate ambassadors were subject to similar demands. On 29 May 1520, Alfonso fired off two requests. The first was both artistic and zoological (another of the duke's interests was exotic animals, of which he had a menagerie in Ferrara). 'Take care to speak immediately to Titian and tell him to do me a portrait as soon as possible and as though it were alive of an animal called gazelle, which is in the house of the most honourable Giovanni Cornaro. It should fill the entire canvas.' Unfortunately, the creature turned out to have died (Venice being an unsuitable habitat for a gazelle). To his order for this wildlife study, Alfonso added a rider: 'And remember to send those spice jars, which were supposed to be sent to us some days ago.' These were a set of majolica vessels that had been ordered from a potter whom Titian had found.

But in Titian, as his biographer Sheila Hale writes, the duke of Ferrara had met his match. 'The painter's sense of humour was subtler than the duke's; he had better manners and more charm.' Furthermore, Titian 'was every bit as wily and stubborn as his aristocratic patron'. And it was not only ideas about art that he had picked up from hearing of Michelangelo and Raphael. Clearly, he had also grasped that a successful artist might enjoy a lifestyle and status far higher than that of a servant; Raphael lived in a lordly style. Raphael's death – as Titian may well have seen it – left him alone in contention with Michelangelo for the title of greatest living artist.

By November 1520, Alfonso was growing impatient for the next mythological painting for his *camerini*, having transferred the deceased Raphael's commission to Titian. 'Exhort him to do what he has promised so that we shall not have cause to be vexed with him.' A few days later, Tebaldi caught up with the artist and discovered that he had been busy on a different work for another patron, a polyptych for Altobello Averoldi, bishop of Pula and papal legate to Venice. This was for a large church in Averoldi's see, Santi Nazaro e Celso in Brescia. So far, Titian had completed one of the five panels, depicting the martyred, almost naked Saint Sebastian. And with this he had scored a triumph among the cognoscenti. People were talking about it, Tebaldi reported, 'because it is a most beautiful picture'. He had done his best to deliver the duke's rebuke, telling Titian that his excuses were as highly coloured as his pictures (a remark one suspects was prepared in advance). The painter had responded by observing that the bishop was paying two hundred ducats for the whole altarpiece, but this figure alone was worth that price. Tebaldi then asked why he did not serve the duke instead, and Titian loyally pledged that he was ready to do so, 'night and day with brush in hand'.

Tebaldi had taken the bait. On 29 November, he went to the painter's studio behind the Ca' del Duca to have a look at this Saint Sebastian. He arrived to find Titian was hosting an informal private view. 'I found many people from hereabouts who were viewing it with great admiration and praising it.' Presumably, they were local enthusiasts for modern art such as Marcantonio Michiel, Niccolò Aurelio, Andrea Navagero, and Giovanni Ram. Titian was expounding his latest achievement to these visitors,

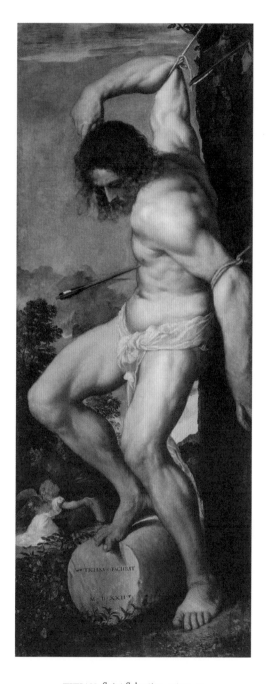

TITIAN *Saint Sebastian,* 1520–2

'that it was the best painting that he had ever done'. Then he continued the conversation privately with Tebaldi. The ambassador said that, 'It was throwing this picture away to give it to a priest, and that he [Bishop Averoldi] would take it to Brescia, a place, etc.' Presumably he meant the town was a backwater. Tebaldi suggested that Titian could easily make a second version of the naked saint for the altarpiece, changing the pose just enough to disguise what had happened. Titian answered that he was most ready to do everything and anything 'that would be pleasing to Your Excellency'.

This exchange reveals a deep contradiction in the Renaissance attitude to pictures. On one hand, this was a sacred image of a martyred saint commissioned by a senior clergyman for the altar of a church. But simultaneously it was a marvel of art, which would give a collector strictly artistic pleasure. The same work, it seemed, could seamlessly switch from the first function to the second. The artist and his patrons, perhaps, thought of it as both.

Tebaldi, who after all was a diplomat not an art expert, conceded that he did not understand *disegno*, but offered his own lay person's opinion, 'admiring all the parts and muscles of the figure, to me it seems similar to a body created by nature, and dead'. His mention of '*disegno*' gives a clue to some more of what Titian had said. The artist must have pointed out that the figure was a remarkable feat of *disegno*; perhaps he said that it was the finest thing of that kind he had ever achieved. What he probably did not add was that his spectacular new figure was borrowed directly from a drawing that Michelangelo had made for the *Rebellious Slave* that he had been carving for the tomb of Pope Julius II (or a related figure). Such seepages from Michelangelo's studio regularly occurred. Sebastiano Luciani, for one, had access to the workshop in Rome where both drawing and partially completed sculpture were stored. With this figure, Titian was competing with Michelangelo on his own ground: the muscular male nude. Here was a superb piece of *disegno*, albeit lifted from Michelangelo himself. But Titian had transformed the original with a spectacular display of everything that his Venetian paint-handling could evoke: the lustrous surface of the skin, the visible softness of the man's flesh despite his bulging muscles, the misty landscape behind, the contrast between the living foot and the broken marble column on which it rests.

Titian himself had probably already reflected that it was shame to send this masterpiece off to Brescia. But redirecting it to Alfonso's palace was a delicate matter since relations between the dukedom of Ferrara and the papacy were always touchy. Initially, though, Alfonso felt that it was worth the risk. The ambassador made the offer that Titian was surely expecting, and the artist smoothly responded that, 'although I would not carry out this fraud against the Papal Legate for any man in the world, I would gladly do so for His Excellency if he were to pay me 60 ducats for the Saint Sebastian'. This was, as Titian pointed out, a good price. But after thinking it over, Duke Alfonso decided that it was not worth the risk of offending the papal legate. Instead, Titian 'should think of serving us well with that work which he is supposed to do for us'.

Alfonso's next mythological picture, almost certainly *Bacchus and Ariadne*, was in a queue, however – and not actually delivered for another three years. In the meantime, Titian had plenty to get on with. In 1519, he had received a down payment on a second altarpiece for the Frari. This was a picture for a family chapel on the side wall of the nave (and was not to be delivered for seven years). The patron, Jacopo Pesaro, was one for whom Titian had worked before. He was eccentrically vain, the fee was not large, and the project was rather complicated. But, in addition to Titian's aversion to letting another artist have a commission that he could grab for himself, from his point of view it had certain advantages.

The position was prominent – in some ways more than the *Assunta* since it was in the part of the church in which the laity were generally allowed. What is more, this was an opportunity for him to rethink and bring up to date the most renowned of all Giovanni Bellini's specialities: the Madonna and Child with saints. One of Pesaro's requirements was that the altarpiece should emphasize his brief moment of military glory. This had been during the obscure conflict known to historians as the Second Ottoman–Venetian War. Essentially, this was just one stage in the slow retreat of Venice from the Balkans and eastern Mediterranean. Jacopo was the papal representative in the war fleet that sailed in May 1501 and was in charge of the papal warships. During the campaign, the little island of Lefkada in the Ionian Sea, known to the Venetians as Santa Maura, was briefly captured. Ever

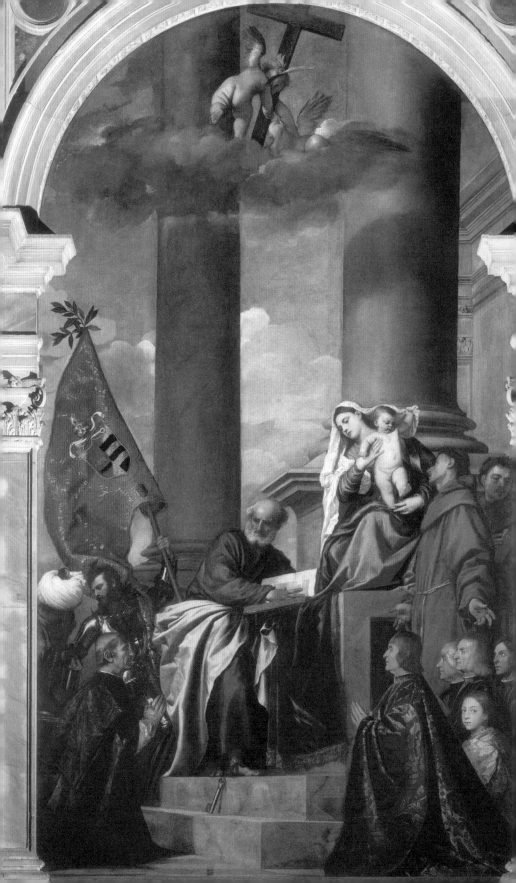

afterwards, Jacopo was immensely proud of the marginal part that he had played in this transient triumph (one of the terms of the peace treaty in 1503 was that Venice had to return the island to the Ottomans). He was also rivalrous of a remote relation, Benedetto Pesaro, who had been the supreme commander of the Venetian naval force in the same war and had an almost blasphemously ostentatious funerary monument on the opposite side of the Frari church. Part of Titian's assignment, therefore, was to make an elegant reference to this forgotten military episode. This he had already done in a picture for Jacopo's private enjoyment of himself being presented to Saint Peter by the pope and carrying a battle standard. In the new altarpiece, behind the kneeling Jacopo on the left-hand side of the picture is a handsome bearded saint who flourishes a magnificent scarlet banner with the Pesaro arms and the papal insignia and topped with the laurel of victory. His shining plate armour is a lyrically Giorgione-esque passage of painting; and rather Giorgione-like too is that Titian has not bothered to make clear exactly which saint he is (perhaps Saint James the Moor-slayer, in which case the turbaned figure would be his attribute).

Another aspect of the commission was that it was to be the centrepiece of a private chapel. Jacopo's branch of the Pesaro family had bought the rights over this section of the nave wall. So Titian had to include portraits not only of Jacopo, but also of three of his brothers – Antonio, Francesco, and Giovanni – plus the only legitimate male heirs that they had collectively managed to produce: Antonio's sons Leonardo, born in 1508, and Niccolò, born in 1515. This he did with only the smallest hint of a school-photograph crush. Indeed, young Niccolò, gazing out of the picture is, along with the armoured saint, one of the most beguiling figures in the picture.

So much for Jacopo's requirements. Probably for his own satisfaction, as well as to display his brilliance, Titian must also have wanted to galvanize the scene with movement. Bellini (and painters who followed him) would have lined up saints and donors, with the Madonna and Child in the centre, while everybody looked serene and reflective. In film-directing terms, Titian reframed the shot, arranging his figures on an oblique wedge leading up to

TITIAN *Pesaro Altarpiece*, 1519–26

Mary and the infant Christ on their throne. This diagonal into the space is balanced and offset by the banner slanting backwards and outwards. Almost no one gazes towards us, the viewers, as Bellini's holy figures generally do. Saint Francis looks upwards and inwards to the Christ Child; Saint James the Moor-slayer – if it is he – outwards and downwards to the Moor. Saint Peter glances across at Jacopo. The hinge or pivot of it all is the Madonna and Child: she looks at Jacopo, while the infant, facing at ninety degrees away from her, responds to Francis. According to technical analysis, Titian worked out all this three-dimensional visual geometry without too many problems. It was the final element, the setting of the whole scene, that gave him trouble. He tried out at least two solutions before he got the answer. Ultimately, his solution was to add a pair of enormous classical columns behind the group of Madonna, infant, saints, and donors. These do not make much sense architecturally – the pillars are set very far apart and it is unclear what sort of structure they belong to – but visually, they function perfectly, leading the eye off at an angle to the wall and echoing the rhythm of the massive Gothic pillars of the nave.

Raphael's subject for Alfonso d'Este had been *The Triumph of Bacchus*. Alfonso transferred the assignment to Titian with a change. This slightly passé idea of a triumph – in essence, a procession – was swapped for a different Bacchus-related episode: the god of wine's discovery of the Cretan princess Ariadne abandoned and disconsolate on the island of Naxos. This story was extracted from two classical poets, Ovid and Catullus, with a learning and skill that suggests that a literary expert – perhaps Alfonso's court poet Ludovico Ariosto – had a hand in it. Titian, too, knew this writer well enough to paint his portrait later, so perhaps they discussed it together. At any rate, this revised theme offered many more dramatic possibilities to the painter – and he seized them.

On seeing the forlorn princess, Bacchus leaps from his chariot, one foot suspended in mid-air as if in a freeze-frame. The reddish-purple cloak swirling behind him like Superman's cape gives a sense of his velocity. This is a figure that might have been conceived to illustrate the concept of motion. Quite possibly, it was. In Alfonso's *camerino* – the room out of the private suite where these mythological paintings were hung – Titian's work

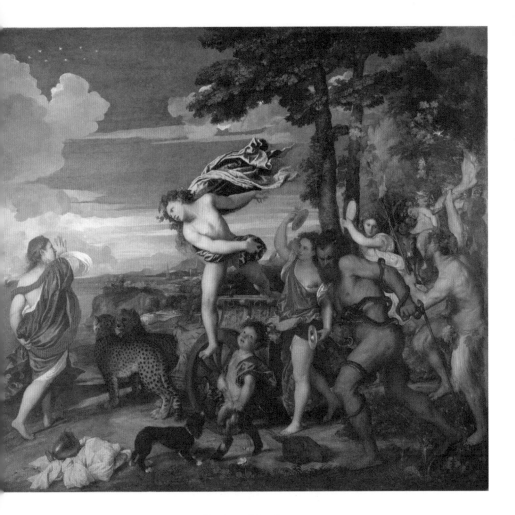

TITIAN *Bacchus and Ariadne*, 1520–3

was directly juxtaposed with Giovanni Bellini's. The space was rectangular, with windows along one of the long sides and three paintings hanging opposite, one of which was Bellini's *Feast of the Gods*. Titian's *Bacchus and Ariadne* was almost certainly on an end wall, and the direction of light within the pictures suggests that it was positioned with a window to its left towards which Bacchus is flinging himself. Such details – how the room was arranged, where the light fell – were important to the artist (as they had been in the Frari). This was why he had refused to finish *The Worship of Venus* before he had seen where it would be placed. With *Bacchus and Ariadne*, he upped his game from that first mythology, presenting Alfonso with a feast of painterly pleasures. Firstly, movement. According to Ovid,

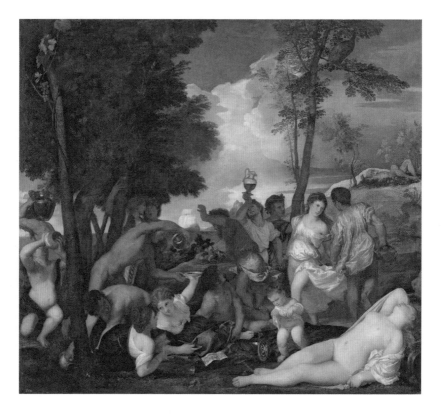

TITIAN *The Andrians*, 1523–6

Bacchus jumped down to prevent Ariadne from being frightened by the beasts that drew his chariot, but these two cheetahs – no doubt portraits of specimens in Alfonso's private zoo – are calm and static. All the others, even the barking dog, are active. Ariadne whirls away in alarm, while Bacchus's train of followers are all advancing in different ways. A child satyr marches along pulling the severed head of a calf; an adult rushes in from the right waving the creature's leg above his head. Silenus, drunk on a donkey, brings up the rear. All these diverse elements are integrated with a melodic elegance to rival Raphael's. In addition, Titian offers land-scape: a distant prospect of a coastal town, high mountains like those of his native Dolomites, a sky with billowing clouds (and also the stars into which Ariadne was transformed), and the wood from which Bacchus and his train are emerging. Then there is his brilliant use of lighting. Sunlight catches just those points that the artist wants to stress – Bacchus's head, right arm, and chest, for example, while his other arm and leg are sunk in half shadow. The whole composition is organized in this way, not just by line and form, but by the highlights and dapples of outdoor reality. Lastly, he demonstrated virtuoso command of what oil paint could do. In some areas, there is minute precision – for example, the wildflowers that grow at the feet of the gigantic man entangled with snakes. In others, such as the drapery of Bacchus, Ariadne, and the leading maenad, wearing orange and blue – the areas signalling energy and action – the handling of paint is much freer. One can see the marks of the brush.

This was a picture for Alfonso to savour for a lifetime, examining it closely, finding new details. The naturalism with which Titian treats human flesh is extraordinary. He based the naked giant on the *Laocoön*, a famous classical sculpture that Titian could not have seen, since he had not yet been to Rome. But, working from copies, he was able to transform the marble into living, sunburnt skin and muscle. In *The Andrians*, almost certainly the final picture that he delivered to Alfonso, he accomplished everything he had done in *Bacchus and Ariadne*, plus one more thing. The works that he had so far produced for the duke lacked a female nude. But here he added one of the most beautiful that he ever painted. She is a variation on the sleeping Venus motif borrowed from Giorgione and ultimately derived

from a renowned classical sculpture in the Vatican. Titian probably blended this with a carving from a Roman sarcophagus, but most crucially from observation of real, naked living flesh. One of his many excuses for not going to Ferrara when Duke Alfonso summoned him was that he needed to stay in Venice where he had life models: a man who posed for him in the nude and several prostitutes who did the same. One or more of these contributed her body to this masterpiece, allowing Titian – as the goddess Aphrodite had for the mythical sculptor Pygmalion – to transform cold marble into living flesh.

During the 1520s, Titian continued to be matched against Giovanni Bellini, who had died in 1516, including in Ferrara, where he eventually repainted the landscape of Bellini's *Feast of the Gods* to give it more asymmetrical dynamism, to match his own works and to link it directly with *The Andrians*. In 1522, he was ordered to finish a painting that Bellini had begun in the Sala del Maggior Consiglio of the Doge's Palace – or else all hope of the long-promised *sanseria* would be lost. So he had to collaborate posthumously with the great man, which perhaps made him all the keener to demonstrate how much he excelled his famous predecessor. This urge may explain why he accepted another commission for an altarpiece in a Venetian church. The fee was small and, as it turned out, he had trouble in getting it paid at all.

The commission did not come from nobles of the Venetian state but from the middle-class members of the Scuola di San Pietro Martire. This was one of the so-called *scuole piccole*, the city's small confraternities (as opposed to the six large ones). It had no meeting house, merely rights over an altar in a church, but it was in a prominent place: the second on the left in Santi Giovanni e Paolo, one of the grandest churches in the city. Despite the prominence of their altar, the members of the Scuola di San Pietro Martire must have been aware that it could not compare with those of the *scuole* of Saint Vincent Ferrer and Saint Catherine on the opposite side of the church, both of which displayed masterpieces by Giovanni Bellini. In 1525, they agreed to pay for a new painting. At this point, a dispute broke out. The managing committee sent a petition to the Council of Ten complaining that certain members wanted to give this commission to an artist

who was not up to the job. They asked to be allowed to pay themselves for a picture by a painter 'first in that art', which would be 'made with a beauty and perfection that befit this reverend confraternity and the whole church'.

There followed a competition between Jacopo Negretti (1548–1628), known as Palma il Giovane, and Titian as to who would paint this picture. Palma was a member of the *scuola*, and probably behind the petition, but, nobly, he did not want to snatch the job for himself, but to compete with the leading artist in town. In the mid-1520s, he probably ranked as the number-two painter in Venice. This contest was therefore set up by artists for their own interest and satisfaction. Another painter, an outsider from Friuli called Giovanni Antonio de' Sacchis and nicknamed Il Pordenone, also seems to have taken up the gauntlet. Titian was probably keen to vanquish both of these rivals, but even more so to show his superiority over Bellini. The subject also provided an opportunity to demonstrate – publicly, in the heart of Venice – what he could now do. The confraternity's patron saint, San Pietro Martire, was a thirteenth-century Dominican friar from Verona who had been murdered while travelling by an assassin hired by heretics. This was a scene that would allow an altarpiece with all the dramatic action that he had given classical mythology in *Bacchus and Ariadne*. But this was not a Grecian idyll; it was a violent blood-soaked tragedy. Palma died suddenly, possibly of the plague, in 1528, but in any case Titian's victory was probably assured. In that same year, a street brawl occurred in which one Alvise of Cyprus, described as Titian's 'servant', died from a stab wound from a patrician ruffian named Battista Quirini. It was a blow to the head very much like the one that killed the saint, 'a wound under the left eye, from which he passed away from the present life'. Perhaps Titian's imagination needed no extra charge, but the brutal end of someone close to him – whether valet or assistant – could hardly have failed to affect his imagination.

His altarpiece no longer exists. It was burnt in 1867 amidst an art-historically catastrophic fire, together with Bellini's painting of Saint Catherine of Siena. Almost everyone who saw it before it was destroyed felt that it was Titian's greatest masterpiece, and it was precisely the power with which he depicted extreme fear that struck most observers. In a letter published in 1537, only seven years after it was finished, Pietro Aretino

described how the painting brought home to viewers, 'all the living terrors of death and all the true sorrows of life' in the face and figure of the fallen saint. He described the forensic detail in which these were captured: the 'cold and livid appearance of the tip of the nose and the extremities of the body' and the face of the saint's fleeing companion, 'white with terror' as he swirls away from danger like Ariadne, were regularly mentioned. It was left to the twentieth-century art historian Charles Hope to note the originality with which Titian had made a group of elder trees, thrashing in the wind, 'almost a protagonist in the action' (the central trunk is part of the sacred drama, extending the saint's raised arm upwards to the palm of martyrdom held by angels in the sky). Indeed, to judge from copies, they seem to have carried the turbulent emotion of the picture as much as the human figures. So this was also a triumph for Titian the landscape painter. Aretino's letter was addressed to a Florentine sculptor and garden designer, Niccolò Tribolo, and described how amazed he and his companion Benvenuto Cellini had been on seeing this tempestuous drama of a painting.

In Ludovico Dolce's *Dialogo della pittura* from 1557, quoted in the previous chapter, the main speaker is Aretino, who had died the year before. The character in the dialogue makes exactly the same points about this painting as the living Aretino had in his letter. The *Dialogo* is concerned with the supremacy of Titian as a painter. It begins with a recollection by Aretino of going to mass in Santi Giovanni e Paolo and seeing the magnificent altarpiece and the works of Bellini. The latter is described as 'a good and careful master', but Titian had surpassed him (and Giorgione), by 'a thousand leagues'.

Aretino had arrived in Venice in 1527, and almost immediately bonded with Titian and became his publicist. He described and praised the painter in numerous letters, which were published in book form and became sixteenth-century best-sellers. With his art at full power and Aretino's assistance, Titian's fame grew beyond Venice and small northern Italian courts such as Ferrara. Eventually, he became the favourite artist of Holy Roman Emperor Charles V and his son, Philip II, the greatest rulers in Europe. He became a truly international artist.

MARTINO ROTA (AFTER TITIAN)
The Martyrdom of San Pietro Martire, c. 1560

CHAPTER SIX

STUPENDOUS CITY: REMODELLING VENICE IN THE ROMAN STYLE

J acopo Sansovino was rudely awakened on the night of 18 December 1545. He had been sleeping in his apartment on the north of Piazza San Marco, in lodgings adjoining the Torre dell'Orlogio, the clock tower that afforded a splendid view of the basilica, the piazza, and the waters of the lagoon that lay beyond. The architect's rest was disturbed by officials of the Venetian state, who took him across the piazza to the Doge's Palace, where he was thrown into prison. This unexpected change of fortunes had come about when the vault of the first bay of the Biblioteca Marciana, the Library of San Marco, which he had designed (and the construction of which he was supervising), had quietly collapsed earlier that night. For a while, it seemed that not only the library, but also Sansovino's career was in ruins.

He was interrogated on 22 December by a high-ranking committee. Sansovino attempted to pass this embarrassing subsidence of his masonry as a minor incident, which was not at all his fault. Asked the reason for the ruination of this brand-new structure, the architect responded that he could not think of any, except for the ice that had been gathering on the vault and a military galley that had been discharging its guns nearby. When that happened, he added, the whole structure shook. Had he ever mentioned, the board inquired, that ice might endanger this expensive project?

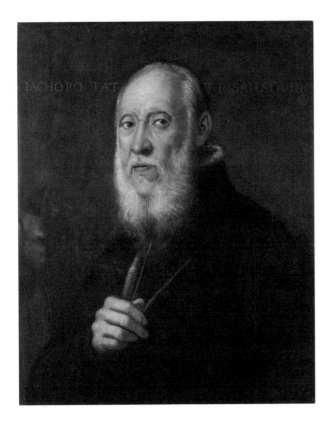

JACOPO TINTORETTO *Portrait of Jacopo Sansovino*, 1570

No, Sansovino admitted, he had never said anything to anybody; he had never imagined that there would be such a build-up of ice as had actually occurred because he thought the vault would have been covered with lead by the time the frost came. Unfortunately, heavy rain had slowed progress.

Clearly, none of these unfortunate events could be blamed on the architect. Finally, however, Sansovino was asked whether it would not be safer to reroof this structure with *travatura*, wooden beams, instead of stone. Sansovino was obliged to admit it would. Why, then, had he not done so in the first place, as he had been advised by one of his questioners, the procurator Antonio Capello? 'Because', the architect answered, 'I wanted to make the vault longer lasting, more proof against fire, and more beautiful'.

There was the nub. Stone vaults were standard in Florence, where Sansovino had been born and had initially trained, and in Rome, where he had further developed his ideas. Moreover, he had begun his career as a sculptor rather than as an expert in constructing buildings. The library was not the only project of his to suffer from structural problems. The Fabbriche Nuove, a utilitarian block of offices and shops at the Rialto, had poor foundations and dangerously thin walls so that it had to be repeatedly and expensively restored.

At the time of his misfortune over the collapsing vault, Sansovino was still in the process of adapting to the rather different circumstances in which he found himself: supervising large projects on the marshy silt of Venice, where tastes and attitudes were not the same as those in his native Tuscany. But artistically and personally he was a pliably adaptable man.

Sansovino was released from the cells and kept his job, but at a price. He was ordered to pay for the repairs. For two years, he was obliged to work without his salary, and it was twenty years before he managed to write off the thousand ducats that he was obliged to borrow to put right his costly mistake. His employers, the Procurators of San Marco, had clearly shown who was in charge, and that they did not want any more important state edifices falling down. For his part, though he complained to his ally Cardinal Bembo that it was a lot of fuss about not very much – 'only one window fell', together with the vault above it – he put up with this treatment. He valued his position in Venice too much to rebel or leave – and it was worth keeping. For more than two decades, Sansovino was effectively the state architect of Venice, as well as its most prominent sculptor. Until his death in 1570, he maintained a near monopoly on building in the ceremonial centre around Piazza San Marco. He transformed this, the grandest space in Venice, more fundamentally than any single individual has done before or since.

In modern terms, what he achieved was partly urban renewal and partly town planning. Jacopo de' Barbari's view of the city shows that around 1500 the general appearance of the piazza was much the same as it is five and a quarter centuries later. Most of the crucial features were already in place: Doge's Palace, San Marco itself, with its campanile, and the long space stretching in front of the church. But if de' Barbari had looked closer, he

would have discovered a mass of bustling, decrepit disorder. There were five, somewhat sleazy inns, typically shown in contemporary prints with courtesans peering out of the windows, plus a meat market in the decaying building south of the campanile that faced the palace. Surrounding the two columns at the end of the smaller Piazzetta San Marco at the south-east corner of the main piazza were clustered wooden shacks that were used as vegetable stalls and also lavatories. Around the corner, facing the lagoon, was a little row of popular cheese and salami shops. All of these facilities had their uses and supporters. To a reader of urbanist Jane Jacobs' theories, they sound like just the kind of unplanned, chaotic features that make for a living city. But as a grand entry to an imperial capital, this array of shambolic stalls, public loos, knocking shops, and sausage vendors was clearly not imposing. Less controversially, the row of medieval buildings south of the piazza was falling down and needed to be renewed.

Bit by bit, Sansovino, supported by the Procurators of San Marco, set himself to remedying all this. On 7 April 1529, he was appointed *proto-maestro* – or *proto* – of San Marco (this was a relic of Venice's Byzantine roots, '*proto*' meaning 'first' in Greek). This post meant that he was both chief architect but also responsible for the upkeep of all the structures that the procurators themselves supervised – like a borough surveyor. He quickly made a start by clearing away the ramshackle stalls around the two columns. Then in 1531, no doubt urged by Sansovino, the procurators *de supra*, who were responsible for the area around San Marco, tried to remove the scatter of food stalls from the whole piazza and the Piazzetta. It was a Sisyphean task. Even though they were threatened with fines and even imprisonment, for decades afterwards the stalls kept creeping back – which suggests that what they were doing was popular and profitable. However, Sansovino and his employers – and ultimately the doge himself, Andrea Gritti – were intent on a different goal. They were determined to make the heart of Venice grander, more decorous, more dignified and fitting.

To this end, the procurators decided to demolish the south side of the piazza and the west side of the Piazzetta. In July 1536, Sansovino was instructed to make a model for this new structure, and it was perhaps at this point that he made a fundamental decision. The fronts of the old buildings

along the south side of the piazza were in line with the north wall of the campanile, as can be seen in Gentile Bellini's painting (see pages 32–3). Sansovino decided to shift the position of this whole block so the entire piazza became a trapezoid, wider towards the basilica, narrower at the other end. This opened up more expansive view of San Marco and revealed a slice of the Doge's Palace behind the campanile. Thus he created a view that has been painted and photographed uncountable times over the centuries. Sansovino made Piazza San Marco into the perfect picture that it is. But the buildings that he planned were not built until after his death, and probably not as he intended. Instead, the ambitious scheme began with the demolition of some bakers' shops, just on the Piazzetta side of the campanile.

It had been decided that this was the perfect spot on which to construct something that Venice had embarrassingly lacked for many years: a building grand enough to contain the magnificent library presented to the Venetian state by Cardinal Bessarion in 1468. One of the conditions of the bequest was that his precious manuscripts should be suitably housed and available to scholars. Obviously, it had taken the authorities some time to fulfil that, but Sansovino's design for the Biblioteca Marciana did the job superbly.

It is a masterpiece, so richly embellished with classical architectural elements that all you see on a sunny day is a long row of Ionic columns and capitals and balustrades, topped off with a richly sculpted entablature and frieze stretching down the Piazzetta like a long procession of patricians. And that was no doubt exactly what Sansovino's masters wanted. His new building represented not so much what we now call gentrification as the patricianization of the site.

Crucially, however, it was a building that knew its place. It is a marvellous complement to the west wall of the Doge's Palace opposite, but it never upstages it. It operates more like a piece of theatrical scenery: a backdrop to the star attractions of the palace and the basilica of San Marco. A powerful element in Venetian opinion would have welcomed that tactfulness. Later in the century, there was a move to raise the building by a storey on the grounds that this would improve its proportions and make them more correctly classical. It failed, apparently, because to do so would, in the words of the then *proto*, 'suffocate' San Marco and the palace.

Sansovino added two other elements to the ensemble around San Marco. He designed the Zecca – or Mint – that stands on the waterfront next to the southern end of the Biblioteca Marciana. He intended this for the state rather than for the procurators specifically, and produced a building that *looks* marvellously strong, with its facade of ribbed rusticated columns. Vasari called it the finest and richest of Sansovino's buildings, but also the 'strongest'; you might say that it performs strength, flexing its masonry muscles, but – again – does so discreetly (and would have been even less obtrusive before a third storey was added in 1558, contrary to Sansovino's original scheme).

The Biblioteca Marciana, with one of the two columns in the Piazzetta San Marco on the left

Engraving of the facade of the Loggetta designed by Jacopo Sansovino, 1530–42

Sansovino's third addition to the heart of Venice was the Loggetta, a small structure at the base of the Campanile di San Marco in which nobles met and chatted, protected from the rain and surrounding hurly-burly, before attending meetings in the palace opposite. It is essentially a beautiful architectural frame for low-relief panels of white Istrian stone and free-standing bronze figures in niches. Deborah Howard, doyenne of historians of Venetian architecture, suggested that it is not so much a small piece of architecture as a large-scale sculpture. Its message is political propaganda in a fashionably classical idiom.

According to Sansovino's son Francesco, the three reliefs embody 'the sea and land empire of their lordships' (the doge and Senate of Venice). But these colonial possessions have been turned into the naked bodies of

classical deities. Jupiter stands for Crete; Cyprus is represented by Venus, since that was her birthplace. In the central panel is Venice herself, female and curvaceous. The personification of La Serenissima as an imperious yet sensual female figure is a creation of Sansovino and the artists who followed him (notably Veronese). It is both strange and perfectly apt.

*

Thus Sansovino, you might say, composed the centre of Venice into a series of prospects (or pictures). But the harmonious result was the product of an interplay between numerous Venetians, who had strong and differing views, and this imported expert – a foreigner from distant Tuscany. Sansovino's original name was Jacopo Tatti. He was born in Florence in 1486, the son of a mattress-maker, and apprenticed to Andrea Sansovino, a somewhat older and considerably less talented contemporary of Michelangelo. The young Jacopo venerated his master to the extent of taking his name. That allegiance put him on the opposite team to Michelangelo, with whom he clashed in 1518 when the great man removed him from a project to construct a new facade for the church of San Lorenzo in Florence. When Michelangelo cancelled this commission, Sansovino wrote him a furious letter alleging

Central panel of the frieze on the facade of the Loggetta, representing Venice as Justice

that with the former, 'there are neither contracts nor good faith, and all the time you say no or yes as it suits and profits you'. Expecting Michelangelo to do anyone else any good 'would be like wishing water would not make anyone wet'. Michelangelo simply ignored this outburst and filed it away. In the mid-1520s, Sansovino blossomed in Rome (while Michelangelo was tied down in Florence), carving notable pieces of sculpture and beginning to design buildings. Like Michelangelo and other Florentine artists, he assumed that someone who had mastered *disegno* – meaning, as we have seen, not just drawing, but a deeply internalized sense of the form, structure, and proportions of the human body – could take on architecture as easily as sculpture or painting. What he brought to Venice, therefore, was not exactly what John Ruskin later disdainfully called the 'Roman Renaissance', but a style that had been refined in Rome by both Florentines and also the Urbino-born but partly Florence-trained Raphael.

On 5 August 1527, the painter Lorenzo Lotto mentioned a piece of art gossip in a letter, that two refuge sculptors had recently appeared in town. One was Jacopo Sansovino, then forty-one, 'who in Rome and Florence is held in high esteem second only to Michelangelo'. He had fled Rome, which had been sacked with appalling cruelty by the mutinous army of the Holy Roman Emperor the previous May. The pillage, torture, and extortion went on for weeks, until Pope Clement VII, who had been besieged in the Castel Sant'Angelo, surrendered. Sansovino was imprisoned together with a group of hostages whose names read like the index to a history of Renaissance art – Parmigianino and Rosso Fiorentino were fellow prisoners. Like the others, Sansovino would have been released only after parting with what money and valuables he had.

Together with Bartolomeo Ammannati, another refugee sculptor and architect, Sansovino fled through war-torn Italy. Their native city of Florence was convulsed by an insurrection against the Medici. Eventually, Sansovino concluded that his best option was to escape abroad. He might go to France, where King Francis I was keen to recruit leading Italian artists, or even England, whose King Henry VIII was planning a tomb for himself of megalomaniac proportions. But he stopped en route in Venice, 'to make himself ready and provide himself with many things, for he was

despoiled of everything', as Vasari related (no doubt repeating Sansovino's own account).

News of his appearance in town came to the ears of Doge Andrea Gritti (1455–1538), who must have been delighted that fate had brought this visitor to his realm. He quickly found the sculptor and architect a suitable job working on repairs to the domes of San Marco. A major artist such as this, an outstanding practitioner of the very latest styles, was just what the doge required. So Sansovino never continued his journey; instead, he spent the remaining forty-three years of his life in Venice. As we have seen, in 1529, he was appointed *proto*, a post that he occupied until his death in 1570.

Obviously, Venice suited him. Many years later, his son Francesco explained why the efforts made to lure his father back to Rome so that he could supervise the rebuilding of Saint Peter's – the greatest architectural project in Europe – came to nothing. 'It was all in vain, because he said that one should never give up life in a republic and find oneself living under an absolute prince.' He had evidently had enough of despots, even relatively benign ones such as Pope Clement VII and his successor Paul III.

Sansovino must have had a shock when in October 1529, just six months after he had been appointed *proto*, Michelangelo turned up in town. The great sculptor, a dedicated anti-Medicean, had joined in the defence of the Florentine Republic until, alarmed by the situation, he abruptly fled, pausing in Venice on the way to France.

Doge Gritti would certainly have employed Michelangelo if he had been able to. Indeed, according to the artist's biographer Ascanio Condivi, at some point during the 1530s or 1540s, the artist was offered a handsome salary merely to 'honour the Republic' with his presence. But he returned to Florence in November 1529 after a few weeks. Sansovino was supposed to have patched up his relationship with Michelangelo, but evidently he was still bitter. In 1535, Benvenuto Cellini and Niccolò Tribolo, two Florentine sculptors and potential rivals, came to visit him. Sansovino entertained them in his apartment on Piazza San Marco. But despite an 'excellent dinner', the atmosphere soured. Cellini complained that, 'all through the meal Sansovino never once stopped boasting about his great achievements, running down Michelangelo and all other sculptors, and praising himself beyond belief.

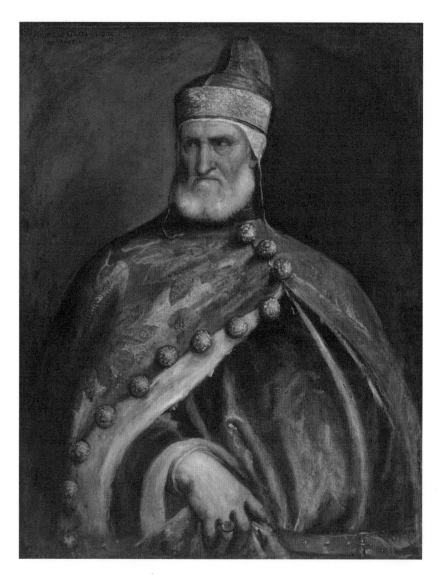

TITIAN *Portrait of Andrea Gritti, c. 1546–50*

This began to annoy me so much that I felt sick with every mouthful I took.' Cellini and Sansovino rose from the table, both 'fuming' with rage.

Earlier in his career, Andrea Gritti had been a leading figure in the Wars of the League of Cambrai, a mind-bendingly complex sequence of alliances, battles, massacres, sieges, and truces that involved most of the major powers in Europe. But in essence it was an attempt by the pope to crush the power and independence of Venice. Now the wheel of fortune had revolved. The power of the Papal States was humbled, its capital sacked; Venice had emerged as the only major centre in Italy free of foreign control.

To Doge Gritti, this seemed the perfect moment to set about the reconstruction of Venice as a second, watery Rome. He was of the same generation as Pope Julius II and, though the two men were bitter political foes, their tastes in art and architecture were closely allied. Julius saw himself as the successor of the ancient Roman emperors. He supported and encouraged Michelangelo and Raphael lavishly in their attempts to rival the masterpieces of antiquity. Perhaps Gritti also saw himself as Caesar.

Titian's portrait of him, though painted after the sitter's death, suggests the doge's conception of himself. It echoes the powerfully imperious figure of Moses from Pope Julius's tomb by Michelangelo. The portrait of Gritti was also cast in the idiom of the imaginary portraits of Roman emperors that Titian painted in the 1530s (all of which were burnt in a disastrous fire in 1734).

During the last decade of his life, Gritti began the process of rebuilding Venice in the image of ancient Rome. Sebastiano Serlio, another artistic refugee who arrived in Venice in the late 1520s, gave credit for the architectural flowering of the city to the doge. This was because he had 'taken into the service of his illustrious republic' remarkable designers who were in the process of making Venice 'stupendous', a 'city of noble and *artificiosi* [skilfully conceived and executed] edifices'.

Despite the fact that few of his designs were ever built, Serlio had more of an impact on the late Renaissance in Europe than almost any other architect. He was one of the first and most influential 'paper architects' (as those whose work is mainly theoretical or fantastic are sometimes described). This was because of his *Treatise on Architecture*, published in seven books, the

first two of which appeared in Venice in 1537 and 1540, before he moved to France. Although Serlio himself was originally Bolognese, these volumes were highly Venetian in conception. Serlio used the relatively new medium of commercial printing, of which Venice was one of the great centres. But also he used it in a remarkably innovative way.

Crucially, his treatise was an *illustrated* manual of architecture. Serlio's text is clear, learned, and useful. But the bulk of the lessons that it teaches are delivered through numerous large and beautiful images. Serlio made the secrets of the architect's art and builder's craft clear to any interested reader, thus revealing professional secrets to anyone with sufficient interest. That was why a later writer, Giovanni Paolo Lomazzo, noted unkindly that Serlio had produced 'more dog-butcher architects than the hairs of his beard'. Serlio's book changed how the world looked, and also how it thought. It was translated into a number of languages; William Shakespeare seems to have been among its readers. It was probably from Robert Peake's English translation, which appeared in London in 1611, that the playwright learned about Giulio Romano, whom he mentioned in *The Winter's Tale*.

Serlio was son of a furrier. At first, he worked as a painter, though little or none of his work survives. In the early 1520s, he attached himself to the Sienese architect and painter Baldassare Peruzzi, whom he named as his master. In 1525, Serlio called himself '*pictor et architectus*', painter and architect. He was likely specializing in architectural drawings and paintings of buildings and cityscapes. He probably chose Venice as a safe haven from the imperial army, which swept past Bologna en route to Rome in 1527. At any rate, Serlio was established there by 1 April 1528, when, describing himself as an architect, he wrote his will. One of the two witnesses was Lorenzo Lotto, suggesting that Serlio had already become part of the network of Venetian artists.

Some years later, in 1534, Titian was commissioned by the Scuola Grande di Santa Maria della Carità to paint a large picture of the Presentation of the Virgin. Five centuries later, this is still in its position, although the committee room of the *scuola* has now become part of the Gallerie dell'Accademia (and an oblong was casually cut from the lower left of the canvas in 1570 to make room for a new door). The *Presentation* is a marvellous work, crammed with

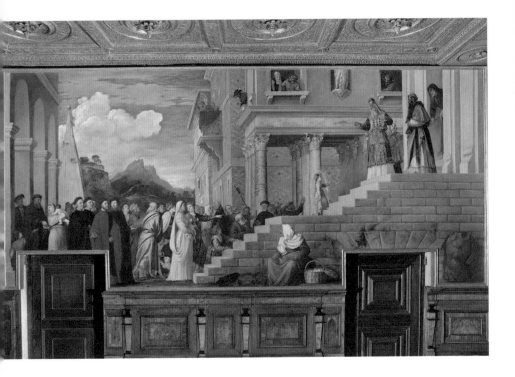

TITIAN *The Presentation of the Virgin,* 1534–8

SEBASTIANO SERLIO *Treatise on Architecture, Book Two,* 1663 edition

many items that Titian painted with superb skill on a regular basis, including a mass of portraits (among them prominent members of the *scuola*) and a magnificent Alpine landscape. It also has a much larger and more elaborate architectural backdrop than anything the artist had previously depicted. Here Titian seems to be asserting his mastery: demonstrating that he could create this traditional style of picture even better than Carpaccio and the Bellini brothers, whose speciality it was, with superb portraits of the members of the *scuola*, a landscape more thrilling than anyone else could portray, and an architectural setting in the most fashionable and scholarly idiom.

On the right of the painting, just behind the figure of the Virgin herself, ascending the steps to Solomon's Temple, is a Corinthian loggia. The colonnade is of richly veined marble, and each column is topped by a beautifully accurate capital closely resembling the one so precisely portrayed in some engravings that Serlio had published in 1528, signing himself *'professor di Architectura'*. Of course, Titian may have bought a set of these. But there

are some clues suggesting that the connection between the two men was closer. One intriguing pointer suggests that they knew each other well at the time the artist was working on his picture. In 1537, Antonio Brucioli – a Florentine writer, religious dissident, and yet another exile who had taken refuge in Venice – published a volume of dialogues. In one of these, the principal speakers were none other than Titian and Serlio. The setting is Titian's studio at Birri Grande. Serlio is characterized as having delved into architecture more deeply than anyone else of the time. For his part, Titian is described as making nature even more beautiful in colour and proportion than it actually was. Their discussion takes as its starting point a rainbow that Titian has been busy painting when Serlio interrupted his work.

It is therefore quite possible that Serlio, the established architectural expert in town, helped Titian to design the setting for this picture. The balcony jutting from the building behind the one with the splendid loggia is similar to that in the third chapter of Book Two of the architect's *Treatise*, which is on perspective – but this was not published until 1545. So perhaps Titian had access to Serlio's drawings. The receding walls and columns in

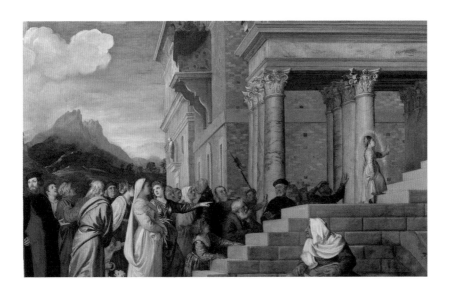

TITIAN *The Presentation of the Virgin*, 1534–8 (detail)

The Presentation of the Virgin are much like those of a classical stage set – and similar to the woodcuts of the backdrops in Serlio's *Treatise*. The steps up which the youthful Virgin is ascending to Solomon's Temple are a lucid exposition in orderly recession, as seen by someone standing in front of the centre of this enormously wide picture. Every piece of stone is depicted as a satisfyingly solid rectangular block, just as an architectural theorist who was also in love with geometry – someone such as Serlio – would conceive them. It is possible that Serlio himself designed the architectural setting for his friend: he apparently did just that for a lost painting by Giovanni Cariani.

However, the *Presentation* is only partly a virtuoso representation of architecture. In classical stage sets, the vista ended with a distant gateway. Here, in contrast, the view opens out to reveal mountains and, above them, a fabulous, fleecy, billowing cloud. There is a consensus that the distant jagged peaks are real ones, from Titian's native Dolomites (though there is dispute about exactly which they are). The feeling that this part of the painting gives you is much like the sensation of standing in the artist's home town, the heights rising all around with serrated summits like teeth or crowns. It is as if he had signed the picture: this is by the man from Cadore.

Just as extraordinary as the Alpine landscape is the sky above. If the steps are an exercise in logical orderliness, the cloud is jetting energy, the opposite: free, fractal, its shadows and softly gleaming highlights tenderly observed. John Constable, an ardent admirer of Titian the landscapist, spoke of the sky as the 'chief organ of sentiment in a picture'. Titian's cloud looks like a celestial manifestation swirling above the scene. The art historian David Rosand argued that, like the temple and mountains, it stands for divine wisdom. It is just the kind of natural phenomenon – like the rainbow in Brucioli's dialogue between the two men – that Titian depicted so brilliantly.

Though this imagined dialogue about rainbows never took place, many other similar conversations clearly did, between Titian, Aretino, Sansovino, and their circle. This was a tight group of friends and allies, none of whom were native Venetians. For decades in the mid-sixteenth century, they dominated taste in Venice. Others – also enormously talented – were unable to compete. One of these was the painter Lorenzo Lotto.

CHAPTER SEVEN

LORENZO LOTTO:
MAKING STUDIES OF
POOR PEOPLE

I n March 1542, Lotto completed a strange and marvellous altarpiece
for the church of Santi Giovanni e Paolo, known in Venetian as San
Zanipolo. This painting represents a highly unusual subject, *The Alms
of Saint Antoninus of Florence*. It was uncommon partly because this saint –
a fifteenth-century Florentine bishop – had been canonized only in 1523.
His real name was Antonio Pierozzi. He was loved by ordinary people, who
gave him the affectionate nickname 'Little Tony', by which he was known.
Ecclesiastically, however, he was a controversial figure who stood for austerity,
religious reform – particularly of his own order the Dominicans – and a belief
that the state had an obligation to help those in need – specifically, those
known in Florence as the *poveri vergognosi*, those who were impoverished
but too ashamed to beg. There were few if any other altarpieces dedicated
to him anywhere at this date, which raises the question: why commission
a huge picture, prominently featuring this Florentine clergyman, and place
it in a major basilica in Venice?

The answer is that it was intended to make a point about the true religious
life. In Lotto's painting, Antoninus is enthroned, with angels whispering
divine guidance in his ears, while charity is dispensed below. At its base,
a gaggle of paupers stretch their arms up in hopes of receiving the charity

being handed out by Dominican friars. Thus the painting was intended to send a message to the friars of Santi Giovanni e Paolo.

In the 1530s and 1540s, the Dominicans – like many Christians throughout Europe – were in a state of dissension. The prior at the time the picture was being painted, Sisto de' Medici, was a committed 'Observant' Dominican, meaning that he believed that the order should return to the austerity of life and dedication to charitable works with which it had begun, centuries before. By no means all the brethren agreed with him. In 1531, some of them had petitioned the doge, insisting that they would rather become Lutherans than be forced to be Observant.

The altarpiece has been described as an 'Observant Manifesto'. It is also perhaps a personal declaration by the artist. His fee was 125 ducats, of which 40 were to be raised from collections at sermons given by Friar Lorenzo da Bergamo, a good friend of Lotto's. The artist waived a further 35 ducats on condition that when he died 'friars of Santi Giovanni e Paolo … have me buried in their cemetery, according to their rite, and dressed in their habit'. In his punctiliously methodical way, he noted in his will of 1546: 'at a meeting of their chapter, and their consent was noted in their record book for 12 May 1542, fol.95'. In other words, Lotto wanted to be treated like a Dominican, and an Observant one at that – laid to rest as simply and modestly as possible. He had already spent a period living in the convent of Santi Giovanni e Paolo during the early 1530s (though his stay in this sanctum concluded, like several other stays in other resting places, with a row). He ended his days more than a decade and a half later as a lay brother in the religious community at Loreto in the Marche.

Many of his portrait sitters were passionately devout. Around the time that Lotto was at work on the *Saint Antoninus* altarpiece, he also painted Lorenzo da Bergamo, whose sermons were helping to pay for it. On 13 May 1542, he noted an order for 'a painting of Saint Thomas Aquinas and in that figure the life-size portrait of the said Fra Lorenzo from the waist up'. Fra Lorenzo's desire to be painted as a thirteenth-century Dominican saint, complete with halo and lily of purity, was not unusual among Venetian Dominicans. A few years later, Friar Angelo Ferretti, a member of the community at San Zanipolo, asked Lotto to paint him as San Pietro Martire

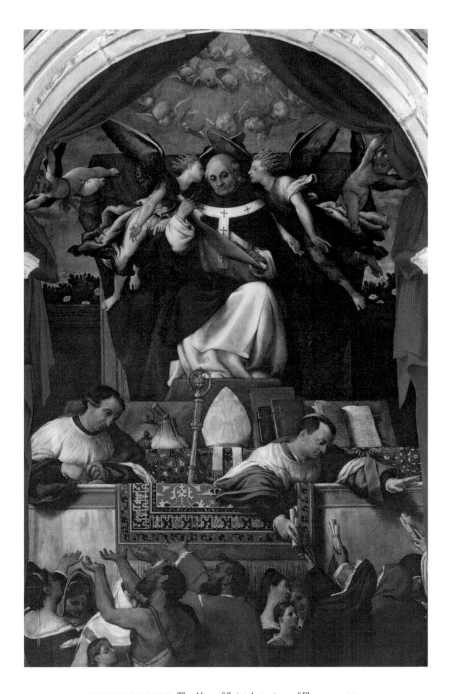

LORENZO LOTTO *The Alms of Saint Antoninus of Florence*, 1542

LORENZO LOTTO *Friar Angelo Ferretti*
as San Pietro Martire, 1549

who had (as depicted in Titian's altarpiece; see page 105) been murdered
on the road by an assassin with an axe. Accordingly, Ferretti appears in his
picture carefully observed from life, but with a large cleaver embedded in
his head and a small sword protruding from his chest.

*

Lorenzo Lotto (*c.* 1480–1556/7) was a restlessly wandering spirit. He was
born in Venice but spent most of his life following a wandering path through
northern and central Italy. Early on, he worked in Treviso and Asolo in the
Veneto region, and in Recanati and Jesi in the Marche. Then he went to
Rome, followed by another stint in the Marche and a long, fruitful period in

Bergamo, where he produced a series of masterpieces and was unquestion-
ably the leading painter in what was admittedly a provincial town. When
he returned to Venice in 1525, there can be no doubt that, as Dal Pozzolo
has put it, 'he was – with Titian – the best painter in the Serenissima'. But
again his affairs went wrong, and in 1533 he was back on the road, scattering
remarkable pictures in out-of-the-way places. In 1540, he was in Venice
once again and began the *Saint Antoninus* altarpiece.

The reasons for this odyssey were partly economic, partly aesthetic, and
partly temperamental. Evidently, he had difficulty in attracting lucrative
commissions in his native city. His art had an unsettling quality that was not
to the taste of wealthy and aristocratic patrons (the kind to whom Titian's
blend of naturalism and classicism was irresistible). Consequently, his prices
were low and – as his records suggest – he had difficulty in getting paid.
The result was that, while in 1540 Titian was living in a moderately grand
house, surrounded by family and assistants and courted by the great of the
world, Lotto was lodging in the apartment of his cousin's son, unmarried,
aging, and frequently strapped for cash.

It seems likely that Lotto's idiosyncrasy as an artist was linked to the
eccentricity of his personality. His mind, as he wrote in 1529, was 'much
afflicted by various and strange disturbances'. When he left Venice once
more in September 1542, six months after finishing the *Saint Antoninus*
altarpiece, he described himself as 'old, alone, without any stable domestic
arrangements, and very anxious of mind'. Another of his traits was garru-
lousness, certainly on paper, and probably also in person. In Lotto's case,
such utilitarian documents as wills, business letters, and jottings of expenses
tend to swell with cris de coeur, affirmations of belief, laments about the
mockery of his enemies, and sundry scraps of gossip.

One of the recipients of charity at the bottom of the altarpiece – a
bearded, red-robed man – may well be a self-portrait of the painter. Several
clues suggest this. The head of the man in red is just below the artist's sig-
nature, 'Laurentio Loto', and furthermore he is wearing a wreath of laurel,
which refers to his name, Laurentius or Lorenzo. There is also an unusual
piece of evidence: the garment this man is wearing. On 22 October 1541,
as Doretta Davanzo Poli has pointed out, Lotto bought enough tan cloth

to make a tunic, and a similar amount of red, also presumably for a tunic. Furthermore, this is a portrait of a specific garment (just as the face of the man is a real physiognomy). 'A close analysis', Poli writes, 'reveals a cut in the left sleeve, which is partly frayed, showing dark threads in the lining and three stitches.' We know about this red tunic because of the account book that Lotto kept in the later years of his life. There, in the summer of 1541, he twice notes expenses for paying ordinary people to pose as the poor in the altarpieces. The second jotting combined several sittings: 'Making studies of poor people several times for the painting of Saint Antonino'. They are, like Lotto himself – if it is indeed him – and his torn sleeve, tenderly and precisely observed: the woman in a dark robe with a slightly wattled, middle-aged neck, gazing upwards. The bearded, bare-shouldered man's lack of respectable clothing suggests that he might be a beggar. It has been said that the little girl holding a stick with her eyes closed is blind. All of them are particularized, as are the two deacons. It is unlikely that we will ever discover whom these people were. But that Lotto had warm feelings

LORENZO LOTTO *The Alms of Saint Antoninus of Florence*, 1542 (detail)

for ordinary folk is clear from his account book and also from his surviving wills. The last wishes that he expressed in his testament from 1546 – one of two that have survived – was a bequest of ten ducats for 'Donna Lucia of Cadore, laundress at San Moisè, in Corte da Ca' Barozzi, or else to her son Giovanni Maria at present aged about ten. This is because she has constantly shown me every Christian kindness.'

*

As noted above, it seems that the jarring, out-of-kilter feeling of Lotto's pictures was too unsettling for upper-class Venetian tastes. Their mood suggested tensions, and there were plenty of those, both social and religious, in the city. As time went on, an increasingly wide range of people were able to have their features recorded – a development that not everybody approved. Titian's friend Aretino lamented, 'To your disgrace, oh century, you allow even tailors and butchers to appear in painting, just as they are!' According to an anecdote recorded by the seventeenth-century writer Carlo Ridolfi, the painter himself advised some Venetian officials departing to administer the city of Bergamo that they should have themselves painted by the Bergamasque painter Giovanni Battista Moroni, who made portraits 'from nature' (and actually did number a tailor among the subjects of his soberly factual portraiture).

In contrast, Titian himself excelled at depicting aristocrats, presenting them with the air of nobility and casually effortless elegance that were thought suitable in a person of distinction. It was not so much that he was dishonestly flattering, as that he edited their appearance in a certain way. Thus in a picture from around 1529, Federico Gonzaga, Marquis of Mantua (son of Isabella d'Este and nephew of Alfonso), has an air of understated distinction, sumptuously dressed and absent-mindedly patting his charmingly devoted, courtier-like dog (overleaf). In some extreme cases, such as Emperor Charles V, who suffered from a grotesquely protruding Habsburg jaw, he probably had to work harder to create an image of regal dignity.

Some clues to Titian's approach to painting people can be gathered from a letter that he sent to Federico Gonzaga on 12 July 1530. On this occasion, he had to put pen to paper himself because he was stuck in Bologna with

TITIAN *Portrait of Federico II Gonzaga, c.* 1529

no literary friend to help him. As a result, for once we hear his real voice. As the scholar Giorgio Padoan noted, the language in this letter was 'much influenced by Venetian dialect', with grammatical errors and syntax 'at various points … simply pulled to pieces'. The painter's meaning, however, is 'clear and expressed with vigour'.

Titian was in Bologna because of a love affair, but not one of his own. A middle-aged Andalusian gentleman named Francisco de los Cobos had fallen heavily for a beautiful young woman named Cornelia Malaspina. This *tendresse* had political importance, because Cobos was secretary to Charles V, the most powerful person in Europe. Consequently, when

Cobos asked Federico Gonzaga to arrange for a good portrait of Cornelia, the marquis summoned Titian from Venice. But when the painter arrived, he encountered problems. There was a sweltering heat wave, and Cornelia, who was not well, had left town.

Titian wrote to Federico, coming straight to the point. His sitter was not in Bologna, and 'having been overcome by the great heat and also a little under the weather, and so as not to fall wholly ill myself, I did not go any further'. Nonetheless, he did not want to disappoint the marquis completely. If a picture of the sitter by someone whose name Titian had forgotten ('that other painter') could be sent to Venice, Titian could produce another portrait from that. In ten days, 'I will show her to you.' It seems that he was simultaneously offering to Titianize an existing image, 'the portrait that other painter made', and also to make a representation of Cornelia's 'features and beauty', which he had been told about and was 'afire' to paint 'in a way that no one knowing her would say I had not painted her several times already'. If Federico was not satisfied with this proposal, Titian could go after Cornelia and work from her directly at Novellara, where she was recuperating. But, the painter ended, 'I believe there will be no need of that.' As it turned out, there was not. Cobos was delighted with the picture when he finally received it, and all the more impressed by the fact that it had been done without the artist ever seeing the subject.

The portrait of Cornelia has vanished. But the incident suggests that Titian was able to create a powerful impression of physical reality without laying eyes on the person he was portraying. Indeed, he made a number of portraits (admittedly, not his best) of people he never met, including Suleiman the Magnificent and Francis I of France. Was his celebrated naturalism – the impression, often praised by contemporaries, that his portraits were almost alive – an illusion? Better to say that it was a product of his nature. It was a cliché often repeated in the Renaissance that every painter paints himself. But clichés often express truths. Titian's sitters appeared good-looking, healthy, poised, and confident. He studied them closely, no doubt, when he had a living sitter, but what one observes and selects is partly a reflection of one's self. In contrast, Lotto's subjects were melancholic, passionately engaged, gravely pious, but seldom relaxed or tranquil.

Titian evidently had an instinctive knack for getting on with the aristo-
cratic and powerful. He was addressed by Federico Gonzaga as a friend in
the early 1530s, and also he seems to have been on excellent personal terms
with Charles V, who reportedly bent down to pick up a brush the painter
accidentally dropped during a portrait sitting (a story that did not originate
with Titian). Not all his circle were dukes and monarchs, by any means, but
Titian seems to have had a genuine empathy for such people, and it shows.

*

From Lotto's account book, *Il libro di spese diverse*, we discover about his
social world. Among his friends were Jacopo Sansovino, who tried to help
him win commissions, and Sebastiano Serlio. For example, on 15 February
1541, Lotto obtained a quantity of the most beautiful and rare of red paints,
'*lacha de grana*', or red lake, from 'misser Sebastiano Serlio architeto bolog-
nese', taking advantage of the fact that the architect was in his debt to get
hold of this expensive pigment. *Il libro di spese diverse* is also full of clues
about Lotto's taste: it itemizes his physical surroundings. He was, after all,
a visual artist whose work was concerned with the detailed observation of
people and things. Some of the objects in his collection may have doubled as
props for his work. On 1 January 1548, he noted that he had pawned one of
his most prized possessions with a broker in the Jewish Ghetto, 'a Turkish
carpet for a table with thick pile and wide length'. He used the Venetian
term for such an item, *mastabe*, which is derived from the Arabic *mastabba*
– suggesting that Lotto had a connoisseur's knowledge of Middle Eastern
textiles. This could be the very textile, of the type now called a 'Lotto rug',
that fills the lower centre of the *Saint Antoninus* altarpiece. Certainly, it is
lovingly characterized, the feel of its wool distinguished from the stone,
linen, and other fabrics all around (a good deal of the picture is devoted to
depicting various kinds of cloth). This is a *portrait* of a particular carpet, just
as much as the poor below and the friars above it are depicted as individuals.

In the autumn of 1546, Lotto fell ill and spent a month and a half staying
with a goldsmith and jeweller named Bartolomeo Carpan – often mentioned,
together with his brothers Antonio and Vettore, in *Il libro di spese diverse*.

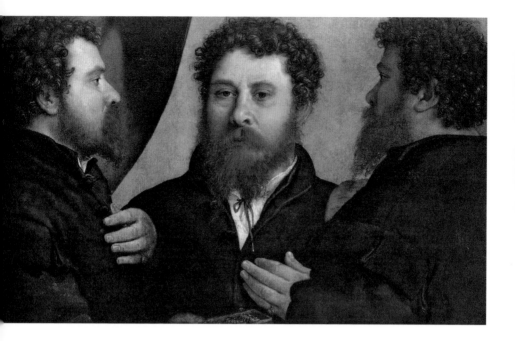

LORENZO LOTTO *Triple Portrait of a Goldsmith, c.* 1525–35

It seems that Lotto recuperated at Carpan's house in the parish of San Stai. Thanks to the care of Bartolomeo and his wife, he recovered his health completely. On 24 November, in gratitude, he gave Signora Carpan 'two braccie of black Sicilian cloth to make a pair of sleeves'. It was a character- istic gift; there are many fine sleeves, carefully and appreciatively observed, to be seen in his work. He was also very fond of Carpan, with whom he often exchanged jewels and pictures, several times noting a special price between 'dear friends'.

It is highly probable, though not certain, that Carpan was the subject of one of Lotto's most unusual portraits. It is a view of a man who seems to be a goldsmith, since he is holding a box of rings in the manner of a person who trades in such things. The style suggests that it dates from around 1530. And though Lotto knew a number of jewellers, including Bartolomeo's two brothers, it was Carpan to whom he was closest. The sitter is shown three times, from the side in profile, almost head on, and from behind in

three-quarter profile. It gives all the information that a sculptor would need to make a bust of this person. In fact, a century later Anthony van Dyck imitated Lotto's picture (which was then in the English royal collection) for a triple portrait of Charles I, which was sent to Rome for Gian Lorenzo Bernini to use as the basis for a marble carving of the Stuart king.

Probably Lotto's painting had an almost opposite purpose. It was intended to demonstrate that anything sculpture could do, painting could do better. This was part of the *paragone*, the comparison between the arts, which, as we saw in Chapter 3, was a stock theme for discussion in the Renaissance. The question of which was the more powerful, painting or sculpture, sharply divided opinion (with painters and sculptors taking predictably opposite positions). A picture could rival a sculptor's ability to show something from multiple points of view, just as Lotto did in this portrait.

He did so again in 1543–4, when he made a painted version of a small bronze relief by his friend Sansovino, representing Christ in Glory. Both still exist; Lotto's picture is not so much a copy as a translation of Sansovino's relief into the language of colour, pigment, and painting. Lotto has added air, space, atmosphere, landscape, texture, and – until it was removed by a nineteenth-century restorer – red blood streaming from Christ's wounds. Thus this work was apparently a contribution to an intellectual discourse about the status of the arts. Perhaps the idea of painting it might have come up in conversation between the painter and sculptor, or between either of them and the patron (who annoyed Lotto by haggling about the price).

Simultaneously, to Lotto, it was probably a depiction of the most momentous of truths: redeeming grace descending to humankind from on high. He described the subject as 'a painting of the triumph of the Saviour Jesus in the act of shedding his blood into the air'. There is no question that Lotto was a fervent believer. On the back of a little painting of the Crucifixion painted in 1544, an inscription added by its owner, a friend of the artist, states that this is a work by Lotto, 'a very devout man'. Because of his devotion, he had painted it in Holy Week, 'and finished it on Good Friday at the passion time as the Passion of our Lord Jesus Christ' (that is, the ninth hour, or three o'clock in the afternoon). Thus, the painting was a spiritual exercise on Lotto's part.

In the 1540s, however, fervent belief was no guarantee of orthodoxy. Indeed, it was precisely those who took theological questions most seriously who might get into trouble. The religious ground was shifting and splitting under the feet of the most pious. It was a quarter of a century since Martin Luther had promulgated his theses, and the developments that it had instigated were still in flux. In 1541, at the Colloquy of Regensburg, Cardinal Gasparo Contarini – an almost exact contemporary of Lotto's, from an aristocratic Venetian family – tried hard to find middle ground between the Lutherans and the church of Rome. The attempt failed, and in 1542 the hardline Cardinal Gian Pietro Carafa persuaded Pope Paul III to form a Roman Inquisition on the lines of the Spanish Inquisition, with Carafa in charge. 'Even if my own father were a heretic,' he announced, 'I would gather the wood to burn him.'

The Venetian government was slow to follow since it traditionally guarded its sovereignty and resisted interference by the pope. But as John Martin notes in his study of heresy and the Inquisition in Venice, the 'papacy's pressure on the Venetians to fall in step with the other Italian states' was relentless. In 1544, the papal nuncio to Venice, Monsignor Giovanni della Casa, was given the responsibility of representing the Inquisition in the Republic. Della Casa pursued various cases, including that of Angelico da Crema, an Augustinian friar whose sermons at the church of San Barnaba had caused consternation to the authorities and who pleaded that he be burnt at the stake. Della Casa, an urbane humanist best known for a book on etiquette, suggested that it would be sufficient for his tongue to be cut out. In the event, the friar got away with life imprisonment, from which he almost immediately escaped. But the atmosphere in Venice was rapidly chilling. Opinions that had previously been acceptable might now be dangerous.

In the September of 1546, a few weeks before Lotto came to stay with Carpan, there was a remarkable gathering at the goldsmith's house. Carpan invited a number of people, many of them fellow jewellers, to listen to a controversial preacher named Fra Agostino da Genova. This man had given sermons earlier in the year at various churches, including San Giacomo dall'Orio and San Bartolomeo, that – like those of Angelico da Crema – had outraged his ecclesiastical superiors. Nonetheless, Carpan wanted to

listen to what he had to say. This event generated considerable interest. Fra Agostino's subject was predestination, which was one of the hottest topics in the furious religious disputes of the mid-sixteenth century. The question divided not only the reformers from those who came to be seen as ortho-dox Catholics. Whatever Fra Agostino held, it was clearly controversial. He preached and debated about the question for a marathon eight hours. Years later, when this meeting was investigated, it was observed that not everybody present agreed with him. It seems highly likely that Lotto was there, and also quite probable that he argued with Fra Agostino.

Over the coming years, several people closely associated with Lotto ended up in front of the Inquisition. Bartolomeo Carpan came to its atten-tion in 1549, was arrested in 1568, and charged with being a long-standing Lutheran. His nephew Mario d'Armano, too, was investigated for religious transgressions in 1559. What did Lotto himself believe? The question has been much debated but no clear answer has been agreed – perhaps because there was none. As we have already seen, Lotto was an extremely pious man but also an inquiring one. This is clear from a series of letters concerning sixty-eight panels in wooden inlay, or intarsia, that he designed for the choir stalls of Santa Maria Maggiore in Bergamo. On the one hand, he stressed his piousness and probity in comparision with a Dominican intarsia maker who – Lotto believed – was plotting against him. In contrast with this underhand friar, the painter stressed, he was '*di natura et religion christiana*'; he had a truly Christian disposition. On the other hand, he had an urge to think things out for himself. In 1528, he questioned the programme worked out by the theologian advising the confraternity who had commissioned the stalls. He added that certain preachers and religious thinkers in Venice agreed with him.

Lotto obviously listened hard to sermons and pondered them. On another occasion, he suggested a fresh subject for a stall design, 'Joshua stilling the Sun', because he had heard a sermon about it. He was so inclined to trust his own idiosyncratic thought processes that some of the covers for the choir stalls, symbolizing the scene beneath, completely stumped his clients. Answering one puzzled enquiry, he became quite testy. 'Regarding the drawings of the covers, know that they are things not written, that require

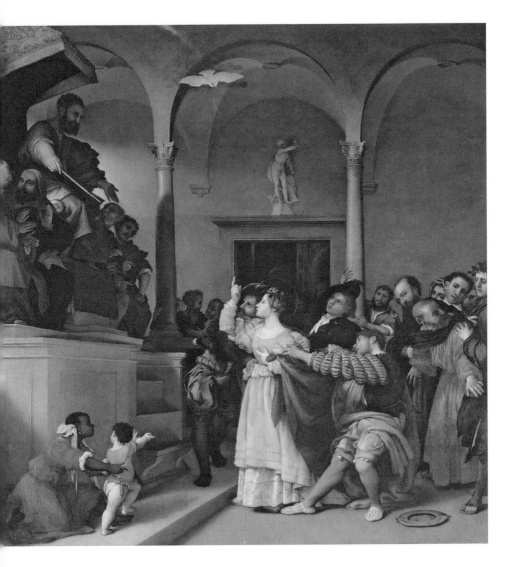

LORENZO LOTTO *Saint Lucy Altarpiece*, 1532

the imagination to bring them to light.' Some of the visual conundrums that he introduced into his portraits – a lizard on a young man's desk, another holding out a golden paw – are just as hard to decode, the reason being that they are the artist's own quirky inventions.

We do not know exactly which sermons he attended. But there was an array of fervent and heterodox preaching available in Venice. It is hard to believe, for example, that he did not listen to the Lenten sermons given by Bernardino Ochino, vicar-general of the Capuchin friars, in 1542. Shortly afterwards, Ochino was summoned to Rome. Instead, fearing for his safety, he fled to Protestant Switzerland, a defection as dramatic as the flight of Burgess and Maclean to Moscow in 1951. A hardening of theological dividing lines was taking place in the mid-sixteenth century similar to the ideological iron curtain that descended in the mid-twentieth century.

Lotto's attitude to debate and the challenging of authority is suggested by an extraordinary altarpiece that he delivered to the church of San Floriano in Jesi in 1532 (previous page). It had been commissioned by the Confraternity of Santa Lucia, and instead of depicting that saint grouped with other holy figures – the standard formula – the main panel depicts furious defiance in which Lucy remonstrates with a Roman magistrate. The young woman, representing pious truth and virtue, wags her finger at this figure of authority. As a concept of what an altarpiece could be, it is just as radical as Titian's *San Pietro Martire* (see page 105). But since it was tucked away in a small town in the Marche, few connoisseurs can have seen it (and that is still true today).

Although painted for a confraternity that doubtless thought of itself as orthodox Christian, by a painter who probably believed the same of himself, the painting seems filled with the spirit of the Reformation. In retrospect, another project on which Lotto was probably working at the same time has an even more distinctly Protestant flavour. It seems that he contributed a set of designs for the title page of the first Italian translation of the Bible. This was by Antonio Brucioli (*c.* 1498–1566), whose dialogue between Titian and Serlio we encountered in the last chapter. Brucioli was a serial dissenter. He had been exiled twice from Florence, once for opposition to the Medici and the second time in 1529 – by the revived Florentine

Republic – for Lutheranism. Finding an environment of relative freedom in Venice, he became a prominent member of the *poligrafi* – Venetian predecessors of the London Grub Street writers who scratched a living with their pens. His translation of the Bible, though far from accurate, was in the words of Raymond Waddington, 'probably the most circulated and read of reformist Italian books'.

The painter's responsibility for these images is controversial. But Peter Humfry, a leading Lotto scholar, argues that, although the process of converting his drawings into woodcuts (done by someone else) had muffled his characteristic graphic style, there are still 'convincing parallels' with his other work. The vehemence with which Moses prostrates himself when receiving the tablets is one; the poetic Nativity at night is another.

Brucioli's Bible penetrated a new reading public that had previously not existed. A copy found its way into the book collection of the miller Menocchio, whose home-made world view was considerably weirder than Lotto's (Menocchio, the subject of Carlo Ginzburg's classic study *The Cheese and the Worms*, was eventually burnt at the stake).

Brucioli worked as a bookseller as well as an author. In July 1548, his entire stock was seized by the Holy Office and burnt. Brucioli himself was exiled, and after he returned in 1555, he was arrested again, charged on thirty counts of fomenting heresy, and imprisoned. After he was released, Brucioli, deprived of his livelihood, died in destitution. By 1557, his Bible, and Aretino's writings, were put on the register of prohibited books.

Perhaps the increasingly repressive atmosphere in Venice was one of the reasons why Lotto left the city for the last time in 1549. Other motives were financial. He got a commission to paint a large altarpiece in Ancona. But the result, like his last such picture for a Venetian church, a Madonna and Child for San Giacomo dell'Orio, suggests that he no longer had the heart for this kind of conventional religious work.

His final works, done in his late seventies, seem to be fading into the shadows before one's eyes – as, apparently, was the painter himself. Vasari wrote that by this stage, he had 'almost lost his voice'. The last item in his account book is dated September 1556. By the middle of following year, he had died.

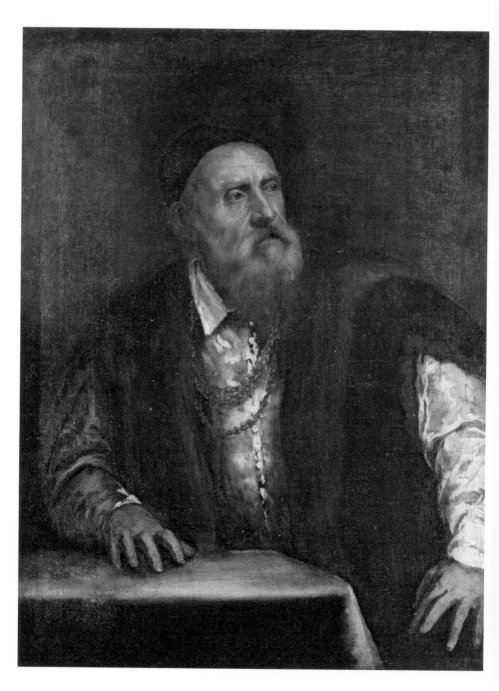

TITIAN *Self-portrait, c.* 1550–5

CHAPTER EIGHT

'A NEW PATH TO MAKE MYSELF FAMOUS': TITIAN IN OLD AGE

One day in the early 1540s, the friars of Santo Spirito in Isola watched Titian climb a ladder. The famous artist had been summoned on a tiresome errand: to carry out running repairs on a faulty altarpiece. This picture, which represented the 'Descent of the Holy Spirit', or Pentecost, had already caused him trouble. It had originally been commissioned more than a decade earlier in 1529, but finishing it had been a long process. The evidence suggests that Titian could not find a composition that satisfied him. According to one of the friars, first he sketched it one way, then changed his mind, and 'after two or three years he sketched it in a different way'. Then he appeared to lose interest and did not start working on it again for a while. In 1541, it was put in place in the church, but Titian continued to adjust it from time to time. Clearly, he still was not satisfied.

Possibly the wall on which it hung was damp. The building itself was part of a beautiful new structure designed by Titian's friend Jacopo Sansovino, but perhaps the Tuscan architect had not solved the problems of the site, on a low-lying marshy island in the lagoon. Or the preparatory layers for the picture may have been defective. At any rate, the surface began to flake and blister, and the artist came to take a look. Once up the ladder, he was heard swearing as he pulled off loose strips of paint surface. The painting had to

be replaced; eventually, the affair ended up in court (which was where the friars gave such detailed testimony).

Titian was in his early fifties when he was poised so irritably on that ladder. He was by then a famous personage, widely acclaimed and also increasingly observed. Unlike his great contemporary Michelangelo, of whom two lengthy biographies appeared during his lifetime, in 1550 and 1553, Titian's life and opinions were not described in detail. However, scattered through the correspondence of the diplomats, dealers, and collectors who came to visit him – and the recollections of those who knew him – there is a great deal of information about how he behaved, what he said, and how he worked. From this, three distinct faces emerge: an affably urbane social personality and amiable host; a sharp, avaricious businessman; and an artist passionately absorbed in his work.

The first is vividly evoked in a letter by a Tuscan humanist named Francesco Priscianese, written from Venice at the beginning of August 1540. Priscianese described how he had been invited to celebrate the Ferragosto, an annual festival of the Assumption of the Virgin at high summer, in 'a delightful garden belonging to Messer Tiziano Vecellio'. He was writing to two Florentine exiles living in Rome, both members of Michelangelo's circle. Priscianese took it for granted that they would know that, 'the excellent Venetian painter [was] a person truly suited to spice every worthy feast with his pleasantries'. Among others, Titian had asked several Tuscan luminaries to spend the evening with him: his great friend, the Aretine Pietro Aretino, and the Florentine Jacopo Sansovino – who according to Priscianese was 'as great an imitator of Nature with his chisel as is our host with his brush' – plus an eminent historian named Jacopo Nardi, also Florentine.

The evening began with a tour of Titian's house, and perhaps also his workshop in a large hangar. Priscianese reported: 'Before the tables were set out, because the sun despite the shade was still making his heat much felt, we spent the time admiring the lifelike images in the excellent pictures which filled the house.' After appreciating the painter's works, they went on to view Titian's garden. He lived then on a byway known as Birri Grande, not far from the present-day Fondamenta Nuove. In the mid-sixteenth century, this zone on the outskirts of the city was being developed. The

painter's house had been built only in 1527; behind it, the land stretched to the lagoon (and beyond that on fine days there would have been a view of the Alps and Titian's native Cadore). It seems that on this marshy waste ground, the artist had laid out an elegant garden in the latest style. Priscianese and his fellow guests 'marvelled' at the 'rare beauty and loveliness' of the place. Its situation was obviously part of the attraction. Priscianese found the whole experience delightfully Venetian:

> The garden is situated on the far end of Venice by the edge of
> the sea, and from it one sees the pretty little island of Murano
> and other lovely places. As soon as the sun set, this part of the sea
> teemed with a thousand of little gondolas adorned with beautiful
> women and resounded with the varied harmonies and melodies of
> voices and musical instruments which accompanied our delightful
> supper until midnight.

He also made an intriguing comparison. Titian's garden reminded him very much of the one that Cardinal Niccolò Ridolfi, leader of the exiled anti-Medici Florentines in Rome, had recently laid out. This tells us two things: that Titian's garden was in an up-to-date design, and that he was aiming at a certain noble style of life. Cardinal Ridolfi was a nobleman and prince of the Church with a household of perhaps one hundred servants and retainers. The painter's household was much smaller, and his dwelling, plainer: 'a long narrow blocklike structure of three floors', according to the scholar Juergen Schulz, with a large hall on the upper floor where the artist and his family lived (the structure still survives, though much altered). However, it represented a certain status.

In Schulz's words, Titian's 'ample and modestly distinguished house was comparable in every way to the suburban residence of a Venetian patrician'. And by this point, Titian had become a nobleman of sorts. After being introduced to Charles V by Federico Gonzaga in the early 1530s, he produced a series of works for the emperor, who made him a count palatine and knight of the Golden Spur, describing Titian as the 'Apelles of this century'. He proudly wore the golden chain of the Order of the Golden Spur in both of his surviving self-portraits.

Of course, this status required an income to match. This explains Titian's second incarnation, as a sharp and unyielding businessman. Many agreed that his personality and manner were highly congenial, except when he was asked to do something he did not want to do – such as deliver a painting he had not finished. There could be problems too over questions of payment. The duke of Urbino's agent, Giovanni Francesco Agatone, complained in 1564, 'He does nothing other than demand money'; and in 1566, 'as I have written before, when it comes to money, [Titian] is the most obstinate man'. Agatone was echoed by many who negotiated with the painter. They found him covetous, sly, unyielding, and sometimes downright dishonest.

However, in judging this behaviour, one has to bear in mind what he was up against: rich, powerful, and often aristocratic clients, some thuggish, in what was a hierarchical society. Titian had only his reputation, which was based on what he created inside a 'barnlike structure, part masonry, part wood', as Schulz characterized it, adjoining his house at Birri Grande. This was described in documents as a '*tezze*' and a '*bottega*' – the first meaning shed, the second, craftsmen's workshop. In it, some of the greatest paintings in the history of art were created, and Titian must have known it. He understood his own worth. He was hugely ambitious, but also – as is often the case with such individuals – intensely self-critical and probably subject to self-doubt. In the early 1550s, the imperial ambassador to Venice, Francisco de Vargas, asked him why he used such enormous brushes, as big as a broom, instead of working in the finer manner of other masters. Titian replied:

> I am not confident of achieving the delicacy and beauty of the brushwork of Michelangelo, Raphael, Correggio and Parmigianino; and if I did, I would be judged with them, or else considered to be an imitator. But ambition, which is as natural in my art as in any other, urges me to choose a new path to make myself famous.

In other words, he wanted to find a way of working that was distinctively his own. That was doubtless true. Certainly, he admired the artists he mentioned, who were his contemporaries and peers. When he visited Parma in 1530, a friend related how, on seeing Correggio's fresco in the dome of the cathedral, he exclaimed, 'At last I have found a painter!', adding loudly that

if he were not himself, he would like to be Correggio (indeed, he borrowed from the latter in the painting known as *La Gloria*). As we have seen, Titian lifted many ideas from Michelangelo and Raphael. But he did not want to be an imitator. The new ways of creating a picture that he devised in that shed at Birri Grande was one of Venice's most influential contributions to the world. In the future, all those artists whose brushwork was loose and free – from Tintoretto, Rembrandt, and Velázquez to Manet and Monet – followed the example that Titian set there.

Titian was not just ambitious, he was in love with the process of painting. At his easel, he sank into a state of deep concentration. This emerges from an unexpected source: a medical-philosophical treatise on the human mind published in 1576 (and therefore in his lifetime). Its author, Antonio Persio, argued that a person's abilities were affected by the ardour of their parents when they were procreated. 'I do not know a better way to demonstrate this', he continued, 'than by the example of the great Titian.' Persio's assumption was that Titian's paintings were like living beings, to which he gave birth.

> I have heard from his own lips and from those who were present when he was working, when he wanted to draw or paint some figure, and had before him a real man or woman, that person would so affect his sense of sight and his spirit would enter into what he was representing in such a way that he seemed to be conscious of nothing else, and it appeared to those who saw him that he had gone into a trance.

For Titian, such a sitting was only part of the process. It was followed by a prolonged period of rigorous scrutiny and intermittent reworking, which could go on for many years – and in some cases was interrupted only by his death.

There is an account of his methods given by Jacopo Negretti, that is, Palma il Giovane, who talked to the seventeenth-century writer Marco Boschini – who noted that Palma had been 'fortunate enough to enjoy the learned instruction of Titian', so this was eyewitness testimony. According to Palma, the master began by sketching in a picture, 'with a great mass of colours'. Boschini himself had seen these, 'formed with bold strokes made with brushes laden with colours'. Thus, 'he made the promise of an exceptional figure appear in four strokes'.

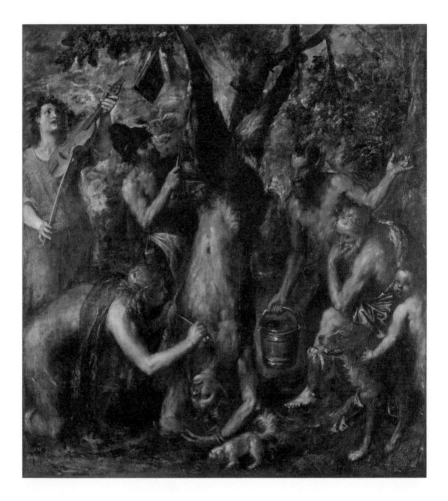

TITIAN *The Flaying of Marsyas, 1570–6*

Next, however, came a pause: 'He used to turn his pictures to the wall and leave them there without looking at them, sometimes for several months.' When Titian wanted to work on his paintings again, 'he would examine them with the utmost rigour, as if they were his mortal enemies, to see if he could find any faults; and if he discovered anything that did not fully conform to his intentions, he would treat his picture like a good surgeon would his patient, reducing if necessary some swelling or excess of flesh, straightening an arm if the bone structure was not exactly right.'

Then, while one picture was drying, 'he would turn his hand to another and work on it in the same way'. Obviously, Titian mulled carefully over what he was doing: according to Palma, he would say, 'that a man who improvises cannot compose learned or well-constructed verses'. So his method was both fast and slow. It was also instinctively, intimately physical. One can often see the velocity of his brush and, Palma told Boschini, 'in the last stages he painted more with his fingers than his brushes', softening transitions by rubbing them with his finger. But his painting was also carefully pondered.

The result is that there is an unresolved question about many of Titian's late works: are they finished or not? It is unanswerable because in some cases he may not have decided himself. At his death, there were works turned against the wall, awaiting a final brushstroke or two. These were not 'finished' or 'unfinished', they were pending. The matter is further complicated by the fact that he was finding new ways to paint, and as he did so, he taught people new ways to see. Slowly, taste altered. Boschini reported that the 'most sophisticated connoisseurs' found his rough 'unfinished' sketches 'entirely satisfactory in themselves'. In some moods, Titian did too. *The Flaying of Marsyas*, one of the most rapturously, richly executed of his works, the surface smeared with his fingers, done at the end of his life, is partially signed – suggesting that he considered it completed to perfection as it was.

As he grew older, doubts were frequently expressed by another group of connoisseurs: those who had not caught up with what he was doing. Giorgio Vasari visited the artist in his studio in 1566, and 'found him at his painting with brushes in his hand, although he was very old'. Following that last observation, Vasari mused that perhaps it would have been better for his reputation if he had gracefully retreated into retirement (Titian in 1566

would have been a minimum of seventy-six years old, perhaps a couple of years older). 'It would have been well for him in these his last years not to work save as a pastime, so as not to diminish with works of less excellence the reputation gained in his best years, when his natural powers were not declining and drawing towards imperfection.'

There were moments when Titian presented himself as ancient and feeble. Upon receiving an unexpected tax demand in September 1568, he replied that he was a poor old man, no longer able to work for his living and had thus been 'unjustly condemned' to pay this bill. Many people, however, are less than candid when dealing with questions of tax. At other times, Titian did not feel he was past his best as a painter. He was questioned on exactly this point by the Spanish ambassador to La Serenissima, Diego Guzmán de Silva, who described their difference of views. Writing to the Spanish governor of Milan, the Marqués of Ayamonte – who, like connoisseurs and patrons throughout Europe, was highly interested in acquiring a Titian – he said as much. In his own opinion, Titian's 'earlier paintings were good', but 'the new ones are not'. Presumably, he put this point to the artist with diplomatic tact; at any rate, he elicited the reply that Titian liked his own newest paintings quite 'as much as his earlier ones'.

In contrast to his reaction to financial problems, Titian does not seem to have been concerned by criticism of his work. When a young Florentine writer and humanist named Baccio Valori il Giovane (1535–1606) visited his studio, the painter showed him a painting of the penitent Magdalene. Baccio objected that she was 'too attractive, so fresh and dewy' to be a starving anchorite in the desert. Titian 'answered laughing that he had painted her on the first day she had entered, before she began fasting, in order to be able to paint her as a penitent indeed, but also as lovely as he could, and that she certainly was'.

Niccolò Stoppio, an agent of Flemish origin who searched out classical antiquities, wrote on 26 February 1568, that 'everyone says' that Titian, 'no longer sees what he is doing, and his hand trembles so much that he cannot bring anything to completion, but leaves this to his pupils'. This, however, was extreme exaggeration motivated by professional jealousy. Stoppio was writing to a client, a member of the super-rich Bavarian banking family

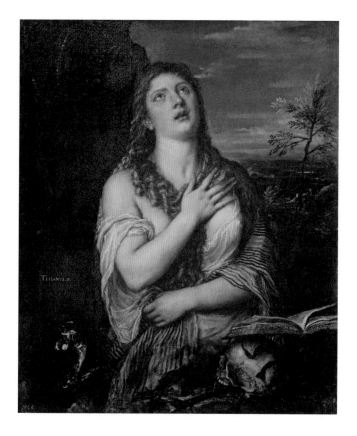

TITIAN *Mary Magdalene*, 1560s

of the Fuggers. He was irritated by the fact that a rival, Jacopo Strada (1507–88), currently had better access to the great artist than he did. Strada and Stoppio were both members of a fledgling profession in which the roles of curator, scholar, and dealer were combined. On the day that he wrote, he was infuriated by the fact that Titian was painting Strada's portrait. He imputed the basest of motives to them both. 'Titian and he are like two gluttons at the same dish.' The painter 'will take another year over it', Stoppio predicted, and if in the meantime Strada does not do as he wants, it will never be finished. 'Titian has already demanded a sable lining for a cloak, either as a gift or for cash.'

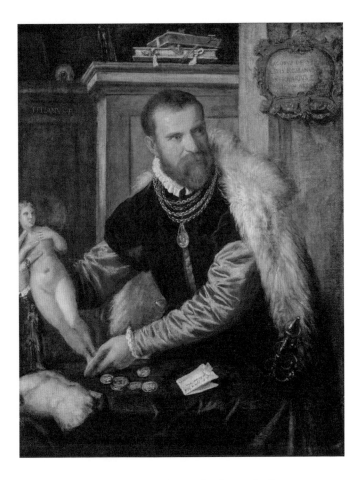

TITIAN *Portrait of Jacopo Strada, c.* 1567–8

Meanwhile, Stoppio predicted, 'Strada encourages his hopes so that he can get the portrait out of him; but he is wasting his time.' Yet, in a letter written the previous year to a different Fugger, Stoppio had boasted of his own privileged access to Titian, claiming that years before, the painter had made two alterations to the much-admired picture of Venus and Adonis on his – Stoppio's – advice. He then passed on some unkind remarks that Titian was supposed to have made about his current sitter. Asked by a friend of Stoppio's what he thought of Strada, the painter replied that:

[He was] one of the most pompous idiots you will ever find. He doesn't know anything beyond the fact that one needs to be lucky and to understand how to get on with people, as Strada has done in Germany, where he shoots them every line you can imagine, and they, being open by nature, don't see the duplicity of this fine fellow.

These, he insisted, 'were Titian's own words'. But they correspond suspiciously closely with Stoppio's own opinion. Nonetheless, numerous art historians have accepted this tale and read nastiness into the face of Titian painted. John Pope-Hennessy, for example, wrote that, 'the features contrast with the splendour of dress; they are petty, and are stamped with guile and a particularly unattractive sort of eagerness'.

Looked at with an unprejudiced eye, it is just as easy to see the acute judgment and shrewd intelligence that made Strada more successful than Stoppio. Nevertheless, it is true that there was an element of quid pro quo in Titian agreeing to paint this, probably his last portrait. He did indeed end up with that fur and wanted Strada to help him to sell studio versions of his mythological paintings to Emperor Maximilian II. Strada, on the other hand, got a superb portrait of himself by the world's greatest painter to hang in his house in Vienna, which was part museum, part research institute, part showroom. The picture displays his wealth and his learning. He holds a classical statuette of Venus; some of the ancient coins about which he was an expert are scattered on the desk; one of his treatises is on a shelf behind. It also disproves Stoppio's claims on two counts. This is visibly not the picture of someone whom the artist despised. Nor is it the work of an artist so decrepit and dim of sight that he could no longer paint. On the contrary, it is a masterpiece that demonstrates how Titian could deploy different levels of 'finish' to sensational effect. Some areas – such as the red satin or silk of Strada's sleeves – are dashed in with lightening strokes that brilliantly evoke its sheen; others, such as the skin of the face, have been smoothed and softened with the artist's fingers. When you look at the fur, you can feel its feathery fluffiness as if you were touching it. If Titian could paint like this in approximately his eightieth year, no wonder he was not bothered by criticism.

*

By the 1570s, Titian was considering arrangements for his final resting place – and for a monument fit for a famous artist. His great opposite Michelangelo Buonarroti – with whom he had competed, and from whom he had also learnt – had shown the way, even in death. The latter had wished to be buried in the Roman church of Santi Apostoli, near to his house. Above his tomb there was to be a carving in marble, by his own hand, of the dead Christ mourned by the Virgin Mary. However, he was reburied in the church of Santa Croce, where a grand memorial – not of his own design – was eventually erected.

Titian was no doubt paying close attention. Initially, perhaps he planned to be buried in his home town of Pieve di Cadore. But at the end of 1572, the painter had a ferocious quarrel with the commune of Cadore, carried out at a distance by correspondence. This dispute concerned the appointment of his nephew, a notary, to an administrative post, which had upset other notaries, including members of Titian's family. The great man had weighed in, writing with 'great passion from my heart', citing the 'many benefits I have extended to you', stressing how much he loved his 'dear homeland'. 'I would never have believed', he went on, 'that I would receive in recompense for those loving and good deeds a persecution' being visited on his poor nephew. But this outpouring made no difference; the quarrel rumbled on for another eighteen months or so, by which time Titian had decided that his tomb would instead be in the Frari. Unfortunately, this new plan also ran into trouble.

Titian made an arrangement with the friars: he would donate a painting in exchange for burial rights. The position selected was the second chapel on the right in the nave, the Cappella del Crocefisso, the 'chapel of the crucifix'. This was a marvellously fitting spot. The basilica of the Frari already contained two of his greatest masterpieces. Over the high altar was his *Assunta*, the painting that had made his name. Diagonally opposite the Cappella del Crocefisso, on the left-hand side of the nave, was his later and almost equally celebrated *Pesaro Madonna*. By adding a third altarpiece to this ensemble, Titian would have transformed this whole sacred space into an extended display of his own genius. The *Pietà*, placed nearer to the entrance, would have functioned as a majestic overture to the other two. The vehement figure of the Magdalene gestures passionately and turns her gaze

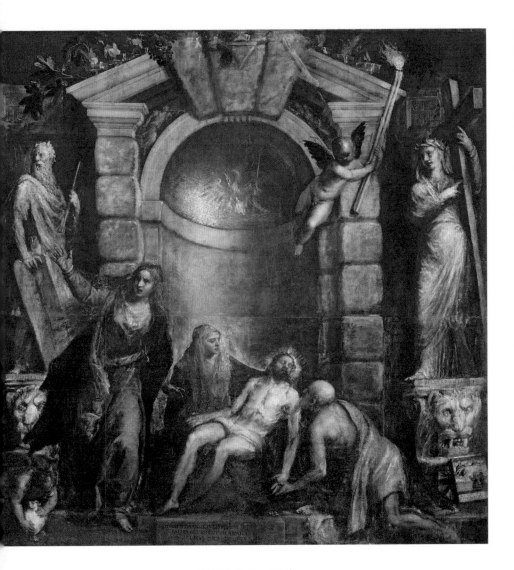

TITIAN *Pietà*, 1575–6

TITIAN *Pietà*, 1575–6 (detail)

out of the picture to the left – so she would have seemed to look towards the east end of the church and the two other Titian paintings.

However, something went badly wrong. Titian installed the picture but the friars moved it to another spot. Thereupon he demanded it back – and used his contacts to make sure that happened. On 1 March 1575, the papal nuncio to Venice, Giovanni Battista Castagna, told the friars that they had to return to the artist, a 'painted image of the Pietà that had previously been placed on a certain altar ... which has been removed from the altar by you'. It seems that Titian's *Pietà* had interrupted the orderly flow of miracles. Above the altar that he had selected for his tomb hung a wonder-working thirteenth-century crucifix. Nail holes in this object, which still exists, suggest that the pious were in the habit of attaching ex-votos – requests for divine help and thanks for assistance received – to it. Either Titian's painting was impeding access to this source of succour because the artist had placed it underneath the crucifix – perhaps to monopolize its supernatural

benefits himself – or he had had the miraculous cross shifted altogether. In either case, the friars were unhappy about the change – and moved the Titian instead – thus contravening the agreement and infuriating the artist.

However, Titian of course worked other miracles – artistic ones – time and again, to create the appearance of life itself with dabs and sweeps of the brush. As he grew older, he did so with ever greater audacity. The surfaces of his canvases became a melange of splodges and stipples – and yet out of them flesh, air, space, and light still somehow emerged. The face of Mary Magdalene in the *Pietà* was not much more than a mass of careless-looking dabs and daubs; yet there she was, alive and passionately grieving.

The Spanish ambassador, Guzmán de Silva, observed the slow development of the *Pietà* in that workshop at Birri Grande. As we have seen, he took the view that the artist's physical powers had declined. In February 1575, he reported to his superior, Ayamonte, in Milan that, 'Titian's trembling hand may not affect the atmosphere and spirit of his paintings, but it does affect the application of paint and other things that can be executed only with a steady hand.' Ayamonte agreed that nothing Titian could do now would be worth much. Even if he still had the imagination to conceive a marvellous work, he could no longer physically execute it. He was wryly amused that, 'instead of those he painted earlier, he would rather take one of the recent ones into the other world with him' (that is, the *Pietà*, hung above his tomb). As the days went by, perhaps because he was getting used to what we now call 'late Titian', Guzmán de Silva began to appreciate the old man's efforts more and more. On 19 March, he wrote, 'the bodies are not all there, the souls will be, and this is what gives them life'. In Milan, the marqués too was getting more enthusiastic: 'a blotch by Titian', he agreed, 'is better than anything done by another painter'.

For a moment, it seemed that he might acquire such a blotch. Titian seems to have suggested that the *Pietà* might be available for the marqués – if, and only if, a pension owed to him were to be paid. One of the artist's abiding sorrows was that payments promised him by his Habsburg patrons Charles V and Philip II were delayed for years by the imperial accounts department in Milan. Charles's heir Philip was, if anything, even more of an enthusiast for Titian's work than his father. During the 1550s and early

1560s, Titian had produced the magnificent, and deeply sensual, series of mythological paintings for Philip including *Venus and Adonis*, *Diana and Actaeon*, and *The Rape of Europa*. The Habsburgs intended to reward him generously, but such was the state of their finances and the bureaucratic complexity of their vast realms, that the intended funds were frequently delayed. But although in this case the sum in question was dispatched from Milan, no more was heard of the marqués getting the picture. In his studio, Titian continued to potter.

As it stands, the *Pietà* is an assemblage of no fewer than seven pieces of canvas of differing weave and texture, sewn together. Quite when or why Titian had these extensions added is not clear. It may be that the picture that he originally placed in the Frari was just the central group of dead Christ – the quivering brushstrokes suggesting his flesh is dissolving into ectoplasm in front of our eyes – Madonna, and the kneeling, elderly male figure. The beard and red robes of the last suggest Saint Jerome, but that saint lived centuries after the Crucifixion and is not normally included in such scenes. Whoever he is supposed to represent, this figure looks rather like the aged artist.

Possibly, having forgiven the local authorities in Pieve di Cadore, he had changed his mind and decided to be buried in his home town – with the altarpiece – after all. But it is also conceivable that he made peace with the friars of the Frari and reverted to the idea of placing both tomb and painting there. Perhaps his intentions continued to fluctuate. In any case, events took over. The following year, 1576, Venice was gripped by one of the most terrible plagues in its entire history. Some fifty thousand people died, between a quarter and a third of the population, among them Titian's younger son Orazio and – on 27 August – the artist himself (the documents just give 'fever' as the cause of death).

Whatever his last wishes, he was buried in the Frari – but without the *Pietà*. That was eventually bought by Palma il Giovane, who tidied up one or two passages (though whether Titian himself would have deemed them already finished satisfactorily is impossible to say).

At some point before he died, however, the artist had executed the mosaic of the niche above the central group. This represents a pelican feeding its

young on its own blood – a symbol of Christ – and golden tesserae, each of which consisting of a single perfectly judged blob of paint, so that pigment and glittering glass are effectively one and the same. It is a wonder of art, but Titian was also hoping for the other kind of miracle. Inconspicuously in the lower right-hand corner, a little picture is leaning against the plinth of one of the statues. It is an ex-voto panel, similar perhaps to some that hung from the miraculous Crucifixion in the Frari. On this image, the painter and his son are on their knees imploring the Madonna and her son for salvation.

TITIAN *Pietà*, 1575–6 (detail)

CHAPTER NINE

THE CASE OF THE PAINTER
AND THE FEAST

Paolo Veronese once jotted an aspiration on the back of a drawing.
If he ever had time, the painter wrote, he 'would like to represent a
magnificent banquet under a noble loggia'. There the Holy Family
– the Virgin, Christ Child, and Saint Joseph – would be waited on by 'the
richest cortège of angels that one can imagine', serving 'regal food', such as
'sumptuous fruits in silver and gold dishes'. Though he never painted this
exact picture, he succeeded spectacularly in his ambition. No one has ever
transformed religious art into such scenes of worldly splendour. Veronese's
seventeenth-century biographer Carlo Ridolfi (1594–1658) praised the artist
for the eye-popping abundance of people and luxurious possessions that
he depicted:

> In his paintings you can admire outlandish and majestic gods,
> grave characters, matrons full of grace and charm, kings richly
> adorned, the diversity of draperies, various military spoils, ornate
> architecture, joyous plants, beautiful animals and many of these
> curiosities that can well satisfy the eye of the viewer with the most
> pleasant entertainment.

Of all Veronese's works, none was more abundantly endowed with such
ingredients than the *Marriage at Cana* that he produced for the refectory

of the Benedictine monastery of San Giorgio, which stands next to the basilica of San Giorgio Maggiore on the island of that name. This work is dated 1562–3, when the painter was thirty-five years old. The huge canvas (following pages) was a triumph among the cognoscenti.

A monk from the monastery named Benedetto Guidi described the acclaim for the painting two years after it was finished. 'All the sculptors and the painters come to admire it three, four, and six times … and PAOLO is praised with eternal fame.' According to a credible story, Veronese depicted himself front and centre, dexterously playing a viol and clad in a splendid costume of white brocaded cloth (see page 162). He looks like a gentleman, leading a little ensemble that is adding a mellifluous musical ambiance to the festive scene: orchestrating the action, you might say.

As we shall see, this masterpiece was transported to Paris by the invading French in 1797 and never returned. But it was not intended to be glanced at as one walked through a museum. The monks of San Giorgio were expected to eat in the refectory every day of their lives, in silence, with the ebullient painting packed with people and noise as a backdrop for their meditations. They were expected to look at it for years, from numerous different angles as they sat at long tables along the sides of the hall (this surely was the reason why it has seven vanishing points and five horizon lines). The picture contained everything they had renounced, the pomp and pleasures of the world, and in the blue sky above Christ's head, filled with flying ducks, perhaps a hope of heaven above.

The setting was crucial. When you go on a guided tour of the monastic buildings (now the home of the Fondazione Cini), you climb a monumental staircase designed, like the refectory itself, by Andrea Palladio (1508–80) between 1560 and 1562. At the top of the steps, you walk through a grandly sober doorway into a high, oblong space stretching gravely and elegantly into the distance. There, filling most of the end wall, very much like a theatre stage or cinema screen – and at almost ten metres by seven, or just over sixty-seven square metres, quite as big – is the *Marriage at Cana*. It is not the original painting, which remains in the Musée du Louvre, but a reproduction, precisely similar in dimensions, every colour meticulously matched, even the weave of the canvas accurately mimicked.

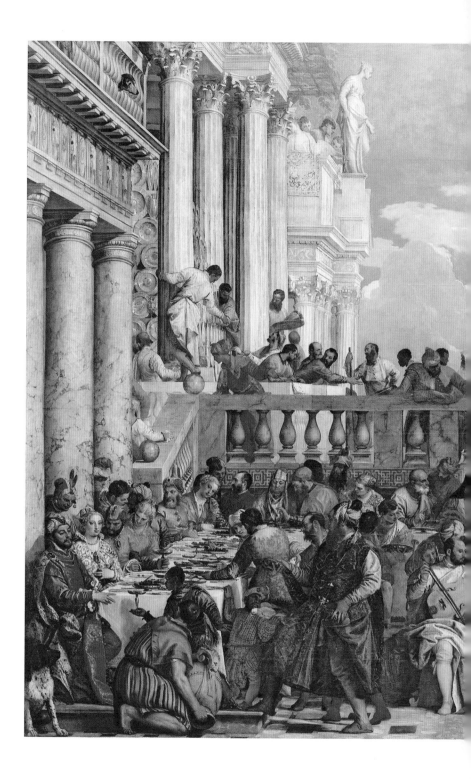

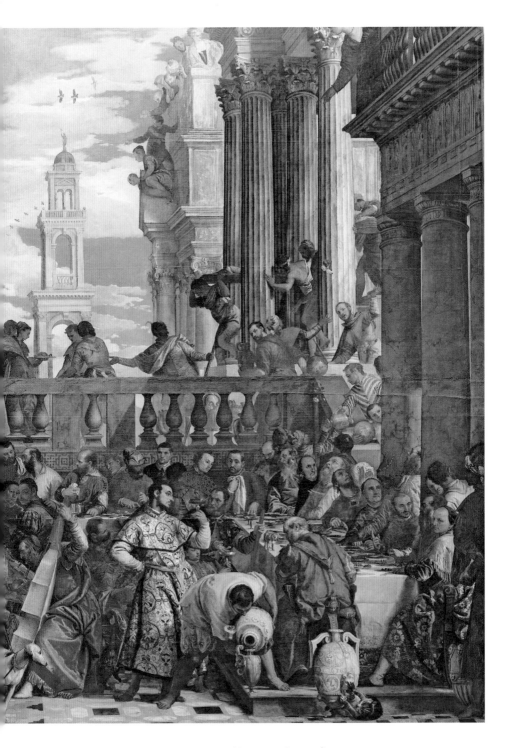

PAOLO VERONESE *Marriage at Cana, 1562–3*

PAOLO VERONESE
Marriage at Cana, 1562–3 (detail)

PAOLO VERONESE
Marriage at Cana, 1562–3 (detail)

In 2009, the British film-maker Peter Greenaway arranged a remarkable project for the Venice Biennale. Its premise was the idea that Veronese's crowded and monumental painting, with its vast set and dozens of diverse characters – was a predecessor of the cinema. This was one of a series of installations by Greenaway that took an old master picture and reconfigured it as a movie.

The auditorium for this one was the refectory at San Giorgio Maggiore. Greenaway counted 126 figures in the composition (plus 'seven dogs, a cat, at least ten flying ducks, and certainly a parrot, a rose-tinged green parakeet from the Middle East, psittacula krameri, probably painted from direct observation'). Around the walls, he placed enlarged details from the painting. The visitor could eavesdrop on dialogue too, scripted by Greenaway. The chief wine steward (who may be a portrait of the artist's brother Benedetto), magnificently dressed in white brocade, holds up a glass of the miraculous wine that Christ has just produced from water and remarks, 'I like it. No cloudiness. Completely clean. Almost a smart sparkle.'

At one point, Greenaway showed an aerial plan of the banquet with each figure plotted in position, the kind of diagram an Orson Welles or Robert Altman would have in mind when working out a complicated tracking shot. They would have needed to know exactly where everyone was going to be as the camera passed them. According to Marco Boschini, who knew Veronese's son and grandson, the artist really did work in a way a little like this. Unlike Titian and Tintoretto, who made changes as they worked, Veronese began by deciding exactly where every one of his performers should be. He 'would at first place the shape of figures in proportion to the canvas, always aiming at placing them in a spacious field, richly covered with majestic architecture'.

<div align="center">*</div>

Veronese's background was less opulent than such works as the *Marriage at Cana* might suggest. He was born in Verona in 1528 with the name Paolo Bazaro and came from a long line of *spezaprede*, or stonecutters. As a child, like his brothers, he was trained to follow in the family trade. But by 1541, the two oldest boys had transferred to other, perhaps somewhat more socially elevated, artistic professions. Antonio was an apprentice embroiderer, and the thirteen-year-old Paolo was training to be a painter. From this point, it is possible to trace his rise through the mutations of his name. In 1553, he was still humbly calling himself 'Paullo spezapreda' (Paul Stonecutter or Mason). Two years later, perhaps after the death of his father, he had become, 'Paulo Caliaro Veronese'. This substitution is suggestive. Caliari was the name of his maternal grandfather. His unmarried maternal grandmother, Maddelena Dragina, had had two children by two different men – which suggests that she was a semi-courtesan kept by male lovers. The artist's grandfather was a youthful nobleman named Antonio Caliari. After he died, Maddelena had another daughter with a member of the aristocratic Bevilacqua Lazise family, in whose house she lived for the rest of her life.

Socially, therefore, Veronese was a hybrid – descended from artisans on one side and nobility on the other. The Bevilacqua Lazise, though not exactly related, did not forget him. One of Veronese's earliest works was an altarpiece for their family chapel. It is plausible that Paolo was his mother

Caterina's favourite son. When he had established himself in Venice, she came to live with him. One guesses he grew up hearing her talking about these – tenuously related – patrician forebears. At any rate, he became the supreme painter of calmly luxurious upper-class life. And many of his paintings are dominated by serenely beautiful, queenly, and commanding women.

Veronese made a speciality of huge pictures of biblical and ecclesiastical banquets. His first, *The Feast in the House of Simon*, was painted in 1556 for the refectory of the monastic church Santi Nazaro e Celso in Verona. It was a masterpiece, containing most of his trademark ingredients: the fluently organized composition of numerous figures, imposing classical, rich, yet harmonized colours, splendid textiles, servants, bustle, and a couple of dogs under the table, which caught the eye of Ridolfi, to whom these animals appeared 'so beautiful that they seem alive'.

As the art historian Richard Cocke has pointed out, Veronese could be funny. This was an aspect of his elegantly courtier-like approach. In *The Book of the Courtier*, a guide to suitable manners at court, Baldassare Castiglione devoted a long section to humour, which, it was pointed out, depended on incongruity. When in the correct context, and executed in a seemly fashion, wit and jokes were part of the polished charm of an ideal courtier. This was what, in visual terms, Veronese aimed to be. His gags could be broader in a mythological picture such as *Mars and Venus*, in which the love-making of the gods is interrupted by a horse peering inquisitively round the corner.

He applied the same principles to religious works. The *Marriage at Cana* is populated by a substantial kennel-full of dogs. One strolls along a table among the dishes, another gazes longingly down from a balustrade above the banquet, a third directs a curious look at a nearby cat, and so on. These canine additions to his cast of characters are all part of the overriding aim of embellishing the scene so as to provide entertainment and pleasure to the viewer. This was not impious or disrespectful; nonetheless, as we shall see, it eventually caused the painter to run into a spot of trouble.

By 1555, having outgrown Verona, around the age of twenty-seven, Veronese transferred his operations to the capital of the Veneto, Venice. In January of that year, he paid rent for a house near Santi Apostoli, his first Venetian dwelling. He arrived there a fully formed artist, so although his

manner became a model for many successors, he was less 'Venetian' than fellow provincials such as Giorgione and Titian who had moved to the metropolis first and developed their styles afterwards.

Veronese was a fluent, rapid, and apparently infallible exponent of the brush, which – Ridolfi noted – was never 'put in the wrong place'. This ease was part of the secret of his extraordinary productivity. He himself proclaimed that this sense of tone, colour, and form was a 'gift of heaven' – like perfect pitch – and that 'labouring at that without natural talent was like sowing in the waves'.

On moving to Venice, he was hailed as the new star of Venetian art. Around 1555, a competition was arranged between seven artists who were chosen to paint roundels on the ceiling of the reading room of Sansovino's Biblioteca Marciana. Veronese won and was awarded a gold chain that was still cherished by his descendants a century later. Perhaps around this time, it was related by his pupil Antonio Vassilacchi, he bumped into Titian in Piazza San Marco. 'Paolo greeted him with due reverence and was affectionately hugged by Titian, who added that it made him happy to consider Paolo as uniting in his person the decorum and the nobility of Painting.'

PAOLO VERONESE *Marriage at Cana*, 1562–3 (detail)

Thus Veronese was Titian's chosen heir as '*capo de Scuola*' – head of the Venetian school. He and his art were courtly, refined, and – as this anecdote suggests – suitably respectful of Titian. In all these respects, he was the opposite of his older contemporary Tintoretto, whose style was disruptive and who was personally curt, aggressive, and had apparently quarrelled with Titian early in his career. Veronese, in contrast, was just like one of his own paintings. He dressed in 'precious clothes and wore velvet shoes' (also devotedly preserved by his grandson). The earnings from his art were invested in property, so that 'he was able to buy many farms and accumulate wealth and furnishings worthy of any knight, leaving his sons well settled with property so that they were able to live suitably without hardship or effort'. In other words, with pigment brushes and canvas, he transformed his family from stonemasons to noblemen just like his grandmother's lovers.

Veronese followed up his success in the competition for the ceiling of the library with a series of other brilliant successes: more spectacular ceiling paintings for the Doge's Palace and the church of San Sebastiano and, in 1562–3, the *Marriage at Cana*. A decade later, in 1572, another great feast, the *Supper of Gregory the Great*, was painted for the Servite refectory at Monte Berico, outside Vicenza. Then, a year later, he completed a huge, tripartite painting of the Last Supper for the refectory of Santi Giovanni e Paolo (see pages 168–9). In this work, the central arch contains the divine drama of Christ and the Apostles. To either side, there is entertaining incident, the kind of divertingly observed behaviour that actors call 'business' – a man who is picking his teeth, a jester with a parrot on his arm, the master of ceremonies inviting guests to the meal.

This time, however, there were unexpected repercussions for the painter. On 18 July 1573, he was summoned by the Holy Tribunal, or Inquisition, to answer the charge that his painting was indecorous and unsuitable for a sacred building. It seems likely that the Venetian inquisitor, Fra Aurelio Schellino da Brescia, was using the picture to demonstrate his zeal in the presence of a new papal nuncio, who had just arrived from Rome and sat on the tribunal. As a Dominican, Schellino would have been one of the few who could have seen it in the refectory of San Giovanni e Paolo (a Dominican institution). Quite possibly, he had reported the picture to himself.

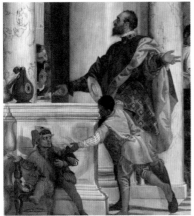

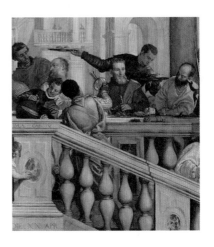

PAOLO VERONESE
Last Supper, 1573 (detail)

PAOLO VERONESE
Last Supper, 1573 (detail)

The resulting interchange was unusual and fascinating. In a sense, this was the first artist interview ever recorded. Even if, as Cocke has argued, the surviving document is 'not an exact transcript of what was said', nonetheless Veronese's voice cuts through clearly: confident, self-assured, witty. Asked who was present at the Last Supper, he replied: 'I believe that there was only Christ and His Apostles; but when I have some space left over in a picture, I adorn it with figures of my own invention.' This was the nub: Veronese had embroidered the religious drama with extraneous figures who, in a stage play, would be extras and bit parts. The Inquisitor's list of undesirable staffage in the picture – 'buffoons, drunkards, Germans, dwarfs, and other such scurrilities' – echoes the roster of minor characters in a *commedia dell'arte* production. Veronese's defence of his subplots and added incidents – the buffoons, the German with a nosebleed – was essentially theatrical. Twice, when pressed on this matter, he replied in the same way. 'I did it because I assumed that these were outside of the place of the supper'; and 'While I may not have considered many things, I intended to cause no confusion, especially since those figures of buffoons are outside of the place where Our Lord is depicted.' In other words, they were not in the same scene.

*

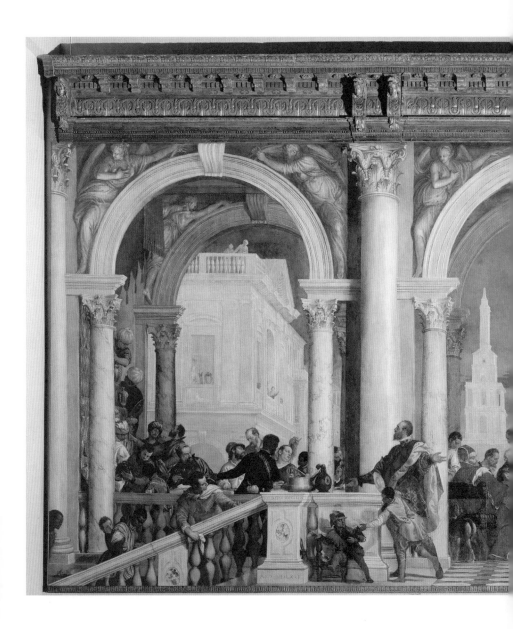

PAOLO VERONESE *Last Supper*, 1573

PAOLO VERONESE *Fresco at Villa Barbaro, 1560–1*

Boschini wrote of Veronese's work that, 'This is not painting, it is magic that casts a spell on people who see it.' And indeed such an enchantment seems to have befallen the Villa Barbaro at Maser, some fifty kilometres north-west of Venice. The interior of the building, an elegant design by Palladio, was covered in frescoes by Veronese in 1560–1 (just before he painted the *Marriage at Cana*). Consequently, the walls are inhabited by virtual beings, presences that might be called 'ghostly' if they did not look so vigorously alive. Some of these are the kind of mythological figure you would expect to see on the walls of a Venetian gentleman's country retreat:

on one ceiling, Bacchus teaches humankind how to make the best use of the grape; elsewhere, the gods of Olympus relax on handy clouds. In a lunette above a door, the Madonna and Child are comfortably at ease amongst this pagan company. Others, however, make much more unexpected appearances. A door seems to open in the central hall, and a page peers out. From another painted entrance, a little girl emerges, and from a third comes a jaunty huntsman, with a horn, accompanied by a couple of dogs (his face, by the way, is generally thought to be another self-portrait of the artist).

In a different room, in a more elevated position, the mistress of the establishment looks out from an internal balcony, flanked by a nurse and a couple of engaging pets, a parrot and a miniature dog. Here is Giustiniana, wife of Marc'Antonio Barbaro. Together with his brother Daniele, Marc'Antonio owned the estate at Maser, near Treviso, where the villa stands. The pair

PAOLO VERONESE *Fresco at Villa Barbaro*, 1560–1

commissioned the design of the building from Palladio and the frescoes from Veronese, choices that could not have been bettered. Meanwhile, in a spirit of gentlemanly amateurism, Marc'Antonio himself apparently undertook the carving of the slightly eccentric figures in the grotto outside.

For long periods, however, while Marc'Antonio was absent on his diplomatic duties, his wife Giustiniana was probably in charge of the villa and the estate. Daniele was a bachelor clergyman with literary interests to pursue. Apart from the fact that she had four children, we know little more about Giustiniana than can be deduced from this wonderful painting of her by Veronese. He gave her an elusive double nature. She is a spectator, gazing out at what is happening below. But, of course, in reality we are looking at her, and she has that attractive power that came to be called 'star quality'. It is almost as if she were spotlit, centre stage with dog, parrot, and nurse as supporting players. This impression is an illusion, naturally, but one apt for the time that Veronese was painting. In sixteenth-century Venice, houses were turning into performance venues, the people within them dividing into actors and audience. The whole city was becoming theatricalized.

There is only one piece of paper that suggests Veronese was practically involved in theatrical performances. It contains a series of costume designs for the opening production at the Teatro Olimpico at Vincenza in 1585, which was of Sophocles' tragedy *Oedipus Tyrannus*. We cannot be sure whether Veronese actually originated these costumes or just made a note of them because they interested him. But fascinated he must have been. He was living in a city in which political, religious, and social life was acted out in lavish civic performances.

There were processions such as the one at Sant'Angelo in which Veronese caught a fatal chill (consequently dying at the relatively early age of sixty in 1588). In addition, there were grand state ceremonies that involved the doge, senators, and a cast of hundreds, the festivities of the *scuole* on the name day of their patron saints. To Venetians such as Veronese and his patrons, it might well have seemed that this was how the most solemn events of the Christian story should be enacted, with pomp, sumptuous costumes, and milling crowds.

*

Not everybody was appreciative of the transformation of life, as Shakespeare put it, into a stage. Nor was the theatre itself without dangerous opponents. The Inquisitor's criticisms of Veronese's *Last Supper* echo contemporary accusations against the theatre. One sharp exchange in this culture war involved Carlo Borromeo (1538–84), archbishop of Milan, cardinal, and a driving force of the Counter-Reformation. His target was comedy in general, especially the popular variety, and in particular the acclaimed troupe called I Gelosi, or 'the Zealous ones' – eager, presumably, to please. The idiom in which they worked was known in the sixteenth century as the *commedia degli zanni* (comedy of trickster servants), *commedia all'improvviso* (improvised comedy), or *commedia delle maschere* (masked comedy). The eighteenth-century playwright Carlo Goldoni dubbed it with the name that finally stuck: *commedia dell'arte*, or 'professional comedy'.

Emily Wilbourne, a historian of Renaissance theatre, notes that the major characters in a *commedia dell'arte* performance were 'complemented by other bit parts – soldiers, slaves, dwarves, merchants, crowds, pages, and so on', all 'folded' into a five-act structure. At Trausnitz Castle, in northern Bavaria, there is a narrow set of spiral steps in the outer wall, which is in its way extraordinary because it is a theatrical staircase. It is known as the *Narrentreppe*, or Stairway of Fools, because its walls are inhabited by a cast of characters from the *commedia dell'arte*. There, as you climb upwards, you encounter Pantalone, the old, thin man, 'lean and slippered', who has not yet given up the delusions of youth, and his larcenous servant Zanni, clad in oversized white trousers and jacket. As the scholar Peter Jordan noted, Pantalone is a 'geriatric Don Juan'. He wears unsuitably youthful clothes: tight-fitting red hose and jacket. Though far from Italy, the *Narrentreppe* is essentially Italian, and in some respects specifically Venetian. The artist who provided the designs, Friedrich Sustris, was trained in the studio of his father Lambert, who had settled in Venice and worked with Titian.

The earliest female star whose brilliance has left a trace on the historical record was Isabella Andreini (1562–1604). In the spring of 1589, a man named Giuseppe Pavoni was in the audience when her troupe, I Gelosi, performed in Florence. The occasion was a magnificent one, the wedding of Grand Duke Ferdinando de' Medici of Tuscany and Christine of Lorraine.

Pavoni gave Isabella what amounted to a rave review. Isabella and her husband Francesco were the leading performers of the group. Her speciality was the *prima donna innamorata*, or the lovelorn leading lady. One of the pieces that I Gelosi put on in Florence was *La pazzia d'Isabella* (The madness of Isabella). In this play, a tragic misunderstanding makes Isabella think her lover has deserted her for another, driving her utterly and vocally insane. This was, despite the tragic turn of the plot, a dazzling display of vocal mimicry. Pavoni described how Isabella, 'went running through the city, stopping now this one, now that one, and speaking now in Spanish, now in Greek, now in Italian, and many other languages, but all without reason'. Next, she went through a series of cameo impressions of all the other actors in the troupe, of 'Pantalone, of Gratiano, of Zanni, of Pedrolino, of Capitan Cardone and of Franceschina', and did so – he enthused – 'so naturally and with such absurdities that it is not possible to put into words the worth and virtue of this woman'. Finally, she returned to sanity as a result of drinking certain 'waters', whereupon she gave a disquisition in 'elegant and learned style, explaining the passions and travails of love'.

Isabella left the audience in Florence wowed, full of 'such whispering and wonder' that 'for as long as the world goes on, her beautiful eloquence and worth will be praised'. Perhaps her stellar performances had an impact in far-flung places. The description of her bravura turn – both Isabella's pathetic loss of reason and her discourse on love – bring Shakespearean heroines to mind: Ophelia from *Hamlet*, Kate in *The Taming of the Shrew*, Portia in *The Merchant of Venice*. Possibly it is no coincidence that several of Shakespeare's witty, clever female characters feature in plays set in the Veneto. And perhaps she affected Veronese too. Although it has been suggested that Isabella was the subject of a portrait by him, the identification is far from certain; the heroines of paintings such as *Lucretia* are a better index of the impact that she and other actresses had on his imagination. It would be wrong to talk about straightforward 'influence' of the theatre on Venetian painting (or vice versa); the two sprang from the same culture. But they had features in common, not least a propensity to elude ecclesiastical policing.

*

PAOLO VERONESE *Lucretia, c.* 1580–3

In 1574, the year after Veronese's interrogation, Archbishop Borromeo received a letter from a worried father in Piacenza who feared that 'evil and abominable comedies [performed by] those profane men and ignominious women were corrupting young people': 'These infamous ham actors perform every kind of lasciviousness and libidinousness on their stages, dressing women as men, and boys as women.' Borromeo took this danger seriously. When I Gelosi arrived in Milan in 1581 at the invitation of the governor of the city, he and his minions were ready. But they were outmanoeuvred by the actors, in much the same manner and spirit that Veronese adopted with the Inquisitor.

A couple of years later, Borromeo admitted to a sense of failure. Of what use, he lamented, were the decrees of the Council of Trent (in which he himself had been a leading voice) against heretical and immoral books, if such plays remained unbanned: 'How much more penetrates the soul that which the eyes see than that which can be read in books of that kind!' It was relatively easy to control the written word, and the church did its best to do so, issuing an *Index Librorum Prohibitorum* (List of prohibited books). But how to control an expression on the face of a comedian or a figure in a painting? Yet such things could communicate powerfully, perhaps more so than words, as Borromeo was uneasily aware.

The Inquisitor asked Veronese: 'Do you not know that in Germany and other countries infested by heresy, it is habitual, by means of pictures full of absurdities, to vilify and turn to ridicule the things of the Holy Catholic Church, in order to teach false doctrine to ignorant people who have no common sense?' In answer, Veronese readily conceded that what these Protestants did was wrong. And there is no reason to doubt that he was an orthodox Catholic. Ridolfi wrote that, 'He ruled his family with great prudence, keeping his children away from harmful acquaintances and practices teaching them with every piety about religious observance and moral disciplines.'

Veronese's disagreement with the Inquisitor was not about belief or faith, but about the proper place of imagination in the creation of a work of art. This was the nub of the most crucial passage in his defence. The Inquisitor demanded, 'What is the significance of those armed men dressed

as Germans, each with a halberd in his hand?' Veronese replied: 'We paint-
ers take the same licence the poets and the jesters take.' That painting and
poetry were closely linked was a Renaissance cliché, derived from a remark
by the Roman writer Horace: *ut pictura poesis*, or 'as is painting so is poetry'.
But Veronese's second comparison was more unusual. By 'jesters' he must
have meant performers of the *commedia dell'arte*. The implication is that in
the same way that they were in the habit of filling out the skeleton of a plot
with added gags, songs, incidents, and added characters, so could artists.

Initially, in the case of the Inquisition versus Veronese, the judgment
went against the painter. He was to alter his picture so as to make it more
fitting and less frivolous:

> The aforesaid Paolo should be obliged to correct his picture within
> the space of three months from the date of the reprimand, according
> to the judgments and decision of the Sacred Court, and altogether at
> the expense of the said Paolo. 'Et ita decreverunt omni melius modo'
> (And so they decided everything for the best).

In the long run, however, the painter (or perhaps his patron) suavely out-
witted his accusers. The new nuncio turned out much less severe than his
predecessor, and the whole affair dwindled away. Veronese made only one
small change to his huge painting. He added an inscription: 'FECIT. D.
COVI. MAGNV LEVI – LVCAE CAP. V.' And by this he changed the
subject, from one New Testament feast to another: his picture now claimed
to represent not the Last Supper, but the Feast at the House of Levi. The
painting, completely unchanged, was now intended to illustrate a short
passage from the fifth chapter of the Gospel of Saint Luke. 'After this,
Jesus went out and saw a tax collector named Levi sitting at the tax booth.
"Follow Me", He told him, and Levi got up, left everything, and followed
Him. Then Levi held a great banquet for Jesus at his house, and a large
crowd of tax collectors and others were eating with them.' Veronese added
a date, 20 April, well before the interrogation, implying that he had always
intended this to be the subject. It was a small alteration after all: same cast,
costumes, and set, just a different title.

STAGING THE CITY

I n 1816, a Colonel Isaac A. Coles 'conversed at length on the subject of architecture' with a keen amateur architect, Thomas Jefferson. Although Jefferson's vision as founding father of the United States had been radical, his views about the art of building were conventional for an English-speaking person of the eighteenth century and were slightly old-fashioned by the early nineteenth: that the subject had been summed up for all time by Andrea Palladio's *Four Books of Architecture* (published in Venice in 1570). The former president proclaimed that this 'was the Bible – you should get it and stick close to it'.

Palladio is, as the art historian James Ackerman put it, 'the most imitated architect in history'. He also had a powerful effect on Venice, designing all or part of several of its most notable buildings and – in the process – creating some of its most familiar views. But if Palladio altered Venice, the city also adapted the architect's ideas. Shut your eyes and think of Venice – in the centre of your mental image there is quite likely to be a crystalline conception ostensibly by Palladio. The basilica of San Giorgio Maggiore is one of the world's most looked at (and photographed) buildings. Its brilliant white limestone reflects the sun and catches the eye; the snappy interlocking triangles of the facade are as instantly memorable as a good logo. However, it is not so much a three-dimensional architecture as a *diagram* in Istrian stone. The columns of the portico are not real, free-standing cylinders, but

The Basilica of San Giorgio Maggiore

a series of semi-circular shapes bulging out of the wall behind: a sort of carved picture in low relief – a solid, permanent stage set.

It was a solution that developed through a long process of discussion and consensus. By the late sixteenth century, the rambling structures of this medieval church and monastery were badly in need of restoration. When reconstruction began, Palladio designed the grand refectory for the monks in the manner of an ancient Roman mansion or bath (the room for which Veronese painted the *Marriage at Cana*). Five years later, he made a model for a new church, and in 1566 building began. However, the Benedictine monks postponed construction of the boldest feature of his scheme: a free-standing portico in the manner of a Roman temple. Palladio felt that these added 'grandeur and magnificence' to the country villas that he devised for nobles, but perhaps the architect's portico was a bit too magnificent for a church in this position.

The renovation of central Venice was a hotly debated subject at the time (and ever since). Various radical schemes were proposed. In 1560, Alvise Cornaro – of whom more below – suggested that a theatre should be floated in the lagoon between the island of the Giudecca and the easterly point of Dorsoduro (so just beside San Giorgio Maggiore).

After part of the Doge's Palace was destroyed in a disastrous fire in 1577, it was suggested that the wing facing the lagoon could be rebuilt according to a design by Palladio. There was also the proposal to raise the height of Sansovino's Biblioteca Marciana by a storey. These ideas were supported by one group of nobles, prominently including Palladio's patron Marc'Antonio Barbaro, who loved richly classical architecture – and also favoured more friendly relations with papal Rome. They were opposed by a group, known as the '*giovani*', of younger patricians who favoured plainer styles of architecture – and who also valued Venice's traditional independence from the pope. Of course, tastes in building and politics need not go together, but often they seemed to. In addition, there was a more instinctive conservatism amongst Venetians – you even might call it a sense of architectural tact. When put to the vote in the Senate, radical schemes often lost by a large majority. Possibly the reason for objecting to the proposed redesign was not only a liking for things the way that they were, or a dislike of expense.

As we have seen, there was also the feeling, expressed by the building supervisor or *proto*, that to add another level to Sansovino's library would 'suffocate' the Doge's Palace.

Similarly, a full Roman temple-style facade on San Giorgio Maggiore might have looked, perhaps, too aggressively *Roman*. Instead, the monks settled on a compressed version, a little like an unassembled flat-pack facade, that did not rival the Doge's Palace, San Marco, and the library across the water. Quite who designed it is not clear. It was built in the 1590s, years after Palladio's death. The actual design may have been made by the *proto* of the day, following an idea developed by the architect for other projects, such as the church of San Francesco della Vigna, which has a site so constricted that a full temple portico would have been impossible. Whoever designed it, the facade of San Giorgio Maggiore is not as elegant as Palladio's own schemes. From the purist point of view, it is a mistake that the four inner columns are raised high off the ground on plinths, whereas the outer two piers rest on the ground. But on the other hand, if those columns had been bigger perhaps the church would have looked too forceful. In Venice, everything is finely balanced.

<p style="text-align:center">*</p>

Like Veronese, the person known to posterity as 'Andrea Palladio' was a hybrid being: a stonemason refashioned as an archaeological scholar, author, and architect. He was educated, you might almost say created, by upper-class amateurs and enthusiasts for the arts. In time, he became a notable authority on Roman building, best-selling author, and one of the most influential architects that Europe has ever known. Among his accidental, posthumous achievements was that he had a profound effect on the appearance of Georgian Britain (and parts of the United States). But his talent always remained an unstable compound: sometimes the antiquarian scholar came to the fore, sometimes the practical builder, quite frequently the artist.

He was born in 1508 in Padua, son of a miller named Pietro della Gondola. The future architect was accordingly named Andrea di Pietro della Gondola. One of his godparents was a sculptor named Vincenzo Grandi. Perhaps through Grandi's connections, young Andrea was apprenticed

to a stone-cutting workshop in Padua. A few years later, in 1523, he and his father moved to Vicenza, and Andrea was attached to another, more go-ahead masonry business. But the encounter that changed Andrea's life came years later, in his twenties, when he first met Gian Giorgio Trissino (1478–1550). The latter was a diplomat, scholar, author, poet, dramatist, and the architect of his own villa outside Vicenza. The respect between Trissino and the youthful stonemason was mutual. Palladio described Trissino as 'the splendour of our times'. And the learned gentleman-architect probably found the younger man's practical knowledge of masonry and foundations most helpful.

This may explain how Andrea di Pietro was rechristened. In Trissino's epic poem *Italy Freed from the Goths*, the hero, the Byzantine general Belisarus, has a guardian angel named Palladio who watches over him and offers advice on such matters as the construction of army camps and how to build mills on the Tiber. Perhaps Andrea di Pietro, the future Palladio, first showed his worth by providing assistance on just the kind of topic treated in the first few chapters of his *Four Books*: 'Of Sand', 'Of Timber', 'Of Foundations', 'Of Walls'. Like Professor Higgins in George Bernard Shaw's *Pygmalion*, Trissino undertook this promising mason's education.

He proceeded to fill his mind with classical archaeology. According to an early seventeenth-century biographer, 'Trissino, realizing that Palladio was a very clever young man and quite gifted in mathematical sciences, resolved to explain Vitruvius to him and also to show him the ruins of the ancient world.' Their first journey to Rome was in 1541; for Palladio, it was life changing. But Trissino, though he had an enormous impact on the young man, was not Palladio's only mentor. During the following decades, he also collaborated closely with the diplomat, writer, patron of the arts, and entirely inactive clergyman Daniele Barbaro (1514–70), brother of Marc'Antonio.

Barbaro had a strange career. In 1550, he was appointed to be the next patriarch of Aquileia, the current incumbent, Giovanni Grimani, having been accused of heresy. But Grimani eventually cleared his name, continued to be patriarch, and indeed outlived Barbaro, leaving the latter with an imposing title, Patriarch Designate, income from ecclesiastical sinecures, but plenty of time to pursue his intellectual interests.

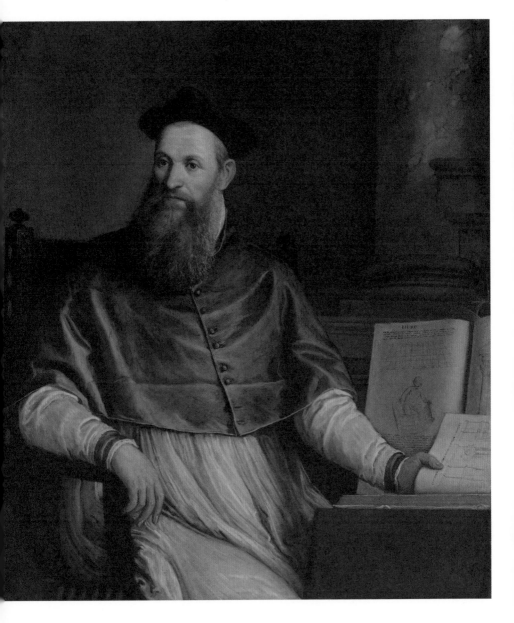

PAOLO VERONESE *Portrait of Daniele Barbaro*, 1565–7

Barbaro's portrait by Veronese displays his double identity: he is dressed in the robes of a bishop and adopts the pose of a senior clergyman giving audience (the pope made him a cardinal *in pectore*, that is, secretly). Barbaro is flanked by the two books of which he was proudest, which are displayed on the table beside him: a treatise on perspective, *La pratica della perspettiva*; and his translation with commentary of the sole architectural treatise to survive from the ancient world, Vitruvius's *Ten Books on Architecture*. The latter was published, with illustrations by Palladio, in 1556, around the time the architect was building the villa at Maser for Daniele and Marc'Antonio (with frescoes, as we have seen, by Veronese).

In his edition of Vitruvius, Daniele Barbaro made clear his view of the hierarchy of the arts. Most other arts, including painting, he argued (following Plato), dealt in trivial and misleading illusions, 'of little worth and abject, as things born of simple imagination and from fallacious conjecture'. In contrast, Barbaro believed, architecture was the power of reason made visible. That is its dignity. It is the art of arts, and the architect is the one who 'approves and judges' what is produced by the other, lesser practitioners, such as masons, carpenters, sculptors, and painters. This, then, was an activity fit for a gentleman, a thing of the mind requiring knowledge of both Latin and geometry. Its mathematical beauties were ultimately derived from the harmony of the Universe, thus ordained by God.

*

In Venice, there was often an interplay between architectural experts and the inherited, indigenous sense of how things should be done. Deborah Howard has recounted how a series of intense dialogues took place between exponents of Vitruvian theory and the *proti*, or master-builders. As we have seen, the term *proto* or *protomaestro* was a word that the Venetians derived from Byzantine Greece. It came to mean something like 'superintendent of works', as opposed to the *'architetto'* or architect. The latter was the creator of designs and plans, rather than someone who worried about drains and scaffolding. Unlike Sansovino, Palladio was both: he knew about classical architecture, better than anyone; he also knew about such matters as foundations. But like so many important artists and architects who worked in

Venice, he was not truly Venetian. Also, on occasions, his archaeological zeal – or that of his patrons such as Marc'Antonio Barbaro and his brother Daniele – got the better of him.

The question of the Rialto Bridge was one of these. With the churches of San Giorgio Maggiore and (as we shall see) Il Redentore, Palladio made a defining contribution to the cityscape. But in the case of the bridge, which is just as fundamental a structure to Venice, he failed – and rightly so.

In 1444, the old wooden bridge – itself by no means the first structure on the site – collapsed because of the weight of a crowd watching the ceremonial wedding flotilla of the duke of Ferrara. It was soon replaced by another timber structure, to be seen in Vittore Carpaccio's painting *Miracle of the Holy Cross at the Rialto Bridge* from *c.*1496 (see page 53). Clearly something less flimsy was required. After 1514, when a great fire destroyed the entire Rialto market area, a friar and architectural theorist named Giovanni Giocondo (*c.*1433–1515) suggested that a stone bridge be built. But nothing happened. The market was reconstructed, not to Fra Giocondo's fancifully classical design, but more or less as it had always been, only less flammable. It took almost a century before the bridge as we know it was finally finished.

There were excuses for the delay. This project posed great technical difficulties. On the one hand, the Grand Canal is wide at this point; its bed is deep, shelving, and made up of mud and silt, the footing in the bank reinforced with wooden piles, some of them even in the sixteenth century already half a millennium old. On the other, it was desirable for the span to be high since large boats might need to sail through, dock, and unload. The combination added up to a structural headache.

Over the years, discussion of the subject occasionally sputtered back into life. Various architects – including, apparently, Michelangelo – proposed schemes. Palladio drew up several, including one with no fewer than five arches based on the bridge built by Emperor Augustus at Rimini, and another that he illustrated in elevation and plan in Book III of his *Four Books of Architecture* when it was published in 1570. This last was much admired by connoisseurs throughout Europe, and imitated, as Robert Adam did with Pulteney Bridge in Bath (1774). To the great sorrow of architectural

enthusiasts, Palladio's original design remained on paper (although more than a century and a half later, Canaletto imagined what it would have looked like). For shoppers and pedestrians, this was probably just as well.

What Palladio designed was not so much a bridge as a Roman forum or Greek agora suspended over water. The public would have entered it at either end through columned porticoes. Within, there would have been four rows of shops, with two open porticoes in the centre giving views in either direction along the canal. Howard analysed the hazards that it would have posed: the 'two hefty piers would have created serious obstacles to shipping' (and a long dark, dank transit under the arches for all boats on the water). Then there was 'the daunting steepness of the flights of steps at either end', especially for the elderly and less sure-footed such as 'elderly senators whose

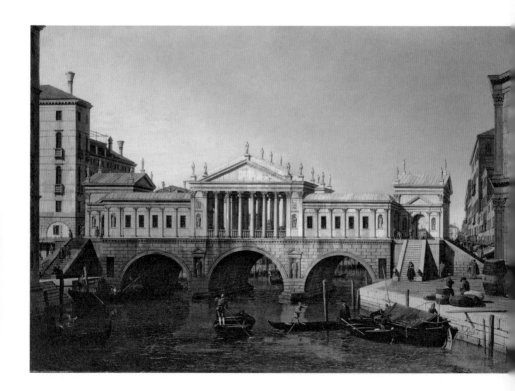

CANALETTO *Capriccio View with Palladio's Design for the Rialto Bridge*, 1742

processions involved crossing the bridge'. The shopping mall inside would have been 'a deep, shady cleft without views towards the Grand Canal except in the centre'.

Palladio's design – and Fra Giocondo's earlier scheme for the Rialto – belonged to a long line of Utopian city improvements. The latter had proposed that the Rialto market be rebuilt in the form of a perfect square, covering the whole island. This would be surrounded by straight canals on every side, with four gates symmetrically positioned, and a square piazza in the middle. Around this central area would be porticoes, and the various business outlets in the area would be grouped: the food stalls and shops around the outside, the most expensive luxury-goods sellers in the centre.

Such ideas hugely appealed to those, like Daniele Barbaro, who thought of architecture as a blend of abstract geometry and archaeological scholarship. Most Venetians, however, probably agreed with Sanudo, who dismissed the model made by Giocondo, 'who is not from here and does not understand the place'. Jane Jacobs, defender of twentieth-century New York, would have been on their side. She was an eloquent advocate of the organic city, not ordered by architects with compasses and set squares but unconsciously and organically by the people who live there. Cities, she argued, should not be laid out in terms of cerebral geometry but consisted of 'organised complexity, like the life sciences'. Palladio's bridge would have been inconvenient and unpleasant to use – and probably so too would Giocondo's market.

Clearly, most Venetians took Jacobs' point of view. In the late 1580s, well after Palladio's death, the authorities edged towards a decision about the bridge through endless consultation and even crowd sourcing. First, in 1587, some thirty architects and builders were asked their opinions, plus members of the public (one of whom produced a model for a new bridge made by his grandfather, showing how long this project had been mooted). Next, the three magistrates responsible for supervising the Rialto wrote a report. Among these was Marc'Antonio Barbaro, who unsurprisingly wanted a three-arch scheme designed by Vincenzo Scamozzi, follower of Palladio. One of his colleagues agreed, the other wanted a single arch. And so, by an enormous majority, did the Senate when it was put to the vote. The collective judgment of the city was clear.

After more consultation and deliberation on how to build this wide span in such an awkward position, the person appointed to take charge was not an architect learned in Vitruvius, but a *proto* in his late seventies. Antonio da Ponte (1512–97) was a longer-lived contemporary of Palladio's who had never acquired the additional layers of erudition that the latter had added to his original skills as a mason. Da Ponte was no intellectual; he could not compose an elegant report or pen a stylish drawing, but he had a long lifetime's experience of building on the soft and shifting ground of Venice. He was largely responsible for the Rialto Bridge we still walk across.

Some of the ways he set about his task were unconventional – and controversial. He set the wooden piles of the foundations in three groups, descending like steps as they went deeper, and he placed the masonry of the abutments at each end of the bridge at a forty-five-degree angle. These caused consternation to Marc'Antonio Barbaro and other critics. But as Howard argues, da Ponte, presumably through experience and intuition, had found a 'brilliant statical solution'. The stepped foundations were necessary because there is less solid ground deeper below the nearer you got to the centre of the stream. The angled masonry held the outward forces of the arch without slipping sideways. So the whole structure remains tautly balanced despite its silty, swampy location. The proof is that it has stood there to this day, still in excellent condition.

An aspect of the design that da Ponte did not care greatly about was what went on top of it; he suggested 'some decorations as befits the site'. It is not known who was responsible for the sloping shopfronts and arch at the top (borrowed from Serlio). But these are the one component that does not quite work, in fact, looks slightly silly. Without these fussy additions, the span would be perfectly, gracefully, functionally beautiful.

*

Palladio's erudition could also be highly creative, often – as tends to be the case with knowledge – because there were gaps in his understanding, so he made mistakes and in the process came up with something new. Eventually, he wrote a guide to Rome that, like his architectural primer, was popular for centuries. However, he did not get Roman architecture entirely right.

This was not unusual – a great deal of art history consists of creative mis-understandings. Palladio looked at the remaining Roman ruins – often a chaotic jumble of tumbled and half-buried walls – and interpreted them. In the process, they came out more carefully ordered, symmetrical, and harmoniously proportioned than they had actually been.

Ackerman described this archaeological romance, which deeply affected the appearance of the world. 'Palladio loved the ruins but, like most lovers, he saw only what, and how, he wanted.' So, 'admiring the effect of temple porticoes, he would put them on villas, or cut them up and put pieces of them on churches'. This touches on one of Palladio's fundamental difficulties. For much of the time, he was trying to design structures that the Romans simply had not had – or alternatively, which had existed but for which there were no remains that he could examine. This was the case with Roman country houses, so Palladio was forced into wildly original innovations.

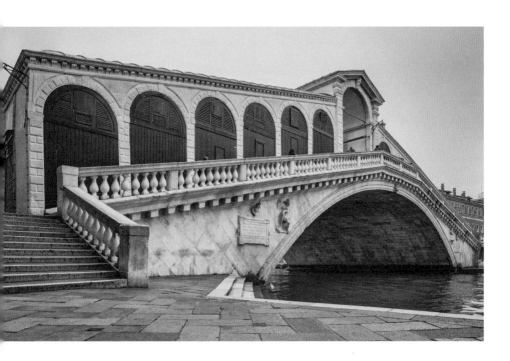

The Rialto Bridge, showing the supporting stone abutments at forty-five-degree angles

A marvellous, though unusual, example is Villa Capra, also known as La Rotonda, built for a priest named Paolo Almerico outside Vincenza. Palladio's villas were normally intended partly as attractive rural residences, partly as agricultural hubs. The Villa Barbaro he designed for the Barbaro brothers at Maser is more typical. It is a treasure house of art. But it is also flanked by barns, stables, grain stores, dovecotes, and other practical facilities. Villa La Rotonda, however, was intended only to be lived in, looked at, and also looked out from. Palladio explained that the unprecedented layout of this structure was entirely determined by the urge to create beautiful prospects. 'Because it enjoys the most lovely views on all sides, some screened, others more distant, and others reaching the horizon, loggias were made on each face.' Those inside can enjoy the scenery from every side, but just as importantly, those outside can appreciate the building from 360 degrees.

The site, Palladio went on, 'is one of the most agreeable and delightful that may be found, because it is on a hillock with gentle approaches, and is surrounded by other charming hills that give the effect of a huge theatre'. Palladio is using the word partly in the old sense: a place for concentrated observation, as in 'operating theatre'. But he is also saying that it is like an actual theatre. Classical performances were often held in semi-circular auditoriums in which the audience looked down towards the stage. This was the converse: the spectators looked up. But the principle was the same. In this case, the performer was Palladio's extraordinary building. If it were not so familiar, we would more easily see how inventive it is: a rectangular block on a hill with a Roman temple facade stuck on every side.

*

Whether or not Palladio was completely responsible for its appearance, San Giorgio Maggiore is a superb eye-catcher. As the architectural historian Manfredo Tafuri noted, it is visible from far down the busy commercial street of the Merceria as you approach the Piazza San Marco. It appears as you float out the Grand Canal, and can be seen from all along the promenade of the Riva degli Schiavoni. The gleaming white, jazzily zigzagged front in Istrian stone composes all these prospects in the same way that Turner famously popped a bright red buoy amidst a painting of sea and sky.

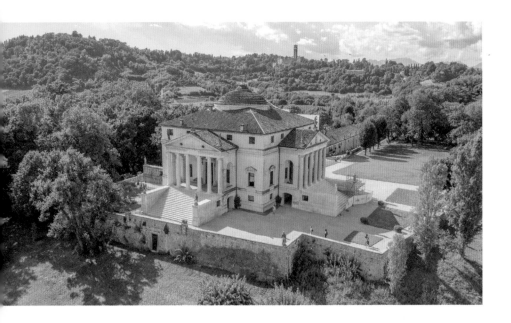

ANDREA PALLADIO *Villa La Rotonda, Vicenza,* from 1567

The Venetian government was fully aware of this fact. In 1609, the new doge, Leonardo Donà, erstwhile leader of the *giovani* faction, ordered the demolition of some buildings that obscured the frontage of San Giorgio, 'to free the perspective of the facade of the church'. This is a perfect piece of what has been called urban scenography: the city as stage set. And every year, on Christmas night and 26 December, the feast of Santo Stefano, it was the location of a real performance. Dignitaries would be carried over the water to venerate the relics of Saint Stephen (these having been brought to the church in the twelfth century). It was just one of many occasions throughout the year when Venice became the backdrop for civic theatre.

In addition to these regular festivities, there were also special occasions. Then artists and architects would erect something even more like stage scenery – as Palladio, Tintoretto, and Veronese did for the state visit of the new king of France, Henri III, in 1574. Henri, the fourth son of Henri II, had been ruler of Poland. When his brother unexpectedly died, he slipped away from Krakow, and travelled home by a circuitous route that avoided

unfriendly Protestant territory. He announced that, en route, he would like to pass through the territories of Venice. The Senate was delighted to welcome such an important guest, but there was little time to make preparations. The French ambassador made his request on 30 June; Henri arrived on 18 July.

Nonetheless, presumably at frantic speed, Palladio designed a triumphal arch and elegant loggia on the Lido, decorated with equally rapidly executed paintings. Henri and his party had spent the night before his official entry on Murano. Doge Alvise Mocenigo and the Signoria sailed there to meet the monarch, then escorted him to the Lido, where they were awaited by the patriarch and clergy. Everybody then processed into the loggia, where there was an altar and a solemn *Te Deum* was sung. Only after that did the entire party board the magnificent state barge, the *Bucintoro*, to be rowed across to the Piazzetta, San Marco, and the Doge's Palace to the sound of gun salutes, bells, and music, with thousands of boats in attendance.

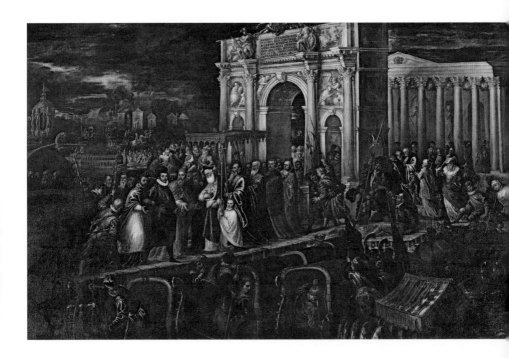

ANDREA VICENTINO *King Henri III of France being received by Doge Mocenigo, Patriarch Giovanni Trevisan, and the Signoria in 1574,* 1593

Palladio's final design for a Venetian church was intended as a permanent setting for a ceremonial. It was one of the most important, marking a crisis as dark as any the city ever lived through. The Feast of the Redeemer was inaugurated – and the Chiesa del Santissimo Redentore (Church of the Most Holy Redeemer), known commonly as Il Redentore, was built – in fulfilment of a vow taken by the Senate on 4 September 1576.

This had been a moment of desperation. The plague had been spreading with ever-increasing virulence since the summer of the previous year. It is estimated that up to a third of the population, around fifty thousand people, died before it finally abated. The government had taken extreme measures to halt it, including an eight-day curfew in which the inhabitants were confined to their houses (in other words, what we have more recently come to call a lockdown). Nothing worked, so, rationally enough, the government turned to God. In November 1576 (prematurely, since the plague was not officially declared to be over until the following July), the Senate began to consider exactly where this church should be built. There were several proposals. The Franciscan nunnery in Santa Croce, sited next to the modern-day bus station, was suggested. So too was a position at San Vidal, across the Grand Canal from the Accademia. Both sites were rejected for reasons that were partly political, partly aesthetic. The discussion of the location of this new church became entangled with divisions between those who supported an alliance with the Counter-Reformation papacy and those who did not. This was further complicated by disagreement between the proponents of a rich, Roman, classical style of architecture – led as usual by Barbaro – and, in opposition, advocates of a more austerely puritanical way of building.

Barbaro made a speech arguing for a round church at San Vidal. Since the fifteenth century, lovers of classicizing architecture had dreamt of Christian places of worship that were circular. Donato Bramante, among others, had designed them; Palladio built one for Marc'Antonio and his brother Daniele beside their villa at Maser. The attraction was geometrical and mystical at the same time: a circle was a perfect form, echoing the spheres of heaven.

However, Donà did not like the idea of the centralized plan. 'Why', he asked the senators, 'are you looking for magnificent buildings? There is no need of a Temple, whether round or not. I think God would not support this.'

Instead of the San Vidal site, he advocated one on the island of Giudecca, which was backed so enthusiastically by the then doge that he offered five thousand ducats of his own money towards the costs. This site might have appeared even more out of the way than the one at Santa Croce. Because of the unique topography of Venice, however, it was not.

The Canale della Giudecca is a wide stretch of water – more than anywhere else in the city you feel as though you are on the open sea when crossing it. A church in the position commanded sightlines from the entire Fondamenta delle Zattere promenade on the other side of the canal, from most of the Riva degli Schiavoni, and most importantly from the Piazzetta and the Doge's Palace. It was thus simultaneously both distant and prominent. It fitted marvellously in the urban scenography of the city.

Il Redentore, seen across the Canale della Giudecca from the direction of the Doge's Palace

JOSEPH HEINTZ THE YOUNGER
Procession for the Festa del Redentore, c. 1648–50

Palladio's design for Il Redentore was approved on 17 February 1577, and by the standards of such big projects, progress was swift, finishing by 1592. But in the aftermath of the plague, the city and its government could not wait that long. The first procession was held that very year, on 11 July to celebrate the end of the pestilence. The Festa del Redentore took place thereafter on the third Sunday of July, and has continued ever since.

The ceremony was a show with a cast of thousands, as is depicted in a painting from *c.* 1648–50 by Joseph Heintz the Younger (1600–78), a German painter who ended up in seventeenth-century Venice and made some of the very first Venetian *vedute*, or views. In his depiction, a column of hundreds process along the Zattere and across a pontoon bridge – thus, literally walking on water – to the other shore. The canal is dotted with gondolas carrying spectators; more watch from the *fondamenta*. Everything converges on Palladio's church.

The interior of Il Redentore

Behind its stage-set facade, there was a second theatre. Its function was to provide a setting for the feast day. The space under the dome constituted a stage on which the principal performers, the doge and his entourage, could assemble. The interior is one of Palladio's greatest masterpieces. As you walk through it, the space unfolds and expands around you. Here, and in San Giorgio Maggiore, you realize that Palladio was not only a learned and ingenious deviser of structures. He was a great artist, as Ackerman put it, 'the magician of light and colour, the architectural counterpart of Veronese'.

TINTORETTO
AND TINTORETTA

Jacopo Tintoretto, like Vincent van Gogh, was a person who operated at speed. Cristoforo Sorte, who worked side by side with Tintoretto at the Doge's Palace in the late 1570s, wrote a short account of his colleague's character and talents in a little book, *Observations on Painting*, published in 1580. His abiding impression of the great man was rapidity, in every respect: 'I have observed in M. Giacomo Tentoreto, who, as in his gestures, in his face, in the motions of his eyes and in his words is ready and quick in reasoning.' When at work, according to Sorte, Tintoretto was a blur of decisive activity: 'In a moment he immediately puts in place the cast shadows, dark areas, half tones, form and flesh very well imitated, and with such boldness and skill, speed and promptness, it is a wonder to see him work.'

You can see those rapid, sweeping strokes when you look at a passage – almost any passage – from one of Tintoretto's paintings. Take the group of sleeping apostles huddled at the bottom of *The Agony in the Garden* at the Scuola Grande di San Rocco (see page 199). The art historian Tom Nichols analysed how Tintoretto summoned up these figures out of darkness (or, at least, a patch of canvas primed in nocturnal brownish black). Lying at the front, Saint John – his nose, curly hair, half his unconscious face, and his curled-up knees swathed in drapery – was created out of deep shadow with a minimum of marks. Tintoretto had taken a broad brush

to sweep in 'the slanting diagonal highlights for John's raised legs'. These are an example of what the seventeenth-century writer Marco Boschini called *'il colpo sprezzante'* – the bold, apparently casual stroke that adds the finishing touch to the process of creating form through paint.

Before Tintoretto had done that, he had roughed in the area of cloth wrapped around the saint in darkish pink, a different shade from the blackish-brown gloom from which the disciples James and Peter materialize. And there were subtleties to those marks, despite their appearance of swaggering brio. Nichols notes Tintoretto's 'brush is only lightly loaded, leaving a stroke which dies at each edge and tapers away into shadows at its extremities'. The highlights on the disciple's robes are drawn with a broad brush, the shapes of the leaves in the bush above, with a narrower one. Tintoretto had thus precisely calculated not just the tone, colour, and position of each stroke, but also the amount of pigment to be used. The result of this 'dry-brush technique' is a paint mark that has a beautiful physical texture, emphasizing and making visible the coarse weave of the canvas in a way that recalls Paul Gauguin or the contemporary artist Lee Ufan.

Here is magic performed before your eyes, by a conjuror who does not bother to disguise how the trick is done. This extraordinary casual, brilliant aplomb was at once an expression of his temperament, a display of his skill, an advertisement of his individuality, and the product of a business plan. The faster Tintoretto painted, the cheaper he could price his pictures – and undercut the competition.

*

One of the paradoxes of Tintoretto's personality was that although he was a successful entrepreneur and founder of the longest-lasting of all Venetian family painting workshops, he was also a solitary spirit. There are a number of signs that he did not get on well with his colleagues. He behaved in an aggressively competitive way, and almost humorously at the same time. Once, for example, it seems that he poached a commission for an important altarpiece. The job had already been given to Veronese, but Tintoretto said that he would paint it so much in his rival's manner – and presumably at a lower price – that no one would be able to tell the difference.

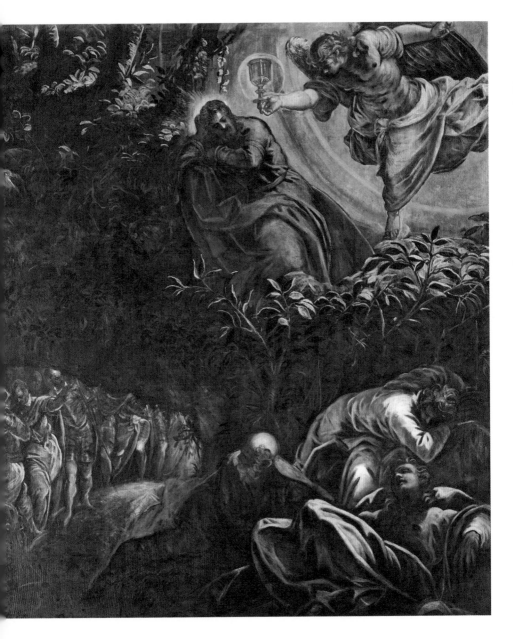

JACOPO TINTORETTO *The Agony in the Garden*, 1579

The picture – the *Assumption* from around 1555, now in the Accademia – is indeed rather Veronese-ish, particularly in colour. Apparently, Veronese himself, though otherwise an admirer of Tintoretto's, complained that this way of working in other people's styles undermined the profession. Obviously, he felt that it was fundamental that if you went to Tintoretto, you got work that *looked* like a Tintoretto, not a Veronese. This sounds like a bit of a prank by the former, but also distinctly sharp practice.

Tintoretto, for his part, sounded paranoid on occasion. In an application to the Senate submitted in December 1575, he begged for a reduction of taxes imposed on him, explaining that this had been done on the basis of 'false information' – lies – emanating from other artists, 'by whom I am hated'. Nor was this just paranoia; it seems that he really was resented. His seventeenth-century biographer Carlo Ridolfi noted that Tintoretto's business methods aroused:

> the hatred of other painters, since it seemed to them that he damaged the reputation of art by not maintaining the requisite decorum. Whence perhaps some thought that he put so small a value on his paintings because he produced them without effort, although in truth nothing ever came from his hand that had not been fully thought through.

There are several anecdotes about Tintoretto's outrageous price-cutting. One concerned the two paintings that he made for the chancel of Madonna dell'Orto (which happened to be his parish church). Each side of this structure consists of a huge Gothic arch just short of fifteen metres high. Tintoretto proposed that he fill these two spaces with paintings, a suggestion that the prior, 'deeming that a year's revenue would not be sufficient for such an undertaking', dismissed with laughter. The artist, however, said that he would do it for the cost of the materials, making a gift of his labour.

This account was not published until almost half a century after Tintoretto's death, although Ridolfi had excellent sources: the painter's surviving children. Giorgio Vasari, however, published a very similar story just two years after it happened. In 1564, the brothers of the Scuola Grande

di San Rocco had decided to add 'some honourable and magnificent work' to the ceiling of the Sala dell'Albergo of their *scuola*. They decided to hold a competition between the most established painters in town. They therefore asked Giuseppe Salviati, Federico Zucchero, Veronese, and Tintoretto to submit sketches, so they could choose the one they liked best (Titian had been their first choice, but he had proved too expensive or too busy). But Tintoretto decided to short-circuit this procedure, as Vasari reported: 'While the others were engaged with all possible diligence in making their designs, Tintoretto, having taken measurements of the size that the work was to be, sketched a great canvas and painted it with his usual rapidity, without anyone knowing about it, and then placed it where it was to stand.' So the brethren arrived to find that, instead of just producing a sketch, Tintoretto had finished a full-sized painting of San Rocco in Glory and installed it on the ceiling (where it still is). Some members of the *scuola*, and no doubt also the artists they were backing, were irritated by this. When they pointed out that they had only asked for a little sketch, however, Tintoretto replied to say that, first, he always worked like this; second, it was a more honest way of going about things, since the customer could see exactly what they were getting; and finally, if they did not feel like paying him for it, he would make them a free gift of the picture.

The records of the *scuola* record that there was indeed a competition announced 'between 3 or 4 of the most excellent painters in Venice' for the ceiling commission on 31 May 1564. Furthermore, this competition was cancelled a month later on 29 June – by which point Tintoretto's picture was in place. Vasari describes 'many contradictions' before Tintoretto got his way. We know the name of at least one of his dogged opponents. If the job was not given to Tintoretto, Zuan Maria Zignoni offered to pay fifteen ducats contribution, instead of the normal one or two. Clearly, he just loathed Tintoretto and his work. He was not alone.

Such manoeuvres by the painter were partly to do with aggressive competition and aimed at getting his work into prominent places. But there was probably more to it than that. Both the commissions at Madonna dell'Orto and the Scuola Grande di San Rocco resulted in out-and-out masterpieces. The cycle at San Rocco, which took two decades to complete, is one of the

JACOPO TINTORETTO *Self-portrait*, 1547–8

greatest one-person exhibitions by anyone in the world. It is hard not to feel that Tintoretto also deeply wanted, indeed needed, these assignments. He must have sensed what he could do given these vast areas to fill with paintings. One explanation for his behaviour and the unusual tactic that he adopted was that in his earlier life Tintoretto's immense talent had been blocked from full expression. The blockage had a name: Titian.

Tintoretto was probably born in the early autumn of 1518. Unlike Titian, Veronese, or Giorgione, he was a native of Venice, although there is some evidence that his forebears were immigrants from Brescia. His father, Battista Robusti, was a dyer, which explains the nickname by which the painter was known: 'Little Dyer'. The name might have been dismissive to begin with, perhaps a brush-off by other, older artists. But the way he used it himself suggests bravado. He liked this persona: not courtly, not elegant.

While Veronese and Palladio improved the social tone of their names, Tintoretto dialled his down. In a self-portrait painted around 1547–8, when

he was approaching thirty, he looks small but formidable: full of nervous energy, with a powerful gaze recalling Sorte's phrase 'the motions of his eyes'. Like Picasso, he has what the Spanish call a '*mirada fuerte*', or 'strong look'.

Ridolfi relates a story that Tintoretto was briefly a pupil of Titian's, living in the master's house and copying his works, but after a short time Titian threw him out because 'the worm of jealousy' entered his heart. Boschini tells the same story, but suggests the problem was that the younger artist was too '*spiritoso*' – perhaps he answered back too much. This tale has often been doubted, but there seems to be some truth behind it. It is clear from various incidents that Titian and his circle did not like Tintoretto, and perhaps vice versa. It is possible to see why. Veronese, on the other hand, was a more emollient personality, who did not arrive in Venice until the early 1550s, by when Titian was well into his sixties. Furthermore, he was respectful. Titian would have encountered Tintoretto earlier. And the little dyer's son was not so deferential. According to Ridolfi, he wrote a personal manifesto on the wall of one of his rooms: 'Michelangelo's draftsmanship and Titian's art of colouring'. You might paraphrase this as a mission statement. Tintoretto's aim was to combine Michelangelo's command of anatomy, foreshortening, and the structure of form together with Titian's brilliant handling of paint, his ability to evoke the physical textures of things – and human flesh.

From Titian's perspective, this was complimentary only up to a point. It acknowledged his great abilities, but it also highlighted his deficiencies. These were exactly the aspects that Michelangelo himself had zeroed in on – as Titian (and doubtless Tintoretto too) would have been well aware. In 1544, Titian travelled to Rome, where he was given a workshop in the Belvedere by Pope Paul III and stayed for more than eighteen months. During this time, according to Vasari, he and Michelangelo paid a studio visit and saw Titian's first version of the naked *Danaë* being painted. Afterwards, Michelangelo, speaking privately to Vasari, praised Titian's naturalism and handling of paint (*colore*), but added that, 'it was a pity that in Venice men did not learn to draw well from the beginning'. If he had, Michelangelo went on, Titian would have been a supremely gifted artist. Titian would probably have heard all about this, and so too would everyone

else (including the young Tintoretto). The truth was that some of Titian's skills were hit and miss. He sometimes fudged perspective and foreshortening (the fountain in *Sacred and Profane Love*, to give one example). His grasp of anatomy could be shaky.

Such things did not much matter to his admirers (or posterity), but Titian perhaps felt that these were weaknesses and knew that Florentines such as Vasari certainly felt they were. So he might have resented a brilliant youth who set himself to become that perfect painter that Titian (according to Michelangelo) had failed to be.

It is impossible to know if the teenage Tintoretto really did get thrown out of Titian's workshop. But there is evidence that Titian was a grudging teacher. Paris Bordone, another painter who trained for a time in his studio, complained he was 'not very ready to teach his young men'. For his part, Tintoretto had a sharp tongue. Ridolfi narrates a family anecdote in which Tintoretto, in reply to a long rambling letter from his brother, full of enquiries, curtly replied, 'Dearest Brother, the answer to all your questions is No.'

Even if there was no actual row between the two artists, Tintoretto's challenge to Titian is clear from his breakthrough picture *The Miracle of the Slave*. Tintoretto painted this for the Scuola Grande di San Marco in 1548, when he was twenty-nine. It is an astonishing tour de force of freeze-frame drama as Saint Mark swoops down head first from the top of the canvas, like a comic-strip superhero, to prevent the henchmen of a cruel Roman from torturing a slave who had converted to Christianity. The naked body of this heroic early Christian, surrounded by a litter of miraculously shattered implements of torment, is seen in equally extreme foreshortening but in the opposite way. His head is nearest to us, his legs furthest away. The two figures therefore make up an almost textbook demonstration of mastery of the human body in space. Around the central miracle, the crowd of onlookers sways and surges, some leaning in to get a better look, others rearing back. The chief executioner turns towards the presiding judge holding up a supernaturally broken mallet. In the process, he transforms himself into an elegant human corkscrew and ties the whole composition together.

The Miracle of the Slave is a proclamation of a picture, a declaration by the young Tintoretto of what he could do – and also a boast to other painters:

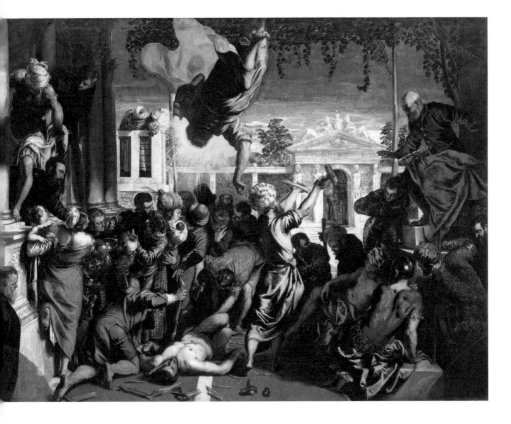

JACOPO TINTORETTO *The Miracle of the Slave*, 1548

anything you can do, I can do better. At that date in Venice, it might have been aimed at one individual in particular: Titian.

*

The show-stopping virtuosity of this canvas raises the question: what had this marvellous artist been doing during his twenties? The answer seems to be, first, a great deal of work that has largely disappeared. And second, that he was scuffling for a living. For a while, he took on any kind of painting work that paid, including executing numerous evanescent external frescoes that have more or less all vanished. Apparently, he also joined the artists 'of small success' who decorated furniture that was sold in Piazza San

Marco. One such job, a little more elevated, was producing some canvases for Pietro Aretino's sitting-room ceiling. The writer wrote him a letter that was published (one guesses this free publicity might have served as payment). Aretino praised the pictures – 'beautiful, lively, and effortless' – and also the promptness with which they had been delivered, 'in less time than normally might have been devoted to the mere consideration of the subject'.

By the time he wrote his next letter to Tintoretto, in April 1548, Aretino was having doubts. He was hugely impressed by *The Miracle of the Slave*, his occasion for writing. But he added a warning: 'Blessings be upon your name if you can temper haste [*prestezza*] to have done with patience in the doing.' This became a staple theme of Tintoretto's critics: he was extraordinarily brilliant, but he messed up by rushing – that impulsive *prestezza*. Vasari, in the second edition of his *Lives* in 1566, described him as 'the most extraordinary brain that the art of painting has ever produced': 'swift, resolute, fantastic, and extravagant'. But he often spoiled it all by 'working at haphazard and without design, as if to prove that art is but a jest', and leaving 'as finished works sketches still so rough that the brush-strokes may be seen'.

One thing Aretino and Vasari had in common, apart from being Tuscan, was that they listened carefully to Titian. And this line of argument drew a careful distinction between Titian's approach and Tintoretto's. The former's works might seem broadly brushed and rough, but in fact they were slowly executed and carefully pondered; whereas Tintoretto really did paint at a tremendous lick (as Sorte bore witness).

To his defenders, who were often younger and less socially smooth, it was his vehement impetuousness that made Tintoretto's work attractive. Doménikos Theotokópoulos, a young Cretan painter who was in Venice around 1567–8, just after the second edition of Vasari's lives appeared, wrote in his copy beside the denunciation of Tintoretto that the latter's *Crucifixion* at San Rocco was the best painting 'in the world' and that what Vasari wrote was 'spiteful and deceitful'. In other words, the Tuscan did not know what he was talking about (a common view in Venice). Although the young Cretan – 'El Greco' to posterity – was noted as a 'disciple of Titian' when he went on to Rome, in fact his work is a lot closer to Tintoretto's, which he clearly admired and had looked at hard.

Andrea Calmo (1510–71) was an actor, author, and one of the *poligrafi*, or writers on anything who thrived in a Venetian version of Grub Street until the censorious Counter-Reformation depressed the local publishing industry. In 1548, he published a letter to Tintoretto, who was obviously a friend, and had only admiration for the painter's velocity of execution: 'twiddling with your paintbrush and a small dash of white lead, and mixing some red earth [*ambuoro*] you create a figure portrayed from Nature in half an hour'. Calmo applauded this fiery little person. He compared Tintoretto to a 'single peppercorn' that could overpower the flavour of much greater quantities of a more soporific ingredient, 'ten bunches of poppies'. In Calmo's opinion, here was the new star of Venetian art. 'You should be glad that, young as you are, you have been endowed with great verve, a light beard, a profound intellect, a small body but great spirit, though young in years, old in judgment, and, in the short time that you were a student, you learned more than a hundred who are born masters.'

Like Whistler – another painter who, as we shall see, was criticized for working in an impetuous rush – Tintoretto could have answered that it was not the time that he took that mattered, but the skill and knowledge that he displayed. (Jackson Pollock, who owed a surprising amount to El Greco and Tintoretto, could have said the same.) His trademark swiftness of execution was based on long years of self-imposed study. Ridolfi describes a solitary, driven artist sequestered at night in his lamp-lit studio, where 'he spent the hours meant for repose with the models he used to devise the inventions that he needed in his work. Only rarely did he allow anyone, even a friend to enter.' Ridolfi relates how, as a student, Odoardo Fialetti (1573–1638?) asked the aged master how he ought to study to improve his skills. Tintoretto answered that he must draw. Fialetti wondered what else he should do, and Tintoretto said he must carry on drawing and then draw some more. Coincidentally, or not, this is exactly the advice Michelangelo jotted down for one of his own pupils: 'draw, draw, draw'.

This is what Tintoretto did himself, as is clear from surviving drawings. Ridolfi describes how as a young man he set himself to draw living models in various poses from different angles, in 'an endless variety of foreshortenings'. This study of real bodies was backed up by investigation of what was

MARIETTA ROBUSTI *Head of a Man*
(Emperor Vitellius), 1570s / 80s

inside them. According to Ridolfi, Tintoretto dissected corpses, a revolting procedure in times before refrigeration that was considered a necessary part of artistic training by Florentines such as Leonardo and Michelangelo, but which we do not hear of any earlier Venetian performing. In addition, he studied sculptures, ancient and contemporary, including classic carvings and works by Sansovino and Michelangelo. Although he apparently never visited Rome or Florence, he had some small models of Michelangelo's marbles from the Medici Chapel. These he drew again and again.

Tintoretto's assistants evidently went through the same training programme. Of that there is plenty of evidence in the form of drawings in his style, but apparently not by him – and one particularly poignant example, a copy of a marble bust of a jowly middle-aged man, possibly the obscure Emperor Vitellius. Its touching quality, however, does not come from the unexciting subject, but from an inscription, apparently added by Tintoretto himself: 'This head is by the hand of madonna Marietta'.

Marietta Robusti is one of the most tantalizing personalities in the history of Venetian art. In some respects, she is even more elusive than Giorgione. There are at least some wonderful paintings of his to look at; but in Marietta's case, there is just this sheet of paper with a few, quick decisive marks in chalk – that and the impression of a remarkable talent. The first account of her was published in 1584 by the Florentine poet Raffaello Borghini in *Il Riposo*, a dialogue about the arts. She was then about thirty years old, and – according to Borghini – beautiful, graceful, a skilful performer on various musical instruments including the harpsichord and lute. She was also an accomplished painter, having done 'many beautiful works'. However, Borghini admitted that he did not know much about these, although he mentioned a self-portrait and a portrait of Titian's sitter, the dealer and antiquarian Jacopo Strada (whom we have met before). Borghini also says that the great Habsburg rulers – the Emperor Maximilian II, Philip II, and Archduke Ferdinand II of Austria – had all wanted Marietta to join their courts. But her father, Jacopo Robusti (that is, Tintoretto), 'greatly loving her, did not want her taken from his sight'. Instead, she married a jeweller named Marco Augusta and remained in Venice, not failing 'continuously to paint'. The idea that she might have been recruited to a major European court was not fanciful. An older contemporary from Cremona, Sofonisba Anguissola (1532–1625) had spent some time in Madrid as painter and lady-in-waiting to the queen of Spain. Woman artists were fashionable in sixteenth-century Italy (the career of Lavinia Fontana is another example).

Apparently, Tintoretto loved Marietta dearly. According to Ridolfi, when she died around 1590, 'he mourned her with unceasing tears for a long time … taking it as a loss of his own inner being'. But perhaps he also insisted that she stay nearby for a practical reason. He needed her in the workshop. She was his oldest child, possibly born around 1553–4 and presumably illegitimate since he did not wed his wife, Faustina de Vescovi (who was not Marietta's mother), until several years later. Marietta (known as 'la Tintoretta', as if she were his smaller female alter ego) was probably therefore his senior assistant, at least among his children – and perhaps the most talented. Apart from the little drawing of the Emperor Vitellius, several paintings have been attributed to her – all in different styles, none

very plausible or doing her much credit. It is likely that when we look at many 'Tintoretto' paintings of the 1570s and 1580s, we are seeing her brilliant brushwork as well as his (and, eventually, the work of her younger brothers Domenico and Marco too).

*

Like Veronese's, Tintoretto's art sometimes seems almost cinematographic, but in a different way. Similar to certain film directors, Tintoretto excelled at using unexpected angles. His research techniques went far beyond simply copying statuary. Ridolfi relates that he – and presumably his students – hung modelled figures 'by threads to the roof beams to study the appearance they made when seen from below, and to get the foreshortenings of figures for ceilings, creating by such methods bizarre effects'. This allowed scrutiny of bodies from all manner of unusual vantage points: a low-flying Evangelist overhead, for example, in *The Miracle of the Slave*. When planning more complicated groups, Ridolfi tells us, Tintoretto began much as a modern set-designer might. First, he made small figures in wax or clay, 'which he dressed in scraps of cloth, attentively studying the folds of the cloth on the outlines of the limbs. He also placed some of the figures in little houses and in perspective scenes made of wood and cardboard, and by means of little lamps he contrived for the windows he introduced therein lights and shadows.' In such a way, he might have come up with a staging as utterly original as *The Adoration of the Shepherds* in the upper hall at the Scuola Grande di San Rocco. There are thousands upon thousands of nativities in Christian art; but it is hard to think of another one that is acted out on two storeys of a building.

In Tintoretto's picture, Mary, Jesus, and Joseph are occupying a hayloft up a ladder from the stable floor where the shepherds are kneeling and the cow is chewing. Apart from the Holy Family, the people in the painting are obviously ordinary sixteenth-century individuals, farm hands and servants, dressed in the clothes of the day. But it is not the costumes that give this Adoration its tender mood. That's a partly matter of lighting. The sky has turned orange and the barn is dark and shadowy, except for the supernatural illumination of the newborn Christ and the luminous angels above. This

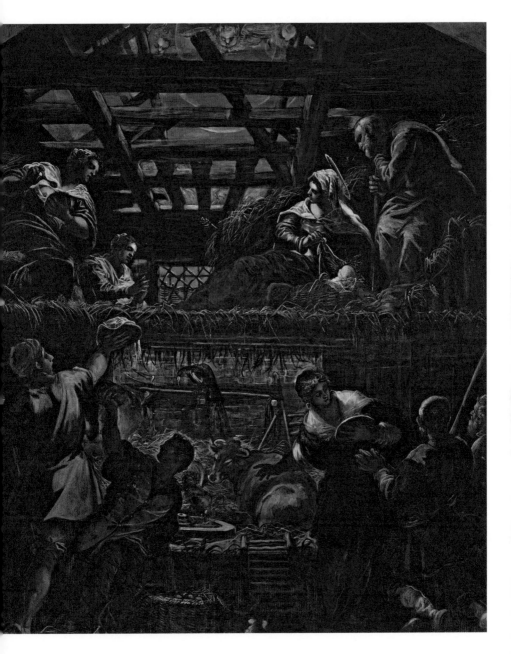

JACOPO TINTORETTO *The Adoration of the Shepherds*, 1578–81

JACOPO TINTORETTO *The Adoration of the Shepherds*, 1578–81 (detail)

JACOPO TINTORETTO *The Adoration of the Shepherds*, 1578–81 (detail)

catches just those points to which Tintoretto wants to direct our attention – the side of the older, kneeling shepherd's head, for example, the cow's straw bedding, and the eggs in the basket – while other sections, such as the young man in the jerkin seated in the lower left, are silhouetted against it.

Tintoretto has also used, in cinematic terms, an inventively unusual camera angle. This makes excellent sense when you stand in front of the painting. Because of the arrangement of the room, this canvas had to occupy an oblong position between two windows and is hence higher than it is wide. Tintoretto put these awkward dimensions to brilliant use – so that you, the spectator, are standing below, looking over the shoulders of the shepherds and the serving women, up towards the trio of sacred figures nestling amid the straw.

On the walls and ceilings of the three main rooms of the Scuola Grande di San Rocco there are some sixty of Tintoretto's paintings, done over more than two decades. As already noted, it all amounts to one of the greatest one-person exhibitions anywhere – up there with Michelangelo in the Sistine Chapel – and also, it is hard not to believe, a personal testament. Tintoretto hung on to the successive commissions for more and more

paintings at this institution with his normal tactics: making cut-price offers, driving deals. But, as Nichols argues, there is no reason to disbelieve his protestations of 'great love' for the *scuola* and 'devotion to the glorious San Rocco'. He was, no doubt, simultaneously a shrewd businessman, ambitious artist, and pious Christian.

His paintings at the Scuola Grande di San Rocco are, in Vasari's words, full of strange ideas and 'new and fanciful inventions'. They can be earthy and funny, like *The Adoration of the Shepherds*. Others are solemn, sombre, even terrifying. In *Moses and the Brazen Serpent*, Jehovah can be seen in the sky above, almost entirely in shadow to show his anger, like a cruising B-52 bomber, attended by dark clouds and a backup team of muscular angels. The serpents that he is unleashing on them represent death. Tintoretto painted this during the great plague of 1576, which killed Titian and much of the rest of the population.

Tintoretto's paintings can be seen as so many sermons. Like good preaching, they are fresh, original, sometimes humorous, and full of everyday touches. But they are all intended to bring sacred events vividly before the view. And here Tintoretto's other quirks, his speed and sketchiness, also added to the message. These were not decorations for a noble house, like Veronese's paintings, presenting heaven as a sumptuous Italian court. Here was an imaginative vision – overwhelmingly powerful and intense – produced with the most inexpensive of means: rough canvas and earth pigments.

On the far wall of the Sala dell'Albergo at San Rocco, covering the whole upper part, is the world-changing event that brought salvation itself, the Crucifixion (following pages). It is the size of a medium cinema screen (more than twelve metres, or forty feet, across). The figure of Christ on the cross presides over it, his head bowed and dark. But around him there is a complexity of figures, incidents, and episodes that you could spend hours (or a lifetime) gazing at. This picture is difficult to describe in words. Even John Ruskin, an endlessly eloquent expounder of Tintoretto, fell silent in front of it. But there is one adjective that helps: Shakespearean. Like *Hamlet* or *King Lear*, it contains an entire world.

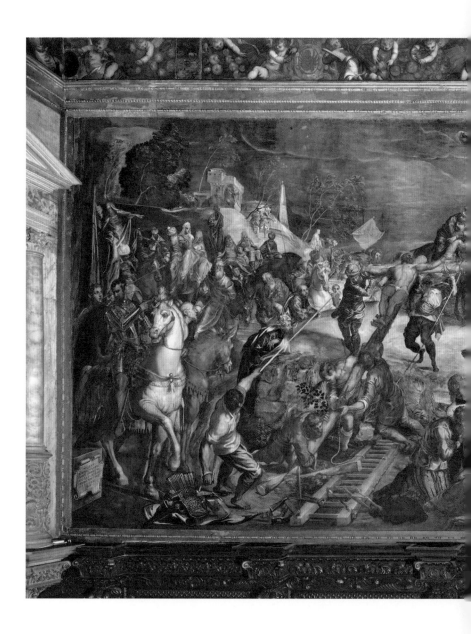

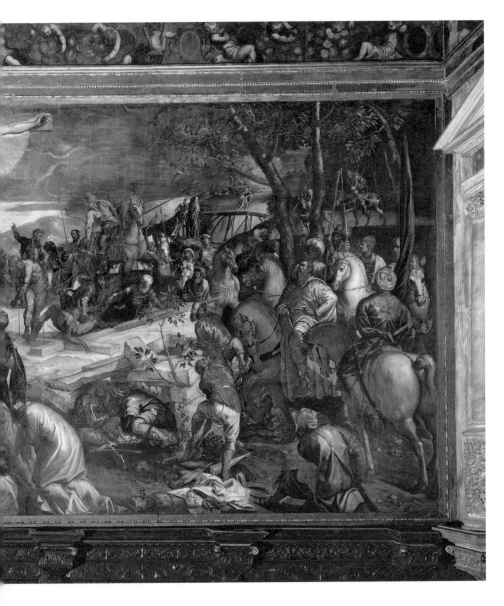

JACOPO TINTORETTO *Crucifixion,* 1565

TRAVELLERS, ARTISTS, AND COLLECTORS IN SEVENTEENTH-CENTURY VENICE

T he early seventeenth century saw the beginning of the long love affair between the English and Venice – a romance complicated, like most matters of the heart, by many misunderstandings. The courtier-poet Sir Philip Sidney was there from November 1573 until August 1574, during which time he sat for a portrait by Veronese and bought a number of books – including a copy of Jacopo Sannazaro's pastoral poem *Arcadia*, which presumably inspired his own work of the same name (and may have been handed on to Edmund Spenser).

Humbler English travellers also made their way there, including a cockney with an unusual name. Inigo Jones was born in 1573 and baptized at Saint Bartholomew the Less in Smithfield. His father was a cloth-worker, but young Inigo started working life as an apprentice joiner; then, somehow, he travelled to Italy, where he bought a copy of Palladio's *Four Books of Architecture*. On its flyleaf, he wrote 'Venice 1601' and the price: two ducats. Precisely how he got there is a mystery. In a text written after the architect's death, his pupil John Webb has Jones explain, rather grandly: 'Being naturally inclined in my younger years to study the Arts of Design, I passed into foreign parts to converse with the great masters thereof in Italy.' Webb added that Jones, 'many years resided [there] ... especially at Venice'. Both statements are probably true but omit all detail.

In 1603, Roger Manners, the fifth earl of Rutland, paid £10 to 'Henygo Jones, a picture maker'. It seems likely that Jones had been talent-spotted, perhaps after he had graduated from joinery to creating stage sets (by 1605, he was accomplished enough to design a masque for the royal court). Someone (perhaps Rutland, who had studied at the University of Padua) thought it was a good idea to send him to study in Italy. Jones may have travelled with Rutland's younger brother, Francis Manners, who went on a late Elizabethan grand tour to France, Switzerland, and Italy between 1599 and 1601. After several years of working for Queen Anne of Denmark and her son Henry, Prince of Wales, mainly as a theatrical designer, Jones set off once more for Italy in 1613. This time, he travelled in the entourage of Thomas Howard, second earl of Arundel.

If the first journey was his introduction to the arts of Italy, the second was a postgraduate course. Using his copy of Palladio's *Four Books* as a guide, and frequently travelling separately from the earl and his party, Jones immersed himself in Roman ruins and contemporary buildings. The annotations in his copy of Palladio and a sketchbook, now at Chatsworth, add up to an architectural diary-cum-intellectual autobiography.

These notes make clear how closely he followed his Italian teachers – not only Palladio, but also Serlio and the still-living Scamozzi. However, Jones was far from being a passive follower or imitator. He was a participant in the conversation, tracking Palladio from villa to palazzo, measuring and analysing, and also interrogating Scamozzi in person, as he noted on the margin of a page: 'Friday the first of August 1614 I spoake with Scamozo in this matter and he hath resolved me in this in the manner of voltes' (Scamozzi, who died in 1616, was then sixty-five). In this instance, he accepted Scamozzi's explanation, but often Jones was dismissive of his opinions, as he noted in his copy of *Four Books*: 'This secret Scamozzi being purblind understood not'; 'in this as in most things Scamozzi errs'; 'Most writers of architecture do leave over those parts which they understand not, as Scamozzi.'

Jones would have been aware of the division among Venetians between those who preferred a scholarly classical manner of design, notably the Barbaro brothers, and Leonardo Donà, who was doge from 1606 to 1612

INIGO JONES *Queen's House, Greenwich, London,* 1616–35

and proponent of a much plainer style. In the late sixteenth and early seven-
teenth centuries, while Jones was passing through Venice, the city saw some
striking alterations to its architectural landscape, including the completion
of the sober New Prisons and the so-called Bridge of Sighs connecting
them to the Doge's Palace. As we have seen, Doge Donà opened up the
view of the facade of San Giorgio Maggiore in 1609. He also built a new
dwelling for his own family, the Palazzo Donà dalle Rose – a huge bare,
barracks-like structure on the Fondamenta Nuove. It is unlikely that Jones
was impressed by the design (apparently Donà so disdained architectural
elegance that he did not even employ an architect). But Jones must have
been aware that Donà and his party were anti-papal (the English imagined
wrongly that they were quasi-Protestant), and that their opposition to Rome
went along with a taste for sober plainness.

This accords with Jones's own conclusion, jotted down in his sketchbook on Friday, 20 January 1614: 'In architecture ye outward ornamentes oft to be Sollid, proporsionable according to the rulles, masculine and unaffected.' That series of adjectives defines what we know as Georgian architecture, as well as several of Jones's own masterpieces – including the Queen's House at Greenwich and Saint Paul's, Covent Garden. Eighteenth-century British architecture is not exactly 'Palladian' (as it is usually described); but it was, in part at least, the consequence of Jones's meditation on what he saw in Italy.

Englishmen were by no means the only northerners learning in seventeenth-century Veneto. A couple of Danes with the names Rosencrantz and Guildenstern were the contemporaries of Roger Manners at the University of Padua in the mid-1590s. In July 1600, Peter Paul Rubens, a twenty-three-year-old painter from Antwerp arrived in Venice. It was a short stay, because – according to his biographer Giovanni Pietro Bellori – a gentleman from Mantua was lodging in the inn where Rubens was staying. This person was a servant of Vincenzo Gonzaga, duke of Mantua. Rubens showed some of his work to this Mantuan, who in turn showed it to the duke, who in turn promptly employed him as a court painter. So this first visit to Venice was not lengthy, but even so, he seems to have had time enough to take a thorough look at several of the most important works in town.

As always, Rubens vacuumed up potentially useful ideas. Titian's *Assunta* had a visible effect on his own paintings of the subject. He borrowed the motif of the Good Thief being raised from Tintoretto's *Crucifixion* in the Scuola Grande di San Rocco for his own *Elevation of the Cross*. He must also have made the short journey – just a few canals – from that *scuola* to the church of San Sebastiano. Decades later, when he was composing the ceiling of the Banqueting House in London's Whitehall, Rubens remembered Veronese's ceiling in the church. The basic design of his *Union of the Crowns of Scotland and England by James I* is borrowed from Veronese's *Esther before Ahasuerus* there. Indeed, the entire conception of the ceiling was adapted by Rubens and Jones from the characteristic Venetian arrangement with an elaborately carved wooden framework and paintings on canvas. For that matter, the Banqueting House altogether – both Jones's building, begun in 1619, and Rubens's paintings for the ceiling, finally installed in 1636 – is

an amalgam of ideas from Venice and the Veneto. The whole ensemble, the centrepiece of the early Stuart court, is a masterpiece of cultural importation and adaptation: a set of northern-European variations on a Venetian theme.

This type of interchange usually worked better than the political kind. Sir Henry Wotton (1568–1639) was three times English ambassador to Venice, but he was more skilled at the art of 'intruding the fine arts into diplomacy', as Timothy Wilks and Edward Chaney put it, than diplomacy itself. He was liable to misunderstand Venetian hostility to the pope, as when he sent a portrait of Fra Paolo Sarpi to London with the hope that it would give 'some pleasure to his Ma[jes]tie to beholde a sound Protestant, as yet in the habit of a Friar'. But Sarpi, though a brave proponent of the Venetian cause during the Papal Interdict of 1606–7 and target of a papal assassination attempt, was not a 'sound Protestant', more a liberal-minded patriot.

If Wotton missed some of the local ideological nuances, he was quick to grasp the essence of Venetian painting. He commissioned a portrait of Doge Donà, which he sent to Robert Cecil with the comment that it was 'done truly and naturally but roughly alla Venetiana'. In other words, he had grasped the nature of Venetian *colore* – that is paint-handling, brush marks, which might be loose and free. According to Carlo Ridolfi, Wotton commissioned portraits of himself by Domenico Tintoretto and Leandro Bassano, as though he wanted to compare and contrast the styles of two leading workshops. But Wotton had missed the founders of those still-flourishing businesses: Jacopo Bassano (*c.* 1510–92) had died more than a decade before he arrived in town; Jacopo Tintoretto, not long after, in 1594.

There were notable painters in early seventeenth-century Venice – Domenico Tintoretto was far from negligible. But there was also a sense that – temporarily at least – the glory days had passed. The most interesting artists to work in the city – Bernardo Strozzi from Genoa, the German Johann Lys, the Roman Domenico Fetti – were immigrants from outside. Several great painters spent only brief periods in the city but were profoundly affected by Venetian art. Rubens was one; his greatest pupil was another.

In 1622, Anthony van Dyck was travelling around Italy. At the back of a sketchbook, he listed '*le cose di Tiziano*' (works by Titian) wherever and whenever he saw them. Often, he jotted down a quick aide-memoire of the

The interior of the Banqueting House, Whitehall, London,
with ceiling paintings by Peter Paul Rubens, 1636

composition, noting the fall of light, and made a note of a particular feature. Thus, when at the Villa Borghese in Rome, he drew both *Sacred and Profane Love* and *Venus Blindfolding Cupid*. On the second, he drew an arrow pointing to the torso of the goddess Diana and the words '*quel admirabil petto*' (what a wonderful breast). Although he had been in Italy only since the previous winter, he was thinking and writing in Italian, even to himself.

In the late summer, Van Dyck travelled north from Rome via Florence and Bologna to Venice. There, he made a thorough artistic – and especially Titian-themed – survey of the city, going out into the lagoon to see the Titians in the church of Santo Spirito in Isola, up the Brenta to the Villa Malcontenta and Lady Arundel's summer lodgings. He also made quick notations of local life. On the reverse of a sheet on which he made a note of Titian's *Annunciation* at the Scuola Grande di San Rocco, he drew a selection of people seen in the street. At the top left, a woman so heavily veiled that only her striking eyes can be seen is labelled '*Cortisana di Venetia*'; beside her, a hooded figure in profile is '*donna ordinaria*'; lower down, another hooded woman is '*citella*', plus an old woman, a water carrier, and a gondolier.

In addition to obvious sights such as the Frari and the Doge's Palace, Van Dyck investigated the private collections of the Venetian merchant Bartolomeo della Nave and his fellow Flemings Daniel Nijs and Lucas van Uffel. He must have had help in arranging the entrée to these places, perhaps even a guide – it is possible that Van Uffel was his mentor. They were connected by Van Dyck's friend, Cornelis de Wael, a fellow artist and art dealer with whom Van Dyck had stayed in Genoa.

Van Uffel – who traded in arms and owned ships – was a member of the international network of merchants, connoisseurs, and collectors. He came from Amsterdam, but had been living in Venice for more than half a decade when Van Dyck met him. It seems that they bonded. Van Dyck drew – and then later engraved – a painting that Van Uffel owned that was thought (wrongly) to be a Titian. He dedicated it, 'as a sign of affection and loving inclination', to his distinguished friend. It is quite probable that while he was in Venice, the young painter stayed with Van Uffel, who would have been ideally placed to introduce his protégé to other collectors after spending much of his fortune on a large collection of Italian and northern paintings.

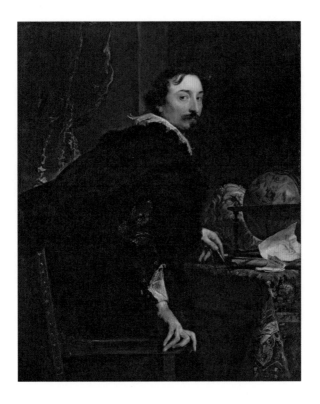

ANTHONY VAN DYCK *Portrait of Lucas van Uffel, c.* 1622

While in Venice, Van Dyck made two pictures of his friend. One shows him in his study. The table in front of him is covered with a splendid Turkish carpet scattered with objects suggesting his cultivation and connoisseurship: a drawing and a classical marble head, a celestial globe, a recorder, and the bow of a viola da gamba, implying that he was a versatile musician. Eventually, after Van Uffel returned to Amsterdam and died there in 1637, his collections were auctioned. Rembrandt was one of those who took note of the masterpieces on view at the sale.

This was part of a much larger process: the flow of pictures out of Venice and into the greatest collections of Europe. A younger generation of British enthusiasts – educated by Wotton, Arundel, Jones, and others – were at the forefront. King James I's favourite George Villiers, first duke of Buckingham,

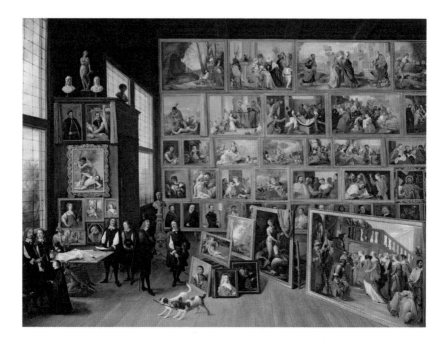

DAVID TENIERS THE YOUNGER *Archduke Leopold Wilhelm in his Gallery, c.* 1650

had a superb array of paintings, which Rubens admired when he lodged among them at York House in 1629. 'When it comes to fine pictures by the hands of first-class masters,' he wrote from London, 'I have never seen such a large number in one place as in the royal palace and in the gallery of the late Duke of Buckingham.' Charles I built a collection that was every bit as magnificent, as did the first duke of Hamilton (1606–37). This Scottish courtier had the good fortune to get hold of the paintings amassed by della Nave, on whom Van Dyck had paid a call; after della Nave's death in 1636, Hamilton's brother-in-law, Basil Feilding, second earl of Denbigh, arranged for him to purchase this cornucopia of masterpieces.

However, his luck did not last long. After the defeat of the royalists in the Civil War, Hamilton was executed, like his master the king, and their collections were sold off. Much of Hamilton's went straight into the hands of Archduke Leopold Wilhelm (1614–62), the younger brother of the Habsburg Emperor Ferdinand III. Some two hundred paintings were

dispatched to him in Brussels in 1649. Many can be seen in pictures made for him by David Teniers the Younger, the first in a new genre: the portrait of a collection. In these – conceptual catalogues rather than depictions of how the paintings were actually displayed – it is possible to spot paintings that we have met before as they were being produced in Venice: Giorgione's *Self-portrait as David*, Titian's *Portrait of Jacopo Strada*.

Now they were en route to their final destinations. Most of Leopold Wilhelm's holdings ended up as the core of the Habsburg collections in Vienna (today in the Kunsthistorisches Museum). Many of Charles I and Buckingham's pictures made their way to Madrid, where Leopold's cousin King Philip IV was every bit as avid an aficionado of painting (they are in the Prado Museum). Remarkably, however, in the mid-seventeenth century, great artists were working and learning inside these wonderful galleries.

*

As the art historian David Freedberg has observed, by the last decade of his life, Titian was the painter whom Rubens loved above all. At the time of his death in 1640, he possessed eight paintings and two sketches by Titian himself, and an extensive study collection containing no fewer than thirty-three copies of the master's works. Justus Sustermans (1597–1681), the Flemish painter who lived and worked in Italy, declared that Rubens 'loved Titian as a lady her lover'. Sustermans told Marco Boschini that he saw Rubens often, and 'when we came to talk of Titian, he assured me ... with an accent of profound conviction, that Titian had made painting delightful, and that he was the greatest master that had ever existed'. Boschini is far from being an unimpeachable source. Art historically, he was an ardent patriot, bent on proclaiming the superiority of Venetian artists, pictures, paint-handling, and brushwork. He divided painters into two basic categories: 'foreigners' and 'Venetians'. And among the latter, Boschini believed that Titian was the greatest, the '*Dio dela Pitura*' (God of painting) to whom all other artists could only aspire to be servants.

Even so, what Boschini claims Sustermans told him rings true. Rubens obviously *did* love Titian. But the painterly romance between these two masters did not reach its height until 1628, almost three decades after

Rubens's visit to Venice. In the autumn of that year, he went to Madrid on a vital diplomatic mission, an attempt to negotiate a peace treaty between England, Spain, and the United Provinces of the Netherlands. Art was a crucial aid to him in these delicate negotiations. Rubens wrote to his friend Nicolas-Claude Fabri de Peiresc that Philip IV took an 'extreme delight in painting'. Rubens had rooms in the royal palace, and the king visited him 'almost every day'. Obviously, these were ideal circumstances in which to explore political possibilities.

Rubens stayed in Spain for six months. In the long run, his negotiations led to nothing. But his journey had important artistic consequences – and not only on his own work. In the royal palaces of Madrid and the nearby monastery of El Escorial, he was surrounded by great painting – especially Venetian works. An inventory made in 1686 of the collection in the Alcázar Palace in Seville totalled seventy-seven paintings by Titian, forty-three Tintorettos, and twenty-nine Veroneses (plus sixty-two by Rubens himself). At El Escorial, there were nineteen more Titians. Not all of these had been acquired in 1628; nonetheless, it was more or less as if Rubens were living inside the modern-day Prado Museum.

He took full advantage, studying Titian intensively. And Rubens's way of understanding his great predecessor was a visual, painterly one: he copied Titian's pictures. Francisco Pacheco recorded that Rubens made a copy of every Titian in the royal collection. That was probably an exaggeration, but he certainly made his own versions of many, including *The Rape of Europa*, *Venus and Cupid with a Mirror*, *Diana and Callisto*, and *Adam and Eve*.

These are not precise imitations, but as Larry Keith put it, the process was 'more of a personal dialogue': Rubens conversing with Titian, noting where they agreed and disagreed, what he could learn from the other. His technical procedures, as Keith notes, are often quite unlike the Venetian's. Sometimes, the Rubens version was distinctly, deliberately dissimilar from the original. And there are cases where you might think the Rubens was an improvement. Audaciously, for example, he added a bright-red parrot in the upper left of *Adam and Eve*. Obviously, he felt the picture needed an extra note of colour (he was right). He did not alter Eve greatly, except to make her flesh seem softer in the manner of his own female nudes,

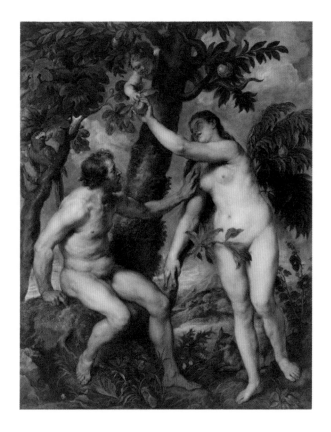

PETER PAUL RUBENS (AFTER TITIAN) *Adam and Eve*, 1628–9

but Adam is quite different: simultaneously more muscular and chubbier, leaning forwards rather than rearing back, more cautiously interested in his companion – in a word, more Flemish.

Possibly, he is a surrogate for Rubens himself, who in 1628 was fifty-one years old and recently widowed, but had by no means given up on the idea of marriage. At the end of 1630, he wed again, to a teenage bride, Helena Fourment. From that point on, his love of her and his love of Titian coincided as he depicted her in the guise of the latter's nude *Girl in a Fur*.

In his exploration of the Spanish royal collection, Rubens had a companion who was extraordinarily suitable for the role: a painter of abilities at least equal to Rubens's own but more than twenty years younger, eager,

and willing to learn. At this point, Diego Rodríguez de Silva y Velázquez (1599–1660) had been painter to King Philip IV for five years but had not yet, it seems, completely assimilated the potential lessons of his employer's pictures. He and Rubens looked at them together. Velázquez's biographer, painter Antonio Palomino, described how:

> They went together to the Escorial to see the celebrated Monastery of San Lorenzo el Real and both took especial delight in admiring the many and admirable works of genius in that sublime structure, in particular the original paintings of the greatest artists … in Europe.

Clearly, given Rubens's preoccupations, Titian's works would have been the main topic of discussion between them. Palomino describes Rubens's copies after Titian as being 'done *con magistero y libertad*, which makes them better than the originals' – perhaps an opinion passed down from Velázquez himself. As we have just seen, it is an arguable point of view. What is undeniable is that these copies would have provided a marvellous point of entry: a way of thinking about these masterpieces – and how a living painter could learn their lessons without being overwhelmed.

*

Boschini's writing, and particularly his marathon poem *La carta del navegar pitoresco* (The map of painterly navigation), was a bold – not to say quixotic – attempt to write about a subject for which no vocabulary existed (and still does not really exist now). Namely, paint-handling, brushstrokes, the way pigment is physically applied, and the sensuous effects those marks can have. This, as far as Boschini was concerned, was the essence of the matter: what really counted in the art of painting, the skill in which divided all true exponents of the art from 'foreigners'.

To suggest the expressive nuances of paint, Boschini used metaphorical extravagance in the manner of the Neapolitan poet Giambattista Marino (1569–1625). The 5,370 hendecasyllabic quatrains of the verse describe a series of expeditions by gondola in which a connoisseur, named 'Ecelenza', and a painter-cum-dealer, called 'Compare', explored the painterly universe

of Venice: a town positively crammed with pictures, so that pigment on canvas is one of its principal resources, in the way that coal or iron ore might be elsewhere (as is hinted by the title of Boschini's guide to the town, *Le ricche minere della pittura Veneziana* [The rich mines of Venetian painting]).

He was fond of aquatic comparisons – natural enough as an inhabitant of a town surrounded by water and living largely on food from the sea. Thus Tintoretto's painterly brilliance is compared to the netting of delicious and valuable marine life: 'Oh Tintoretto, fisher of turbot, tuna, pike, sole and sturgeon, fish that the merchant keeps hidden'. In contrast, the inability of Vasari – 'that bright talent' as Boschini ironically calls him – to esteem Tintoretto and Schiavone above Battista Franco is likened to a person at the market who buys 'a mullet from the canals' instead of 'two from the lagoon'. Any Venetian, clearly, would know that that was daft.

In order to discuss what painters do with paint, Boschini deployed a battery of words in novel ways, among them, *spegazzoni* or 'big blots', which he switches in meaning from negative, insisting that 'the Venetian style is founded on blots'. The same transformation applies to *strisciare*, 'to streak', which an obtuse dolt such as Vasari might consider a bad thing to do, but which might be quite literally strokes of genius, as when Titian 'applied a dark stroke with a streak of the fingers to reinforce some corners, and even some streaks of red, almost drops of blood'. Then there are metaphors of acrobatics and dancing, such as his use of *tresco*, meaning a country dance with leaping, clapping, and a sexual charge – but which Boschini uses to mean 'a dance of the brush' of the kind that Tintoretto sometimes seemed to indulge in as the paint marks darted and sprang across his canvas.

The other side to Boschini was that he was a bit of a dealer, an activity that he was inclined to deplore in others. In seventeenth-century Venice, he complained that there were an 'infinite number' of traders in art 'running here and there, never getting tired', like hunting dogs. And they did very well, better than artists. In Boschini's view, painting was (at least potentially) more valuable than gold: '*più vale la pittura che l'oro*'. He noted the way that works done for little or nothing had become immensely valuable, for example the two huge Tintoretto paintings in the chancel of Madonna dell'Orto: 'Tintoretto painted them for 50 ducats each. Now, if one had to

sell them, and I know who you would be, I estimate that to the two numerals that make up the number 50, you would add another three zeros, and not lettering of a pen, but in lettering of gold.'

His choice of the sum that these masterpieces might reach – fifty thousand ducats – was probably not accidental. A smaller but still astonishing price of five thousand ducats was discussed during negotiations in 1664 between the Venetian ambassador in Rome and the agents of Queen Christina of Sweden over the purchase of Veronese's *Family of Darius before Alexander*. The Venetians – and presumably the Pisani family who owned it – valued the painting at more than that amount.

According to Palomino, the conversations he had with Rubens, 'provided a new stimulus to Velázquez and revived the desire he had always had to go to Italy to inspect and study those splendid paintings and sculptures which are the torch that lights the way for art and are worthy objects of admiration'. Accordingly, he sailed from Barcelona on 10 August 1629, arriving first in Venice, where he stayed with the Spanish ambassador before continuing his journey to Rome. It seems, not surprisingly, that one of his priorities was to go to the Scuola Grande di San Rocco, not just for a brief visit, but to linger and learn. Apparently, he made drawings of the *Crucifixion* and also a copy of the *Last Supper*, which he gave as a gift to the king. (A work in the Real Academia de Bellas Artes de San Fernando in Madrid has been identified as this long-lost copy, but the attribution is controversial.)

His brilliantly loose and free handling of paint was not the only aspect of Tintoretto's art the Spaniard could learn from. The picture he chose to copy is one in which Tintoretto displayed his capacity to compose in deep space (and also what Hollywood directors such as Orson Welles knew as 'deep focus'). In this painting, Christ and the disciples, instead of being lined up in front of the spectator, are seated around a table that cuts diagonally back into a large, shadowy apartment, which opens into further chambers behind. Certain crucial figures – Christ himself, some but not all the apostles, the servants at rear – are picked out as if spotlit. In a general way – and even in certain specific details, such as the figure stepping out of a distant door, silhouetted against the light behind – Tintoretto's painting has a good deal in common with *Las Meninas*.

Of course, Velázquez's masterpiece is not a mere imitation of Tintoretto. But in this little painting, you can *see* the Spaniard thinking about his predecessor, and how his example could help him do certain things. Similarly, the *Crucifixion* at the Scuola Grande di San Rocco was a demonstration of how to orchestrate a panoramic, crowded composition – much as Velázquez did magnificently a few years later in *The Surrender of Breda* (1634–5).

It is not hard to guess why he made a beeline for San Rocco. There were superb examples of Venetian painting in Madrid – Velázquez did not need to sail to Venice to see magnificent Titians; he was surrounded by them. And he learnt a great deal from them, especially how brushwork and the interplay between different layers of paint could evoke the look and feel of things. But this type of grand narrative picture by Tintoretto had not been exported (one arrived in Spain two decades after Velázquez's first visit to Italy). And, of course, if you are interested in painting, a chance to visit the Scuola Grande di San Rocco is still one of the best reasons to go to Venice.

Larry Keith has pointed out that 'the phenomenon of artists travelling and taking a keen interest in painters' whom they had never met and who were not even alive was a relatively new development in the seventeenth century, and it 'changed the whole nature of the artistic influence'. It is true that Titian had absorbed lessons at a distance from Michelangelo and Raphael. But Van Dyck, Rubens, and Velázquez were deeply affected by artists who were not contemporaries, and with whom all they had in common was that they faced similar problems.

Boschini seems to have met Velázquez – either on his first visit to Venice, or more likely when the painter returned to Venice in 1649 and 1651 with a mission to buy paintings for the Spanish royal collection. The description that Boschini gave of him – 'a courtly gentleman of such great dignity as distinguishes any person of authority' – sounds like a first-person impression. He also handed on a fragment of conversation that Velázquez was supposed to have had with the Italian painter Salvator Rosa. When it came to painting, the Spaniard apparently said, it was in Venice one found '*el bon, ell belo*' – the good and the beautiful – and among painters it was Titian who carried the standard of victory ('*porta la bandiera*'). He might really have said and believed those last words.

'HELD BY THE EYES AND EARES': OPERA AND PICTURES

Almost forty years after Il Redentore was completed in 1592, a fresh vow was made and another great church begun. The plague of 1629–31 was every bit as severe as that of 1575–7. In those three years, 43,088 deaths were recorded, and the actual total may well have been even higher. On this occasion, the authorities turned for succour not to the Redeemer, but to his mother. In 1630, the patriarch ordered the Sacrament to be displayed for twelve days beginning on 28 April in six Venetian churches dedicated to the Virgin. Effectively, the authorities were imploring her to save the city. Six months later, the Senate voted to commission a new church. It was to be called Santa Maria della Salute – Our Lady of Good Health. The Salute, as it is usually called, is at a nodal point of the city. Whether you are coming down the Grand Canal, looking back from San Marco or the Riva degli Schiavoni in the direction of the canal, or approaching the city across the lagoon from the Lido, the church, shaped as it is like a spindle, seems to turn *towards* you.

On this occasion, the site was chosen quickly and without acrimonious disagreements. There were eight possible locations, but all the others were too hemmed in by other buildings, insufficiently conspicuous, or too tucked away in the urban fabric. But a position near the Dogana del Mare, the customs post, on the narrow northerly prong of Dorsoduro had none of these disadvantages. In addition, it offered a unique opportunity. A building

at this point could be seen from the Doge's Palace, San Giorgio Maggiore, and Il Redentore. Thus it was the final piece in a complex design that had been emerging haphazardly for centuries. It would knit the whole multi-dimensional stage set together. But it took an architect of genius to grasp this.

After the decision to build the church near the Dogana was taken, a competition was launched to find the best design. The initial eleven submissions were whittled down to two. An architect nicknamed Fracao, whose real name was Antonio Smeraldi, initially proposed a structure much like Palladio's Il Redentore, but larger. Baldassare Longhena had a completely different idea. As he explained to the Senate in April 1631, 'I have created a church in the form of a rotunda, a work of new invention, not before built in Venice, a work very worthy and desired by many.' So the dream of Marc'Antonio Barbaro, and many other enthusiasts of Vitruvian classicism, finally became reality. The idea had come to him, Longhena went on, for reasons of religious symbolism. This church, 'being dedicated to the Blessed Virgin, made me think, with what little talent God has bestowed on me, of building the church in the form of a rotunda, being in the shape of a crown'.

This proposal immediately went down well, so much so that Fracao was forced to produce a circular plan of his own. Longhena was dismissive of this, emphasizing that his own conception was 'a virgin work, never before seen, curious, worthy, and beautiful, made in the form of a round monument that has never been seen, nor ever before invented, neither altogether, nor in part, in other churches in this most serene city'. His competitor, he added, had copied the idea 'for his own advantage, being poor in invention'. After further discussion, Longhena triumphed. There were numerous modifications to his scheme, however, and the church was not completed until fifty years later in 1687, five years after the architect died. Essentially, though, it remained as the thirty-four-year-old Longhena had conceived it.

The crucial point about it, in addition to the way it placed the Virgin's crown in the visual heart of the city, was, like Il Redentore, that it was the focal point of a solemn ceremony. With an eye to the symbolism of the day, it was announced that Venice was free from plague on 21 November 1631: the feast of the Presentation of the Virgin. Thereafter, an annual procession took place on that day. The doge, Signoria, and Senate walked from San

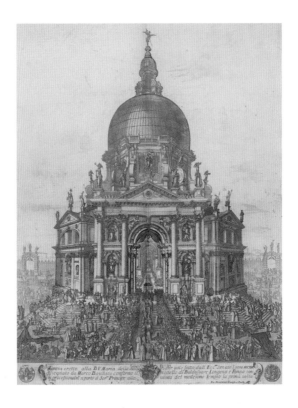

MARCO BOSCHINI *The Feast of the Presentation of
the Virgin, Santa Maria della Salute,* 1644

Marco, where they attended a high mass, through the streets and over a
pontoon bridge to the site of the Salute. At first, a temporary church, built
of wood to a different design, was erected to receive the dignitaries. But after
the new church had been constructed, the procession passed up the steps,
into the building towards the high altar. As Boschini's 1644 engraving of
the event, the first visual record of the new building, makes clear, this was
a performance with two sets: an external one, surrounded by crowds cele-
brating the feast day, and an internal one, which in time would be focused
on the altar designed by Longhena and made by the Flemish sculptor Giusto
le Court, and completed around 1670. This mass of agitated drapery and
clouds carved from solid stone, is a frozen moment from a drama. On the
left (as we see it), Venice is represented, as always, in the form of a stately

young woman; in the centre, the Virgin graciously acknowledges her plea; and the plague, in the form of a defeated hag, is hustled off to the right by a forceful putto. To walk from the sacristy, where wonderful paintings by Titian and Tintoretto are kept, into the sanctuary – the area behind the altar – is like stepping back stage. It is a reminder that while the Salute was being built, Venice was becoming the city above all others of opera.

*

BALDASSARE LONGHENA AND GIUSTO LE COURT
High altar, Santa Maria della Salute, c. 1670

To avoid the Civil War engulfing his country in 1644, a twenty-five-year-old English landowner named John Evelyn went travelling. He found himself in Venice during Ascension Week, the Festa della Sensa, which was accompanied by a two-week fair, during which plays were performed and also a novelty – what we now call the opera. This was not a Venetian invention. The idea originated with a group of Florentine enthusiasts who revived the ancient Greek practice of singing, rather than speaking, dramatic roles with musical accompaniment. The innovation caught on in Italian courts. Then in Venice, it metamorphosed, becoming a hugely popular entertainment for a wide public. The first such drama with music had been performed in a Venetian theatre, to enormous acclaim, just eight years before. In his diary entry for 1 June, Evelyn explained just what opera was. In his words:

> Comedies (& other plays) represented in Recitative Music by the
> most excellent Musitians vocal & Instrumental, together with variety
> of seeanes painted & contrived with no lesse art of Perspective,
> and Machines, for flying in the aire, & other wonderfull motions.
> So taken together it is doubtlesse one of the most magnificent &
> expensfull diversions the Wit of Men can invent.

Obviously, (like the Venetian public) he had had a marvellous night out. Evelyn and his Scottish companion, Lord Bruce, the earl of Elgin, were instant converts to this new art form. There were three reasons the experience so delighted them: the excellent music, both 'vocal and instrumental'; the numerous scenes 'painted and contrived with no less art'; and, lastly, the sheer, almost miraculous spectacle, 'machines for flying through the air and other wonderful motions'. The combination of spectacles and sounds was enthralling, Evelyn wrote. It 'held us by the Eyes and Eares til two in the Morning'. This makes clear that the opera was a mixed visual, aural, and dramatic treat (if he had been more caught up in the story, Evelyn might have added the heart to his list).

The opera that Evelyn described most fully was *Ercole in Lidia*, or *Hercules in Lydia*, which he saw at the Teatro Novissimo, a short-lived but immensely influential institution that had opened in 1641 (*Ercole in Lidia* was to be the final production). What he and Lord Bruce would have been sitting

A twenty-first-century reconstruction of the Teatro San Cassiano, Venice

in was a box, one of 153 distributed over five tiers in a typical Venetian theatre of the time (cheaper tickets were available for the stalls below). A modern visualization of the Teatro San Cassiano, which was the very first public theatre in the world to present an opera, in 1637, gives a good idea of what they would have experienced (with the qualification that the Teatro Novissimo was bigger and the special effects, more spectacular).

The arrangement consisted, then, of several hundred people gazing at a moving, three-dimensional picture framed by the proscenium arch: the stage. The very first commercial opera to be performed – *Andromeda*, at the Teatro San Cassiano, during the carnival season of 1637 – was accompanied by a publication of the complete libretto and a description of the production, especially the startling special effects that it included. Some of these were almost literally, as we say these days, 'immersive', such as the transformation of the stage to represent the ocean where poor Andromeda is chained to her rock: 'The curtain having disappeared, the stage was seen to be entirely sea, with such an artful horizon of waters and rocks that its naturalness (although feigned) inspired doubt in the audience as to whether they were really in a theatre or on an actual seashore.'

Evelyn's contemporary Inigo Jones was exaggerating when he claimed that the Stuart court masques that he designed were nothing 'but pictures with light and motion' (he was locked in a dispute with a man of words, Ben Jonson). But he had a point. We assume that the most important creative force in an opera is the composer. However, it did not necessarily seem like that at the time. It was often the writers of the libretto, poets such as Giulio Strozzi, who rushed out printed versions of the words. The composers were slower to publish their scores, which is why we have many libretti for seventeenth-century Venetian operas but lack the music that goes with them.

When *Bellerofonte* was presented at the Teatro Novissimo during the carnival of 1642, it was accompanied by no fewer than three publications. The libretto and the storyline – together, the scenario – were both in print before the actual performance. In the preface, a new figure emerged, namely the set designer Giacomo Torelli (1608–78). He apologized for the fact that his

GIACOMO TORELLI *Stage set for* Bellerofonte *at the Teatro Novissimo,* 1644

spectacular effects were not even more eye-popping than they were, blaming the narrow site of the theatre, which would not allow even an 'extraordinary architect' to work to perfection. It was clear that he thought himself such a person, although he claimed, not to 'allow myself to be flattered by the speed with which others have adopted, perhaps in order to use them, things first invented, established, and, I might even say, bestowed by me' (perhaps he meant that they were his gift to the city and the world).

The ingenuity of Torelli's stage machines became so renowned that he was rumoured to be in league with the devil and dubbed *Il grande stregone* (the great sorcerer). And he had no false modesty about the importance of his works. After the opera had been staged, he arranged for another, commemorative volume to be issued, containing a narrative of the plot, the libretto, and, crucially, ten engravings of the set designs. He followed this two years later with a deluxe volume devoted to his own achievements, containing twelve illustrations of his works. The preface made a bold claim for the importance of what he was doing. 'Venice, always and on every occasion extraordinary ... has discovered the remarkable also in virtuoso entertainment, having introduced a few years ago the presentation in music of grand drama with such sets and stage machines that they surpass all belief.' In other words, Torelli had added a fresh glory to the splendours of La Serenissima. Clearly, he was a master of publicity as well as stage design.

But his sets, effects, and devices undoubtedly must have been astounding. The transformation that accompanied the prologue to *Bellerofonte* dramatized the appearance of Venice itself from beneath the waves of the sea. At the end of the scene, in the distance, the audience saw 'a most exquisite and lifelike model of Venice' appear. In the self-advertising words of Torelli's book, everyone acclaimed this 'as a tour de force'. Probably the audience did love this magical appearance of a familiar sight on stage. The pleasure lay partly in the illusion, 'the eye was deceived by the Piazza with its public buildings imitated to the life, and it delighted increasingly in the deception, almost forgetting where it actually was'. Next, singers playing the roles of Innocence and Astrea, goddess of justice and a symbol of Venice, joined Neptune in singing a hymn to the great city. As Ellen Rosand notes, it must have been like a painting on the ceiling of the Doge's Palace come to life.

What Torelli and his rival set designers were doing *was* closely related to what painters did. But, of course, only up to a point, because the problems they faced were different. Above all, Torelli was an engineer. His own great innovation was mechanical. There has been controversy about exactly what this was, but it seems likely that he improved the existing system of scene changing. In this, there were slots in the stage floor, so the flats could be pulled on and off by stagehands. Torelli's breakthrough seems to have been to make these scene changes quick, coordinated, and almost labour-free by adding a counterweight to a single capstan, to which all the scenery was attached, so it could all be set in motion by 'one boy of fifteen'. In the words of an anonymous account of *La finta pazza* (The woman feigning madness) of 1641, the first great hit at the Teatro Novissimo, and Torelli's first design to be seen in Venice, the artifice of this change was miraculous, as it 'caused a revolving drum below stage to turn which moved all the scene wings backwards and forwards. There were sixteen of these wings, eight on a side. By this means, all the wings were shifted in a single quick movement, thus creating great amazement on the part of the spectators.'

No seventeenth-century Venetian theatre survives, but the Castle Theatre in the Czech town Český Krumlov is almost intact, with stage machinery, sets, and devices such as the thunder-making contraption (a box with stones that can be rocked up and down, creating a convincing rumble). The theatre dates from the mid-eighteenth century, but these systems are descended from the tradition of Torelli and his contemporaries. When I stood beneath the stage at Český Krumlov, I found myself searching for an association. There was something familiar about the mighty wooden winches, intricate timber structures, and swathes of rope that surrounded me. Then I got it. This was like wandering beneath the decks of Nelson's HMS *Victory*. Indeed, there was a close connection. Both are specimens of pre-industrial technology, the one to fight maritime battles, the other to create illusions.

Torelli did not stay long in Venice. Cardinal Jules Mazarin decided to import this marvellous new entertainment into France, and so in June 1645, Torelli arrived in Paris, where he recreated his first Venetian triumph, *La finta pazza* (the cost of which alarmed the queen of France). He stayed for more than thirty years, only returning to Italy at the end of his life in 1677.

The headhunting of Torelli was the start of a trend. For the next century, the court theatres of Europe were staffed by Italian architects and designers, often ones who had previously worked in Venice. Giovanni Burnacini (1609–55) was the visual mind behind productions at Venetian theatres such as Teatro San Cassiano, the Teatro Santi Giovanni e Paolo, and the Teatro Santissimi Apostoli. In 1651, he was summoned to Vienna to design court festivities, auditoria, and theatrical productions. When he died, his young son Lodovico Ottavio (1636–1707) took over to preside at the imperial court for another half century. And as time went on, such regal performances became ever more bombastic and costly. But the passion and dramatic intensity of masterpieces such as Claudio Monteverdi's *L'incoronazione di Poppea* was replaced by propagandistic razzamatazz such as *Il pomo d'oro*, performed in a vast open-air theatre in Vienna in 1668. The prologue of this featured a recession of twelve equestrian statues, with grand accompanying classical architecture, beyond which was the figure of the Emperor Leopold I, a particularly unglamorous, lantern-jawed Habsburg, and then behind him more classical columns, gods in the sky, on and on.

Back in Venice, there was a touch of megalomania in the zeitgeist. You feel it if you wander into the church of San Pantalon and look up. There, above your head is *The Martyrdom and Glorification of Saint Pantalon* (known to non-Venetians as Saint Pantaleon) by Giovanni Antonio Fumiani (1645–1710). A notice claims that this is the largest oil painting in the world. An alternative view holds only that it is the second biggest. But it is certainly colossal, measuring more than forty-one square metres and made up of forty-four separate canvases. It took the artist twenty-four years to complete, from 1680 to 1704. When looking at the dizzying perspectival recession zooming away into a fictional sky above (overleaf), one can easily believe that this picture required a lot of labour. Fumiani's vast painting is similar to an exceptionally extravagant set for a Baroque opera, but all directed upwards: great arches, capitals, pediments, architraves, fluttering angels and holy beings, all rising vertiginously aloft. It must be said, this is an extraordinarily confusing way of representing the martyrdom of this saint from third-century Anatolia, though one gets the point that there is a great deal of commotion in the heavens.

Of course, the spectacular scenic effects were only part of the appeal of opera. 'The Seanes chang'd 13 times', John Evelyn noted wonderingly in 1645. But he was also much impressed by 'the famous voices', of whom the most celebrated was Anna Renzi (*c*. 1620–after 1661), 'a Roman, & reputed the best treble of Women'. Renzi had first appeared in Venice at the Teatro Novissimo in the work that more than any other, even *Andromeda*, had set the mould for the future of this new form: *La finta pazza*, during the carnival season of 1641. At that date, she was not much more than twenty years old, and evidently brilliant, 'a most gentle Siren, who sweetly enraptures the listeners'. She remained the prima donna of Venetian opera until 1657: one of the first stars in operatic history. Many other sopranos followed her – plus hugely feted castrati, female contraltos, and eventually tenors, baritones, and basses too.

By 1678, no fewer than nine theatres were operating in Venice. It was a city in which not only visitors but also the inhabitants were theatre and opera obsessed. Soon a familiar individual emerged: the opera fan or buff. One of these was Count Antonio Maria Zanetti (1689–1767), who is known as 'the Elder' to avoid confusion with his cousin, who was also a notable figure in the Venetian art world (and is known as Antonio Maria Zanetti the Younger). We shall be encountering both in the following pages.

It is tempting to describe Zanetti the Elder as an amateur, except that he was conspicuously successful as an art dealer and had trained as an artist. Among other items, he dealt in and collected prints, medals, and pictures. He owned a three-volume complete edition of Rembrandt's etchings, and published a lavish catalogue of his collection of engraved gems. Furthermore, he was an opera enthusiast who was engaged and amused by the leading vocalists of the age. This is clear from several volumes of caricatures that still survive, including drawings by Zanetti and the artist Marco Ricci (he was on friendly terms with many painters). Not all the people gently lampooned in these humorous drawings are performers. There are also many artists, including Zanetti himself, Sebastiano Ricci, and Zanetti's protégé Rosalba Carriera.

GIOVANNI ANTONIO FUMIANI *The Martyrdom and Glorification of Saint Pantalon*, 1680–1704

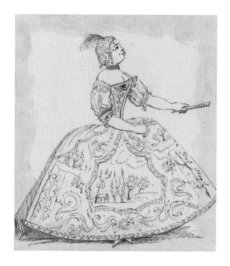

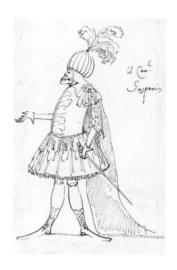

ANTONIO MARIA ZANETTI

Vittoria Tesi, 1720s

ANTONIO MARIA ZANETTI

Antonio Gaspari, 1720s

One who features in a number of drawings was Vittoria Tesi, who is considered the first prominent singer of colour in the history of Western music. A contralto, she was of mixed heritage, born in 1701 to the African servant of a famous castrato and a Florentine woman. Zanetti's treatment of Cavaliere Antonio Gaspari, a celebrated castrato who collaborated with Vivaldi and Handel in the 1720s, is harsher with enormous, splayed feet and cadaverous features. But it, too, is carefully observed: the product of many nights sitting in a box, perhaps in the Teatro San Moisè, where Gaspari made starring appearances in 1719 and 1724. Of course, the humour of Zanetti's sketches does not suggest that he was not a fan. On the contrary, that is just what the drawings demonstrate. The absurdity of opera is part of its pleasure. What is too silly to be said may be sung, but also, as Kenneth Clark pointed out, what is too profound, too emotional, too tender. Those who adore opera must accept that there is often a mismatch between a magnificent voice and the stage presence of a performer, which – from the drawing – one guesses must have been the case with Gaspari.

The worlds of opera and the visual arts were close, not just because set designers were often also painters or architects. People interested in one

were likely to be devoteés of the other. Zanetti's contemporary and fellow art dealer the Englishman Joseph Smith (*c.* 1682–1770) had a box at the Teatro San Giovanni Grisostomo in Venice and married the opera singer Catherine Tofts. He also ended up owning one of Zanetti and Ricci's albums.

The singer Faustina Bordoni (1697–1781) had a triumphantly successful career. A mezzo-soprano, she came to fame at the age of nineteen as a result of her performance in Carlo Francesco Pollarolo's opera *Ariodante* at the Teatro San Giovanni Grisostomo. A few years later, she began to perform in other Italian cities, followed by Vienna, London, where she performed in a series of works by Handel, and, after she married a German composer, Dresden. She was an early example of an international celebrity, a fame further stoked by her rivalry with the soprano Francesca Cuzzoni from Parma. On 6 June 1727, a riot broke out at the King's Theatre, Haymarket in

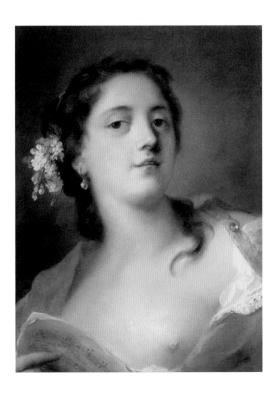

ROSALBA CARRIERA *Faustina Bordoni, c.* 1724–5

London between her loyal fans and Cuzzoni's. Like some later stars ('Elvis', for example), she was known simply by her first name, 'Faustina' – except at the start of her fame, when she was sometimes dubbed 'the new siren'.

It was in that guise that Carriera depicted her in the first of several images. The picture from c. 1724–5 was more of a pin-up than a formal portrait, in which she holds a musical score but also reveals a nipple. It was intended, it seems likely, not for the singer herself but for one of her many admirers (and a great deal more glamorized than the drawings of her by Zanetti and Ricci). Rosalba was an artist perfectly suited to Faustina. In many ways, their careers were parallel. Both were internationally renowned, and each travelled widely. Carriera spent more than a year in Paris, during which she made a portrait of the ten-year-old Louis XV, moved widely in society, and was elected a member of the Académie Royale de Peinture et de Sculpture, an extraordinary honour for a foreigner and a woman. Even more of an accolade was that the painter Jean-Antoine Watteau asked her to make a portrait of him. During a long and industrious life, she also visited Vienna and, though she never travelled to Saxony, Frederick-Augustus II, its ruler, displayed more than a hundred of her pastels in his palace at Dresden.

At the turn of the seventeenth century, Venetian power was nearing its end. The victory in mainland Greece in the Sixth Ottoman–Venetian War (1684–99) was the Republic's final military success, which was reversed in any case twenty years later. After that, there was nothing but decline to second- or even third-rate status in the European league of powers. Culturally, on the other hand, the city was continuing to flourish, as the successes of Bordoni and Carriera both illustrate. A smallish state that could produce the artists, writers, and composers that Venice did – Vivaldi, Albinoni, Goldoni, the Tiepolos, father and son, Canaletto, and the Guardi brothers, just among the greatest of names – was anything but creatively decadent.

A transition was taking place, however, from an imperial city state to what was effectively a resort: a European centre of pleasure and entertainment. This was a role that was to continue, in one mode or another, until today. But, although the mood of much Venetian art fitted with this new function – light-hearted, theatrical, and emphasizing the beauty of the place itself – there was another aspect: darker, more serious, and emotionally intense.

CHAPTER FOURTEEN

'AT EASE WITH CHALK IN HAND': CARRIERA, LAMA, AND PIAZZETTA

W hile in Venice on 14 July 1733, Martin Folkes, a middle-aged British scholar, noted in his journal that he had been to see one of the city's most celebrated artists – one who, moreover, was a woman, which made her all the more of a curiosity. Rosalba Carriera lived in her own palazzo, which – though not the largest – was nonetheless on the Grand Canal (an impressive address for a female artist subsisting entirely on her art). The building is still there, next door to the Palazzo Venier dei Leoni, which today houses the Peggy Guggenheim Collection.

When Folkes met her, he estimated that she was 'now better than 50'; in fact she was sixty, having been born in 1673. By that stage, she had been famous throughout much of Europe for a long time. Her fame was derived especially from her work in pastels, or, as Folkes put it, her 'pictures in crayons', which were 'with Justice esteemed the most excellent pieces of art of that sort'. Rosalba's works, often painted on card or ivory, were intended to be private objects. Seventeenth-century portraits were generally meant to display the sitter's power and rank. Rosalba, in contrast, had begun by specializing in portrait miniatures that were small enough to be carried like a piece of jewelry. Lovers carried them in their pockets; they were put on the lids of snuff boxes; some were sufficiently minute to be encased in rings.

When Rosalba moved on to produce pictures in pastel and watercolour, she retained that sense of intimate familiarity – and thus she caught the

spirit of her age. Reacting against the heavy formality of the Baroque, a new generation wanted to relax, to live and love more lightly. To have one's portrait drawn by Signora Rosalba became the thing to do for visitors from France, the German-speaking lands, and – particularly – England. In 1721, she complained to the Parisian painter Nicolas Vleughels that she had been *'attaqué par des Angles'* – by which she perhaps meant 'besieged'.

When Lady Mary Wortley Montagu visited in Venice in 1739, she found her fellow countrymen and women the 'greatest blockheads in nature': 'The greater part of them keep an inviolable fidelity to the language their nurses taught them. Their whole business (as far as I can perceive) being to buy new clothes, in which they shine in some coffee-house where they are sure of only meeting one another.' There was, however, one other desire that these travellers had which Lady Mary did not mention: to be depicted in Rosalba's subtly flattering style, wearing those newly purchased Venetian clothes. Folkes found himself in her studio, 'extreamly well entertaind with a great number of fine portraits some of my acquaintance very like'.

One of them may have been Gustavus Hamilton (1710–46), the second Viscount Boyne – although, given Folkes's scholarly interests, probably not. Hamilton had been in Venice three years before, from January to March 1730. He was then just twenty but had already succeeded to his title. He was accompanied by Edward Walpole, younger son of the prime minister, who entered Parliament soon after their return to England. Hamilton, on the other hand, had enjoyed his Venetian holiday so much that he returned the following winter for another carnival season, after which he continued his tour of Europe by sailing from Venice to Lisbon together with a party of British grandees, including his friend the libertine and antiquary Sir Francis Dashwood (which tells you all you need to know about Hamilton's tastes).

There are three surviving portraits of Hamilton by Carriera. Two show him wearing a splendid blue coat with a fur collar, waistcoat, and three-cornered hat. His lace veil, part of the carnival disguise, has been pulled apart and a waxed white mask turned to one side, as if he had just revealed his softly handsome youthful face. The third portrait shows him in the heavy dark cloak that was also part of the male carnival costume. It is an image of a young upper-class rake on the razzle in a glamorous foreign spot.

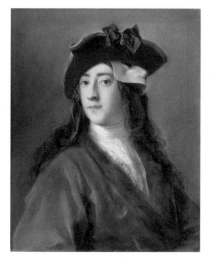 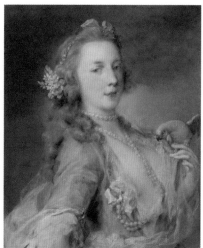

ROSALBA CARRIERA *Gustavus Hamilton,*
2nd Viscount Boyne, in Masque Costume, 1730–1

ROSALBA CARRIERA *A Young Lady*
with a Parrot, c. 1730

During his studio visit, Folkes also saw 'a fine idea [by which he meant an allegory] representing musick'. This was not a portrait, but a picture for which a real individual had modelled. 'The face was taken', Folkes heard, 'from a person now kept by an English Nobleman, but the whole attitude was as fine and well disposed as almost anyth[in]g I have seen.' Possibly by 'fine and well disposed' the great numismatist meant elegantly titillating. Some of Rosalba's works certainly come into that category, such as her *Young Lady with a Parrot*, in which the exotic bird plucks the lace from the young woman's blouse, revealing, as Bernardina Sani wrote, 'her pure white breast', an effect enhanced by 'the vaporous and diaphanous beauty of the pastel medium'. The face of the *Young Lady with a Parrot* looks as if it were drawn from a real sitter, like the 'musick' that Folkes saw.

Rosalba had to tread a careful path. Her artistic stock-in-trade was the private and personal; her imagery was sometimes sensuous. But she herself had to be above reproach. Her male clients sometimes wrote in fevered, slightly embarrassing terms of the excitement that they felt when looking at a pastel nymph or shepherdess they had ordered from her.

By extension, Rosalba herself became the object of lovelorn reverie. Some fell in love with her in earnest. This explains the complex interchange between her and a British diplomat named Christian Cole (1673–1733). He was secretary to the earl of Pembroke and the earl of Manchester, and ended up in Venice when Manchester became British ambassador to the Venetian Republic. There is no question that Cole was a good friend to Rosalba. He taught her English and presented her with a pioneering work of feminism, Judith Drake's *An Essay in Defence of the Female Sex* (1696). Reportedly, he suggested that she should work in pastel; he made strenuous – and eventually successful – efforts to have her admitted as a member of the Accademia di San Luca in Rome. The reason he did all this was that he was in love with her, as is revealed by a letter sent 1 September 1707. Cole wished, he wrote:

> to see Venice again principally to see you again, all seems dead to me during your absence. … You could not begin to comprehend how interesting I find anything which concerns you, and I see that you do not want to believe me when I explained the friendship not to mention other things which I feel for you.

This emotional situation explains the one-sided nature of their correspondence. In a series of letters in the middle of 1705, he encouraged her to provide specimens of her work, 'some small thing […] to be viewed in the gallery of this Academy'. But despite the fact that admittance to the academy was a great accolade, and Cole was working selflessly on her behalf, it was not until three months had passed, and he had written once more, that she sent a rather offhand reply. She had been delayed by this and that and worried that when it finally made its appearance, her work would 'seem ridiculous like the birthing of a mountain'. Still she did not produce it. Cole wrote again in August. At that point, she showed signs of feeling guilt:

> Your Illustrious Lordship should not judge me without compassion, it was my care to serve the English nation that I greatly esteem, that has continuously requested portraits and then a little fever, which from time to time has disturbed me throughout this summer. These are not [real] excuses, but they should excuse my tardiness.

When her diploma piece, a miniature of a girl with a dove and representing innocence, finally arrived in September, it was received ecstatically in Rome. Carlo Maratta, director of the Accademia di San Luca, held it in his hands for an hour and declared that not even the great Guido Reni could have done better. It was shown to the pope. On 27 September 1705, Rosalba was formally accepted into the academy with 'jubilation and applause'.

She tactfully turned down an amorous declaration, and possibly proposal, from another (anonymous) admirer, explaining that her work, 'which greatly involves me as well as a rather cool nature, has always kept me away from love and thoughts of marriage'. With Cole, however sincere his feelings, it is not clear that marriage would have been on offer. Would an English gentleman really have wed a Venetian woman artist, however illustrious? And without marriage, her status would have been similar to that of the 'person now kept by an English Nobleman' mentioned by Folkes.

Of course, we have no real knowledge of her feelings for Cole or any of her more or less serious suitors. Perhaps she really had a 'cool nature', as she declared. Perhaps she was not attracted by men at all. But in any case, her position was delicate. In the late sixteenth century, the Venetian poet and courtesan Veronica Franco (1546–91) acquired some literary status, but lived outside the framework of respectable society. Rosalba achieved independence, fame, and some wealth by leading an ostensibly celibate life. Perhaps this was the price of freedom and success.

Her household was an entirely female one. Folkes noted that all three Carriera sisters were present when he visited. Apart from Rosalba herself, there was Giovanna, who was unmarried, and Angela, who was wife to 'Sigr Pelegrini and was with him in england, for which she expresses a great regard'. Her husband, Giovanni Antonio Pellegrini (1675–1741), was one of the most successful and peripatetic Venetian painters of his generation, working in the Netherlands, Vienna, Prague, and, for a lengthy period, from 1708 to 1713, in England. For Rosalba, however, a married life, even to a congenial husband such as Pellegrini, would have meant that she was 'wife to' someone or other, rather than the unattainable creator of works that produced amorous fantasies of male art lovers far and wide. Marianna Carlevarijs (1703–50), daughter of the painter Luca Carlevarijs, was also a

GIAMBATTISTA PIAZZETTA *Giulia Lama, c.* 1715–20

friend and assistant of Rosalba's, though she was not in the studio on the day of Folkes's visit. She worked in pastels in an idiom so close to Carriera's that their portraits have been confused.

Another important woman painter in Venice at this time took a more difficult route. Rather than adopt a distinctively female idiom, such as pastel allegories and portraits, Giulia Lama competed on the same terrain as her male contemporaries. Among her surviving works are big, dramatic altarpieces, heavy with drama and emotion. But the triumph of women artists in Venice was far in the future. It did not come until 2022, when they dominated the Biennale.

Even during her lifetime, Lama was far from well known. In 1728, when she was approaching fifty, her talent was noticed by the Abbé Antonio Conti, a cosmopolitan enthusiast for science and letters (and great friend of Lady Mary Wortley Montagu). He wrote to the comtesse de Caylus, a French noblewoman and writer, describing this new artist whom he had

discovered, whose work he thought 'better than Rosalba [Carriera], so far as large compositions are concerned'. A native Venetian, Conti had retired to live in the city again a couple of years before this date, suggesting that hers was scarcely a familiar name even amongst connoisseurs. Evidently, he had paid a visit to her studio near the church of Santa Maria Formosa, and seen the pictures that she was working on. Conti was taken by a large painting of the Rape of Europa (also lost), in which Europa's companions dance around the nymph, who is being carried away by Jupiter disguised as a bull. 'The group of these figures is filled with poetry', he wrote, and immediately connected this with the fact that Lama was herself a poet. 'This woman has more strings to her bow. [She] excels in painting as in poetry, and I find in her poems the turn of phrase of Petrarch.'

Furthermore, Conti added, 'in her youth, she studied mathematics'. Indeed, she seems to have been a bit of a polymath; Lama made lace, possibly to supplement her earnings as an artist, but was also interested in a lace-making machine invented by her contemporary, Clelia Grillo Borromeo (1684–1777), a noblewoman from Milan who was also a renowned scientist and mathematician. This suggests that Lama was part of an erudite northern Italian network despite living, as Conti reported, 'a very secluded life'.

Conti obviously enjoyed the company of clever women, as one might guess from his friendship with Montagu and Madame de Caylus. He was taken by Lama's intelligence, although he expressed his admiration in a distinctly ungallant way. 'It is true that she is as ugly as she is witty, but she speaks with grace and precision, so that one easily forgives her face.' To judge from the portrait by her friend Giambattista Piazzetta, Lama's features were not pretty in the rococo shepherdess manner then in vogue. The face that he portrayed is strong, handsome, heavy-lidded, and charged with an emotion that is hard to define. He represented her as an allegory of painting (in itself, perhaps an accolade). Looking at the picture, as Alice Binion noted, arouses curiosity about their relationship, 'and even lends some credence to an old tradition that it was intimate and intense'.

Lama's and Piazzetta's lives ran in parallel for many years. She was born on 1 October 1681; he was a few months younger, born 13 February 1682. Both came from families of artists. Her father was a painter; his was a

woodcarver. Apparently, they trained together in the workshop of Antonio Molinari. Their styles were similar, each heavy, both with feeling and a sense of physical weight. Piazzetta's portrait of Lama, the only known painting by him from life, was done between 1715 and 1720, and there is evidence that they were close around that time. Lama seems to feature in one or two other works of the period, including a Madonna and a semi-clad *Susanna Surprised by the Elders*. Such cooperation suggests, at least, easy friendship. At the time, Piazzetta was a bachelor. Lama never married, continuing to live in the family house on Calle Lunga. Perhaps she worked with her father until his death in 1714, and afterwards took his workshop over.

Conti noted that, 'Painters persecute this poor woman' – but he did not explain the reason for this bad treatment. It is easy to imagine in the competitive world of early eighteenth-century Venetian painting that a female artist might well have encountered hostility from male rivals. For a while, Conti added, she prevailed through her virtue. Again, he did not spell this out, but one can guess what he meant: Lama won through by a combination of ability and determination. In 1722, she was commissioned to paint an altarpiece, of the Madonna and Saints, for her local church, Santa Maria Formosa. A few years later, she painted a Crucifixion for San Vidal, which was her most prominent achievement. This and many of her other surviving pictures, such as the poignant and grisly *Martyrdom of Saint Eurosia*, have an impassioned quality a world away from the rococo pastorals of Rosalba, Pellegrini, and many of her contemporaries.

This was the mood of her one surviving poem, *Lament on the Death of Antonio Sforza*. The latter was a priest, man of letters, and connoisseur of art who lived in the same parish and died in 1735, while still in his thirties. In the poem, she described him: 'Handsome, young, and gentle of aspect/ Soft and kind of word was Sforza;/These graces shone in a frail body'. He must have been a fellow spirit, and perhaps a close friend. 'His intellect more adroit than any other's/To understand lofty matters,/And explain the most abstruse ideas'. But naturally Death pays no attention to such qualities, 'you are blind and deaf, I cannot obtain no compassion from you'.

Luisa Bergalli, a Venetian writer, mentioned Lama (though not by name) in 1726 as, 'most erudite in philosophy, a well renowned painter, so much

so that the main churches try to have her works, and in particular some altarpieces, she acquired great honours in her manner of painting'. But her renown must have been limited or short-lived. In a guidebook published in 1733, Antonio Maria Zanetti the Younger attributed some paintings of hers to the 'school of Piazzetta'. This was only a few years after they were finished, and well within her lifetime. (By chance, these were rediscovered in the spring of 2022, hidden under layers of grime in the almost permanently locked church of San Marziale by restorers at work on a Tintoretto.)

GIULIA LAMA *Martyrdom of Saint Eurosia*, 1728

There were indeed close links between Lama and Piazzetta, although their relationship was not as simple as that of master and pupil; it was more a question of temperamental affinities. One connection was that both were of a serious, literary turn of mind. Piazzetta was so notoriously slow in producing his paintings that the Swedish collector Count Carl Gustaf Tessin called him a 'snail'. But Binion points out that this sluggish rate of production was not – or not only – the result of 'neurotic indecision or compulsive reworking'. She writes: 'Piazzetta was a learned man and composed his images accordingly. As a careful study of his work reveals, Piazzetta familiarised himself thoroughly with whatever story he was to narrate in paint, especially with the literary sources available to him.'

Thus, even when depicting an episode that had been represented innumerable times before, such as David with the Head of Goliath, he went back to the biblical accounts and chose a moment in the story seldom if ever represented in art. Most pictures showed the young hero contemplating the head of the slain giant or holding it up to the viewer. Piazzetta, instead, chose the moment when David grabbed the severed head by the hair to wrap it in a blanket and transport it back to Jerusalem. This earnest, literary approach would have appealed to Lama, the poet / painter who admired the adroit intellect of Antonio Sforza.

Another resemblance is in the stress that they both laid on drawing, especially from the living model. There are some two hundred drawings by Lama in the Museo Correr, all of them life studies of both male and female models. She has been claimed to be the very first woman artist in history to work from the body of a naked man. The question naturally arises of where she could have done these studies. One answer might be in the private drawing academy – a 'scuola di nudo' – that Piazzetta directed. This was open not only to his apprentices, but to all artists. It is documented as at San Zulian, not far from Santa Maria Formosa, in 1722.

Piazzetta, Binion observed, 'felt more at ease with chalk in hand than with a brush'. This was perhaps because of his beginnings, which were not as a painter but as a sculptor, which was his woodcutter father's ambition for him. The publisher Giambattista Albrizzi, who knew him well, wrote that as a child he was given clay to model, then later a chisel for carving.

GIULIA LAMA *Male Nude, c.* 1730

GIAMBATTISTA PIAZZETTA
Young Man and Woman, 1743

From 1705 to 1713 or so, he shared a workshop with his brother-in-law, who
was a sculptor. Drawing is a technique shared by both arts: it deals with
form and volume. And Piazzetta seems first to have become famous as a
draughtsman. As early as 1717, his drawings were sought after by collectors.
For decades, he was the recognized master of drawing in the city. In 1736,
Count Tessin described him as 'a great draughtsman and a noted painter'.
When Francesco Lorenzi, a twenty-two-year-old artist from Verona, came
to Venice in 1745 to further his studies, he attached himself to Tiepolo's
workshop – but went to Piazzetta for life classes. Drawing was Piazzetta's
bread and butter. His 'character heads' were particularly prized (Zanetti
the Younger declared no one drew such works better). He claimed to have
earned seven thousand *zecchini*, or gold ducats, from these over the years,
suggesting that he had drawn more than three thousand. It is possible this
was true – Albrizzi remembered that, 'it was his custom to draw every day
a number of heads from life in chalk or charcoal'. These have a powerful
sense of solidity and texture that come only from close observation of people.
Looking at the study of a young man with his arm around a young woman's
shoulder, and hers on his, you sense what the cloth of his hat would feel
like, the differing qualities of their skins, hers a little softer. The drawing
has a strong, though not quite definable, emotional atmosphere. There is
touching trust between them – perhaps love.

Piazzetta's work is weightier, and more freighted with deep feeling, than the work of most of his Venetian contemporaries (Lama was an exception). Probably, as is often the case with strongly individual artists, these qualities were the result of his character. He was, it seems, thoughtful, laborious studious, solitary, and – one guesses – a little depressive. It was as 'the grand master of light and shadow' that Zanetti the Elder praised him. The connoisseur and polymath Count Francesco Algarotti (1712–64) agreed, noting that his pictures were 'loaded with a chiaroscuro to give things greater prominence, and make them palpable'. Algarotti added a crucial point: what Piazzetta depicted was not idealized but 'entirely founded on the natural and the true'. His art was not un-Venetian; like Lama's, it was part of another current of taste and sensibility, more heartfelt and tragic, that coexisted with the frivolity of the carnival and the spectacle of the opera.

One evening, on my way to an exhibition opening at the Venice Biennale, I stopped for a moment in a quiet campo off the main drag. An elderly priest was standing on the steps of the church of Santa Maria della Fava in the weak sunshine. On impulse, I stepped inside and he followed. For a while, I looked at Piazzetta's altarpiece *The Madonna with Saint Philip Neri*. Then, as if silently to indicate that I should have a look at this too, the priest switched on the light to illuminate Tiepolo's *Education of the Virgin* on the opposite side of the nave. It was indeed worth contemplating, and so was the other. Together, they made up an object lesson in comparison and contrast, both for the viewer and probably the artists too, each trying to outdo the other.

To my mind, Piazzetta won this contest – if that is what it was – not because of the heavenly part of his picture with its slightly dumpy Madonna and regulation cherubim. It was the devotion of Saint Philip Neri, his hands pressed together in prayer, and the deep shadows under his chin and in the hollow of his temple that hold the attention. Somehow the nape of the neck of the bowed angel on the left is full of feeling. It is the human and earthly that give the painting its strength. The same happens in the other churches where Piazzetta and his rival, a decade and a half his junior, both painted pictures: Santa Maria del Rosario and San Stae. It is only when Tiepolo soars onto the ceiling above, into the heavenly sphere, that Piazzetta cannot follow him.

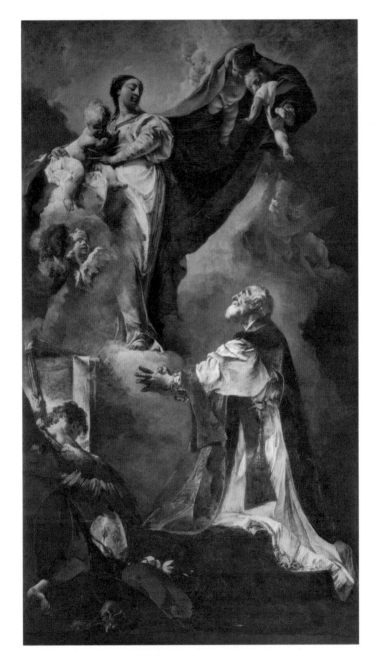

GIAMBATTISTA PIAZZETTA
The Madonna with Saint Philip Neri, 1725

CHAPTER FIFTEEN

CANALETTO'S POINT OF VIEW

O n 16 August 1725, a painting of *Santi Giovanni e Paolo* was hung as part of a display of pictures at the Scuola Grande di San Rocco. It was the custom to hold this ad hoc exhibition in and around the *scuola* on the feast day of San Rocco, and it provided the nearest thing that Venice had to a contemporary art show. It was a good moment for artists to display their work. Since it was a big occasion, everybody turned up and hung about the *scuola*. The skies were likely to be clear, which was useful since it was at least partly an outdoor event.

At the exhibition of 1725, one painting upstaged all others; as an eyewitness wrote, it made 'everyone marvel' and was promptly bought by the imperial ambassador, Count Giambattista di Colloredo Waldsee. The painting was by a twenty-eight-year-old named Giovanni Antonio Canal, now better known as Canaletto.

A decade later, Canaletto produced a magnificent painting depicting the Feast of San Rocco (with the art exhibition in the background). To the side is the shadowy mass of the church of San Rocco, and behind is the real star of the picture, the *scuola* itself, beautifully and accurately portrayed. There is a deep shade on the right, thrown by the facade of the church and more shadows made by the columns on the *scuola* and the crowd outside. Strong darks, of course, imply powerful light. The sky is almost clear, with a few wisps of light cloud (just enough, perhaps, to make the painting interesting).

The doge – Alvise Pisani, if the painting does indeed date from 1735 – has just emerged from the *scuola*, preceded and followed by high officials. Over the heads of the throng it is possible to see some of the pictures on display. There's a Nativity, for example, which might be by an artist such as Giambattista Tiepolo. On the right, beside a door into the *scuola*, is a prospect of the Grand Canal: just the kind of thing Canaletto himself painted. The doge, dressed in a golden, ermine-lined ceremonial robe, and other dignitaries clad in sumptuous patrician red are processing out of the *scuola*. They are walking under an awning to protect them from the summer sun. It is all topographically convincing. Yet at the same time, it is highly theatrical. It would not be hard to believe that this was a scene from an opera, designed perhaps by the romantic realist Franco Zeffirelli, with a chorus of hundreds on stage just about to burst into song. As it happens, the operatic stage had in fact briefly been Canaletto's world.

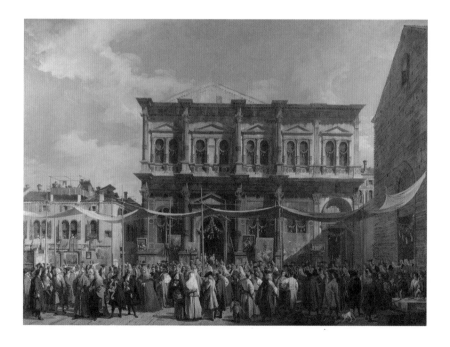

CANALETTO *The Feast of San Rocco, c.* 1735

FILIPPO JUVARRA *The Courtyard of a Palace:*
Project for a Stage, 1713

He was born in 1697; nearly twenty years later, in 1716, he was helping his father Bernardo Canal (1664–1744) work as a set designer for the Venetian theatres of San Cassiano and Sant'Angelo (Canaletto means 'Little Canal', or 'Canal junior', his father being the elder of the clan). In 1719, Bernardo and Giovanni Antonio went to Rome to work on productions of two operas by Alessandro Scarlatti (1660–1725), *Turno Aricino* and *Tito Sempronio Gracco*, which were performed during the Roman carnival of 1720 at the Teatro Capranica. This was an important venue at which works by Scarlatti, the leading Italian composer of opera, had often been performed. There is no record of Bernardo Canal's sets for these productions, but a drawing by the architect Filippo Juvarra gives a good notion of what was expected: grand classical architecture (both Scarlatti plots were derived from early Roman history) and dramatic lighting. Juvarra bathes the left foreground in shadow, leaving centre stage fully illuminated – a space for the star singers to appear, perhaps stepping forward between the columns to the front of the stage for an important aria.

The crucial elements in Baroque stage design were the creation of trompe l'oeil architecture, with convincing false perspectives, and – never to be overlooked – effective lighting. The young Canaletto would have been schooled in all three – before it seems that, in 1720, he abruptly decided to apply all of these skills to a quite different medium: view painting. Apparently, this was last time Canaletto ever designed a theatrical set. According to Zanetti the Younger, he said that at that point, 'he solemnly excommunicated the theatre'; instead, he 'devoted himself entirely to painting views after nature'. This statement with its quirky ironic turn of phrase – 'solemnly excommunicated' – is a rare occasion on which we can hear the artist's own voice.

Jokey though they are, his words suggest a serious decision to change the course of his career. Perhaps he felt ambition stirring within, sensing that he had the ability to paint the urban landscape in a fresh and vivid way. Possibly, he was influenced by the example of other artists, such as Giovanni Paolo Panini (1691–1765), six years older than Canaletto and beginning to establish himself as a master of floridly grandiose classical landscapes and views of Rome. The original exponent of Italian city painting was also present in Rome at around this time. He was a Dutchman named Caspar van Wittel (1653–1736), born in the town of Amersfoort, where he trained as an artist and worked until 1674. He left for Italy in his early twenties, remaining there for the rest of his life, and was rapidly rechristened Gaspar Vanvitelli. It is not hard to imagine the Dutch master, now approaching seventy and suffering from cataracts (hence his nickname, 'Gasparo degli Occhiali' or 'Caspar of the glasses'), showing some of the secrets of his methods to an eager and gifted young fan.

Whatever the spur, it is clear that in the summer of 1720, Canaletto moved from working on stage sets of fake Roman buildings to sketching real ones. There are more than twenty drawings of Roman sights, presumably done around the same time, including one of the Arch of Constantine inscribed '10 August'. During this period, he built up visual records and memories of Rome precise enough for him to be able to paint views of the city decades later. However, it was not to be his subject of choice. Canaletto seems to have soon decided to return to Venice, where his name was inscribed in the register of the painters' guild that year.

The next evidence about his career comes from five years later. We owe it to Stefano Conti, a collector from Lucca. It was his fussy habit always to ask for a description of each work that he bought from an artist. As a result, there is a letter, in Canaletto's beautiful handwriting, describing four paintings that Conti ordered in 1725. Mainly, the artist lists what can be seen and, in the case of *The Rialto Bridge from the North*, the exact viewpoint. The bridge, he explained, is seen from the spot that looks towards the Fondaco dei Tedeschi (that is, from part of the Riva del Vin). Across the canal is the vegetable market, and in the water he put a nobleman's gondola with a canopy and four gondoliers going at high speed. On a sketch, Canaletto wrote an even more concise and revealing note. At the top, he jotted the subject: '*Veduta del ponte di rialto infacza lerberia*' (View of the Rialto Bridge opposite the vegetable market). In the lower right, he put a single revealing word, '*sole*' – sun. In his finished picture, that is indeed the spot at which sunshine, breaking through the clouds, gleams on the surface of the canal.

Such shafts of light helped him vanquish an older competitor. It happened like this. Conti, being a foreigner from Tuscany, needed advice on what was happening in the art world north of the Apennines. A painter

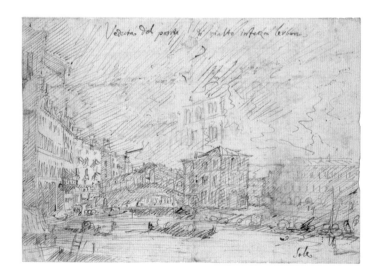

CANALETTO *The Grand Canal near the Ponte del Rialto, c.* 1725

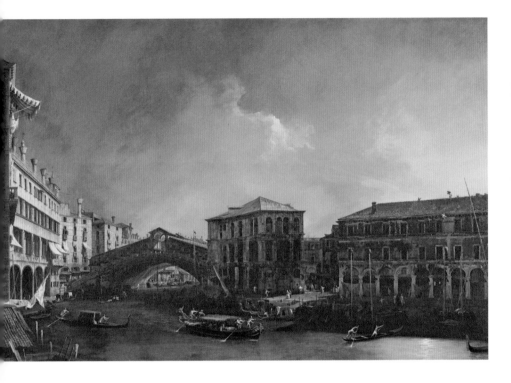

CANALETTO *The Rialto Bridge from the North*, 1725

from Verona named Alessandro Marchesini, who lived in Venice, acted as his agent and made suggestions about what he could buy. In July 1725, he had recommended Conti to give up commissioning pictures from the established master of Venetian views, Luca Carlevarijs (1663–1730), father of Marianna. Luca had had an odd career. Having done little that left a mark in the first forty years of his life, in 1703 he published an impressive work, *Le fabriche e vedute di Venetia*. This volume consisted of 104 plates of places in the city, some familiar, some less so. As its subtitle claimed, they were 'placed in perspective', seen sometimes from unexpected angles, with atmospheric energy and drama. It was an immediate and deserved success.

These engravings functioned as an advertisement for Carlevarijs and his works. After creating it, he was poised to tap into a new and growing market; foreigners passing through Venice who wanted to buy pictures of the city as

lasting souvenirs. He produced a series of paintings of diplomatic dignitaries arriving, with state honours, beginning with the French ambassador, and followed by the English one, Charles Montagu, fourth earl of Manchester (who employed Rosalba Carriera's friend Christian Cole as secretary). These were large paintings that naturally incorporated the architecture around the Doge's Palace. They were intended to record the achievements of the person who hung them on his wall. Carlevarijs also produced pictures recording the ceremonial and civic life of Venice – crowds, processions, regattas – with the city like the most splendid theatrical set behind.

Carlevarijs established a reputation and a list of clients – until, when he was around sixty, a dangerous rival appeared. In the summer of 1725, Marchesini – an acute observer of the Venetian art scene – advised Conti that he should patronize a new artist who had recently emerged: 'signor Antonio Canale [Canaletto], who astounds everyone … who sees his work, which is like that of Carlevarijs, but you can see the sun shining in it'. In other words, Canaletto could do everything that Carlevarijs could, but with startlingly naturalistic sense of the fall of light. How he learnt to produce this effect, Marchesini did not explain and – probably – did not entirely understand. In his correspondence with Conti, Marchesini remarks at one point that Canaletto always 'paints everything from reality'. When Conti suggested a certain subject, Marchesini replied that this was not possible because, 'He paints on the spot instead of at home as Carlevarijs and, wishing to do this, a fixed spot is required and a permanent one.'

Obviously, these remarks are reported from conversations with the artist, and equally evidently the message has been a bit garbled in transmission. It is certainly not true that Canaletto set up his easel on the Grand Canal, as Claude Monet did almost two centuries later. He painted in his studio, just as Carlevarijs did; what is more, both of them would have worked from studies made on the spot (although by the 1720s, Carlevarijs may have had enough visual information on file not to need to gather any more).

So what was Canaletto really talking about? There is a clue in more than a hundred drawings, most of them in a sketchbook or *quaderno* today in the collection of the Gallerie dell'Accademia. It has often been suggested that these were made with a camera obscura, and Philip Steadman has now

demonstrated that this is unquestionably the case. He points out that the character of the sketches reveals that they were traced. Thus, 'in every case the page is completely filled to the bottom and sides', so that structures are cut off arbitrarily at the edges of the paper. For example, a double-page spread of Campo Santa Maria Formosa (overleaf), begins on the left halfway across the facade of the church and misses the cupola and finial of the campanile, which Canaletto has added to the side. As Steadman points out, an artist working by eye would naturally adjust the size of the image to the dimensions of the paper. These sketches are more like the results you might get from pointing a phone at a subject and clicking – especially if there was not space to step backwards. And indeed, Venice not having changed greatly in three hundred years, Steadman was able to show that these sketches closely match photographs taken today of the same scenes.

Therefore, Canaletto was using a camera (as his contemporary Zanetti the Younger stated). But what kind of camera, and what did he learn from it? Steadman notes that to draw these studies on the thick, opaque paper of the *quaderno*, he would have had to use a portable booth-type apparatus that would have projected an image downwards onto the sketchbook. This perhaps explains what he said to Marchesini. To study a new subject, such as Conti had suggested, he would need to be able to place his camera at a suitable vantage point. If there was not one available, Canaletto would not have been able to use the camera.

The drawings suggest one purpose the camera would have had for the artist: it provided a rapid and accurate way of registering architectural detail. This could have been drawn by eye, but in a much more labour-intensive fashion. The drawing in the *quaderno* also illustrates one way in which Canaletto did *not* follow the camera image that appeared on the page in front of him. Steadman points out that right from the beginning, 'Canaletto has greatly enlarged and raised the dome of Santa Maria, to give it the visual prominence it deserves.' As every amateur photographer knows, the camera's image is different from what a human being perceives. Objects that loom close are rendered much smaller and more distant. Canaletto has corrected this: a painting that showed the dome as the camera sees it would look wrong. This perhaps is what Zanetti meant when he wrote

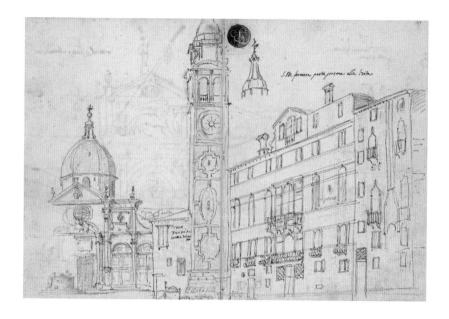

CANALETTO *Page of sketchbook with drawing of Campo Santa Maria Formosa,* 1730s

that Canaletto had 'taught through example the proper use of the *camera ottica*' (the Italian term for the camera obscura); and that he showed how to overcome 'the defects that such use brings to a painting, when the artist trusts entirely the perspective that he can see through such a device'. A painting that Canaletto made of Campo Santa Maria Formosa in the 1730s reveals further modifications. The church is brought forward, its campanile lowered, and a scattering of passers-by added: the actors on Canaletto's stage. Also, lighting has been introduced: strong shadow on one side of the campo, full sunlight on the other. This was not noted in the sketches, but is also something that the camera might have helped Canaletto understand.

By the early eighteenth century, he was not alone in using a camera obscura. It has been argued by Christoph Lüthy that Vanvitelli worked with a reflex version, which projected an image on a glass screen. Apparently, rather than trace this, he imitated it carefully on squared paper. It is likely that he had picked up the technique from Dutch topographical artists such as Jan van der Heyden before he left the Netherlands. Canaletto's follower

and rival Michele Marieschi (1710–43) was caricatured standing beside a portable camera. When Francesco Guardi began painting *vedute* in the 1760s, a diarist noted that he was using a camera. Yet neither Marieschi nor Guardi produced pictures that look like Canaletto's.

Clearly, there were almost as many ways of using the camera before the invention of photography in 1839 as there were after. Just as Degas, Sickert, and Warhol all made use of photography but with very different results, so did Canaletto and his contemporaries with the filmless camera. Perhaps more important to Canaletto than its handiness as a tool for documenting architectural detail was the opportunity it gave him to observe the fall of light. In *An Essay on Painting*, first published in 1762, Canaletto's younger contemporary Count Francesco Algarotti devoted a chapter to extolling the camera as an instrument from which artists had a great deal to learn. But he never mentioned tracing; what struck him was the light and colour that could be seen on its screen. By means of this 'artificial eye', he wrote,

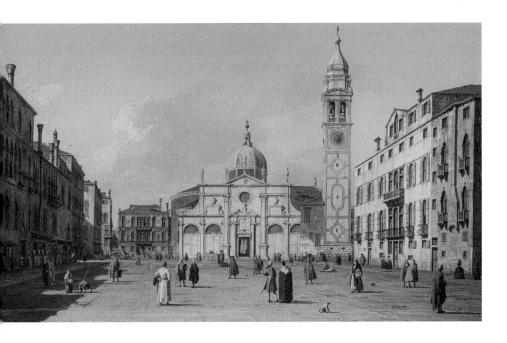

CANALETTO *Campo Santa Maria Formosa*, 1730s

one can contemplate, 'a picture of inexpressible force and brightness; and, as nothing is more delightful to behold, so nothing can be more useful to study, than such a picture'. The colours in a camera picture, he enthused, 'are of a vivacity and richness that nothing can excel', while the shadows 'are strong without harshness, and the contours precise without being sharp'. That last is a point that is forgotten. Camera-obscura images are often compared with photography, but in reality they are subtler, more delicately beautiful.

This 'force and brightness' combined with softness and richness must have been what struck Marchesini and other connoisseurs about Canaletto's works. Carlevarijs's pictures had many merits, but they are tonally and colouristically a little dull. By comparison, to look at a painting such as *The Feast of San Rocco* is to see the sun come out. Like Vermeer, Canaletto has seen how the lens alters and emphasizes the play of light on surfaces – what might be called the photographic 'look' – and found ways to depict it in paint.

It was a brilliant and original achievement, and very different from simply copying the images that he saw in his camera. That, as the example of the dome of Santa Maria Formosa shows, would not work – especially in Venice. As modern visitors know, it is a place that is simultaneously hugely tempting to photograph and unusually challenging for the camera-user. One reason is that it is full of grand buildings located in extremely cramped sites, making it impossible to view them from a distance. The Scuola Grande di San Rocco is an example – to see the same view that Canaletto painted, you would actually need to be in a spot inside the church of the Frari, approximately where Giovanni Bellini's triptych sits on the altar of the Pesaro Chapel. In other words, Canaletto has used his theatrical legerdemain to recreate a scene that no one could possibly have seen in real life. The spacious area in front of the *scuola* in which the doge is processing in the picture is, in reality, much more confined.

Canaletto is always doing this kind of thing: rearranging the street map of Venice to create suitable vistas, and ultimately to make a better picture. He performed a similar manipulation of perspective when painting Santa Maria del Giglio, the ornate facade of which in reality faces a narrow street. For his painting, Canaletto magicked away the building opposite the church, replacing it with a dark shadow, in the centre of which he placed

the spectator in an ideal, though impossible, vantage point. This was a skill that he would have gained from his experience as a stage designer.

Another possibility, for certain historically minded clients, was to paint the city not as it actually was but as it might have been. His picture of the Rialto with a bridge that Palladio designed, rather than the one that was eventually built, is one example (see page 186); as was his image of the four horses of San Marco removed from their usual position on the basilica and stationed on four elegant classical plinths in the piazza below.

Lastly, he was able to free buildings from their normal locations altogether and set them loose to mingle with other, perhaps imaginary or partly imaginary structures in a fanciful setting. This type of work, known as the *capriccio*, was more popular with his local customers who were understandably less keen to buy paintings of places that they saw every day. But his most frequent clients were foreign visitors, especially English ones.

If Carlevarijs established Venetian view painting as a genre, Canaletto made it a popular one – the proof being that several other artists were soon doing it too, among them Marieschi, Giovanni Battista Cimaroli (1687–1771), another favourite with the English, and Antonio Joli (1700–77). By the late 1730s, Canaletto himself was presiding over a busy family business in which his elderly father Bernardo was working alongside his two teenaged nephews Bernardo and Pietro Bellotto, sons of his eldest sister Fiorenza Domenica Canal. The younger Bernardo was an artist of remarkable gifts, as talented a painter of urban landscape as his uncle. Up to a point, 'Canaletto' seems to have been adopted as a family name or even a trademark. In the mid-1750s, Pietro Bellotto, by then resident in France, issued a handbill:

NOTICE FOR THE LOVERS OF FINE ARTS. Architectural and perspective painting that attains the highest degree of perfection. Signor CANALETTO, a Venetian painter, invites all those interested in the fine arts and painting to come to view his unrivalled spectacle.

The claims made by Pietro, and probably Bernardo, help to explain why Canaletto himself was suspected of being an impostor when he transferred to London. In any case, the selling points mentioned by Pietro were the same

as Canaletto's own: that the views he painted were – as the handbill goes on to proclaim – 'seen and depicted from nature on location', and furthermore 'made to seem realistic' through his 'light and delicate' skill with the brush.

As we have seen, in the mid-1720s, Canaletto was attracting attention among those in Venice who took an interest in the local art scene. Soon he acquired an agent who performed similar tasks to a modern dealer. This person was Joseph Smith, a banker, commodity trader, publisher of luxury editions, and, as we have seen, opera buff. Eventually, he became British consul in Venice. Smith was also a collector of books and paintings. No one, as the art historian Francis Haskell noted, seemed to like him. There was an element of snobbery in this; Smith was something approaching a self-made man, the kind annoying to aristocrats, one whose investments always pay off. He lived like a Venetian aristocrat in a palace on the Grand Canal with a country place near Treviso. Horace Walpole bitchily referred to him as the 'Merchant of Venice'. The architect James Adam wrote to his brother Robert in 1760 that the elderly Consul Smith was 'literally eaten up' with vanity (an early misuse of 'literally'). Adam could not stand Smith's 'flummery' – 'mere words, of course, that have no meaning except when he has some favour to ask'.

At some point in the mid-1720s, Smith ordered a set of fourteen views of Venice from Canaletto – part of his collection of the artist's works (the largest in existence) that he eventually sold, together with his library, to George III. Soon Smith, whose artistic interests blended profitably with his financial ones, was arranging work for Canaletto with his fellow countrymen, sometimes on a grand scale. The artist produced twenty-four Venetian views for Lord John Russell in 1731, before he became the fourth duke of Bedford, followed by twenty for the duke's brother-in-law, the duke of Marlborough.

There were more at Castle Howard, commissioned by Henry Howard when he was on the Grand Tour in 1738. A view of the city, or even a whole set, became a fashionable accessory in an English country house. There was another attraction, based – as intercultural bonds often are – on a misunderstanding. English Whigs felt that Venice was a whiggish place: a republic governed by a tight oligarchic circle of rich nobles, with a constitutional monarch shorn of most powers. This was much as they hoped

and intended their own country would be in the years after the Glorious Revolution of 1688. Moreover, like Britain, it was a maritime power, for centuries unconquered because of her position surrounded by lapping waters.

Such was Canaletto's productivity (helped, one suspects, by his family) that the landscape of Venice – subtly reordered and presented under a bright Mediterranean light – became extremely familiar to the British gentry. In June 1741, the countess of Hertford wrote to the countess of Pomfret explaining how, although she was not actually in Venice, her friend was, and so she had been able to join in her travels in a manner that we would now call virtual: 'I have (in imagination) attended you to the doge's palace at Venice, the front of which I am acquainted and charmed with, from a large picture that Sir Hugh Smithson has of it, painted by Canaletti. Lord Brooke also has some views of that city painted by the same master.'

In 1746, Canaletto, who had largely up to then been what John Constable called a 'stay-at-home' kind of artist, decided to go travelling. The traditional explanation for this decision is that the War of the Austrian Succession (1740–8) had made moving around Europe more difficult, causing the stream of potential customers for Venetian views to dry up. There was probably some truth in this. At more or less the same time, Bernardo Bellotto departed for Dresden and his younger brother left for France. But as Charles Beddington has argued, there might have been another reason. Canaletto was getting bored with what he was doing, all the more as most casual visitors wanted pictures of a small range of celebrated sights (just as most twenty-first-century tourists do not stray, or photograph, that far from the Piazza San Marco). Perhaps he needed a fresh challenge.

He was in London by May 1746 and stayed – with one trip back to Venice – until 1755. These nine years amounted to a sizable chunk of his career. Clearly, he like Britain and thrived there. It was a familiar destination for Venetian artists. Canaletto was preceded by Pellegrini, as we have seen, and also by Jacopo Amigoni (c. 1685–1752), who had spent the years 1730 to 1739 in England and recommended the country to Canaletto. There was, however, a difference between Canaletto's business model and that of Amigoni or Pellegrini. The latter were mainly working on decorative schemes in grand houses. Canaletto was trying to interest collectors in a

new type of picture: views of London and elsewhere in England, done in his own manner, and quite often he was painting on spec. On 25 July 1749, he placed an advertisement in the *Daily Advertiser*:

> Signor Canaleto hereby invites any Gentleman that will be pleased to come to his House, to see a Picture done by him, being A View of St James's Park, which he hopes may in some Measure deserve their Approbation.

In effect, this was a private view, held in his studio on what is now Beak Street, every morning and afternoon for a fortnight. This stratagem worked; the painting was bought by the earl of Radnor for eighty guineas. Canaletto mastered the alien idiom of English Gothic architecture (though he was also confronted by some Venetian-inspired edifices designed by Inigo Jones, such as the Banqueting House). He grew so used to Perpendicular architecture, that he played jokes with it. There is a drawing of San Giorgio Maggiore with a very Anglo-Saxon-looking campanile and another of a ruined Roman arch with what looks like King's College Chapel in the background.

Canaletto's pictures of London often have a Mediterranean look, with blue skies and bright sun. This may, it has been suggested, be because his Whig patrons wanted to emphasize the comparison between Britain and Venice (a subtle piece of meteorological symbolism if correct). Eventually, however, he ran out of clients and, perhaps, subjects. A second paragraph in the *Daily Advertiser* in 1751, announcing a view of the Thames at Chelsea, did not result in a sale. George Vertue, a British engraver and antiquarian, thought there were English painters who could do as well. Canaletto had ceased to be a novelty and became that neglected thing, a local artist. He returned to Venice, and – with neither his youthful enthusiasm nor the assistance of Consul Smith – began painting those celebrated views again.

Strolling in the Piazza San Marco in autumn 1761, two young Englishmen 'chanced to see a little man making a sketch of the Campanile in St Mark's Place'. One of them, John Crewe (1742–1829), was just beginning his grand tour, accompanied by his tutor John Hinchcliffe. As his grandson related, 'Hinchliffe took the liberty' of looking at what this artist was doing.

ANTONIO MARIA VISENTINI (AFTER GIAMBATTISTA PIAZZETTA)
Portraits of Canaletto [left] and Visentini, 1735

'Straightway he discovered a master hand and hazarded the artist's name "Canaletti". The man looked up and replied *"mi conosce"* – "You know me". (Probably he was there specifically to be spotted by prospective customers.)

But do we really know Canaletto? The only portrait of him is the frontispiece of a book of engravings of his views of the Grand Canal. It shows a neat, watchful, good-looking man. He did not say much, at least much that was reported by his contemporaries. Vertue noted his 'reservedness & shyness in being seen at work, at any time, or anywhere'. He was perhaps, more than anything else, a brilliant technician, adept at finding novel ways of using techniques and devices such as the camera obscura. A rare inscription on a drawing from 1766 – 'Aged 68 without spectacles' – suggests pride in his sharp vision. He must have enjoyed using his eyes – and spent a lot of time looking carefully at the world around him. At their best, his pictures offered a fresh way of observing not just Venice, but everything. It was a view suited to the age of enlightenment: the focus precise and clear, the colours rich and strong.

CHAPTER SIXTEEN

TAKING FLIGHT
WITH TIEPOLO

O n 20 March 1762, Giambattista Tiepolo made a unique public
statement in a local newspaper, the *Nuova Veneta Gazzetta*. The
item in which this appeared was almost an interview, as the writer
began with the words, 'I have often heard Signor Tiepolo himself say'. What
followed was a lament that young painters these days were not as diligent as
they used to be (not a surprising position for an artist of sixty-six). When
they had learnt a little, he complained, they ceased to study and failed to
make as much progress as their talent allowed. Then he added a thought
that was less curmudgeonly and more intriguing. Painters, he insisted:

> must try and succeed in large-scale works capable of pleasing the
> rich and the nobility because it is they who make the fortunes of
> artists and not the other sort of people who cannot buy valuable
> pictures. And so the painter's spirit must always be reaching out
> for the sublime, the heroic, the perfect.

Canaletto, as we have seen, was a forward-looking artist who devel-
oped a new genre, explored fresh markets, and used a favourite tool of
the scientific enlightenment: the camera. Superficially at least, his almost
contemporary Giambattista Tiepolo was the reverse: a conservative who
imitated sixteenth-century predecessors and worked for an old-fashioned
elite of aristocrats and religious institutions. Yet it was Tiepolo who was

GIAMBATTISTA TIEPOLO *Frontispiece to*
Scherzi di fantasia, *c.* 1743–50

more successful during their lifetimes, both in reputation and wealth. Even
in the twenty-first century, he still has fervent defenders. This enthusiasm
is not surprising considering that his art exemplifies a distinctive quality
of the Venetian imagination: ambiguous, whimsical, verging on sinister.

The frontispiece of his series of twenty-four etchings *Scherzi di fantasia* – a
title that might be translated as 'flights of the imagination' – was unexpectedly
influential. It represents a stone, perhaps even a tomb recording the artist's
own demise in Madrid in 1770, since it comes from a posthumous edition.
He had departed, reluctantly, for Spain at the invitation of the Spanish king.

He could not have predicted that the image would serve as his own
memorial, but even when he drew it – perhaps in the 1740s – it must have
looked ominous. The location is dotted with trees, one with a trunk over-
grown with ivy, another fallen. It has the atmosphere of a graveyard and
is infested with owls. Four of the birds are perched around the stone slab,

and two more can be seen in the distance flapping their way to it. This image inspired a clear and celebrated successor: Plate 43 from the series of aquatints that Francisco Goya published in 1799, under the title *Los Caprichos*. In this, a sleeping figure is surrounded by bats and owls, with the added inscription '*El sueño de la razon produce monstruos*' (The sleep of reason produces monsters). Aquatints are similar in technique to etchings, and *Los Caprichos* is not much different as a title from *Vari Capricci*, Tiepolo's other collection of prints. Goya must have known his works; conversely, Giandomenico Tiepolo, Giambattista's son, owned a copy of *Los Caprichos*. This connection is an intriguing one: Tiepolo was an artist immersed in a decaying Baroque world; Goya, in contrast, was a link to modernity who worked in France in the 1820s, the contemporary of Géricault, Delacroix, and Corot. Yet plainly they had something in common: a vein of fantasy. Suddenly, Tiepolo seems unexpectedly modern – an artist related not just to Goya, but to Max Ernst and Paula Rego.

*

Tiepolo had an affinity with birds in more than one way; in order to unfurl his talent to the maximum, he required space, and plenty of it. This was one reason why he valued patrons who were rich and noble: they had lots of square metres over which his inspiration could expand, preferably upwards. Among others, he worked for the plutocratic Venetian families Pisani, Labia, and Rezzonico, the prince-bishop of Wurzburg in Franconia, and the king of Spain – the last of those unwillingly, but it was an offer that the Venetian government advised him he could not refuse. He would have preferred to stay at home, but departed glumly for Madrid shortly after he was quoted in the *Nuova Veneta Gazzetta*, arriving in June 1762, never to return.

Tiepolo was a prolific artist, and over his long career he produced pictures for all manner of purposes and positions, but the place where he was most able to be himself was directly above the viewer's head. His ceiling paintings are the nearest thing art has to offer that compares to flying high up in the sky. That is true of his fresco of *The Institution of the Rosary*, which fills the central section of the ceiling of the Gesuati church (more formally known as Santa Maria del Rosario). This is a picture about above-ness. The grand

GIAMBATTISTA TIEPOLO *The Institution of the Rosary*, 1737–9

eighteenth-century building, designed by Giorgio Massari, is extremely high and spacious to begin with: a large Palladian hall, with slight Baroque touches. When you look up – a process that quickly causes a crick in the neck – it seems as though the painter has removed a section of the roof, as the contemporary artist James Turrell does when he makes his sky-spaces. Over the nave, a huge sunlit expanse opens out, dappled with cloud and filled with spiritual, airborne life: angels dressed in lime green and apricot; seraphim and cherubim, some consisting of just an infant's head supported by fluttering wings, others with toddler's bodies, swoop and glide. Up on a higher level, enthroned on a mound of soft pearl-grey vapour, sit the Madonna and Child.

An apparition of the Madonna was believed to have appeared to Saint Dominic in 1214 and presented him with the Rosary, a set of prayers and a string of knots or beads that serves as a devotional aide-memoire. In Tiepolo's fresco, an angel courier is transporting a supply of these from the Madonna to Dominic. The saint is in turn handing them on to the faithful – below him a small group of enthusiastic believers, including a doge, hold up imploring arms. Lower down on the staircase, there are various less eagerly devout characters simply hanging around, including a detachment of soldiers with pikes, and several members of the public just standing or lolling on the steps. Some of these – including a dog – are looking at the saint; others are looking at us or down at a tangle of unfortunate, mainly naked figures representing vice and / or heresy, who have fallen off a cornice at the bottom of the stairs and are tumbling down towards the viewer looking up from the floor of the nave, far below in the real world.

All of it is as preposterous as it is wonderful. After Tiepolo, no artist was able to maintain the necessary suspension of disbelief. But he managed to combine a sense of fantasy and fable with a suggestion that it might all be true, that the Madonna – though very distant – is still there in the empyrean, protecting us from aloft. He is perhaps the last great painter in the long European tradition of Christian art.

His successors, even his son Giandomenico, could not do this convincingly, nor could Goya. Even Giambattista was not able to do so all the time. He was notably less successful in his large picture of Christ carrying the

Cross for the church of Sant'Alvise. The effect of this is melodramatic and maudlin: only peripheral incidents – such as a Roman soldier sounding a trumpet, silhouetted against the sky – stay in the mind. As Michael Levey wrote, the Madonna – protector of humanity, powerful yet gentle appearing on high – was Tiepolo's subject of subjects.

No sooner had he finished the frescoes in the Gesuati church than he was given an opportunity to paint a very similar subject a few minutes' walk away in another part of Dorsoduro. Later in the same year, the Scuola Grande dei Carmini approached Tiepolo, 'extolled as the most celebrated of artists', to paint the ceiling of the main hall of their building. Although he was inundated with work, Tiepolo agreed to do so, perhaps because of his piety. On 21 December 1739, the confraternity's minutes noted that the artist 'lived in devotion' to the Madonna of Mount Carmel. Accordingly, he proposed to replace a painting that the *scuola* already had of the Assumption of the Virgin with a different subject, the Madonna bestowing the Carmelite scapular on Saint Simon Stock. This object, consisting of two pieces of cloth connected by bands and worn as a pledge of devotion, was supposed to have been bestowed on the English saint in thirteenth-century Cambridge. Those who had worn it were thought to be released from the pains of Purgatory.

Tiepolo submitted two *pensieri* – proposed schemes – both centring on the Virgin descending from heaven, attended by the prophets Elias and Eliezer and 'many troops of angels' (as Levey says, one can almost catch the artist's pleasure at that last phrase). The supplicant saint would be kneeling to implore some mark of the Madonna's protection. In the finished picture, commissioned in January 1740, she is coming down like a low-flying jet, borne along, Levey wrote, in 'the centre of a cloudburst of flying angels', moving with such velocity that she needs to place 'one hand on an angel's head to steady herself in flight'. In comparison, the panels of virtues that surround this image seem almost comically frivolous (especially the bare-breasted Humility with her smugly demure symbolic sheep). The central vision, however, feels charged with the painter's own faith, to the extent that the kneeling Saint Simon Stock seems like a surrogate for Tiepolo himself. When the ceiling was completed, he was elected a member of the *scuola*.

His piety was probably sincere; his family was also devout. While two of his sons – Lorenzo and Giandomenico – followed him into the family painting business, a third, named Giuseppe Maria, became a priest. Moreover, Giambattista was plainly filled with creative inspiration by the thought of a powerful, protective female figure.

There were biographical reasons why the maternal principle might have been emotionally important for him – although to accept them takes us into the realm of psychological conjecture. Giambattista was born on 5 March 1696, the youngest of six children born to Domenico and Orsola (known as Orsetta) Tiepolo. His father had apparently been a merchant in a small way of business, possibly a sailor and part-owner of a ship. The family name 'Tiepolo' suggests some connection with the great aristocratic clan of that name, but without direct kinship (occasionally nobles such as the Tiepolo would act as patrons to social inferiors and allow them to take their name). An inventory taken after Domenico's death suggests that they lived in modest comfort in a small house with a courtyard, three bedrooms, and a wine store.

Almost exactly a year after Giambattista's birth, his father died. This was a catastrophe for his dependents; the family was plunged into financial crisis. A legal document contains witness statements from five friends of the widow and her children during the painter's childhood. Sophie Bostock, who discovered this evidence, concluded that this one-parent family 'was desperately poor, with its circumstances becoming increasingly dire within five years of Domenico's death'. They moved from one rough area to another. Giambattista's older brothers, Ambroso and Antonio, were obliged to work to support the family. His mother must have struggled to keep the household going. But despite there being no family tradition of working in the arts, Giambattista had an urge to be a painter.

The witnesses recall that as a child Tiepolo drew on the walls of the neighbourhood. One remembered him making pictures above the doors of the furnaces of the state biscuit factory. This would have been when the widow and her children lived in San Biasio (a gritty working-class area near

GIAMBATTISTA TIEPOLO *The Virgin Giving the Scapular to Saint Simon Stock*, 1740s

the Arsenale). By the time he was eleven or twelve, Giambattista could support himself by his art; his mother, hard-pressed though she was, did everything she could to help him, perhaps funnelling her hopes into her talented youngest son. In 1710, at around fourteen, he was apprenticed to Gregorio Lazzarini (1657–1730), a painter of some standing. Soon, he had begun a career of unending effort and industry that lasted for almost sixty years. His boyhood friends remarked on how, 'he always worked, and never missed the opportunity [to do so]'. Partly perhaps that came of an urge to escape the deprivation of his childhood. But he also seems to have possessed the type of unremitting drive to paint and draw that often goes with vast talent (Michelangelo and Picasso are parallels).

Tiepolo succeeded quickly. A posthumous biography of Lazzarini written in 1732 was full of praise for the dead painter's brilliant pupil, 'now famous'. But he had been posed a problem, a conundrum that was set by history: how to be a great Venetian painter now that the glory days of Venetian art seemed to have passed? To Tiepolo and his contemporaries, this came down to a more precise challenge. Was it possible to paint like Veronese without simply imitating him? Just as Rubens, Van Dyck, and Velázquez took Titian as their model, eighteenth-century Venetian patrons and artists venerated Veronese to the point of outright pastiche. Sebastiano Ricci (1659–1734) made nine copies of paintings by Veronese for Consul Smith, one of which the latter apparently sold to George III as an original (there is controversy about whether this was deliberate fraud, a 'resounding deception'). The French artist Charles de La Fosse (1636–1716), who had spent three years in Venice in the late 1660s, unkindly advised Ricci to give up painting Riccis and just paint Veroneses in future.

As a rising artist in 1736, Tiepolo was almost equally condescendingly dubbed 'Veronese's secretary' by Count Tessin. Zanetti the Younger wrote more kindly that Tiepolo had revived, 'the dormant, happy, most graceful ideas of Paolo Caliari [Veronese]'. But even he hinted that this recycling was not quite up to the original. Although Tiepolo's heads were 'no less graceful and beautiful' than Veronese's, the 'sternest' critics 'would let no one say they have life and soul like those of the old master'. Even Tiepolo himself indicated that he was willing to take lessons from his great predecessor.

In May 1743, just as Tiepolo was finishing off the ceiling paintings for the Scuola Grande dei Carmini, Count Francesco Algarotti returned to his native soil. A renowned writer, thinker, and authority on matters cultural whose discussion of the camera obscura has already been quoted, Algarotti had been on a mission to find paintings for Augustus III, elector of Saxony and king of Poland. One of the pictures that he was lining up to dispatch to Dresden was a small version of Veronese's *Rape of Europa*, related to a famous and much praised painting in the Doge's Palace (the detail of the bull tenderly licking the nymph's foot was frequently praised). Tiepolo was one of several artists who gave Algarotti a certificate guaranteeing the authenticity of this little picture, although he probably knew that it was what art connoisseurs call 'workshop'. What is more, he made a little copy of the work for Algarotti himself and confessed that he would pay two hundred ducats to have such a picture constantly before his own eyes as a lesson, an object to study.

The art historians Svetlana Alpers and Michael Baxandall have described what Tiepolo did – at least quite often – as 'performing Veronese'. To put it another way, he was riffing on the visual world created by the sixteenth century. But there was a difference between Tiepolo's performances on themes by the sixteenth-century master and Ricci's; the former was one of those conservative artists who somehow end up seeming avant-garde.

Part of this, paradoxically, was a lesson that he learnt from Veronese: the crucial importance of the inessential. The great German writer Johann Wolfgang Goethe, coming to Venice for the first time in the early autumn of 1786, visited the theatres of the city assiduously and studied the marine life of the lagoon, but bothered to look at – or at least describe his reactions to – only one picture, Veronese's *The Family of Darius before Alexander*, in the Palazzo Pisani Moretta. This was the much-praised picture for which agents acting for Cardinal Mazarin and Queen Christina of Sweden had been asked the astonishing sum of five or even six thousand ducats. The Pisani family were too rich to need to sell it, so the painting remained in their palace, one of the noted sights of the city, until 1857, when it was finally sold to the National Gallery in London for the second-largest sum ever paid for a work of art. Goethe gave only passing attention to the story, derived from

classical history, that was depicted. Instead, he seemed more entertained by an extraneous detail, the expression of one of Darius's daughters, who are lined up to plead for mercy from the victorious Alexander: 'The youngest princess, who kneels behind all the rest, is a pretty little mouse with a defiant expression.' (He might have mentioned the equally entertaining monkey on the pediment just behind her.) Thus he was delighted by exactly the trait that irked the Inquisition: the artist's failure to stick to the point of the story, and instead to embroider it with beguiling but irrelevant detail.

Goethe does not mention Tiepolo, of whose work he seemed unaware. But this is an extremely Tiepolo-esque detail. Alpers and Baxandall noted that Tiepolo's repertoire of visual devices includes many such miscellaneous items. Among these were dogs, beloved of Venetian artists since the days of Carpaccio. They pick out the white bull terrier in the central part of the ceiling of the Gesuati; this beast is apparently dozing on top of the moulding around the painting, but while doing so, he 'gathers the play of light along the upper edge of his shoulder' and the back of his ear. Thus, the bull terrier plays an important part in the picture without paying the slightest attention to its subject: the Institution of the Rosary.

Alpers also spotted Tiepolo's affection for poles, frequently set against the bright sky behind, which support flags and 'appear as masts, tree-trunks, tent-supports, staffs, spears, viols, oars and the Cross'. Then there are the clouds that play such a large part in many of his pictures (as they do in Titian's and Tintoretto's). In Tiepolo's ceilings, such as the one in the Gesuati, they do not merely animate the sky in the background. Like his poles, dogs, and intent observers in oriental dress, the clouds begin to *take over* the picture. About two thirds of the *Institution of the Rosary* is filled with carefully variegated cloud – a blue-grey bank at the lowest level, a warmer fawn-coloured mass higher up, then a high whitish layer with light blue empyrean above that. As often when contemplating a Tiepolo ceiling, you seem to be looking at a skyscape inhabited by various figures perched on billows of cumulus or fluttering in the air.

A painter who depicted so many events taking place above the viewer's head necessarily had to think hard about what people and things might look like from unexpected angles. This is one reason why Tiepolo so

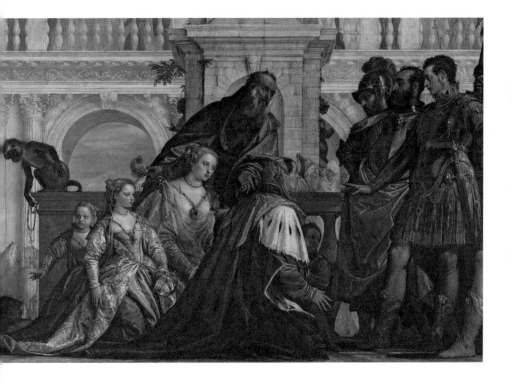

PAOLO VERONESE *The Family of Darius before Alexander*, 1565–7

delighted in visual abbreviations: a whole figure indicated by a couple of knees, a foot, part of a head, and an arm protruding above a cloud. Or a praying figure, seen from below so that only the raised hands and arms are visible, plus again, knees, lower legs, and feet. Few artists can have devoted so much attention to horses seen from underneath, as they would appear while flying through the air. This gives Tiepolo's ceilings an air of logically consistent make-believe. If there were large numbers of angels, animals, and other beings suspended above our heads, this is just what it might look like. What seems to happen in his etchings is that the ostensible 'serious' religious or mythological subject disappears and we are left with just the extras – the staffage or bit-part players – who hang around the margins of his major paintings.

287

GIAMBATTISTA TIEPOLO *The Discovery of the Tomb of
Pulcinella, from the* Scherzi di fantasia, *c.* 1743–50

It turns out that this motley band of elderly men in oriental costume,
beautiful young women and youths, babies, owls, dogs, donkeys, camels,
and snakes are quite enough on their own to sustain an imaginative world.
Indeed, once set in motion, they prove able to generate intriguing situations
and implicit plot developments all on their own, as in the motley arcadian/
creepy group who have come across a memorial slab bearing a carved bust of
the masked character Pulcinella in one of the etchings from the *Scherzi* set.

It is not hard to hazard a guess at one message: there is death even in
the farcical domain of *commedia dell'arte*. But explaining all the details of
these images has given scholarship a lasting headache, probably because no

precise meaning was intended for every figure and object. Tiepolo must have improvised according to whim and fancy. And this was just the point for his contemporaries. Zanetti commended the *Scherzi di fantasia* as 'being of a most spirited and piquant taste'. The French dealer and collector Pierre-Jean Mariette felt Tiepolo's 'rich and fertile genius' shone 'above all in his prints'.

It is still true that the most direct entry point to Tiepolo's imaginative world is via his etchings. But although, as suggested above, these are remarkable anticipations of later work, there is one feat that only his aerial paintings can perform. You could call it space exploration, and – to borrow a piece of contemporary art jargon – you could add 'site-specific' to the description.

*

Alpers and Baxandall imagined Tiepolo setting about painting the ceiling of the Gesuati in 1738, 'standing up on the scaffolding and intuiting his task'. At this stage in the process, Tiepolo would have developed his ideas for the work from initial pen-and-wash drawings into oil sketches. What happened next was that, as they put it, he had to 'tune up' a composition worked out on a canvas a little over three feet high 'into something forty-five feet by fourteen that works well when seen overhead in a particular vault'. The painter could have peered down through the scaffolding, at the floor where we now stand twenty metres below. But he would also have been able to do what we cannot, which is to look straight out of the grand windows, three on each side (the design of which Massari had borrowed from Palladio's Il Redentore). In effect, Tiepolo would have been standing in a bubble of lagoon light that constantly changed.

Because the church is oriented roughly north–south, direct sunlight comes in from the east in the morning and the west in the afternoon. But there are complications. In an obsessively brilliant piece of art-historical writing, they went into these with meticulous, dizzying detail. The main additional factor is something else one cannot see from the floor of the Gesuati: the surrounding roofscape that reflects and/or absorbs light. Alpers and Baxandall seem to have spent days observing the resulting fluctuations in illumination, such as occasionally visible 'moving ripples of light' bouncing

up from the waves of the Canale della Giudecca, the wide expanse of lagoon that lies in front of the church. There is also 'an electrifying occasional five minutes in late afternoon when the sun is low enough in the west both to shine direct through the west windows and to reflect back strongly from the east wall on which it falls'.

It was when Tiepolo moved from his sketch to the actual space with its real, ever-altering illumination, Alpers and Baxandall argue, 'the bud burst'. That is, he added all manner of extraneous bits and pieces – lolling soldiers, billows of cloud, a slumbering bull terrier – that have little to do with the subject but make the painting function in wonderful ways that you can only really experience if you are in that same light-filled structure. That is why this apparently reactionary painter can also seem strangely contemporary – a predecessor of artists who work with light such as Turrell and Olafur Eliasson.

*

After leaving the Palazzo Pisani Moretta, Goethe had an artistic epiphany. As he 'glided over the lagoons in the brilliant sunshine', he perceived everything in terms of light, shadow, and colour. He noticed gondoliers silhouetted against the blue sky as they rowed with easy strokes across the light-green surface of the water.

> The sunshine raised the local colours to a dazzling glare and even the parts in shadow were so light that they could have served pretty well as sources of light. The same could be said of the reflections in the water. Everything was painted clearly on a clear background. It only needed the sparkle of a white-crested wave to put the dot on the i.

He could have been describing a painting from a century later – a Monet or a Sargent. Of course, it was seeing a Veronese that had had this effect on the poet, but a Tiepolo could have done just the same. In that respect, he and his work are like the city itself. Venice, too, can seem outmoded, quaintly irrelevant to the modern world. Then, suddenly, you realize that it is not.

The ceiling of the nave of the church of Santa Maria del Rosario, also known as the Gesuati

THE WORLD OF PULCINELLA

Something about Tiepolo seems to bring out the creative eccentricity in art historians. As we have just seen, his work inspired Alpers and Baxandall to spend long hours observing the changing qualities of light in a Venetian church. The Italian art historian and critic Roberto Longhi was moved to compose a posthumous conversation set in heaven between two very different painters, 'Dialogo fra il Caravaggio e il Tiepolo', published in 1951. This debate is between one of Longhi's greatest heroes, and one of the greatest villains in his polarized view of art. Longhi was instrumental in resurrecting Caravaggio's reputation, and believed passionately in a northern Italian tradition of naturalism or realism to which Tiepolo seemed the opposite: a master of the unreal and fantastic.

Nonetheless, as Roberto Calasso pointed out, Longhi's strange composition is not without humour. For example, Caravaggio does not much like heaven (it lacks the dark shadows that he loved to paint). Furthermore, Tiepolo tends to get the better of their exchanges. At one point, Caravaggio rather rudely asks him, 'What do you do? Painting or stage sets?', to which the Venetian replies, 'Was I wrong if, on watching festive plays, the parades of my noble patrons, I concluded that it was best to indulge them and paint the world as if it were all a theatre?'

It is a good answer, evoking Plato and Shakespeare. Furthermore, one of the truths about eighteenth-century Venice was that the whole city had

become theatrical. One indication of this was that for a good deal of the year, much of the population wore masks like actors in the *commedia dell'arte* or classical drama. So, paradoxically, to paint life as a performance could be said to be truthful and realistic.

A painting by Francesco Guardi (1712–93) – or possibly his older brother Gian Antonio, opinions differ – takes us into the inner sanctum of Venetian society. Not that there was anything holy about it, although its own inmost chamber was hushed, and almost everybody present was masked. Guardi's *Ridotto of Palazzo Dandolo at San Moisè* is a portrait of this room and the crowd that gathered in it, turning, bowing, and nodding as they carry out the ritual of meeting and greeting. To the right, a masked couple sits down for an intimate chat; to the left, a masked women with a black page and a little dog is being accosted by a gentleman in cloak and mask. That combination was typical: a voluminous garment named the *tabàro* with a white mask or *baùta* that covers three-quarters of her face and a three-cornered hat. This

FRANCESCO GUARDI *Ridotto of Palazzo Dandolo at San Moisè*, 1746

most characteristic of masks was made of plaster, leather, or papier-mâché, white for a women, black for a man. Women wore the *baùta* with a hat and cloak, but an oval black *morèta* if they were simply clad in a dress, like this figure in Guardi's painting.

The Ridotto was a place dedicated to gambling. Lorenzo Da Ponte (1749–1838), who was to become (among many other occupations during a long life) the librettist for three of Mozart's greatest operas, was briefly a habitué. He described it in his *Memoirs*:

> In Venice, at that time, there existed the famous gambling house
> commonly known as the Public Ridotto where the rich nobles had
> the exclusive privilege of gambling with their own money, and the
> poor, at a certain charge, with other people's [by which he meant they
> bet with borrowed cash].

Like all such places, the Ridotto was a trap for deluded or compulsive risk-takers. The name has been connected with the Italian word *ridurre*, which could refer to a space like the foyer of a theatre, but also means 'reduce or cut back', which is exactly what happened to the stakes of many who went there, including Da Ponte and his mistress:

> The Ridotto was open only during carnival. The last day came,
> and we had no money and no means of raising any. Forced on
> by the vicious habit and even more by the gambler's delusive hope,
> we pledged or sold the few clothes we had left and scraped together
> ten sequins [ducats]. We went back to the Ridotto, and in the
> twinkling of an eye lost that too. Our feelings on leaving the rooms
> can easily be imagined.

The actual gambling took place in the central chamber, where 'a silence greater than in church' reigned. The gamblers sat around small tables, presided over by a nobleman who had, by law, to be unmasked. This slightly sinister conclave can be glimpsed through a door in Guardi's painting. But most of the picture is concerned with something different: a society in which almost

everybody is in costume like an actor in a play. There are passages in the painting where it is hard to know if one is looking at fantasy or a depiction of everyday life. Near the back of the crowd, behind a woman in a superbly elegant *baùta* and *tabàro* over a blue satin gown, there is a man who seems to be wearing the white conical hat of the *commedia dell'arte* character Pulcinella.

It is not only in Guardi's picture that real life and the theatrical kind overlap and blur together. The playwright Carlo Goldoni was paraded through the Ridotto after the triumph of one of his plays, and listened to savage criticisms of another, failed drama while he was masked and presumably anonymous (though the extent to which Venetians could recognize each other in spite of masking is unclear). In the latter case, Goldoni resembled a character in one of his own comedies. A third Goldoni play, *Le donne gelose* (The jealous women), is partly set in the Ridotto, and the humour of the plot turns on masking. As James Johnson explains in his book on the Venetian mask, *Venice Incognito*, the central character is 'Signora Lucrezia, a happy widow with a sharp tongue', who has been 'tormenting two ladies she detests by toying with their husbands'. She goes to the Ridotto, where the women's husbands, a haberdasher and a jeweller, both masked, 'approach to pay their doting respects'. However, these men's wives have followed them, naturally also masked – but that does not stop them all recognizing each other. Eventually, 'the wives explode. Chaos erupts, the husbands flee.' Lucrezia turns on the luckless porter who is her escort (and in love with her too) and who undermines the whole point of wearing disguise by persistently addressing her as 'Siora mascara Lugrezia' (My masked Lucrezia). Part of the joke is that this character is called Arlecchino, which was of course the name of one of the characters, or 'masks', of the *commedia dell'arte*.

Goldoni was in the odd position of attempting to write realistically about a society in which much of the population was semi-permanently in amateur-dramatic disguise. His theatrical revolution consisted in treating *commedia dell'arte* situations and characters much more naturalistically – and eventually removing their masks altogether. However, Goethe, who attended the performance of Goldoni's *Le baruffe chiozzotte* (Brawling in Chioggia) and loved it, saw nothing strange or unnatural in Venetian actors covering their faces.

PIETRO LONGHI *Portrait of Carlo Goldoni, c.* 1750

Masks, which in our country [i.e., Germany] have as little life and meaning for us as mummies, here seem sympathetic and characteristic expressions of the country: every age, character type and profession is embodied in some extraordinary costume, and since people run around in fancy dress for the greater part of the year, nothing seems more natural than to see faces in dominoes on the stage as well.

This was a contradictory state of affairs for a playwright who aimed at a sort of eighteenth-century kitchen-sink naturalism – and equally so for a painter specializing in genre scenes of domestic life. This was the problem facing Pietro Longhi (1701/2–85). After a false start as a painter of grand pictures of history and myth, Longhi drastically changed direction when he was almost forty, and began to specialize in subjects from everyday reality. He was a near contemporary of William Hogarth, but his work is less savagely

satirical than that of the English painter, and stranger in mood. The reason for that is not so much that Longhi was a proto-Surrealist as that Venice itself was strange, precisely because for at least half the year, from the beginning of the carnival season in October until the beginning of Lent (plus other festival times), numerous Venetians went around masked like characters in a play. Goldoni made a comparison between his own writing and the artist's pictures in a sonnet beginning, 'Longhi, tu che la mia musa sorella / chiami del tuo pennel che cerca il vero' (Longhi, you summon the sister of my muse, your brush like my pen is seeking truth).

One of Longhi's oddest, and most successful, pictures is *The Rhinoceros*. But, though it feels a little like a work by the Surrealist René Magritte, it is based on a real event. In 1741, an orphaned rhinoceros was brought from

PIETRO LONGHI *The Rhinoceros*, 1751

India to the Netherlands by a Dutch sea captain named Douwemout van der Meer. Either he or her previous owner named her Clara. She quickly became one of the most celebrated animals in Europe, being the first live rhino to be seen in that continent. Once they arrived, she and Van der Meer began a seventeen-year tour, Clara travelling in a specially built wooden carriage, her skin kept moist by the application of fish oil.

The two of them had already visited France and most of the German-speaking world before they appeared at the Venice carnival of 1751, creating a sensation. Longhi painted a series of variations on his picture of the event. In the one at the Ca' Rezzonico, he included three portraits: Clara herself, placidly munching a few strands of straw, Van der Meer waving Clara's horn, and also the nobleman Giovanni Grimani (wearing a smart green jacket with a red-and-gold waistcoat), who commissioned the picture. In other versions, he is replaced by a figure wearing a *tabàro*, *baùta*, and three-cornered hat.

*

The confusions that caused comic episodes on stage and ambiguities of identification in paintings had the same effect in real life. At one point in the 1770s, Lorenzo Da Ponte was in the habit of going regularly to the Caffé dei Letterati. Many years later, he related how, 'One evening when I was there in a half mask, a gondolier came in, and looking round fixed his eyes on me, and made me a sign to go out.' Da Ponte followed the gondolier out to a gondola moored on the *riva* of the canal. He assumed his mistress was inside, for she sometimes came to fetch him. But as soon as he got into the boat, 'The gondolier let down the usual curtain over the entrance, so that inside the darkness was complete. Greeting each other at the same moment, we knew by the strangeness of the voice that the gondolier must have made a mistake. As I sat down, I had taken her hand to kiss it, as our custom was. It was much plumper than my friend's. She immediately tried to withdraw it, but I held it gently but firmly, assuring her earnestly that she had nothing to fear.'

This misunderstanding was soon happily resolved, so for a while Da Ponte had two mistresses rather than one – which generated its own dramas and

confusions. The whole incident is like a scene from the stage. A decade or so later, Da Ponte was to write the libretti of *La nozze di Figaro*, *Don Giovanni*, and *Così fan tutte*. The last, with its plot turning on disguise and mistaken identity, was probably largely his own invention. As David Hockney has emphasized, this marvellously improbable concoction only makes dramatic sense when staged in eighteenth-century costume. In modern dress, the notion that the central female characters would not recognize their lovers because the latter were wearing Albanian clothes makes no sense at all. Whereas, in Venice, such confusions were entirely possible according to Da Ponte's own recollection (unless he made that story up too).

Comedy was taken seriously in the eighteenth century (just as it sometimes is in the twenty-first). During the early 1750s, French cultural life was split by the *Querelle des Bouffons*, the 'battle of the comics', a bitter dispute about which was superior: French or Italian comic opera. In Venice, a similar row broke out between Goldoni and the supporters of good old-fashioned raucous comedy. The playwright was out to modernize the Venetian stage – which meant bringing it closer to everyday life. In the preface to an edition of his works in 1750, he lamented that the *commedia dell'arte* contained nothing 'except filthy harlequinades, dirty and scandalous love scenes and jokes, poorly invented and poorly developed plots, with no morals and no order'. Such coarse knockabout might entertain 'dissolute young men' and make 'mannerless boors laugh', but it bored and angered people of culture and good morals.

The leader of the anti-Goldoni fightback was Carlo Gozzi (1720–1806), a member of an impoverished aristocratic family. After a period spent as a soldier, Gozzi belonged to a waspish and reactionary club that called itself the Accademia dei Granelleschi, or 'academy of those with balls'. This was dedicated to the preservation of the purity of the Italian (that is, Tuscan) language and resisting the influence of French culture. Gozzi and his allies thought the *commedia dell'arte* was marvellous just as it was. He claimed it would 'never fail to have a sure effect on the people, who will always have the right to enjoy what they like and to laugh at what they find funny, without paying any attention to the masked Catos [the reformers] who want to prevent them from liking it'.

By 1761, the polemical attacks on Goldoni, especially from Gozzi, became so vicious that the playwright fled in exile to Paris. All of this might seem to make Gozzi look like an aggressive bully, which he probably was. But the artistic effects were unexpected. As a move in his campaign against Goldoni (and also against Pietro Chiari, another reforming playwright), Gozzi put on a performance of a fairy tale that he had rewritten, *L'amore delle tre melarance* (The love for three oranges). This was highly successful, partly because it was performed with great gusto by a *commedia dell'arte* troop that had been reduced to unemployment by the success of Goldoni's works. A further irony is that although the story was filled with political point-scoring and coded references to Gozzi's reactionary views, outside Venice nobody seemed to notice these. The Swiss-French writer Madame de Staël spoke for many in proclaiming that, 'Gozzi, the rival of Goldoni, has more originality in his compositions.' She admired his ability to, 'mingle buffoonery and harlequinade with the marvels of poetry; to imitate nothing in nature, but to give free scope to the gay illusions of fancy, to the chimeras of fairy magic'.

One of the most renowned of Gozzi's plays was *Turandot*, which was first performed at the Teatro San Samuele in January 1762 by the *commedia dell'arte* troop of his friend Antonio Sacchi. Afterwards, it was translated into German by Friedrich Schiller, produced by Goethe at Weimar in 1802, and has had a long history in various languages and versions, pre-eminently Puccini's musical version, which is among the most popular of all operas.

*

With Gozzi and Goldoni, we come back to truth versus imagination, which was the point at issue in Roberto Longhi's dialogue between Caravaggio and Tiepolo (and a dichotomy that runs through much of the history of pictures in Venice). In a fitting end for a fairy tale, the two ideals were resolved by one of the last great artists of eighteenth-century Venice, who was at once a realist and a fantasist (and also happened to be Giambattista Tiepolo's oldest son).

Late in his life, Giandomenico Tiepolo (1727–1804) painted a series of frescoes in his family's summer retreat, the Villa Zianigo near Mirano on

the mainland. Obviously, these were done for his own enjoyment, and that of his relations and his guests – which is one aspect that makes them seem modern: this is not work the artist had to do, but what he wanted to paint. His themes were the world as a spectacle and the masked clown as everyman.

These pictures are no longer on the walls of the Villa Zianigo, having been detached in the early twentieth century and almost sold to a French collector. Fortunately, instead, they were bought by the Italian state and the commune of Venice. When the Ca' Rezzonico opened as a museum in 1936, they were installed in six rooms on the top floor, which immediately became one of the most poetically Venetian places in the city.

Giandomenico would not have had much leisure for frescoing his own house when he returned from Madrid in 1770 after his father's death. It seems likely, therefore, that the frescoes date from the last years of the Republic and perhaps after its end – since Giandomenico outlived the independent Venetian state by seven years. Only one picture is both signed and dated: 'Dome / Tiepolo f. / 1791'. It filled the long, right-hand wall in the *portego* or entrance hall of the villa and is, in a way, a portrait of an audience of people looking at a picture; what we mainly see are their backs and profiles (following pages). They are queuing up to stare through holes in the walls of the structure on the left, which looks like a small house. It was a form of attraction that Goldoni dubbed '*Il mondo nuovo*' (The new world).

In his study of this picture, Darius Spieth suggests a series of less poetic synonyms, such as 'a magic lantern, a cosmorama, a raree show, a pantoscope, or, more simply put, a peep show'. In other words, this shanty contained one or other of the many predecessors of the cinema. Inside, there would have been *vedute ottiche*, or optical views. Spieth describes these as 'hand-colored, printed panoramas'. The effect would have been improved, Spieth writes, by 'lenses (to enlarge the panoramas) and mirrors (to add spatial depth), as well as paintings at the sides and on the bottom of the box interiors'. Just as in an opera set, or one of Giambattista Tiepolo's grand ceiling paintings, lighting was crucial. In this case, it would have been provided by the bull's-eye windows and open lantern of the rotunda perched above the box in Giandomenico's fresco, and also a hinged flap that allowed the light levels to be altered, changing day to night.

Here, then, is Giandomenico painting as a social realist, but depicting the Venetian public doing what they so liked to do: watch a theatrical performance, which took the form here, as it so often did, of a kind of picture. Elsewhere in the villa, Giandomenico became less of a realist and more of a fantasist. He had inherited his father's talents, but not all of them equally. As we have seen, at least some of the time, Giambattista was able to carry off grand religious paintings with conviction. Giandomenico's, in contrast, fall flat. But as a painter of everyday life, he was more observant and convincing than Pietro Longhi, and his visual fables and caprices are

GIANDOMENICO TIEPOLO *Il mondo nuovo*, 1791

every bit as memorable as his parent's. In those, Giandomenico, late in life, became a great artist.

Elsewhere in the villa, he conjured up a world inhabited by Pulcinellas. In some, the familiar *commedia dell'arte* character with high conical hat, masks, and white costume has multiplied so that the whole scene is filled by his clones. On one ceiling (overleaf), a quartet is playing on a rope, on which a bold Pulcinella is nonchalantly swinging above our heads. It feels like a playful parody of the grand aerial paintings that Giambattista had so often painted – with the assistance of his sons – in which gods, saints,

GIANDOMENICO TIEPOLO *Pulcinella Acrobats,* 1797

angels, and virtues float and fly among the clouds. In the domestic version, however, they have been replaced by clowns having a bit of fun.

*

When Giandomenico signed his fresco of '*Il mondo nuovo*' in 1791, the Republic of Venice had just six years to go as an independent state. It fell, or perhaps 'crumbled away' would be more accurate, on 12 May 1797 under a twin threat: French forces commanded by Napoleon Bonaparte and insurrection by Venetian revolutionaries hoping for a more democratic government. It was after this seismic political shock, in which the traditional world seemed to collapse into a pile of rubble and plaster dust, that Giandomenico probably began a set of drawings with the innocent-seeming title *Divertimento per li ragazzi* (Entertainment for children). There were originally 104 of these, but a number have vanished since the series was divided and sold in the 1920s. They are beautiful works, the most powerful and memorable he ever made. A number of them are innocent enough to suggest that they really were intended as a sort of wordless book for the young. James Byam Shaw, author of a standard text on his drawings, thought just that:

> One may imagine that the charming frescoes of similar subjects
> on the walls and ceiling of the villa at Zianigo were popular with
> the neighbouring families; that the children asked for more, and
> that he drew these scenes in the winter evenings, and told their story,
> simply to amuse those children when they came to visit him. I believe
> I am not sentimentalising, in thus taking the title-page inscription at
> its face value.

In some cases, that reading works well. In one, Pulcinella rides a camel, for example; in another, he plays (perhaps unwisely) with ostriches. Much of the narrative concerns his biography. He is born and then nursed (surrounded by grown-up Pulcinella nurses and attendants). Once adult, he tries all manner of careers. He is a tailor's assistant, a performer in the circus, even a painter of mythological pictures just like the Tiepolos, father and son.

GIANDOMENICO TIEPOLO *Frontispiece for* Divertimento per li ragazzi, *c.* 1797

Thus far it might all seem fit for a children's storybook. But the mood is more complicated than this suggests. It is sometimes gentle and playful, but also dark, angry, and despairing. Venetian youngsters of the early nineteenth century may have been tougher than their twenty-first-century successors. But even so, it seems hard to believe that they would have been beguiled by images of Pulcinella being buried, beaten, arrested, imprisoned, exiled from Venice, hung, and executed by a squad of rifles.

The title page makes it clear that this is an elegy or meditation of something that has died. The innocuous words *'Divertimento per li regazzi'* are inscribed on a tomb, contemplated by one surviving Pulcinella. A ladder leaning on the side of the monument implies that he may soon climb into the tomb too. He looks at his own grave and gets ready to enter it.

There were real-life parallels for the grimmer incidents that Giandomenico drew in the period of French occupation. On 23 June 1797, a young sailor named Antonio Mangarini was executed by firing squad in the Campo

di San Francesco della Vigna. Two more Venetians suffered the same fate after a couple of French soldiers were killed in a brawl. Johnson describes how, when a noble and naval commander Niccolò Morosini published a letter criticizing the actions of the Municipality (the Napoleonic successor of the Venetian state), his possessions were seized and he was banished for life. Is this the scene being played out in the drawing known as *Pulcinella's Farewell to Venice*, in which a crowd of well-wishing Pulcinellas and a young woman say goodbye to one of their number, who looks to be departing from the quay near the prisons, with San Giorgio Maggiore in the background?

It is hard to resist the feeling that these drawings are Giandomenico's farewell to the Venetian world that he had known – and perhaps to the world altogether, since he was now more than seventy. Delightful as it had sometimes been in the years before 1797, possibly human existence itself struck Giandomenico as a '*divertimento per li ragazzi*'.

GIANDOMENICO TIEPOLO *Pulcinella's Farewell to Venice, from* Divertimento per li ragazzi, *c.* 1797

THE POET
AND THE EMPEROR

R ight from the beginning of his stay, George Gordon Byron (1788–1824), known more commonly as Lord Byron, took pleasure just from being in the city of Venice. A week after his arrival in November 1816 – suitably enough by night, gliding up a dark Grand Canal – he wrote to his friend Thomas Moore: 'Some three years ago, or it may be more, I recollect your telling me that you had received a letter from our friend Sam, dated "On board his gondola." *My* gondola is, at this present, waiting for me on the canal.' That emphasis on '*my*' hinted at his satisfaction in fulfilling a long-cherished desire. The poet went on to announce that he had decided, 'to remain at Venice during the winter, probably, as it has always been (next to the East) the greenest island of my imagination'.

A little later that winter, Byron proclaimed, 'I am going out this evening – in my *cloak* & *Gondola* – there are two nice Mrs. Radcliffe words for you' – thus revealing the source of some of those Venetian reveries. Ann Radcliffe (1764–1823) had devoted an atmospheric section of her best-selling Gothic novel *The Mysteries of Udolpho* to the city. These chapters were not based on first-hand experience, since Radcliffe had never been to Venice, but recycled from travel books. Evidently, however, though he claimed to 'hate things all fiction', Byron had absorbed and remembered it, and with it the romance of masks and gondolas. He also confessed that Friedrich Schiller's novel *Der Geisterseher*, translated into English as *The Armenian or The Ghost Seer*,

'took a great hold of me when a boy ... I never walked down St. Mark's by moonlight without thinking of it and "at nine o'clock he died!"' This novel concerns a young German nobleman in Venice at carnival time who is shadowed by a mysterious masked figure he calls 'the Armenian', who makes this sinister announcement to the hero and companions one evening in the Piazza San Marco. Perhaps this sinisterly intriguing character prompted Byron's interest in the Armenian language, which he began studying each morning at the monastery of San Lazzaro.

Venice, therefore, had been fixed in Byron's mind long before he first saw it. He expected a place of romantic and phantasmagorical masked revelry. 'It has not disappointed me,' he continued to Moore, 'though its evident decay would, perhaps, have that effect upon others.' Nor was he disappointed by 'the gloomy gaiety' of the gondolas and the silence of the canals.

To Byron, Venice may have been 'a fairy city of the heart', as he wrote in his poem *Childe Harold's Pilgrimage*, but about one thing he was correct in sober fact. In 1816, Venice was in 'evident decay'. Since the French

Engraving from Childe Harold's Pilgrimage, *Canto IV, Stanza 4, 1855*

conquest of 1797, the city and its territory had been occupied and looted, and was now in a deep economic depression. The end of French rule had been accompanied by a naval blockade and a succession of bad harvests. In June 1814, the British consul in Venice reported that, 'the people here are all stagnated and in a very poor way – no mercantile business done here whatever'. A week after Byron's arrival, the situation was, if anything, worse, and the Foreign Office was informed of 'general suffering' and the 'truly deplorable state' of the city. The metamorphosis that had overcome the place was largely the work of one man: Napoleon Bonaparte.

In a letter that Byron wrote to the editor of a Venetian newspaper, he declared himself ambivalent about the defeated emperor. This publication had reprinted an article from a German literary magazine, claiming that Napoleon was Byron's 'idol'. The poet denied it, 'I beg leave to assure you that I am neither admirer nor vituperator of Buonaparte – were I either one or the other I should not conceal it.' However, Byron was being economical with the truth. If not exactly an 'admirer', he was something more complicated and intense. He was bound to Napoleon, his biographer Fiona McCarthy observed, 'by ties as strong, or stronger, than those of any of his sexual liaisons'. In the manner of true fan, the poet amassed a collection of Napoleonic memorabilia, including a lock of Bonaparte's hair, snuffboxes, and a cameo pin bearing his portrait. Once, he wrote a letter on headed paper pillaged from the imperial mansion at Malmaison.

Clearly, to an extent, the poet identified with the all-conquering soldier. Both had attained enormous success rapidly at an early age. Napoleon's was military; Byron's was literary, following the publication of the first canto of *Childe Harold's Pilgrimage* in 1812. But Byron was not the only one to see the parallel, positively and negatively. In 1821, a newspaper paired them as the 'two greatest examples of human vanity – in the present age'. A decade later, the historian and politician Lord Macauley noted that, 'Two men have died within our recollection, who, at a time of life at which few people have completed their education, had raised themselves, each in his own department, to the height of glory.'

Byron's disappointment with his hero was partly that Napoleon was not romantically doomed enough. His *Ode to Napoleon Buonaparte*, written in

1814 after Napoleon's first exile to Elba, laments that the emperor had not – like several Byronic heroes – expired in the ruins of his defeat.

> but yesterday a King!
> And arm'd with Kings to strive—
> And now thou art a nameless thing:
> So abject — yet alive!

When it came to Venice, however, the difference between Byron's emotional, elegiac cast of mind and Napoleon's ruthless practicality became clear. As we have seen, Byron confessed that he did not even dislike the 'evident decay' of the city, a description he obviously relished. His only regret was 'the singularity of its vanished costume'. That is, the inhabitants now wore much the same clothes as Londoners. Evidently, he would have preferred a more picturesquely old-fashioned style of dress. Like so many visitors in the years to come, Byron enjoyed the fact that Venice was *not* modern, not part of the go-ahead, early nineteenth-century society from which he came. He positively preferred its lack of the noise that went with commerce and success – whereas, he supposed, most Londoners would 'miss & regret the rattle of hackney coaches – without which they can't sleep'.

Napoleon, on the other hand, was the first in a long line of would-be reformers, which later included the Futurists, who were determined to drag the place into the modern age. He wanted to rationalize this most irrational of places, systematize its higgledy-piggledy street plan, abolish its ramshackle constitution. Ostensibly at least, he aimed to bring the freedoms of the Enlightenment to this antiquated spot. He announced: 'I shall tolerate none of your Inquisitions, your medieval barbarities. Every man must be free to express his opinions. I will be an Attila for the Venetian Senate [Attila the Hun having tried and failed to conquer the city].' His plan was to transform Venice from the capital of a tottering, outdated empire into a provincial outpost of his pan-European state.

For a while, he succeeded. Napoleon, Robert Holland has written, 'displayed towards Venice an animosity beyond any other military occupation of his entire career'. He did this partly because of his 'accumulating

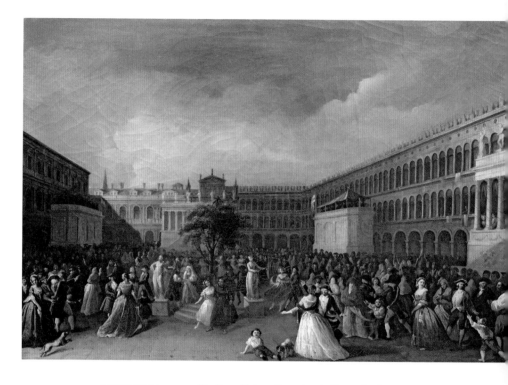

GIUSEPPE BORSATO *The Tree of Liberty Erected in the Piazza San Marco, 1797*

personal power', and also partly because the 'Grand Tour associations' of the place – frivolous, play-acting, aristocratic – 'clashed with everything he stood for': heroic willpower, rationality, efficiency. As Napoleon's armies approached, the city had experienced a rush of change, a metamorphosis that was recorded in paintings by the successor of Canaletto and Guardi. In May 1797, the Great Council voted to abolish the Most Serene Republic of Venice, and the last doge, Ludovico Manin, relinquished power. Instead, for a few months, Venice was ruled by a municipality (Municipalità Provvisoria di Venezia), a government in the spirit of the Jacobins of the French Revolution. Three weeks later, on 4 June, a 'Fair of Liberty' was held in Piazza San Marco. There were four orchestras, dancing around a Tree of Liberty, followed by a *Te Deum* in San Marco. The event was depicted by Giuseppe Borsato (1771–1849), a painter specializing in *vedute* who had

studied under Agostino Mengozzi-Colonna, son of Giambattista Tiepolo's old collaborator Gerolamo Mengozzi-Colonna. To its supporters, this was promised to be a benign transformation. They hoped that Venice would continue much as it had before, but governed in a more democratic manner without the corrupt old senatorial order.

These expectations were quickly dashed. In August, French commissioners compiled a list of works of art that were to be 'harvested'. To Napoleon, it was obvious that the finest pictures and sculptures in the huge territories he controlled belonged in the imperial capital, Paris. The process that followed was a strange blend of museum acquisition, tourism, and raw power. Cynthia Saltzman, author of *Napoleon's Plunder*, points out that the French officials putting the list together seem to have relied on the standard French guidebook, Joseph Jérome de Lalande's *Voyage d'un Français en Italie*. But rather than just admire his top recommendations, they marked them down for looting. It was an early version of Tripadvisor backed by overwhelming armed force.

Among sixteen paintings on the initial roster, no fewer than six were by Veronese, including the *Marriage at Cana* from San Giorgio Maggiore. There were also three Titians and three Tintorettos (later reduced to two, as it was argued that the *Last Judgment* from Madonna dell'Orto was too large to move). Only one Giovanni Bellini, the altarpiece from San Zaccaria, was thought worth taking.

In October 1797, France then swapped Venice and its adjoining areas with Austria, but by the terms of the agreement, the Austrians did not take over until January 1798. In the meantime, Napoleon had issued instructions to remove some more desirable items: 'the Horses of San Marco, the Winged Lion on the column in the Piazzetta, plus all the maps, all the papers pertaining to the Republic of Venice, which can be useful to us, be in our possession'. He also wanted 'all the galleys, cannon boats etcetera from the Arsenale, and the Doge's state barge'. Eventually, the last of these vessels was burnt on an island opposite the Piazzetta San Marco so as to recycle the gold and silver decorations. The treasury of San Marco was also raided and many items melted down. The hero of the mid-nineteenth-century novel that covers these years, Ippolito Nievo's *Confessions of an Italian*,

begins as an enthusiastic supporter of the Venetian revolution, but is rapidly disenchanted. He reflects that:

> Our French friends wracked their brains daily to see what they could pluck from us. Paintings, medals, manuscripts, statues, the four horses of San Marco: all took the road for Paris. We can console ourselves that science had not yet invented ways to move buildings and transport towers and cupolas or Venice would have been left as it was when Attila's first successors came through.

The French returned in 1806, after Austria had been defeated at the battles of Austerlitz and Jena, and governed until 1814. Under their rule, strenuous attempts were made to make Venice a modern and rationally ordered city, which – since it was neither – involved a great deal of demolition. A whole quarter around the monastery of Sant'Antonio – a

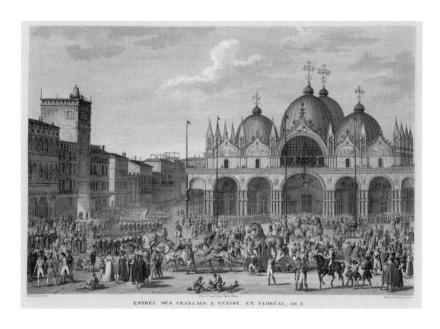

ENTRÉE DES FRANÇAIS A VENISE, EN FLORÉAL, AN 5.

JEAN DUPLESSI-BERTAUX (AFTER CARLE VERNET)
The Horses of San Marco Being Removed, 1797

GIUSEPPE BORSATO *The Entry of Napoleon into Venice, 29 November 1807*, 1807

fishermen's neighbourhood that had featured in the plays of Carlo Goldoni – was razed and replaced by public gardens (part of which eventually became the Giardini of the Biennale).

Napoleon was in Venice, briefly, from 28 November to 8 December 1807. Borsato painted a series of *vedute* depicting his entry and progress down the Grand Canal. He arrived, like so many visitors before and since, at the far end of the canal. There, near the modern-day bus terminal of Piazzale Roma, the architect Gian Antonio Selva had designed a magnificent neo-classical arch, which was placed in the centre of the waterway. The imperial barge passed through this temporary structure on its way to San Marco.

Subsequently, plans were made to transform the buildings around the Piazza San Marco into a suitable imperial palace. This involved the destruction of the fifteenth- and sixteenth-century edifices opposite the basilica and also a church designed by Jacopo Sansovino, San Geminiano. Venetians tried at least to reduce the alterations in the piazza to a minimum. When,

after years of argument and various proposed schemes, the Ala Napoleonica was finally built, it was as unobtrusive as possible – without, for example, the triumphal arch in the centre bearing the name 'Napoleon' in huge letters that was planned at one point. It was completed in 1815, just in time for the Battle of Waterloo and Napoleon's final fall from supreme power. A gigantic statue of the emperor that had been erected in the Piazzetta was quickly removed. More slowly, the works of art began to return.

Napoleon was a divisive figure while he was alive, and – in Venice – remains controversial in the twenty-first century. This was made clear when the statue that had briefly stood in the Piazzetta resurfaced in 2003. It was an eight-foot-high marble carving of Napoleon in the guise of a Roman emperor, heroically nude, holding the world in one hand and lifting his other arm in a gesture of peace. The artist was an indifferent sculptor from Verona named Domenico Banti. The statue was jointly purchased at auction by the French Committee to Safeguard Venice and an Italian bank for $300,000 and presented to the Museo Correr. At which point, fierce controversy erupted, with both Silvio Berlusconi and the separatists of the Northern League weighing in. A mock trial was held in the Doge's Palace. The prosecutor declared: 'Napoleon was a criminal. He raped, sacked, and pillaged. The Republic of Venice had no need of him.' The verdict was guilty.

But the debate as to whether Venice should be preserved or modernized continued long after Napoleon and Byron were dead. Indeed, it is far from over. At first, the supporters of Bonaparte had the best of it. In 1819, a distinguished French official, the comte de Daru, published a seven-volume *Histoire de la République de Venise*. His book was a prime source for what might be called the black legend of Venice. Essentially, his objective was to defend the French destruction of the Venetian Republic on the grounds that it deserved extinction. Daru began by noting with some satisfaction that, 'Venice has disappeared with no hope of returning, effaced from the list of nations … delivered up, exhausted, reconquered and enslaved for always.' This fate was deserved, he argued, because although in origin it was egalitarian and relatively democratic, the city had become a rigid oligarchy that was more oppressive than any other system, whose inhabitants were 'reduced to envying not just free men but even the inhabitants of monarchies'. Daru's

DOMENICO BANTI *Napoleon*, 1808–10

history was greeted with acclaim, not least in Britain. A lengthy critique in the *Quarterly Review* claimed that 'history has no parallel to that silent, mysterious, inexorable tyranny'. With the exception of patriotic Venetians, almost everybody accepted Daru as an authority on the history of the city.

In his two plays on Venetian themes, Byron chose characters who were both pro and anti the Republic. The first of these was *Marino Faliero, Doge of Venice*, written in blank verse in 1820 and published in 1821. This dealt with the fifty-fifth doge of Venice, who was executed in 1355 after an attempted coup d'état. It was the conflict in this ruler between private feelings and public duty that attracted Byron, as he told his publisher John Murray:

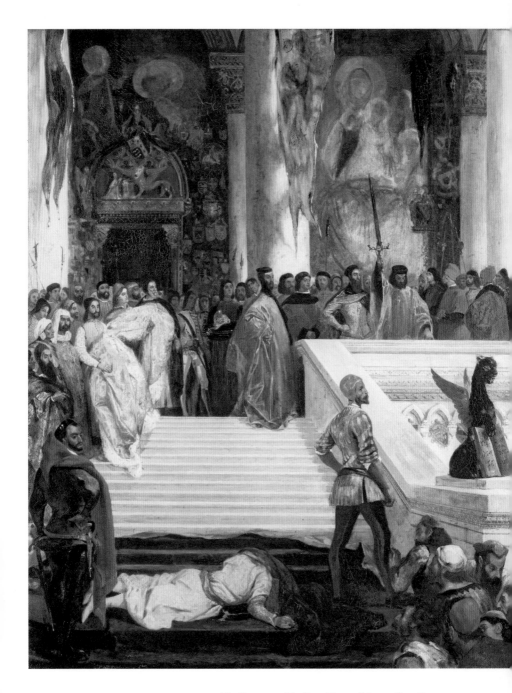

EUGENE DELACROIX *The Execution of the Doge Marino Faliero*, 1825–6

I mean to write a tragedy upon the subject which appears to me very dramatic – an old man – jealous – and conspiring against the state of which he was the actual reigning Chief – the last circumstance makes it the most remarkable – & only fact of the kind in all history of all nations.

Faliero had tried to overthrow the oligarchical Venetian system and become a hereditary prince. But for those, like Daru, to whom the Republic was dark and sinister, the doge was a hero because he rebelled against it. Initially, Byron's interest was fired by the Doge's Palace itself, where he imagined you could still see 'the staircase whereon he was first crowned & then subsequently Decapitated'. This neat combination of glorious rise and fall was the theme of Eugène Delacroix's painting *The Execution of the Doge Marino Faliero*, which was inspired by Byron's drama (via a French play staged in Paris). The picture represents the moment after the doge had been executed, his headless body lying at the base of the Scala dei Giganti in the Doge's Palace, with the executioner holding up his sword from the gallery above.

Delacroix had never been to the city and his architectural setting has only a vague resemblance to the actual building (about which both he and Byron were in any case mistaken; it was built more than a century after Faliero's failed conspiracy). It is possible, however, that the painter had in mind not only fourteenth-century Italy, but France in the 1820s. The painting went down badly at the Paris Salon of 1827, one reviewer making a connection between this scene of an overambitious ruler's doom and the recent coronation of the autocratic Bourbon king, Charles X. In other words, this could be seen as a veiled attack on the restored Bourbon monarchy. Perhaps it was, but Delacroix was fascinated by the overreaching, doomed hero – like Napoleon in Byron's ode, a ruler reduced to 'a nameless thing: So abject' – but, unlike the emperor, very obviously dead.

*

One of the diversions of Venice that Byron particularly enjoyed was the opera. He was a regular member of the audience at Teatro La Fenice, pleased by the cheapness of the entertainment, and also its quality. 'I have a box, which costs me about 14 pounds sterling for the season instead of four

hundred as in London, and a better box and a better opera.' Interestingly, Byron appreciated the visual spectacle as well as the performance: 'besides the music the Scenery is most superb'.

In the early nineteenth century, Venice was still a highly opera-conscious town (and, as we shall see, continued to be). Several of Gioachino Rossini's early triumphs had been at Venetian theatres, including La Fenice. In February 1818, Byron told Murray that he was going to see 'an opera from our "Othello" – and one of Rossini's best, it is said'. He added, 'It will be curious to see in Venice – the Venetian story itself represented.' His own plays with their tragic dilemmas, sexual tensions, and histrionic death scenes, lent themselves to operatic drama. Gaetano Donizetti's *Marino Faliero* (1835) was ultimately based on Byron's work. Act II was set in the Campo Santi Giovanni e Paolo by night; the scenery for the Paris production looked darkly and sinisterly Venetian, but only in general. It did not resemble the actual place in any detailed way at all – except that there is a canal.

LUIGI VERARDI (AFTER DOMENICO FERRI) *Illustration of the Campo Santi Giovanni e Paolo from the opera* Marino Faliero, *Théâtre Royal Italien, Paris,* 1835

FRANCESCO HAYEZ *I Due Foscari*, 1838–40

In the city itself, however, the history of the place was not as easily fictionalized as in Paris or London. Byron's second Venetian play, *The Two Foscari*, was the source for Verdi's opera *I Due Foscari* of 1844. This had a libretto by a Venetian, Francesco Maria Piave, but nonetheless was not performed in Venice in case it offended the Foscari family. The play, written at headlong speed in 1821, concerns another doomed doge, torn between love for his son and duty to the state. As the title suggests, there are two leading characters: Francesco Foscari (1373–1457), the aged doge, and his son Jacopo. Again, the Venetian state is the villain, persecuting Jacopo, who is tried, tortured, and condemned to perpetual exile for treason. His father is obliged to endorse this sentence out of patriotism, but he is a broken man. The Council of Ten orders him to abdicate, which he does – then dies.

There was a feedback loop between literature, the stage, and painting. The story of the Foscari, as related by Byron and Daru, was the source for paintings by Delacroix and also Francesco Hayez (1791–1882). The latter,

one of the major painters of nineteenth-century Italy, was a native Venetian who continued to add the word 'Veneziano' to his signature long after he left the city, so it is not surprising that his versions of the Doge's Palace were more architecturally accurate than Delacroix's (though equally dramatic). He was asked to revise the designs for a production of Verdi's opera. But this was after he had painted the subject more than once.

In Hayez's painting from 1838–40, the condemned son stretches out his arms to his stricken parent, who is a self-portrait of Hayez himself. The doge insists that Jacopo obey the verdict, lamenting that he must put his role as ruler before that of father. Behind Jacopo stands his enemy, Pietro Loredan, stony faced and implacable. It is easy to imagine Francesco Foscari sung by a baritone, Jacopo by a tenor, and Loredan by a bass – as indeed they are at the end of Act II of Verdi's drama.

*

Byron also did much to publicize an enduring Venetian tourist sight: the so-called Bridge of Sighs, which passes over a canal between the Doge's Palace and the New Prisons. In the very first line of Canto IV of *Childe Harold's Pilgrimage*, he mentioned this decorative little structure through whose lacy stonework grills of its windows the prisoners who passed over it caught a last glimpse of the city:

> I stood in Venice, on the Bridge of Sighs;
> A palace and a prison on each hand:
> I saw from out the wave her structures rise
> As from the stroke of the enchanter's wand

When the Hungarian pianist and composer Franz Liszt came to Venice more than twenty years after Byron, he was ostentatiously channelling the poet (whose lifestyle and rock-star-like celebrity he shared). Liszt wrote a series of travel articles describing his experiences, including a public letter to Heinrich Heine, published in the *Gazette Musicale* on 8 July 1838. It began, 'I stood in Venice, on the Bridge of Sighs.'

One of the first to feel the gloomy attraction of the place was the British painter William Etty, who was in Venice in November 1822, six years after

WILLIAM ETTY *Bridge of Sighs*, 1835

Byron had arrived and four since the publication of Canto IV. Etty, too, loved Venice and was especially fascinated by the Bridge of Sighs. He wrote to his brother Walter, describing the unfortunate prisoners who called 'for mercy' but 'were seen no more'. Etty noted a 'little portal by the water's edge' by which 'a black gondola' would slip to pick up the body of a luckless convict whose turn had come to be 'heard of no more'. This was a place where the romantic tourist loved to shudder. Etty reported how, 'Oppressed with suffocating ideas, I gladly emerged from the gloomy cells into life, daylight, and liberty.' In reality, all these notions were – like so much that romantic travellers believed (and still believe) – completely mistaken. As the architectural historian Andrew Hopkins has pointed out, the bridge was built in 1600 to provide various functionaries with 'an efficient means of access to the prisoners' (the latter being taken directly to the cells). The decorative apertures on the bridge were not to allow the condemned a last glimpse of the world, but to give the officials 'light and fresh air'.

While he was in Venice, Etty made sketches of the bridge, and ten years later, he translated these into an ambitious oil painting. When this was exhibited at the Royal Academy of Arts in London in 1835, the critic of the *Morning Post* was immensely struck by the sense of 'indefinable dread' that it instilled in the viewer, above all the detail of the corpse being placed in the gondola with a solitary star in the night sky above. It is scarcely surprising that a few years later, in his Venetian dream, Charles Dickens produced a close equivalent in words to Etty's painting. He saw a cell where:

> I had my foot upon the spot, where, at the same dread hour, the
> shriven prisoner was strangled; and stuck my hand upon the guilty
> door – low-browed and stealthy – through which the lumpish sack
> was carried out into a boat and rowed away, and drowned where
> it was death to cast a net.

Napoleon may have altered the physical fabric of the city, but Byron did as much or more to transform the way people saw it. It was his works that popularized a new way to experience the city: as a supremely suitable place for poetic reverie on decline, decay, and the inevitable changes brought by the passage of time. This was of course a profoundly Romantic theme.

Among many thousands of others, J. M. W. Turner was a keen reader of the poet's works. In 1818, Turner exhibited *The Field of Waterloo* at the Royal Academy with some verses from Canto III of *Childe Harold's Pilgrimage*; he probably read Canto IV soon after it was published in the spring of the next year. Within eighteen months, he was in Venice for the first time, and could see for himself what the poet had described:

> a sea Cybele, fresh from ocean,
> Rising with her tiara of proud towers
> At airy distance, with majestic motion,
> A ruler of the waters and their powers

From 1833 to 1837, and then from 1840 to 1846, Turner exhibited at least one large painting of Venice at each Royal Academy exhibition. But considering how prominent Venice was in his art, it is surprising how little time he actually spent in the city. His three visits amounted to approximately four weeks in all. His first stay was in September 1819, where he was noted as having arrived on the 8th and left for Rome on the 13th. In the intervening days, Turner produced 160 pencil sketches. The fever of work suggests the excitement that the city aroused in him. In addition, perhaps – though the question is controversial – he also made a few watercolour paintings. The Turner scholar Ian Warrell has argued that these were done on the spot (and not, as was often the case, worked up later from drawings and memories). Turner, he writes, 'found time, early one morning, to paint the small group of breath-taking watercolour studies that respond so directly to the special quality of Venetian light'.

Whether or not he managed to paint them entirely *sur le motif*, as the French put it, or added washes afterwards, unquestionably these little pictures register an overpowering visual experience. Turner must have seen it and assimilated what he saw at astonishing speed. But then, this was the perfect place for a supreme exponent of water and light-filled space, and a supreme painter of watery watercolours (if a picture did not work, he advised immersing it in a bucket, so that the pigments would flow and blur).

No one, not Canaletto, not Guardi, not even Titian, had previously conveyed the vaporous delicacy of Venetian light as these watercolours do.

J. M. W. TURNER *San Giorgio Maggiore, Venice*, 1819

The atmosphere seems in them like some delicious liquid (which in a way it is, since the moisture of the lagoon causes that soft, luminous quality). This gives a clue to Turner's originality. He was treating the city as a *land-scape*. In contrast, the eighteenth-century view painters, though they often altered and edited the architecture to make a better picture, were concerned with making portraits of buildings. Turner was far from indifferent to the poetry and history of the place. But he treated the tower of San Giorgio and the distant roofscape of the Lido much as he did another favourite motif: the mountain known as the Rigi, which looms above Lake Lucerne in Switzerland. That is, he regarded it as a slab of stone interrupting or reflecting the rays of dawn. His interest was in the early morning, lapping lagoon, and soft Venetian air. Although his stay was brief, and even if it took him a while to develop fully, Turner had found one of his great themes.

CHAPTER NINETEEN

LOVE IN LIFE:
BYRON, TURNER,
AND GIORGIONE

Turner wrote the words 'Beppo' on three watercolours from his last stay in Venice in 1840, suggesting that he had in his mind Byron's long, comically digressive poem about the carnival and love *Beppo: A Venetian Story*, written in 1817. In one picture, showing the view from his hotel window towards San Marco, he seemed more intrigued by what he could see in the foreground on the roof of the building next door. In amongst its tiles and chimney pot, there are a trio of female heads, perhaps Venetians taking the evening air on their terraces. One of these is wearing a mobcap; a couple more are apparently looking straight at the elderly Englishman sketching in his window just above them, a few yards away. On the back of the sheet is a note reading: 'This b[elongs] to the Beppo Club'.

Evidently the painter, like the poet, was capable of being a voyeur – and also appreciative of local female beauty. Maybe he was thinking of the connection that Byron had made between the women he saw in the city and the paintings of centuries past:

I said that like a picture by Giorgione
Venetian women were, and so they are,
Particularly seen from a balcony
(For beauty's sometimes best set off afar),
And there, just like a heroine of Goldoni,
They peep from out the blind, or o'er the bar;
And truth to say, they're mostly very pretty,
And rather like to show it, more's the pity!

Byron did not only think of Venice as imbued with tragedy and decline. From the beginning of his stay, for him it was a place to have fun: a party city. A week after his arrival, after mentioning approvingly the gloomy silence and 'evident decay' to Murray, he went on to the lively night-time scene in the Piazza San Marco: 'St. Mark's – and indeed Venice – is most alive at night – the theatres are not open till *nine*, and the society is proportionably late.' Furthermore, there was an exciting prospect to look forward to: 'the Carnival too is coming'. When it arrived, Byron plunged into the melée of masking, visits to the Ridotto, late nights, and opera boxes, just like an eighteenth-century rake such as Sir Francis Dashwood. The dissipation of his Venetian life shocked his friend Percy Bysshe Shelley. For other visitors, partly because of Byron's example, Venice was simultaneously a reminder of mortality and decline, and also a city of pleasure, love, and promiscuity.

*

On 14 April 1817, Byron visited the Palazzo Manfrin on the Cannaregio Canal, where a famous collection of paintings could be viewed every Monday and Thursday between ten in the morning and four in the afternoon. The poet, describing this excursion to Murray, played the bluff philistine and claimed: 'I know nothing of painting – & that I detest it.' Nonetheless, he described several pictures that he saw that day in a way that suggested he was susceptible to art. What Byron found in the paintings that he admired was *naturalness*. The work that made the deepest impression on him – to judge by the poetry that it touched off – was an image he refers to as 'Giorgione's wife', which was part of a group then labelled as 'La Famiglia di Giorgione'.

In *Beppo*, he recommends the reader to make a trip to the Palazzo Manfrin, and adds:

> That Picture (howsoever fine the rest)
> Is loveliest to my mind of all the show;
> It may perhaps be also to your Zest,
> And that's the cause I rhyme upon it so;
> 'Tis but a Portrait of his Son and Wife and Self;
> but such a Woman! Love in life!

GIORGIONE *Tempesta*, 1506–8

Here, he thought, was a woman like 'Venetians as it were of yesterday – the same eyes and expression – & to my mind there is none finer'. This was not someone invented out of other art but an actual person, seen freshly and delicately, someone Byron would have liked to meet, seduce, or perhaps purchase like a courtesan.

Considering how much confusion envelops this painter, it is quite surprising that when Byron thought he was admiring 'some fine Giorgiones' at the Palazzo Manfrin, he was partially correct. It is likely that he saw one that is still universally thought to be the artist's masterpiece: the *Tempesta*, or the Tempest. In the mid-nineteenth century, this was certainly known

as 'the family of Giorgione' and was hanging in the Manfrin gallery. A clergyman named Reverend Henry Christmas who visited Venice in 1851, apparently with his copy of *Beppo* in hand, complained that he could not share Byron's enthusiasm. The great painter had depicted himself in apparel 'somewhat brigand-like', and his wife and child in 'nothing at all'. He allowed there was 'much loveliness' in the female figure, but her face was 'in no wise remarkable for expression'. Was this the countenance, Reverend Christmas obviously asked himself, that struck Byron as 'love in life'?

Possibly it was not. There was another work in the Manfrin gallery also sometimes referred to as 'La Famiglia di Giorgione': a run-of-the-mill picture. But there is a reason for believing that Byron would have been affected by the *Tempesta*: in it, Giorgione depicted the kind of person who attracted Byron in reality.

The poet spent much of the summer of 1817 not in Venice itself, but – as wealthy Venetians were in the habit of doing – in a villa on the mainland. He rented one near the village of La Mira, on the bank of the Brenta, some fourteen miles from the city. One evening, he and his friend John Cam Hobhouse were 'sauntering' along the river when they noticed a couple of pretty girls among a group of peasants. It turned out that they were cousins. The younger one was alarmed when Hobhouse made advances, but the other, older woman, Margarita Cogni, made what sounds like a playful pass at Byron. The poet was known for what his biographer Fiona McCarthy called 'considerable if erratic generosity'. So she shouted out, like a beggar asking for spare change, 'Why do not you who relieve others think of us also?' She certainly got Byron's attention. As he put it, in his raffish libertine's fashion, 'in a few evenings we arranged our affairs – and for two years – in the course of which I had more women than I can count or recount – she was the only one who preserved over me an ascendancy – which was often disputed & never impaired'. According to Byron's friend Thomas Moore, she was a woman he had 'picked up in rags &c who was nothing better than what is in vulgar slang called a blowing' (that is, a prostitute). But Byron liked Margarita's earthy gusto (among other qualities); he described her as 'a thorough Venetian in her dialect – in her thoughts – in her countenance – in every thing – with all their naivete and Pantaloon humour'.

In *Beppo*, Byron described the woman in Giorgione's *Tempesta*, if that was what he really saw, as:

Love in full life and length, not love ideal,
No, nor ideal beauty, that fine name,
But something better still, so very real,
That the sweet model must have been the same;
A thing that you would purchase, beg, or steal,
Were 't not impossible, besides a shame:
The face recalls some face, as 't were with pain,
You once have seen, but ne'er will see again.

He wrote those words that summer of 1817, at just the time when he encountered Margarita on the road beside the river.

*

It was partly the example of Lord Byron that drew George Sand and Alfred de Musset to the Hotel Danieli in 1834 – and caused the tension and comedy that ensued. They were two young writers. Sand's real name was Amantine-Lucile-Aurore Dupin de Francueil; she was twenty-nine when they met, he was twenty-three, a diminutive poet, novelist, and dramatist who hero-worshipped Byron, leading his detractors to call him 'le jockey de lord Byron', 'Byronnet', or 'Mademoiselle Byron'. According to Musset's friend Heinrich Heine, early reading of Byron had 'seduced him into affecting in the costume of that lord, the satiety and weariness of life that at that period was the fashion amongst the youths of Paris'. Musset's Byronism no doubt played a part in the choice of Venice as a destination for the lovers.

When they arrived, Sand took to her bed with dysentery, and Musset sampled the city's nightlife, leading to suspected venereal disease. He then became ill with typhoid, whereupon Sand fell for Pietro Pagello, the Italian doctor who was treating him. In a neat feminist reversal of the norm, Sand later wrote: 'The frustrated roué, whose dreams of being a French Lord Byron had been reduced to a few nights of Casanovan dissipation, was now the cuckolded poet-lover and it was (I) who was playing the role of Lord Byron.'

She travelled back to Paris with Pagello, then resumed the liaison with Musset, before they finally broke up in 1835. He wrote an autobiographical novel based on the affair, *La Confession d'un enfant du siècle* (The confession of a child of the century). After his death, she gave her own fictionalized account in *Elle et lui* (Her and him) – to which Musset's brother wrote a response, *Lui et elle* (Him and her), in which the Sand character is the villainess – as did Louise Colet, a later lover of Musset, in *Lui*. These were followed by parodies, one of which was entitled *Eux, drame contemporain, par Moi* (Them, a contemporary drama, by me). Thus another drama, a romantic comedy, was added to the many already associated with the place: an up-to-date one in which both principal characters vied to play the role of amorous poet and each subsequently mined it for literary material.

In 1999, the Musset–Sand romance became the subject of a feature film, *Children of the Century*, starring Juliette Binoche and Benoît Magimel. Just as Venice is an ideal setting for plays and opera, so it is for cinema. We shall soon encounter many other examples.

*

When he looked at Venice, Turner also sensed amorous possibilities in the humid air. The reviewer for the conservative journal *Blackwood's Edinburgh Magazine* was on the ninth page of a splenetic review of the Royal Academy's exhibition of 1836 when he turned his attention to a painting by Turner entitled *Juliet and Her Nurse*. The writer, a clergyman and amateur artist named Reverend John Eagles, had already savaged John Constable's *Cenotaph to the Memory of Joshua Reynolds* before he got on to the subject of this strange masterpiece of Turner's. Everything about it infuriated him. The brushwork was also far too loose and free to please a reactionary taste such as Reverend Eagles's. To him, it looked like a 'strange jumble':

It is neither sunlight, moonlight, nor starlight, nor firelight. …
For the scene is a composition as from models of different parts of
Venice, thrown higgledy-piggledy together, streaked blue and pink,
and thrown into a flour tub. Poor Juliet has been steeped in treacle

J. M. W. TURNER *Juliet and Her Nurse*, 1836

to make her look sweet and we feel apprehensive lest the mealy architecture should stick to her petticoat.

'Amidst so many absurdities', Eagles added, 'we scarcely stop to ask why Juliet and her nurse should be at Venice.' This, however, is an interesting question. Turner was presumably well aware that Shakespeare's *Romeo and Juliet* was set in Verona. But nonetheless, he added a pair of figures standing on a high roof terrace in the lower foreground, whom no one would guess were two characters from the sixteenth-century play.

What Turner has painted is contemporary Venice, from a viewpoint somewhat similar to the one that could be seen from the roof of the Hotel Europa, where he had stayed three years before, in September 1833. From there, it was possible to look down into Piazza San Marco – and that is what Turner has painted – the centre of the modern city at its nocturnal peak of promenading, socializing, and gossiping. Some of the figures, as Ian Warrell

has pointed out, are wearing bicorne hats, suggesting that they are Austrian military officers out on the town. To the right of the square, light pours out from Caffè Florian, the hub of gossip, intrigue, and networking. In his novella *Massimilla Doni*, written in 1837, just after a visit to Venice, Honoré de Balzac described the attraction of the café for inhabitants of the city. 'A great many persons spend the whole day at Florian's; in fact, to some men Florian's is so much a matter of necessity that between the acts of an opera they leave the ladies in their boxes and take a turn to hear what is going on there.' Two of Balzac's characters venture into the interior of Florian's, where they listen to the conversation of some of the superior men of the town, who discoursed the subjects of the day. The most interesting of these was the eccentricities of Lord Byron, of whom the Venetians made great sport. The other main topic was opera.

In Turner's painting, the light radiating from the café may be the result of the gaslights, a recent innovation in the piazza in the 1830s. In any case, Turner has exaggerated it to give a necessary counterpoint to the facade of San Marco. In the distance, fireworks – another popular evening entertainment – can be seen in the sky above San Giorgio Maggiore. In other words, Turner has painted an aerial view of the contemporary city at play, just as Byron had described it twenty years before.

So why drag Shakespeare into it? Turner presumably had in mind Act II, Scene V, in which the nurse reports back on her conversation with Romeo, telling Juliet that he is ready to meet and be a husband to make her a wife – news to bring 'the wanton blood up' into her cheeks. He is reminding the viewer that Venice is a place of amorous intrigue. Turner made his point plainer when the painting was engraved in 1842 by adding a few lines from *Childe Harold's Pilgrimage*:

> But Nature doth not die …
> Nor yet forget how Venice once was dear,
> The pleasant place of all festivity,
> The revel of the earth, the masque of Italy!

*

The Hotel Europa was located in the Ca' Giustinian, also sometimes called the Palazzo Giustinian Morosini, a fine late-fifteenth-century Gothic mansion in a magnificent position at the mouth of the Grand Canal, opposite the Punta della Dogana, with views over the basin of San Marco to the island of San Giorgio Maggiore and across the piazza towards the basilica of San Marco. Among others who chose the hotel were Giuseppe Verdi (it was close to most of the major theatres), George Eliot, and Théophile Gautier. Turner's stay there in September 1833 coincided exactly with that of the vicomte de Chateaubriand, who wrote a lengthy description of the city in Book VI of his *Memoires d'outre-tombe*. Not surprisingly, however, this aristocratic French writer failed to notice – or at least mention – the dumpy, undistinguished figure of the English painter.

On 20 August 1840, Turner checked into the Europa for his second and final stay. He probably did not offer much in the way of elegantly polished company; at meals, he sat with the English watercolourist William Callow, who recalled that the two painters occasionally 'conversed'. For most of the rest of the time, Turner must have been looking hard and drawing. Callow saw him one night, busy as the sun set over San Giorgio Maggiore – which at that point in the year would have been about eight in the evening. Dawn and dusk were, of course, two of Turner's favourite times of day.

During his brief sojourns, he filled hundreds of sketchbook pages with quick drawings and – then or later – painted quantities of watercolours based on these observations. To what extent, if any, those were actually painted in Venice rather than back in London is debatable. But his picture of the room in the Europa in which he slept (overleaf) is a strong candidate for one that was – because it is quickly done, personal, and filled with the thrill of just *being there*, waking up, opening the window, and seeing the campanile of San Marco, the rooftops of Venice, and the waters of the lagoon outside. On the back, he wrote, 'From my Bed Room Venice' – words in which Warrell detected 'almost child-like sense of wonder at his good fortune in being the temporary possessor of the view before him'.

Turner's painting suggests that he must have stayed on the highest, fourth floor of the Europa, which – before the invention of the lift – probably did not contain the grandest rooms, but had other attractions for an artist.

J. M. W. TURNER *The Artist's Bedroom in the Hotel Europa*, 1833

It seems that you could see a wide panorama of the city from its windows. His painting of the room itself has the kind of space-enlarging wide-angle sweep now popular with those advertising Venetian apartments for rent on the internet. As Warrell notes, 'the eye scans in quick succession the stuccoed ceiling, the patterned walls and the open windows'. Through the one on the left, it is easy to spot the campanile of San Marco, and below it, to the side, the shadowy mass of the Procuratie Nuove. We are therefore looking down from the north-east corner of the palazzo, over the roofs of what is now the Hotel Monaco towards the distant form of the Doge's Palace. Recent research suggests that this little painting was probably done during Turner's first stay at the hotel in 1833, in the excitement of occupying such a splendid apartment – and surveying such a magnificent view (that is, a few years before he painted *Juliet and Her Nurse*, with its vista down into the piazza, as noted above, approximately from this vantage point).

'On the right', Warrell goes on, 'bright yellow curtains enclose Turner's bed, perhaps also serving as netting to ward off mosquitoes.' During this visit, he deduces, 'Turner seems to have used the room as a makeshift studio,

though there is no evidence of this in the watercolour, presumably because he was actually sitting at his worktable.' It was evidently done in a hurry (a crease in the paper created a little dry rivulet in the ceiling), and much of what it depicts would only really have been of interest to the artist.

This would have been a bedchamber flooded with light because it seems that there was at least one more window, not visible in the watercolour, but possibly the vantage point for several other rooftop panoramas (unless Turner climbed to the roof terrace above to observe these). One such fabulous little work represents a view north from high at the back of the hotel with a glowing sky behind, palest lemon and airy bluish white. You can feel its delicacy and freshness, mixed with the warmth of the coming day. In the foreground is the bluish-grey shadow of the low block of buildings between the Ca' Giustinian and the church of San Moisè. The bulk of the church and the rear of its Baroque facade with gesticulating statues are touched in with a series of grey and reddish dabs of the brush. To the left, in the distance, is the campanile of Santo Stefano, to the right, the bell tower of San Marco – revealing that this is another wider-than-natural

J. M. W. TURNER *The Campanili of Santo Stefano, San Moisè, and San Marco, from the Hotel Europa,* 1840

panorama. In reality, it would be necessary to turn one's head through 130 degrees to see all three of these monuments. The artist has scrunched the perspective. Why? Not as a preliminary to any painting. Probably he just loved and wanted to preserve this sight and this moment.

The interior of the Ca' Giustinian has been altered a great deal since the mid-nineteenth century, and its function has changed too. Now it is the headquarters of the Biennale di Venezia. But in 2004, before the art festival's staff moved in, Francesco da Mosto explored the empty structure with a film crew in an attempt to track down Turner's bedroom. The best match that he could find to the prospect to be seen through the window in the artist's watercolour was in a long narrow space that at some point, perhaps in one of those subdivisions of which hoteliers are fond in their ceaseless quest to cram more guests into a small area, had been turned into a bathroom. Who would have thought, da Mosto mused, that this place so important in the annals of art 'would end up a *bagno*?' But spaces can have endless functions over time.

*

In 1844, 112,644 tourists visited Venice, only slightly fewer than the permanent residents, who numbered 122,496 the following year. As the years went by, the number of travellers only increased. A few weeks after Turner began his final stay at the Hotel Europa, on 27 November 1840, the Austrian authorities gave permission for an Italian consortium to begin building a railway bridge from Mestre on the shore of the lagoon into Venice itself. This was a remarkable feat of engineering, which utterly transformed access to the city. At 3,600 metres or around two miles long, its 222 arches resting on 80,000 wooden piles, it was the longest bridge over water in the world. It was constructed with impressive speed, being opened to the public just over five years after the go-ahead was given, on 15 February 1846. Never again would visitors, like Byron and Hobhouse, have to arrive on a boat rowed across the water.

The journey became ever more rapid. For a while, those setting out from Paris had to take a train to Turin, via the Mont Cenis tunnel, then change

View of the new railway bridge from Mestre on the mainland to Venice,
from L'Album: Giornale Letterario e di Belle Arti, 18 January 1845

to another from Turin to Venice. But from 1880, there were through trains. As a result, in 1881, the painter Luke Fildes was able to leave London on Saturday night and arrive in time for breakfast on Monday morning.

Tourists and transient visitors such as Fildes, who came to sketch and paint, are often regarded as nuisance, a sort of pestilence that descends on the city. This is an opinion held not only, and understandably, by native Venetians, but also by tourists about other tourists (this horror of encountering other travellers, especially compatriots, goes back to Lady Mary Wortley Montagu's time, if not before).

Yet they – I, we – are part of the history of Venice too. From the nineteenth century onwards, what they have done, written, painted, drawn, and thought about the city has included much that is original, beautiful, and – crucially – triggered by their experience of it. You cannot understand the place or its significance without including the effect and contribution of these temporary Venetians, who woke up with a sense of pleasant surprise at being here.

One visitor to the city who lamented the advent of the railway bridge was John Ruskin. When he approached the city in 1845, travelling for the first time without his parents, hoping to see the distant prospect across the lagoon that he remembered from earlier trips in 1835 and 1841, he was appalled to discover that it had been obscured. The almost completed bridge cut off 'the whole open sea & half the city, which now looks as nearly as possible like Liverpool at the end of the dockyard wall'. It was as if the modern world had flung out a column to attack the place.

'My Venice', Ruskin recalled, 'like Turner's had been chiefly created for us by Byron.' Perhaps that shared reading was why he instinctively accepted Turner's image of the city. In 1836, aged sixteen, sitting one day in his family home at Herne Hill, his eyes had fallen on Reverend Eagles's review in *Blackwood's Magazine* of *Juliet and Her Nurse*. It caused him 'great anger' and he composed a furious rejoinder. It began:

> Many-coloured mists are floating above the distant city, but such
> mists as you might imagine to be aetherial spirits, souls of the mighty
> dead breathed out of the tombs of Italy into the blue of her bright
> heaven, and wandering in vague and infinite glory around the earth
> they have loved. Instinct with the beauty of uncertain light, they move
> and mingle among the pale stars, and rise up into the brightness of the
> illimitable heaven.

This, though rather vague as a description of the painting, suggested a deep sympathy with Turner's vision of Venice. Even so, Ruskin reflected, 'for me, there was also still the pure childish passion of pleasure in seeing boats float in clear water. The beginning of everything was in seeing the gondola-beak come actually inside the door at Danieli's, when the tide was up, and the water two feet deep at the foot of the stairs; and then, all along the canal sides, actual marble walls rising out of the salt sea, with hosts of little brown crabs on them, and Titians inside.' That is, he felt the instinctive thrill that anyone might experience waking up in a hotel room, opening the shutters, and finding Venice outside. In the future, Ruskin's thoughts, words, and pictures of and about Venice were to have as deep an effect on the experiences of generations of visitors as Byron had ever had.

CHAPTER TWENTY

RUSKIN'S STONES

O n 27 November 1849, Effie Ruskin noted that her husband John had been studying the facade of the basilica of San Marco with obsessively close attention (much more than he was devoting to her, his bride, although she does not say so). On that day, he had been 'stretched all his length on the ground drawing one of a series of exquisite alabaster columns surrounded by an admiring audience of idlers'. (Those columns are not alabaster, but marble or porphyry, a mistake that indicates the fundamental incompatibility of the Ruskins.) The intensity and minuteness of his examination of the city had been mounting ever since his first stay in Venice in 1835 and continued to grow. By February 1850, he had begun to amass measurements, diagrams, sketches, and descriptions of San Marco in a dossier, the *St M. Book*, with further large sheets of drawings attached. He brought his own ladders and climbed up the structure to inspect carvings and pillars close up.

'John excites the liveliest astonishment of all and sundry', Effie wrote. 'I do not think they have made up their minds yet as to whether he is very mad or very wise.' Nothing interrupted him, she went on, 'and whether the Square is crowded or empty he is seen either with a black cloth over his head taking Daguerreotypes or climbing about the capitals covered with dust or else with cobwebs'. In the end, he produced more information about San Marco than he was able to cram into even his monumental

three-volume work *The Stones of Venice* (1851–3). On the advice of his father, he rewrote it to make the analysis less formidable to the reader. Even so, Ruskin was haunted by a sense that he still had not properly seen and understood this building. Though he had tried to measure them on the spot, Ruskin could not state the dimensions of its arches with sufficient accuracy, thwarted by 'their excessive complexity' plus the modifications caused by time, 'the yielding and subsidence'.

Ruskin loved this building. But from the very start, he was bothered by its elusiveness – and also its fragility. He had scarcely arrived in Venice for his visit of 1845, aged twenty-six, before he had decided that the city was on the point of disappearing – and so extended his stay for a week, 'to get a few of the more precious details before they are lost for ever'. As it was, he was 'barely in time to see the last of dear old St Mark's'. 'They' were '*scraping* it clean', he lamented, outraged. 'Off go all the glorious old weather stains, the rich hues of the marble which nature … has taken ten centuries to bestow.'

*

Four months before John was lying in the piazza drawing columns, Venice had been subjected to methods of destruction a great deal more drastic and fast-acting than even the most intrusive methods of architectural restoration. On 15 July, the very first air raid in history had been carried out over the city. The *Morning Chronicle* reported how on that day, 'two balloons armed with shrapnels' were released from the deck of an Austrian warship and floated on the wind towards the city: 'exactly at the moment calculated upon, i.e., at the expiration of twenty-three minutes, the explosion took place. The captain of the English brig Frolic, and other persons then at Venice, testify to the extreme terror and the morale effect produced on the inhabitants.'

Apparently, the experiment was not repeated, but it testifies to the ruthless brutality that the Austrians were prepared to unleash on the city. This was a matter of imperial power and control. It had turned out that Venice, far from being merely a picturesque town dedicated to the pleasures of tourists, still contained patriotic citizens who remembered the old Republic – and,

NAPOLEONE NANI *Daniele Manin Announcing
the Republic of Venice*, 1877

perhaps even more, the short-lasting but more democratic Municipality.
In 1847, one of these, a liberal lawyer named Daniele Manin, presented a
petition to the Austrian authorities demanding Venetian home rule. He
was imprisoned for treason, but his action proved timely. It coincided with
a series of revolts against reactionary autocratic governments that broke out
in many parts of Europe and Italy.

On 17 March, the Austrian governor was forced to release Manin
together with Niccolò Tommaseo, a republican from Dalmatia who had
also been imprisoned. They were carried around the piazza in triumph,
a scene represented and romanticized in a painting by Napoleone Nani
from 1877, which shows the exultant crowd passing those ancient columns

that so interested Ruskin. Austrian control of the city collapsed, and a few days after his release from prison, Manin was declared president of a renewed Republic of San Marco. It was not a coincidence, by the way, that he shared a surname with the last doge. His grandfather Samuele Medina was born Jewish but had converted to Christianity in 1759. The sponsor of his conversion was Ludovico Manin and, as was the custom, Medina then adopted his name.

By the end of 1848, the Austrians had regained control of the mainland, but the Venetians were determined to carry on. Even after their most powerful allies, the Piemontese, were defeated at the Battle of Novara in March 1849, the assembly still voted for 'Resistance at all costs!' Crucial to defending the city were the forts on the mainland, and especially Forte Marghera, near Mestre, at the other end of the new railway bridge (which itself therefore became a tactically crucial point in the siege, with troops stationed at the halfway point).

IPPOLITO CAFFI *Bombardment of Marghera on the Night of 24 May 1849*, 1849

In April, the Austrian army began an artillery bombardment of the fort using vast quantities of high explosive. Over the course of a month, seventy thousand shells were fired and five hundred defenders killed. The spectacle as seen from the Venetian end of the railway bridge presented an entirely novel subject to the view-painter Ippolito Caffi (1809–66). The inheritor of the traditions of Canaletto and Francesco Guardi, Caffi produced a new and horrifying variation of *vedute* with his *Bombardment of Marghera on the Night of 24 May 1849*. This looks more like an anticipation of the First World War than a throwback to the eighteenth century. Three days later, on 27 May, the fort surrendered, and at the end of August so did the short-lived Republic of San Marco. A decade and a half later, Caffi's diversion from landscape painter to war artist proved fatal when the ship from which he was observing the Battle of Lissa – a later engagement in the wars of the Risorgimento – was sunk in action, drowning him along with the crew.

This vicious conflict might seem very far from Ruskin's preoccupation with medieval masonry. Its aftermath was of more interest to Effie, who passed the time flirting with Austrian officers (with the result that a loyal friend of one of these later challenged her husband to a duel). There was, however, a deep connection between what Ruskin thought he saw when he looked at those ancient columns and the radical politics that inspired the uprising. When he contemplated San Marco and the other medieval buildings of Venice, he came to believe that he was looking at a concrete physical manifestation of a better way of organizing society.

The uncertainty that Effie reported in early 1850 as to whether her husband was 'very mad or very wise' has never been entirely resolved. *The Stones of Venice* has been described as one of the most brilliant but also 'one of the silliest books ever written about architecture'. Both are true.

The essence of Ruskin's endeavour was that he believed that it was possible to read 'a building as we would read Milton or Dante and getting the same kind of delight out of the stones as out of the stanzas'. Slightly changing the metaphor from poetry to prose, he expressed the same thought in *St Mark's Rest* (1877): 'Great nations write their autobiographies in three manuscripts – the book of their deeds, the book of their words and the book of their art.'

The first remark about stones and stanzas comes early on in one of the most influential pieces of writing Ruskin ever penned: the chapter in the second volume of *The Stones of Venice* entitled 'The Nature of Gothic'. In this, he attempted not only to define this style of building, but to pin down its spirit: what, it seemed to him, it said and what it *meant*. Finally, he wanted to formulate in eloquent words just why it was that Gothic was in every way the most beautiful and profound of all methods of making buildings ever developed by humanity.

'The Nature of Gothic' sounded a deep chord with many of Ruskin's contemporaries. William Morris wrote that it would in future days 'be considered as one of the very few necessary and inevitable utterances of the century'. It was one of the reasons why in mid-nineteenth-century Britain, idealistic young people such as Morris poured energy and imagination into making furniture in the medieval manner, by hand, and weaving tapestries. Ruskin's words also encouraged them to observe the forms of flowers and leaves with careful attention for the purpose of designing textiles and wallpapers for middle-class homes.

In other words, this book – derived from peering at the architectural details of San Marco from a ladder and going round the Doge's Palace contemplating every capital with the closest attention (as Ruskin directed the reader to do) – changed the way people lived. It still does to an extent, affecting everyone who owns William Morris curtains or wallpaper, or walks down the high streets of many British towns. Furthermore, it explains the fact that such unexpected structures as tea rooms in Sunderland and a stock exchange in Melbourne were designed in the manner of fourteenth-century Venetian palaces: the reason is to be found in Ruskin's writings.

In one respect, he was simply engaged in a rebellion against previous generations. *The Stones of Venice* was intended not just to demonstrate the spiritual, moral, and aesthetic greatness of medieval Venice and its buildings, but also to convince the reader of the iniquity and ugliness of what came later: that is, what we call the Renaissance and Baroque periods (which make up much of what is actually to be seen in Venice, and provide many of its most celebrated landmarks). Page after page of Volume III, subtitled 'The Fall', excoriates Venetian architecture of the sixteenth, seventeenth,

and eighteenth centuries, which Ruskin named as 'Roman Renaissance' and 'Grotesque Renaissance', respectively. In the stones of Venice, he deciphered decadence, both ethical and – what to his mind could not be separated – artistic.

The story that he read in these churches and palaces was one of precipitous decline, caused by pride and lack of faith, which, in the format of many a preacher (as he was, in an art-critical mode), Ruskin analysed under separate headings. 'The moral, or immoral, elements' that formed the spirit of Renaissance building were, he wrote, two: 'Pride and Infidelity; but the pride resolves itself into three main branches – Pride of Science, Pride of State, and Pride of System: and thus we have four separate mental conditions which must be examined successively.' And he went on to do so, at length.

The causes of Ruskin's strong and scornful feelings are clear from the way that he introduces Volume III. First, he asks his readers to immerse themselves in the gorgeous spectacle of 'a group of Venetian palaces in the fourteenth century', or indeed any town with substantial Gothic structures surviving, such as Rouen, Antwerp, Cologne, or Nuremberg (this was, of course, long before the bombs of the Second World War fell on all of those). Then, he instructs them to take a stroll down a modern thoroughfare:

> for instance, if in London, walk once up and down Harley Street, or Baker Street, or Gower Street; and then, looking upon this picture and on this, set himself to consider (for this is to be the subject of our following and final inquiry) what have been the causes which have induced so vast a change in the European mind.

Venice, it transpired, foreshadowed the disaster that had overtaken London. Ruskin was born in 1819 in Brunswick Square, a short walk from both Gower Street and Harley Street. The idioms revered and imitated by the generations of Ruskin's father and grandfather, which we call 'Georgian' and 'Palladian', were of course derived partly from Venice and the Veneto, especially Andrea Palladio's *Four Books of Architecture*. In rejecting this, Ruskin and others were doing what young people so often do: condemning their elders and what they had achieved and admired as stupid, flawed, and deeply *wrong*. This is a generational battle that often plays out. What he

and his contemporaries objected to was a world created by their elders that seemed dreary, conventional, mechanical.

Ruskin did not take a political stand at the time of the Republic of San Marco, but he did in the 1860s, when he campaigned against the exploitation of the poor and selfishness of the rich. He believed that the beauty of a building, carving, or painting was inseparable from the enjoyment and freedom that the person who made it experienced while at work. The defects of eighteenth- and early nineteenth-century architectures were the deficiencies of Europe in the midst of the Industrial Revolution. Everything was standardized. Production lines did not yet exist, but factories did. And what Ruskin found in the capitals and columns of a Renaissance palace or church was just what was often complained of in the age of mass-production: every pillar was identical to all the rest, soulless, and – though handmade – looked as if it had been turned out by a machine. This was the initial Renaissance mistake: 'the unwholesome demand for perfection, at any cost'. And he believed the price for this 'manipulative perfection' was steep: 'Perfection is not to be had from the general workman, but at the cost of everything – of his whole life, thought, and energy.'

There had, he argued, been just such a loss. Once a building such as the Doge's Palace had been the creation of a whole society; then the creative roles had been restricted to a few elite 'masters' (such as Palladio and Daniele Barbaro), and all the others reduced to slaves, executing ideas sent down from above: 'We want one man to be always thinking, and another to be always working, and we call one a gentleman, and the other an operative; whereas the workman ought often to be thinking, and the thinker often to be working, and both should be gentlemen, in the best sense.'

Although Ruskin expended the minutest attention, and intoxicatingly eloquent prose, on San Marco, it was not the 'incrusted' Byzantine architecture that he most admired (officially at any rate) but Gothic. The reason why he embarked on writing a three-volume study of architecture in Venice was, at least ostensibly, to reveal the greatest of Gothic to the British reading public. His reason for selecting Venice was only partly the 'magnificence' of its medieval streets. It was what strikes any visitor, indeed what impressed me when I first started strolling through the city: that here

JOHN RUSKIN *Drawing of the St Jean d'Acre*
pillar on the south facade of San Marco, 1879

is a pre-modern European metropolis that is, to an amazing extent, intact. Ruskin acknowledged that other Gothic towns might have been yet more splendid in their heydays, but they had been much more knocked about in the process of modernization. 'She was not supremely distinguished above the other cities of the middle ages. Her early edifices have been preserved to our times by the circuit of her waves; while continual recurrences of ruin have defaced the glory of her sister cities.' Therefore, Venice was the place above all others to discover the secrets of the vanished past.

As we have seen, the city was the epicentre, architecturally, between the cultural currents coming from east, south, and north, which are usually

labelled 'Gothic', 'Romanesque', and 'Islamic', but classified by Ruskin as the 'Lombard', 'Gothic', and 'Arab'. No one before, and perhaps even since, has scrutinized the growth and development of Venetian Gothic arches with quite such single-minded close focus and precision, reminiscent of his great Victorian contemporaries among biologists, such as Charles Darwin or Thomas Henry Huxley.

Ruskin's schematic chart of the evolution of the Gothic arch in the city, which he called 'The Orders of Venetian Arches', still remains useful to scholars more than a century and a half after he drew it (Deborah Howard reprinted it in her comprehensive *Architectural History of Venice*). This minute examination and classification was the counterpart of the soaring prose.

JOHN RUSKIN *Ca' d'Oro*, 1845

Ruskin himself came to have misgivings about the success of the latter. Of his celebrated description of the west facade of San Marco, he noted tartly, 'The words have occasionally been read for the sound of them, and perhaps, when the building is destroyed, may be some day, with amazement, perceived to have been true.'

Equally, though, Ruskin had doubts about his detailed inspections. Just as he wondered whether any drawing or daguerrotype could truly record what was there, so he confessed that his tabulation of rounded arches morphing through multiple ogival, cusped, and pointed forms was a tidied version of reality, in which the differing designs had overlapped and coexisted.

Andy Warhol was once advised to make pictures of what he loved, so he made a series of silkscreen paintings of dollar bills. Just as sincerely, Ruskin drew and painted flowers, rocks, birds, leaves, grasses, meadows, and the stones of Venice. As far as he was concerned, to see something clearly was to understand it. This was an instinctive process of assimilation. By looking hard at a thing, he internalized it, made it part of him. In his autobiography, *Praeterita*, he recalled how on fine days when the ground was dry he used to lie down on the grass and draw the blades as they grew, with the ground herbage of buttercups or hawkweed mixed in among them, until every square foot of meadow, or mossy bank, became 'an infinite picture and possession'.

Drawing and painting thus became a sort of spiritual exercise, the point of which was to pay the closest attention to whatever you were contemplating. In *The Elements of Drawing*, written in the winter of 1856, he proclaimed that, 'I would rather teach drawing that my pupils may learn to love nature, than teach the looking at nature that they may learn to draw.'

It was the same with his pictures of Venice (or, more often, detailed studies of very small bits of the city seen with the closest attention). Ruskin once wrote to his father: 'There is the strong instinct in me which I cannot analyse to draw and describe the things I love – not for reputation, nor for the good of others, nor for my own advantage, but a sort of instinct like that for eating or drinking.' He would like, Ruskin went on, 'to draw all St. Mark's ... to eat it all up into my mind, touch by touch'.

This obsessive absorption turned Ruskin into a highly unusual kind of artist, and – in an eccentric way – a great one. His approach was the

opposite of Canaletto's, so not surprisingly he had nothing but contempt for the master of *vedute*, 'a small, bad painter'. Ruskin had no interest in Canaletto's grand, theatrical, sometimes panoramic effects. To his mind, his eighteenth-century predecessor had just not looked hard enough. 'Professing the most servile and mindless imitation, it imitates nothing but the blackness of the shadows; it gives no single architectural ornament, however near, so much form as might enable us even to guess at its actual one.'

Ruskin's drawing was an act of devotion. 'The greatest thing a human soul ever does in this world is to see something, and tell what it saw in a plain way.' It was also an attempt to preserve what seemed to be vanishing before his eyes. In September 1845, he was 'before the Casa d'Oro, vainly attempting to draw it while the workmen were hammering it down before my face'. He saw his efforts as a desperate doomed act of salvage, 'trying to work while one sees the cursed plasterers hauling up beams and dashing in the old walls and shattering the mouldings, and pulling barges across your gondola bows and driving you here and there, up and down and across'. And he was not wrong: many parts of ancient Venice were threatened with outright destruction or restoration so drastic as to be almost as bad.

Debate about what was valuable about Venice, what should be treasured and what demolished, was not confined to Ruskin and his readers. Since tourism was already one of the city's main industries, it seemed rational to improve the facilities for visitors. As things stood, all the major hotels – the Europa, the Danieli, and so forth – were housed in old palazzi. Surely Venice should offer something more up to date?

Proposals for a newly built complex, offering accommodation, bathing, and entertainment, were made in the early 1840s. After Austrian rule was restored, a local businessman named Giovanni Busetto-Fisola returned to the idea. His proposals were visionary in their way. He suggested that more than half a kilometre of old buildings be torn down along the Riva degli Schiavoni, from the Doge's Palace to the Arsenale. In their place would be an up-to-date resort to rival anything elsewhere in Europe – not just luxury accommodation, but also restaurants, cafés, bars, shops, gardens, and towers from which guests could admire the view and a new piazza. The architect Ludovico Cadorin (1824–92) and the painter Luigi Querena

(1824–87) produced a series of images of the project, rather in the way that contemporary developers produce deceptively attractive 'visualizations' of new shopping centres or skyscrapers. Querena was, like Caffi, a nineteenth-century successor of the eighteenth-century artists who depicted the urban scene. What he painted in this case was a *capriccio* rather than a true *veduta*. In the background, the real city can be seen, but the emphasis is naturally on the proposed development. It gives a notion of what the city could have looked like in the future: it is a glimpse of pompous banality. Cadorin was evidently not a designer who was at ease on such a large scale. Later, he remodelled the interiors of Caffè Florian in a jolly eclectic style well suited to a coffee house. But more than a third of a mile of awkwardly disposed piles of masonry in a jumbled, vaguely historical mishmash of styles would have been another matter.

LUIGI QUERENA *Cadorin's design for the Riva degli Schiavoni, seen from the Ponte Veneta Marina, c.* 1851

It might have happened (and it is not hard to imagine Ruskin's lamentations if it had). As it turned out, the idea was rejected for various reasons. For one, it was too close to the Arsenale, which was still the nerve centre of the Austrian military occupation. But the project was turned down also for more traditional reasons: it would damage the views of the Piazzetta and the Doge's Palace. In other words, exactly the same considerations for which Palladio's and Scamozzi's ideas had been vetoed centuries before.

Subsequently, Busetto-Fisola's thoughts focused on a new site across the lagoon. Mid-nineteenth-century tourism often centred on coastal resorts and sea bathing. A number of bathing places had been set up in the city, including one moored in the Grand Canal opposite Santa Maria della Salute. But Venice also had an enormous stretch of sandy beach, still undeveloped and visited only by the occasional traveller wishing to see the Jewish cemetery or – like Byron – to go for a ride. Before long, buildings very like the ones proposed for the Riva degli Schiavoni began to rise on the Lido: enormous, luxurious pleasure palaces. Cadorin's proposal for the Riva would have looked entirely in place on the Lido.

Lovers of the picturesque glumly noted that the Lido was being developed, or as Henry James put it, 'sadly improved'. With bitter irony, Ruskin quoted a report in the local newspaper of July 1872, whose correspondent had been delighted to discover that, 'this place, only a few months ago still desert and uncultivated' had been transformed into 'a site of delights'. By the turn of the century, the Lido, where Goethe had foraged for marine life, had become one of the smartest and most fashionable holiday destinations in Europe. The massive hotels that had been banned in Venice itself sprang up on this long sand spit, as did luxurious villas and modernizing improvements: the steam ferry whose whistle would so irritate Ruskin, an electric tramline, a boulevard along the seafront, a theatre.

By the 1880s, 160,000 tourists a year were coming here. In many ways, the Lido was the suburb for which there was no scope in the city itself, at least without knocking down what was already there. It was a haven for the wealthy of the world – and also the arty. Eventually, it was itself the subject of literature and pictures.

ENRAPTURED AND REDEEMED: WAGNER AND ELIOT

M any of the travellers who came to the city in ever-increasing numbers spent their time looking at the paintings and monuments of the past. These masterpieces retained a power to catalyse fresh ideas in creative minds (even if these notions would have startled their original creators).

In all, Richard Wagner visited Venice six times, first arriving in August 1858. He reached the city on the 29th and, finding his rooms at the Danieli too small and dark, moved to the Ca' Giustinian, where accommodation was 'almost free for lodgers' in the winter season. Once there, disliking the 'grayish walls' of his main room, he adjusted the décor to suit his tastes.

> I decided to have the large room completely hung with an admittedly
> very cheap dark red wallpaper: this caused a lot of commotion at
> first; yet it seemed worth the effort to go through with it, as I could
> gaze down from my balcony at the wonderful canal with a gradually
> increasing sense of well-being and tell myself that here was the place
> I would complete my Tristan.

In the event, he completed only Act II of the opera *Tristan und Isolde* over the following months; nonetheless, a substantial amount of that masterpiece was written in Venice. Wagner was a person in whose mind the senses merged – what he saw, and also what he touched, apparently affected

GIUSEPPE BORSATO *Commemoration of Antonio Canova in the*
Sala dell'Assunta of the Gallerie dell'Accademia, 1824

the sounds that he conceived in his mind. Bertha Goldweg, the designer
who arranged his apartment in Vienna in 1863, recalled its 'extravagant
splendour in keeping with Wagner's most detailed instructions'. The walls
were lined in silk. On the floor were 'heavy and exceptionally soft rugs in
which your feet literally sank'. The room was lit by 'a wonderful lamp with
a gentle beam'. Wagner remarked to her that, 'he felt particularly at ease in
such a room, as the wonderful colours inspired him to work'.

He was consistent in these demands. At the Ca' Vendramin Calergi, a
fifteenth-century palazzo on the Grand Canal where he died in 1883, he
arranged a 'blue grotto'. Shortly before his death, he confessed to Cosima,
his wife, that he had a 'desire for colours, for perfumes, the latter having to
be very strong', since Wagner took snuff. He described how 'gently glowing
colours influenced his mood', then abruptly changed tack and exclaimed,
'these are my weaknesses' (Wagner was inclined to contradict himself).

In late 1861, he impulsively accepted an invitation from Otto and Mathilde Wesendonck to join them in Venice. This couple were something closer and more awkward than friends of the composer. Otto, a silk merchant, was a passionate admirer of his music; Richard, in turn, was in love with Mathilde. Wagner mused in his autobiography, *My Life*, 'heaven knows what I had in mind when I set off one grey November day to go by rail via Trieste'. But set off he did and stayed in a 'little room' at the Danieli. He found the Wesendoncks 'revelling in enjoyment of the paintings and seemed to have it in mind to dispel my depression by sharing these delights'. Wagner, up to this point, professed to have had no interest in pictures whatsoever.

Nonetheless, Otto 'who was always armed with a huge opera glass, ready to inspect works of art', persuaded him to go along to the Gallerie dell'Accademia. Since its opening to the public in 1817 in the former Scuola Grande della Carità, this had been a prime destination for artistically minded travellers. A painting by Giuseppe Borsato that commemorates the 1822 funerary ceremonies in honour of Antonio Canova gives an idea of what it looked like. The great sculptor's coffin is in front of Titian's *Assunta*, which was surrounded by other masterpieces of Venetian painting (Bellini's *San Giobbe* altarpiece can be glimpsed on the right). This is almost a religious setting, but not quite; the pictures had been taken out of the churches for which they were originally made and placed in a location dedicated to the worship of art. Titian's *Assunta* had been moved from the Frari to the Accademia in 1817, returning to its original location in 1919. The ceiling of the gallery had to be raised to accommodate the seven-metre-high altarpiece; when it was unveiled, Canova called it the greatest painting in the world. Wagner had to admit that, 'despite all my apathy, Titian's *Assumption of the Virgin* made a most exalting impression upon me, so that by this inspiration I found my old creative powers awakening within me with almost their original primordial power. I decided to write *Die Meistersinger*.'

This was a project that he had long been gestating. The idea had come to him sixteen years before while he was taking the waters at Marienbad. He had read a history of German poetry at this time and been struck by the account of Hans Sachs and the sixteenth-century master-singers of Nuremberg. He wrote a draft plot for a comic opera, then put it aside.

Wagner's encounter with the *Assunta* was the prelude to a departure from Venice as abrupt as his arrival and, perhaps, precipitated a remarkable musical idea. After 'four externally dreary days there', following supper with his friends, he suddenly left, much to their 'amazement'. And, as he recalled, he 'started my long and dismal trip back by train on the roundabout land route to Vienna. During this journey I first thought of the musical treatment of *Die Meistersinger*, the poem for which I had retained in my mind only in its earliest form; I conceived the main part of the overture in C major with the greatest clarity.' Doubt has been cast on the notion that the *Assunta* was the trigger for this majestic composition (Wagner implies the connection in his autobiography, but not in his contemporary correspondence). However, there is a link between his music and the picture at a deep formal level. Wagner's overture winds, grand and stately, upwards and upwards; and that in essence is exactly what Titian's great altarpiece does. It is a dynamic spiral in space, climbing from earth to heaven. So it is possible to believe, though not to prove, that the sight of it catalysed musical thoughts that had been forming in his mind for many years.

In Venice, Wagner found himself in an intensely operatic city (indeed, opera was the most popular theatrical form throughout Italy). Admittedly, Venetian performances of his own works were not entirely to his taste; in 1858, he had heard extracts from his operas *Tannhäuser* and *Lohengrin* performed by a military band in Piazza San Marco and was infuriated by the 'dragging tempos'. Giuseppe Verdi was all the rage in the city at the time. His *Ernani* had first been premiered at La Fenice in 1844 and proved an astonishing success. By 1846, it was the most popular opera in Italy, being staged in sixty-five theatres throughout the peninsula (with Rossini's classic *Barber of Seville* coming a distant second). In retrospect, its appeal is partly obvious: it consists of one rousing chorus and knock-the-ball-out-of-the-pitch aria after another. Musically, it is young Verdi at his brilliantly vigorous melodic best. In retrospect, the allure of the drama is less clear. The plot is a barely comprehensible farrago – part tragedy of love and death, part bedroom farce – based on an equally confusing play by Victor Hugo. It is set in sixteenth-century Spain, with a rebellious nobleman turned bandit as a hero. To its earliest audiences, however, it was easily grasped on an

Plate of figures from Giuseppe Verdi's opera Rigoletto, *c.* 1851

emotional level: this was a heady mixture of doomed love and revolt against authority, set to music that was a direct stimulus to the nervous system.

Ernani, and its operatic successors, spilled over into real life. Several contemporaries compared the revolutions of 1848 to the colourful conflicts of the past that they were used to seeing on the stage. To Carlo Leoni, a historian from Padua, the 'glorious events' in Rome and Venice seemed like 'true theatrical performances'; indeed, he felt that they far surpassed those of the Middle Ages. As Carlotta Sorba has pointed out, Italian patriots

FRANCESCO HAYEZ *The Kiss*, 1859

even began dressing like characters in a romantic opera. In particular, the so-called 'Ernani hat', felt with a long feather on one side, become a crucial fashion item during the early years of the Risorgimento. In 1848, these were worn by revolutionaries during the celebrated 'five days' in Milan and subsequently banned by the Austrian authorities. However, feathered hats remained standard accessories for Italian patriots throughout the 1850s. In part, they caught on because the production of Verdi operas was standardized, and this is turn was encouraged by the way that magazines published *figurini* or illustrations of the characters in costume. Thus the visual impact of the operas, and their coded message, spread. This happened with *Rigoletto*, another of Verdi's works premiered at La Fenice, in 1851.

In 1859, Count Alfonso Maria Visconti of Saliceto, a northern Italian nobleman, commissioned Francesco Hayez to paint a work that would symbolize the hopes of patriotic Italians. Hayez produced a picture of a kiss. But it was an embrace containing a symbolic subtext. First, of course, the male figure is wearing an Ernani hat; second, the colours of the couple's clothes – green, blue, red, white – combine those of the French and Italian flags. At this point, Count Cavour and the French emperor had already agreed a secret confederation in 1858 with the aim of expelling the Austrians from Italy – an aim that was eventually successful, although it took another eighteen years to free Venice and the Veneto. In this painting,

A still from Luchino Visconti's film Senso,
starring Alida Valli and Farley Granger, 1954

Hayez managed to combine love, sex, politics, and patriotism in one concise image. *The Kiss* was to become his most celebrated work; he produced another four versions over the next few years. Here, perhaps, he best fulfilled the hope expressed to Canova in 1812 by Count Leopoldo Cicognara, president of the Venetian Academy of Fine Arts, that the eighteen-year-old Hayez might bring new life to Italian painting.

Almost a century after *The Kiss*, Luchino Visconti – a member of another branch of the same noble Milanese family as Hayez's original patron – made a different kind of picture based on the painting: one that moved. His film *Senso* deals with love, sex, patriotism, and politics, but in a more bitterly ironic spirit. It deals with an aristocratic woman, Contessa Livia Serpieri, who has a passionate affair with an Austrian lieutenant. Their kiss has a completely opposite meaning: it is a betrayal of the patriotic Italian spirit.

The film begins with another irony. The opening scenes are set inside La Fenice. As the credits role, we hear the sound of the tenor aria '*Di quella pira*' from Verdi's *Il Trovatore*, Act 3, Scene 2. It ends with a rousing call: '*All'armi, all'armi*'. 'To arms, to arms! here it is / To fight with you, with you to die'. At that point, flyers with the colours of the Italian flag are thrown down from the galleries onto the heads of Austrian soldiers in the stalls. Shortly afterwards, the countess meets her lieutenant in a box and their dangerous, disastrous liaison begins.

<p style="text-align:center">*</p>

Wagner was by no means the only visitor to Venice whose reactions to celebrated paintings might have surprised their creators. Another was a British author, Mary Anne Evans, who wrote under her pen-name 'George Eliot'. She first began to look seriously at art as a reader of John Ruskin. In 1856, Eliot reviewed volumes III and IV of *Modern Painters*, the first volume of which had made its author's name. She was a hugely enthusiastic reader – Ruskin's admitted absurdities aside, she admired above all his eloquent moral seriousness: 'he teaches with the inspiration of a Hebrew prophet'.

George Eliot approached art in a comparable spirit of ethical gravity. And painting was important to her. During her twenty-four years of

non-marriage to George Henry Lewes, together they haunted the National Gallery in London, and visited most of the great collections of Europe, in Munich, Dresden, Madrid, and Paris, among other places. Her tastes, naturally enough, were of her times. Like most Victorians, she revered the Italian Renaissance. Late-fifteenth-century Florence was the setting for her historical novel *Romola*, in which the whimsically eccentric painter Piero di Cosimo figures as a character. In preparation for writing it, however, she studied the crisply naturalistic faces and clothes in Ghirlandaio's pictures.

In the art of the past, she favoured pictures with the Pre-Raphaelite virtues of clarity, naturalism, and clear, bright colour. This taste led her into sharp disagreement with Ruskin on the subject of Tintoretto. Already in 1860, she could scarcely force herself to write a favourable word about him. Even in the Scuola Grande di San Rocco, held to be 'the great scene of his greatness', Eliot 'saw nothing that delighted me in expression, and much that was preposterous and ugly', although she confessed (apparently slightly against her better judgment) that 'one must admire the vigour and freshness of his conceptions'. It seems that she especially objected to the drabness of his colour (accentuated in the nineteenth century by most of his works being covered by stains of candle smoke and dirty varnish).

Describing her reactions to Venetian art in 1860, Eliot picked out, among other pictures, a polyptych painted by Palma il Vecchio from the mid-1520s in the church of Santa Maria Formosa. It had been commissioned by the Confraternity of the Bombardiers, who venerated Saint Barbara, patron of artillery, armourers, military engineers, and all who work with explosives (her father, who martyred her, having been punished with a bolt of lightning). The saint stands in the centre of the altarpiece, cannon at her feet, the largest figure by far. Eliot was struck by her 'calm, grand beauty'. Palma's painting, she went on, was, 'an almost unique presentation of a hero-woman, standing in calm preparation for martyrdom, without the slightest air of pietism, yet with the expression of a mind filled with serious conviction'.

Perhaps Eliot saw Saint Barbara as an image of one of her own heroines. Palma's painting brings to mind Dorothea Brooke, central character of *Middlemarch*, with her blend of moral earnestness, bravery, and self-sacrifice. In the novel (a work that Eliot had not yet written), Dorothea is twice

compared to Saint Teresa, but it is much easier to visualize her resembling this image of Barbara: youthful, steadfast, grasping the palm of martyrdom. Eliot was drawn, one suspects, to pictures of women looking strong and virtuous. Like many other people who saw it, she admired *The Death of San Pietro Martire* more than every other work by Titian (it was destroyed in a fire seven years later, in 1867). But next to this vanished masterpiece, she placed the *Assunta* – and gave it a longer, more careful analysis. It was the robust reality of the Virgin as a woman that most drew her attention:

> For a thoroughly rapt expression I never saw anything equal
> to the Virgin in this picture; and the expression is the more
> remarkable because it is not assisted by the usual devices to express
> spiritual ecstasy, such as delicacy of feature and temperament,
> or pale meagreness. Then what cherubs and angelic heads bathed
> in light! The lower part of the picture has no interest; the attitudes
> are theatrical.

These were by no means the only pictures of heroic womanhood that drew her enthusiastic attention. As we have seen, the Venetian state itself was typically personified as a majestic, regal female figure. Venetian art, consequently, was full of powerful women in dominant roles (whatever their true position in society). And that, rather than religious iconography or political symbolism, was what Eliot saw. In the Sala del Maggior Consiglio of the Doge's Palace, after noting that Tintoretto's *Paradiso* was 'now dark and unlovely', she turned her gaze upwards at Veronese's great canvas in the centre of the ceiling, the *Apotheosis of Venice*:

> which looks as fresh as if it were painted yesterday, and is a
> miracle of colour and composition – a picture full of glory
> and joy of an earthly, fleshly kind, but without any touch of
> coarseness or vulgarity. Below the radiant Venice on her clouds
> is a balcony filled with upward-looking spectators; and below
> this gallery is a group of human figures with horses.

PALMA IL VECCHIO *Saint Barbara*, 1520s

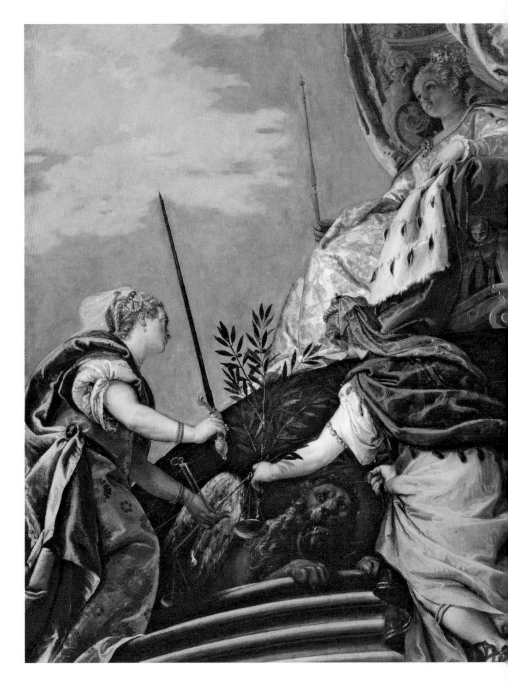

PAOLO VERONESE *Venice Enthroned with Justice and Peace, 1575–8*

Next to that Veronese, her favourite work in the palace was 'another Coronation of Venice on the ceiling of another Sala where Venice is sitting enthroned above the globe with her lovely face in half shadow – a creature born with an imperial'. Everything else in the palace left her 'quite indifferent' and faded from her memory.

Veronese had the power to evoke powerful feelings in Victorians. A couple of years earlier, Ruskin had lost his faith while looking at a picture by the artist in Turin. In religious terms, the great critic experienced a revelation in reverse. He called it his 'unconversion'. Still a moralist, Ruskin had in effect reached the opposite conclusion to Veronese's inquisitor in 1573. It was not that the buffoons, parrots, richly dressed guests, and Germans suffering from nosebleeds were a distraction from the point of the picture. They *were* the point. Ruskin realized that, 'with much consternation, but more delight, I found that I had never got to the roots of the moral power of the Venetians'. And that point was precisely to enjoy all that beauty and vitality.

Typically, Ruskin then went to work to teach himself this lesson, making a careful copy of the painting and had a further revelation, like an aftershock following an earthquake. 'One day when I was working from the beautiful maid of honour in Veronese's picture, I was struck by the Gorgeousness of life which the world seems to be constituted to develop, when it is made the best of.' In a letter to a friend, he reflected that, 'to be a first-rate painter, you mustn't be pious – but rather a little wicked and entirely a man of the world'.

*

On 25 April 1882, Cosima and Richard Wagner paid their customary visit to the Accademia. As usual, they paused in front of the picture that, of all the masterpieces that hung there, meant the most to them: Titian's *Assunta*. It was a work that had a complicated significance for them both, which shifted over the years and was somewhat different for each. The first time that Cosima saw this painting in 1876, it struck her as the closest that visual art could approach to the effect of music. She made an exalted comparison:

It was 'as if I were hearing a Beethoven symphony for the first time'. Later, she was more specific about precisely which symphony. She noted that when they stopped in front of the *Assunta* (which made 'a glorious impression'), she saw that it was 'a totality, rather like the 9th Symphony [of Beethoven]'. One guesses that, as she gazed at the mass of angels, the twisting, soaring figure of the Virgin rising into an even higher cloud of cherubim who seem to be melting into pure, golden light, all this brought the fourth movement, with its choral 'Ode to Joy', powerfully to mind.

Wagner, who had a tendency to reverse his opinions diametrically at frequent intervals, would have none of this, as Cosima recorded: 'R. says, "Oh, we have nothing so perfect in music – that is all experimentation"' (this dismissal presumably included all his own works, as well as Beethoven's and Mozart's). Instead, Titian's altarpiece, at least on that particular day, evoked something more sensual (or at any rate sensuality somehow rising above any actual lust, transcended):

> The glowing head of the Virgin Mary recalls to him his idea
> of the sexual urge: this unique and mighty force, now freed of all
> desire, the Will enraptured and redeemed. He is unable to do justice
> to God, the 'bat', though he feels it is finely painted. However, he is
> captivated by the apostles. What blissful moments do we spend there!
> Every time he regards the head he gives an exclamation of delight.

This brought one of his own masterpieces to mind – not *Meistersinger* but *Tristan und Isolde*, and in particular its ending, the so-called 'Liebestod' (Love-Death), for which Wagner's own preferred name was 'Isolde's Transfiguration'. As Alex Ross explains in his book *Wagnerism*, it was his father-in-law Franz Liszt who came up with the 'Love-Death' tag, where Wagner's intention had been something close to the opposite, 'a seeming death that turns into love'. At the end of the opera, after her lover Tristan has died in her arms, Isolde has a hallucinatory vision that he is still alive. In Ross's phrase, 'a mystic synthesis transpires'. She sees him smile and asks her friends if they do not too. He seems to be rising like Titian's Madonna.

Brighter and brighter
how he shines,
illuminated by stars
rises high?

Isolde hears music emanating from him too:

Do I alone hear this melody,
which wonderfully and softly
[...]
swings upwards,
sweetly resonating
rings around me?

She eventually sinks, 'as if transfigured' (according to the stage direction),
singing, 'In the billowing torrent, in the resonating sound'. In the end, Isolde
will 'be engulfed – unconscious – supreme delight!' On 22 October 1882,
Cosima recorded, Wagner compared Titian's picture directly to his opera.
'R. denies that the *Assunta* is the Mother of God; it is Isolde, he says, in the
apotheosis of love.'

This visit to the Accademia, one of many over the years, was towards the
beginning of Wagner's final stay in Venice. After the first performance of
his opera *Parsifal* at the Bayreuth Festival that summer, the Wagner family
had returned to the city and rented an entire floor of the Ca' Vendramin
Calergi. The previous spring he had said to Cosima that he would like to
die in Venice, and he must have suspected that this would come to pass.
Perhaps Liszt, who joined them for a long stay in Venice that winter, had
a feeling about it too. While at the Ca' Vendramin Calergi, he composed
a piano piece entitled *La Lugubre Gondola* (The funeral gondola), which in
its final version echoed the prelude to Tristan.

For some time, Wagner, who was sixty-nine years old, had been suffer-
ing from angina. At lunchtime on 13 February 1883, he sent word that he
was feeling too unwell to eat. Shortly afterwards, he died of a heart attack.
The event was an international news sensation; reportedly, five thousand

telegrams were dispatched from the city in the following twenty-four hours, presumably mainly by journalists. Reports and lengthy obituaries appeared in newspapers across the world. On 16 February, Wagner's body was taken by water the short distance along the canal to Stazione Santa Lucia. There, as *La Gazzetta di Venezia* reported, it was awaited by most of the Venetian musical and painting worlds. Count Contin, president of the Conservatorio di Musica Benedetto Marcello, made a short speech in German expressing how, 'the Venetian art world was in grief over such a misfortune having befallen art'. Also present were a contingent of journalists and the entire municipal fire brigade. The coffin, 'bronzed in three shades, with a crucifix, cherubs, foliage, lions' heads, in Renaissance style', was placed in a funerary railway carriage, accompanied by three others full of wreaths. Thence it travelled via Vienna to Bayreuth, where the burial took place.

By this date, the association of the city and mortality was a commonplace. Almost a century before, in a poem, Goethe had compared a gondola to a rocking cradle, and the traditional *felze*, or its cabin, to a coffin: the cycle of life encapsulated in one boat. But the momentous demise of this immensely famous composer hugely amplified the theme of death in Venice.

A FAIRYLAND FOR PAINTERS: PICTURESQUE DECAY OR MODERN CITY?

One day in the autumn of 1874, two travellers encountered each other at Caffè Florian. 'I can see that you're a Frenchman', one exclaimed, adding a cri de coeur: 'Heavens how boring it is here!' In comparison with the endless entertainment offered by Paris with its department stores, theatres, open-air dances, restaurants, and cafés, Piazza San Marco might have seemed a little dull. Of course, there were cafés in Venice too, the most elegant and long-established of these being Florian's. But the society of Venetian cafés lacked some of the elements that a Parisian would find at home. In Paris, it was possible to find a meeting place that was public yet frequented by friends and colleagues; somewhere you could drop in and leave at will, and always expect to find like-minded companions with whom to discuss whatever ideas were on your mind.

In the case of the speaker, these were thoughts concerned with painting. He was Édouard Manet, then forty-two and a well-known if controversial figure in the French art world. He had checked into the Grande Albergo (or Grand Hotel), one of the smartest establishments in town, on 13 September, accompanied by his wife Suzanne. The person he addressed was a twenty-three-year-old would-be architect named Charles Toché. After studying architecture, Toché had been on a leisurely archaeological and architectural tour, ending up in Venice. In Manet, he found a mentor, able and willing to talk about the mechanical nitty-gritty of his art: about brushstrokes and

tonal values, and the demanding task of translating the world around into marks on canvas. In Toché, Manet must have discovered what he craved: a listener paying attention as he mused out loud about the problems presented by the pictures that he was trying to make. Suzanne had perhaps heard enough about this subject. James Tissot, who spent time with the Manets in Venice that autumn, had probably listened to similar conversations before. Toché, however, was fascinated. He followed Manet when he went out to work in a gondola, sitting in a second boat and watching the famous painter as he set about depicting what he saw. And, beginning to think of painting as a career instead of architecture, he made notes of their conversations.

He quickly grasped that although Manet made it look easy, the brushstrokes effortlessly just right, almost casual, in reality it was terribly difficult to paint like this. Of a picture of the Grand Canal, sometimes known as *Blue Venice*, Toché noted, 'I don't know how many times Manet started it over again. He spent an inconceivable amount of time on the gondola.' Manet must have worked from a boat moored near the Grande Albergo. In another, even finer picture, he was looking past the watergate of Palazzo Barbaro, from which a worn marble staircase went down to the Grand Canal. Behind the mooring posts, with their cheery diagonal stripes, the Salute is in the distance. In this painting, Manet has managed to convey the quintessential Venetian experience of sitting a foot or two above the water. This is a picture seen from gondola level. The art dealer Ambroise Vollard, also in Venice that September, recalled how the artist made frequent trips by boat to prospect for subjects.

A few years later, the Anglo-American author Henry James noted that the very mention of the name of a place one loves brings to mind 'certain little mental pictures'. When he heard or spoke 'the magical name' of Venice, he simply saw 'a narrow canal' in the middle of the city: 'a patch of green water and a surface of pink wall'.

> The gondola moves slowly; it gives a great smooth swerve, passes under a bridge, and the gondolier's cry, carried over the quiet water, makes a kind of splash in the stillness. A girl crosses the little bridge, which has an arch like a camel's back, with an old shawl on her head,

EDOUARD MANET *View in Venice — The Grand Canal*, 1874

which makes her characteristic and charming; you see her against the sky as you float beneath. The pink of the old wall seems to fill the whole place; it sinks even into the opaque water.

In his imagination, it seems, James saw a painting much like Manet's. Enviously, James felt that painting was a better profession to follow than writing. 'To be a young American painter unperplexed by the mocking, elusive soul of things and satisfied with their wholesome light-bathed

surface and shape' would be 'as happy as is consistent with the preservation of reason'. Even if you were not a painter, he added, 'the mere use of one's eyes in Venice is happiness enough'.

Manet, however, actually being a painter, was conscious of the enormous complexity of translating what he saw into a picture. It was 'devilishly hard', he complained while working on his Grand Canal pictures, 'to give the impression that a hat is sitting properly on the model's head, or that a boat has been constructed from planks cut and fitted according to the rules of geometry'. Toché, fascinated by hearing Manet think aloud, also preserved his friend's reflections on a plan for a picture of a regatta at Mestre, on the shore of the lagoon, where a great mass of boats was assembled on the water. As far as we know, this picture was never actually painted, but when you read Manet's musings about the project, you can almost see it. And you begin to understand how conceptual an art painting really is. Monet's works of the 1870s look fresh, spontaneous, even casual, but actually they are the product of careful thought. First of all, he told Toché, 'faced with such a distractingly complicated scene', he must, 'choose a typical incident and define my picture', as if he 'could already see it framed'. That is, instead of just setting up his easel in front of this kaleidoscopic mêlée of watercraft, passengers, sailors, and sea and flailing away with his brushes, he had to choose some element that would make a picture.

Manet listed the ingredients he had to work with: 'the most striking features are the masts with their fluttering, multicoloured banners, the red-white-and-green Italian flag, the dark, swaying line of boats crowded with spectators, and the gondolas like black and white arrows shooting away from the horizon'. Those gondolas and the other boats, being generally dark, as were their reflections in the rippling sea, provided 'a base' on which he could set his 'watery stage'. On this, he placed his actors, 'figures, seated or in action dressed in dark colours or brilliantly vivid materials, with their parasols, handkerchiefs and hats'. These, too, were a crucial part of Manet's visual scaffolding. For one thing, they could provide what he called the 'necessary *repoussoir*': that is, figures standing in the right or left foreground, framing the central zone. Also, he could make use of the gaps between the figures, which, as he put it, would define 'the specific character

of the areas of water and gondolas that I can see through them'. Then, in the distance on the horizon, appear the islands of Venice and the lagoon, which should not leap to the eye. 'There should be no more than a suggestion of the most distant planes, veiled in the subtlest, most accurately observed tints. … Finally the sky should cover and envelop the whole scene, like an immense shining canopy whose light plays over all the figures and objects.'

Only having puzzled all this out would Manet start putting paint on his canvas. This might be done rapidly and with brio, but also with the skill of a surgeon and precision of a fencer. 'The brushstrokes', Manet insisted, 'must be spontaneous and direct. No tricks, you just have to pray to the God of all good, honest artists to come to your aid!' If luck and those gods had been with him, this would have been a fabulous painting.

<p style="text-align:center">*</p>

Six years later, a British artist named G. A. Storey ran into some other London-based painters at Caffè Florian. One of them was the flamboyant and cosmopolitan American James Abbott McNeill Whistler. They must have wandered from Piazza San Marco down the Piazzetta towards the Riva degli Schiavoni, because at a certain point Whistler saw a potential picture: 'It was moonlight, and the waters shone like silver, the black gondolas looking intensely dark against them. Whistler was in ecstasies of delight – and made three strokes in his notebook. "I've got it" he exclaimed – "That's it – that reminds me of the whole scene."' It is easy to imagine this word-picture as an actual Whistler.

Curiously, it was a painting of a night scene that had forced him to migrate to Venice – that, and the question of applying paint, spontaneously and directly, but with the skill of a master swordsman. Admittedly, there were other contributory factors, including the artist's own recklessness, arrogance, and extravagance. Ruskin's intemperate words were also a crucial factor.

In 1877, freshly returned from a visit to Venice, the great critic had gone to an exhibition at Sir Coutts Lindsay's new Grosvenor Gallery, and his eye fell on a painting by Whistler, *Nocturne in Black and Gold: The Falling Rocket*. This was a brilliant depiction of fireworks in the night sky over Cremorne Gardens, a pleasure park beside the Thames in Chelsea. Whistler had

painted the flaring, bursting flickering, and fading of coloured light against dark sky, smoke, and shadowy trees. He did it by splodges and speckles of pigment that looked as if they might have been flicked from his brush.

Ruskin was outraged. As we have seen, he believed deeply in the value of labour. He wrote a furious attack in a pamphlet in a series he entitled *Fors Clavigera*, which were addressed as letters to working people, intended to transmit his vision to the masses. Whistler's painting, he insisted, was not art but fraud. 'The ill-educated conceit of the artist so nearly approached the aspect of wilful imposture. I have seen, and heard, much of Cockney impudence before now; but never expected to hear a coxcomb ask two hundred guineas for flinging a pot of paint in the public's face.' An irony (noticed by no one) was that this was the accusation made by Vasari and others against Tintoretto, the painter whom Ruskin admired above all others: that he worked too quickly, in a slapdash manner, without the necessary effort.

On reading Ruskin's article, Whistler was equally furious. He sued for libel. And the case *Whistler v. Ruskin* was heard on 25–6 November 1878. The painter claimed damages of £1,000 plus the costs of the action. The jury found in his favour, but with damages of just one farthing; the judge then ruled that each side must pay their own costs. Whistler was ruined and lost his beautiful new dwelling, the White House. Eventually, he was obliged to accept a commission from a London gallery, the Fine Art Society, to make twelve etchings of Venice. For these, they offered an advance of £150 and a total of £700 for the completed plates.

Whistler arrived in Venice on 19 September 1879. At first, he seemed grumpy about this exile, lamenting to his sister about being forced to leave London for 'a sort of Opera Comique country when the audience is absent and the season is over'. It was an unusually severe winter. In December, Whistler reported to the Fine Art Society that he had made himself ill, 'because I rashly thought I might hasten matters by standing in the snow with an [etching] plate in my hand and an icicle on the end of my nose'. In the same letter, however, he declared that he had already 'learned to know a Venice in Venice that the others never seem to have perceived'. This was quite a claim, since Venice had not only been painted for centuries, but constituted a permanent, international artists' colony. But Whistler was

JAMES ABBOTT MCNEILL WHISTLER *Venice*, 1879

serenely, if conceitedly, convinced that he was doing something fresh and new in this most depicted of places. He wrote soon after he arrived: 'The work I do is lovely and these other fellows have no idea! no distant idea! of what I see with certainty.' An art critic named Frank Wedmore put his finger on why this was so. Whistler, he wrote, found 'the shadow under the squalid archway' or 'the wayward vine of the garden' just as interesting as the domes of San Marco, if not more so.

This was perhaps partly because, apart from having a unique eye, Whistler was forced by lack of money (so ultimately by Ruskin) to live in areas in which plaster peeled and archways might be squalid. At first, the painter and his mistress Maud Franklin, a fellow artist, lived in lodgings on Rio San Barnaba, close to Campo Santa Margherita. This was – and still is – a bustling neighbourhood full of local inhabitants going about their business and somewhat off the tourist trail (though there are marvellous things to see thereabouts). Whistler found dozens of subjects within a few minutes' walk: a fish market, beggars standing in a dark passage leading off the campo, a patch of peeling plaster, and worn brickwork above the water of a canal.

JAMES ABBOTT MCNEILL WHISTLER *Giudecca, Venice*, 1879–80

When he wanted to wander further afield, Otto Henry Bacher – one of the students of the American artist Frank Duveneck known as the Duveneck Boys – remembered, Whistler 'would load his gondola, which was virtually his studio, with materials, and the old gondolier would take him to his various sketching points'. This boatman, 'a very handsome sort of man', was called Cavaldoro and hired by Whistler by the month. He 'came to know by his Italian intuition just where James most desired to go. If he did not ride, he would follow his master, carrying the paraphernalia under his arm.'

In the event, Whistler stayed more than a year and produced two sets of etchings, fifty in all, plus around a hundred pastels and about a dozen paintings. In the spring of 1880, he wrote a sort of love letter to the city (actually addressed to his mother): 'After the wet, the colours upon the walls and their reflections in the canals are more gorgeous than ever … and with the sun shining on the polished marble, mingled with the rich toned bricks and plaster, this amazing city of palaces becomes really a fairyland created one would think especially for the painter.'

Certainly the city swarmed with artists. Spanish ones, German ones, American, British, French, Russian: they all worked here. In the autumn

of 1881, Pierre-Auguste Renoir wrote that he had just done a study of the Doge's Palace, while 'six painters were queued up to paint it!' He was at the beginning of a three-month tour of Italy, during which he met Wagner in Palermo and did a lightning portrait of the ailing composer before he grew tired of posing. In Venice, Renoir felt overwhelmed. 'I love the sun and the reflections in the water, and I would travel round the world to paint them. Yet when I actually take up my brush to do so, I realize how powerless I am.'

During his stay there, however, he managed to produce at least one delightfully unusual picture of a hugely familiar scene. Renoir depicted the basin of San Marco in a hazy mist, so that San Giorgio and the Salute have become faint shadows in a looming cloud, touched with gold where the sun is beginning to break through. As a painting – hazy, blurry, made up of quick soft touches – it was absolutely the opposite of the work of John Wharlton Bunney, who, if not one of the six painters queuing up

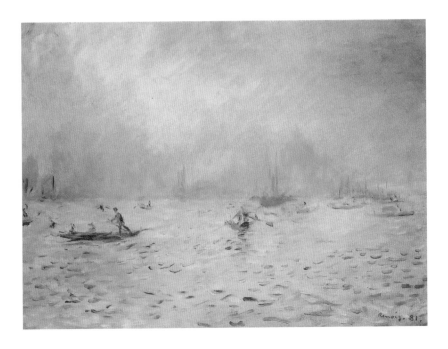

PIERRE-AUGUSTE RENOIR *Venice – Fog*, 1881

with Renoir to paint the Doge's Palace, would almost certainly have been competing for a good spot to work in the piazza.

Bunney (1828–82) was an enthusiastic acolyte of Ruskin's. He had studied under the great man at his Working Men's College, and his loyal dedication was rewarded by a series of commissions that allowed the younger man to give up his job as clerk and embark on a career as a topographical artist. In 1876, Ruskin gave him the biggest job of his life: an enormous study of the facade of San Marco, two and a quarter metres wide by one and half metres high. The fee was considerable, £500, but the labour immense. It required almost six hundred early morning sessions, most *en plein air* with his easel set up in the piazza, spread over six years. The object of the exercise from Ruskin's point of view was to document the appearance of the building in meticulous detail before it was destroyed by 'restoration'.

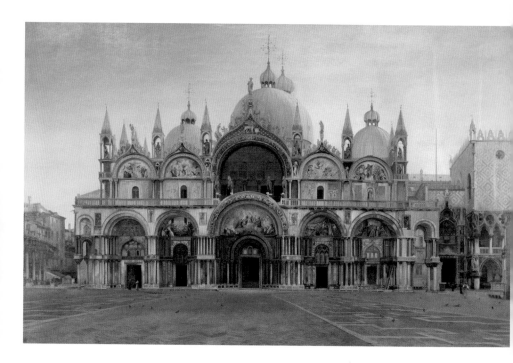

JOHN WHARLTON BUNNEY *Facade of San Marco*, 1876–82

In the summer of 1880, Bunney made some new friends, a newly married couple named Cross. Around teatime on Friday, 11 June, they visited the artist in his studio and viewed his drawings of Venetian scenes (two of which they later bought). At half past nine the next morning, they met him in Piazza San Marco, where he was working on his magnum opus; together they went for a walk to see a painting by Bartolomeo Vivarini. By this time, the three of them were getting on so well that Bunney was emboldened to ask Mrs Cross a question: was she, as someone had told him and his wife, really the famous novelist who wrote under the name George Eliot? She confessed that she was, but asked Bunney to keep this fact 'a profound secret'. The next day, she, her husband John, and Bunney went on a second expedition in search of another painting (Carpaccio's *Two Venetian Ladies*, hailed by Ruskin).

But the newlyweds' stay was cut short. John Cross, twenty years his wife's junior, fell into delirium. On 16 June, he threw himself out of the window of their room at the Hotel Europa (precipitating himself into the sparkling water, gondolas, and mooring posts painted by Manet six years before). Presumably, the Crosses were staying on one of the lower floors, since John was fished out with no ill effects from his dip in the Grand Canal. A week later, the couple departed and, mysteriously, John almost immediately began to recover. Eliot recalled, 'We were no sooner in the railway carriage that took us from Venice than the steady improvement, which has continued ever since, visibly began.'

Quite what the problem was has never been discovered. Perhaps it was the emotional tension of marriage to a personality as powerful as Eliot's; possibly it was a violent allergy to Venice. But although he remembered it later as 'a very fatal place', nonetheless for Cross it still held 'some of the sweetest memories of our short wedded life'.

Allegedly, Whistler, a neighbour of Bunney's in San Biagio, sneaked up behind his fellow artist in Piazza San Marco and stuck a notice on his back. It read, 'I am totally blind.' Bunney was concentrating so hard that he did not realize what had happened. No doubt this prank expressed Whistler's feelings about Bunney's painting and even more about Ruskin's opinions about art. But curiously, though Whistler and Ruskin violently disagreed

about *how* to paint, they were entirely in agreement about what made Venice beautiful: the visible signs of age, the worn surfaces, the peeling plaster: everything that made it look *old*.

Whistler's brushwork was far from being the only topic that roused Ruskin to fury. In 1872, there had been an outburst in *Fors Clavigera* because the noises of the modern world were invading his room at the Hotel Danieli. 'I can't write this morning, because of the accursed whistling of the dirty steam-engine of the omnibus for Lido.' But if Luigi Torelli, the prefect of Venice, had had his way, there would have been a lot more to madden the critic. Torelli was one of many Venetians who wanted to transform their city into a modern metropolis, declaring that Venice must either 'accept and walk with progress, which alone can give prosperity' or be forever left behind. Among other improvements, he proposed a raised road wide enough to take carriages, horses, buses, and pedestrians running along the Riva to the island of Sant'Elena. This was to be supported by six hundred iron columns and flanked by an enclosed area of the lagoon, with seating for the staging of aquatic spectacles. Torelli saw it as the equivalent of the Champs-Élysées or Hyde Park.

He had a point. Venice was an urban fossil, still an almost intact agglomeration of structures ranging from the Middle Ages to the eighteenth century. But how could people live modern lives in such a place? Most visitors, stepping from their hotels, guidebooks in hand, were unaware that this 'fairyland' for painters was also, in part, a poor and insanitary slum. It was a cheap place to live for foreign artists because prices were low, which in turn was because many Venetians did not have much money. This was a fact that could be guessed from looking at the beggars and huddled figures in Whistler's etchings, but it was made heart-tuggingly clear in works by Luigi Nono (1850–1918). The best known of these, *Abbandonati*, depicts a homeless mother and child huddled outside the closed door of a church.

There was numerous proposals for the modernization of the city. Some were actually carried out, including the demolition that created new wider streets such as the Strada Nuova, running from near the station to Santi Apostoli, close to the Rialto. In 1854, an iron bridge was constructed across the Grand Canal next to the Accademia, designed by an Englishman,

LUIGI NONO *Abbandonati*, 1903

Alfred Neville. Drinking water was piped in from the mainland, which reduced but did not eliminate outbreaks of cholera. A steamboat bus service began to run on the Grand Canal in 1881 (causing gondoliers to go on strike). Other schemes – such as new iron bridges from Murano to Fondamenta Nuove, and the continuation of the railway to Piazza San Marco and Giudecca – were never carried out. Still more encountered intense opposition and happened partially, if at all.

Appropriately enough, among the first battlegrounds was the basilica of San Marco. As we have seen, Ruskin had been despairing about the state of this building for decades (see page 342). In the 1870s, a fresh and drastic 'restoration' of the basilica was in progress that caused similar anguish to a Venetian aristocrat, Count Alvise Zorzi. Ruskin wrote an introduction to Zorzi's polemic *Osservazioni intorno ai restauri interni ed esterni della basilica di San Marco* (Observations on the internal and external restorations of the basilica of San Marco), remarking approvingly that it was 'the best thing

I ever saw written on architecture but by myself, and it is more furious than *me!*' Their objection was to the replacement of the original, time-worn stones, and, where that did not happen, their aggressive rubbing with pumice to make them look – the supporters of restoration believed – good as new. Zorzi and Ruskin argued that replacing all the old materials simply produced 'a model' of the original structure, not the real building at all.

William Morris joined in the debate, writing to *The Times*, the ex-prime minister William Gladstone, and the poet Robert Browning, and arguing that San Marco should on no account be altered. But much more important was the discussion that ensued among Venetians. Camillo Boito (1836–1914), author of brilliant short stories and novellas, including *Senso*, the basis of Visconti's film, and also a successful architect, was one of the founding figures of Italian conservation. Stung by a description of Italians as 'barbarians', he made the fundamental point that many of the structures of Venice were on the point of collapse. A few years later, however, Boito presided over the drawing up of a national Italian restoration charter, which stipulated, sensibly, that renovations or replacements should be made only if necessary, with ancient work respected, and the whole process documented.

In Venice, the debate was swinging towards the time-honoured principles of '*com'era, dov'era*' (how it was, where it was). In 1883, a historian, art historian, and eventually politician named Pompeo Molmenti issued a polemic: *Delendae Venetiae* (The destruction of Venice). Why, he demanded, 'reduce Venice to a boring monotonous modern city'? Three years later, when the mayor proposed a scheme for the 'sanitization' of the city and 'the improvement of its viability', Molmenti and his allies returned to the attack, as they did in future years when slum-clearance schemes were proposed. These would have destroyed those crumbling, atmospheric neighbourhoods that Whistler had etched.

Over time, Molmenti and his allies won. Efforts were made to transform Venice into an industrial centre, notably the huge flour mill Molino Stucky, built by a Swiss entrepreneur on the Giudecca between 1884 and 1895. But eventually the mill went bust. Now it is a five-star hotel, the Hilton Molino Stucky. That transformation was emblematic: ineluctably, the picturesqueness of Venice became its principal business.

CHAPTER TWENTY-THREE

'TOO BEAUTIFUL TO BE PAINTED': SARGENT, SICKERT, AND MONET

From the early autumn of 1882, John Singer Sargent's base in Venice was the Palazzo Barbaro. After all, where else would he have stayed? The upper floors of the palace had been rented the year before by his cousin, Daniel Sargent Curtis, a Bostonian lawyer and banker whose wife, Ariana Randolph Wormeley, was the daughter of a British admiral. The Curtises liked this crumbling medieval mansion so much that in 1885 they bought it from the last surviving member of the Barbaro family.

This was a perfect studio and lodging for an artist who was fascinated by the city. Sargent's stays in Venice were frequent, from his first in 1880–1 (he arrived a month before Whistler departed, but it is not known if they met). Over the years, Sargent's pictures of the city – street scenes, interiors, celebrated monuments, out-of-the-way corners – were so numerous that he deserves to be considered at least partly a Venetian painter.

The Palazzo Barbaro (actually a pair of adjoining buildings) is one of the most intact Gothic structures on the Grand Canal. Its beautifully weathered pink stone steps leading down to the water can be seen in Manet's painting from the previous chapter. There, Daniel and Ariana Curtis established a combination of salon and lodging house, both intimate and grand, which was always available for friends and relations to come and stay.

In the following decades, they vied for the leadership of American-Venetian society with Katherine Bronson, a remote relation of Whistler's,

385

whose dwelling, the Ca' Alvisi, was opposite the Salute and had a slightly more spectacular view. Whistler felt that, 'Venice is only really known in all its fairy perfection to the privileged who may be permitted to gaze from Mrs Bronson's balcony.' All the same, as we shall soon see, Claude Monet painted wonderfully while looking out from Palazzo Barbaro.

The aging poet Robert Browning attended soirées at Ca' Alvisi and also at Palazzo Barbaro. Henry James stayed at both. Other guests of the Curtises included Bernard Berenson, Edith Wharton, and the painter William Merritt Chase – by any standards, it was a remarkable circle. In the early summer of 1898, Sargent painted a lasting record of his hosts and the *salone* of the Palazzo Barbaro, scene of so many conversations, meetings, and occasions, including Browning's last public reading. It was a portrait not only of the Curtis family, but also of a marvellous room; Ariana considered the eighteenth-century décor alone justified the price that they paid.

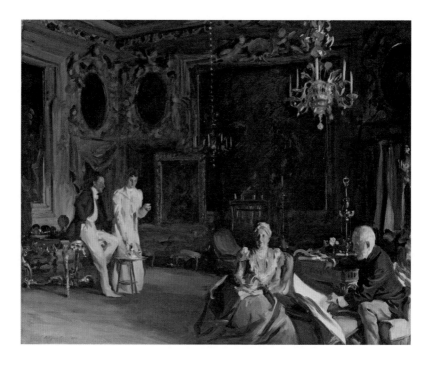

JOHN SINGER SARGENT *Salone at the Palazzo Barbaro*, 1898

The Sargent scholar Richard Ormond has described how, 'streaks of afternoon sunlight, shining through the unseen windows overlooking the Grand Canal, dramatically pick out the figures against the dim encompassing space of the saloon'. On the right, the seventy-three-year-old Daniel is examining a huge folio; next to him is Ariana, 'exuding an air of authority'; and in the background, their son Ralph lounges against a table while his wife pours herself a cup of tea. Above all, it is a depiction of the ambiance of the place, which Sargent loved. He described the palazzo as a fountain of youth, which 'sends one back twenty years, besides making the present seem remarkably all right'.

He intended this little masterpiece as a gift for Mrs Curtis, but she turned it down on the grounds that it made her look too old and her son, too louchely casual. The news that she had declined this present, a painting he 'absolutely & unreservedly adored', sent Henry James into a tizzy. He wrote imploring her to change her mind:

> I can't help thinking you have a slightly fallacious impression of the effect of your (your, dear Mrs Curtis) indicated head & face. It is an indication so *summaire* that I can't think it speaks for itself – as a simple sketchy hint – & it didn't displease me. ... I've seen few things that I ever craved more to possess! I hope you haven't altogether let it go.

But she had. Instead, Sargent presented it to the Royal Academy in London as his diploma piece.

It was during a stay with the Curtises that James finished writing his novella *The Aspern Papers* (1888). This is set entirely in Venice and its plot, inspired by the legends of Byron and Shelley. It concerns the efforts of a scholar to get hold of a collection of letters sent by a wild, Bohemian poet long ago to his lover, who is now an immensely old lady living in dusty penury on a back canal. If the narrative turns on an academic greed for documents, the descriptions of the old lady's palazzo are intensely pictorial. The *portego*, or central hall, for example, possessed 'a gloomy grandeur, but owed its character almost all to its noble shape and to the fine architectural doors, as high as those of grand frontages, which, leading into various rooms, repeated themselves on either side at intervals'. Otherwise, apart from a

JOHN SINGER SARGENT *Venetian Interior, c.* 1880–2

few straw-bottomed chairs, 'old, faded, painted escutcheons', and here and there pictures, 'speciously bad, in battered and tarnished frames that were yet more desirable than the canvases themselves', the vast space was bare.

The art historians Hugh Honour and John Fleming quoted that passage and asked, 'Was James describing an interior he had seen? Or a painting by Sargent?' It is a good question. There are several Venetian indoor scenes by the artist from the early 1880s that are very much like James's room: vast, melancholy, containing little except the light filtering in from the canal outside. The answer might be that, consciously or unconsciously, James had learnt to see Venice like a painting by Sargent – and perhaps not only Sargent.

When the narrator of *The Aspern Papers* first sees this palace, he describes it as 'a house of the class which in Venice carries even in extreme dilapidation the dignified name' (that is, 'palazzo'). Beside it is a garden wall of which he says, 'Blank I call it, but it was figured over with the patches that please

a painter, repaired breaches, crumblings of plaster, extrusions of brick that had turned pink with time.' This sounds like a description of a Whistler. But did James actually have his fellow American's Venetian works in mind? As an art critic, James had been intrigued by Whistler at the time of the Ruskin trial, but amused, ironic, verging on hostile. By 1897, he had come to regard his work as 'one of the finest of all distillations of the artistic intelligence', and the painter himself as a living old master. In the interim, James must have experienced a conversion of the kind that Marcel Proust describes, whereby an artistic innovation at first seems disconcerting and confusing, but slowly over the years one comes to perceive the world in this novel way.

*

In the 1880s and 1890s, Venice was an annex of intellectual Paris, London, Vienna, and Berlin. People met there or perhaps remet. In Hampstead, the writer Israel Zangwill and his wife had been neighbours of the painter Walter Sickert and his first wife Ellen. They were delighted to bump into each other in 1896, when Walter had come to Venice to work.

One day, in an antique shop, Sickert and Zangwill ran into an Australian journalist called Douglas Sladden and his mistress. The four of them ended up having dinner together, Zangwill taking them to a tiny restaurant behind Piazza San Marco. After eating, they strolled over to Caffè Florian and sat at a table outside. The waiter was slow to arrive, so to pass the time Sickert took some charcoal from his pocket and drew a portrait of Zangwill on the marble tabletop. 'It was a bit of a caricature, but by far the best likeness I ever saw of the great Jewish novelist. When the waiter did come, without waiting to take our orders, he went to fetch a damp cloth to clean the table.' Sladden stopped this, but presumably the drawing vanished as soon as they had left.

Subsequently, Sickert painted Zangwill against the highly appropriate backdrop of the Ghetto Nuovo. Zangwill was a feminist, a pacifist, and, for a while, a Zionist, although he later supported the Territorial Movement, which advocated Jewish settlement in places other than Palestine. His parents had emigrated from Poland and Latvia to London, and he was already well known for his novel *The Children of the Ghetto*, published in 1892. Zangwill

later became so associated with this subject as to be dubbed 'the Dickens of the Ghetto'.

Of course, the original Ghetto, from which the word was derived, was the one in Venice. Jews were allowed to settle in Venice under the Republic, which was not the case in all parts of Europe. But they were allowed only to live in this circumscribed area, which was locked and guarded at night. As a result of these restrictions, to accommodate a growing population, the housing blocks in the Ghetto had more storeys than anywhere else in the city, producing the characteristic facades to be seen in Sickert's painting.

Sickert returned to work in Venice for lengthy periods (without Ellen, from whom he had parted because of his incorrigible infidelity). Partly his motive in coming here was financial – he admitted in 1901 that, if he had an income of as much as £100 a year, he would far rather live in London. Venice was a cheap place to live; it was also a reliably lucrative spot to paint.

That is perhaps partly why (although he despised Ruskin) many of his pictures were of that most Ruskinian subject, the west front of San Marco, and quite a number more depicted such equally obvious sights as the Salute or the Rialto Bridge. The other reason might have been because the Venice of shadowy alleys, beggars, crumbly walls, and back canals had been made his own by Whistler – and Sickert had begun as the American's assistant and pupil. At this point, in his late thirties and early forties, he would not have wanted to look like a Whistler clone. But despite some brilliant individual works, such as the portrait of Zangwill, he had yet to find his own, personal Sickertian Venice. He was helped in this search by a spell of bad weather.

The winter of 1903 to 1904 was the rainiest in Venice for forty years. In December, there was a flood, or *acqua alta*, rare in those days. Sickert was obliged to stay indoors. 'It just isn't worth battling with all the elements', he wrote to his friend and fellow artist Jacques-Emile Blanche. 'First of all it would make me ill, and then I wouldn't do anything worthwhile.' That, he went on, was the reason why he had 'only done figure pictures' for his forthcoming exhibition, at the Galerie Bernheim-Jeune in Paris. But perhaps there was more to his change of subject than rainy weather.

In previous years, Sickert had worked in a studio on the top floor of 940 Calle dei Frati, a quiet alley tucked away off a tranquil canal near

WALTER SICKERT *Israel Zangwill*, 1896

the Zattere. On this occasion, he decided to get away from this part of Dorsoduro, 'it smells of the British & the Church of England & Ruskin'. Instead, he found somewhere to stay near a restaurant, the Giorgione di San Silvestro, where he had been a regular customer for some time. Already he had painted a portrait of the proprietor, a wholesale vegetable merchant named de Rossi, in 1901. This man was, Sickert enthused, 'a darling ... so Venetian'. He especially like de Rossi's air of seeming perpetually alarmed: 'his eyes are like two black diamonds or holes burnt in a blanket'. The picture was executed 'with a certain brio and solely for my own pleasure'. He inscribed the canvas, 'al simpaticissimo e genial Sig. de Rossi – l'amico Sickert', and presented it to the sitter.

At the Giorgione, he relished both the food (the menu consisting of Venetian dishes such as *risi e bisi*, a springtime blend of rice and fresh peas) and the clientele. Among the latter was a gondolier, 'the doyen of wholesale

WALTER SICKERT *Les Vénitiennes*, 1903–4

butchers', a maker of iron grills, and various grander customers who had to be carried upstairs on the backs of market porters when the restaurant flooded.

By his own account, it was mostly from the Giorgione that Sickert recruited some 'splendid models'. Among these were some 'very pretty' young women named La Giuseppina and Carolina (the latter nicknamed 'del Acqua', apparently because she did not like water). Both were prostitutes; the pictures in which they featured bore titles such as *Puttana a Casa* (Prostitute at home) and *La Calliera* (Woman of the streets). He began working from these women in 1901, and he did so more intensively in the endless downpours of 1903. After a while, although he kept his lodgings near the Rialto, he started to work again in his top-floor room at Calle dei Frati. He must have liked the seclusion of the space. There, he, La Giuseppina, and Carolina established a cosy routine. He described a typical day: 'From 9 to 4 it is the uninterrupted pleasure of these kind, obliging little models who laugh, to amuse me with smutty talk while posing like angels. They are

happy to be there, and are not hurried. By four I am ready only to close the shutters, lie on my bed and sleep the sleep of the just until seven.' 'Obliging' is an ambiguous and suggestive word. Sickert confessed to Blanche that during that wet winter he caught a dose of venereal disease – so that finally, at forty-three, he could consider himself '*tout à fait* "grown-up"'.

Sickert was also coming into maturity as a painter. For some time, he had concentrated on painting landscapes of Venice and his other favoured base, Dieppe. But many of the most characteristically Sickertian pictures were of figures in shadowy, shabby rooms. Of these, the first was that studio at 940 Calle dei Frati. There, as he related, La Giuseppina and Carolina hung around, chatting, joking, while he made pictures of them and, in time, new recruits, including one known as 'La Inez'. These pictures could almost be defined by the title of a Sickert from a decade later: *Ennui* – boredom. Except that the figures in these works are not bored: they are shooting the breeze, passing the time. He gave them titles such as *Le Tose* (The girls), *Conversations*, *A Marengo* (probably his scrambling of the Venetian expression '*a remengo*', meaning 'to hell with it'). Sometimes one of the models is half-undressed or occasionally naked. Nothing specific ever happens, but there is an implication that possibly an event – perhaps sexual intercourse – might have occurred (or might be about to). These were intimate scenes, as if glimpsed through a keyhole. Before there was a 'Camden Town' Sickert, there were these paintings done on the top floor of an inconspicuous house in Dorsoduro. Perhaps no one had ever relished Venetian lowlife so much.

The winter of 1903 to 1904 was the last season that Sickert worked in Venice, but he understood the importance of what he had done there. In 1920, he wrote to a friend with perhaps only slight exaggeration: 'I regret too late that I painted buildings too much & "from life" ever. If I had my life over again I would have accumulated endless drawings of Venetian life and & movement would have served me to paint from till today.' As it turned out, however, for another painter, the buildings – and even the familiar views of the Grand Canal and Doge's Palace – were still not exhausted as subjects. Yet more masterpieces were to be made from them, paintings as great as any landscape ever painted of the city.

*

Claude and Alice Monet in Piazza San Marco,
6 October 1908

One day in the early autumn of 1908, Claude Monet and his wife Alice stood near the basilica of San Marco in the sunshine. He wore a three-piece tweed suit and check cap; Alice had on a ridiculous hat with a concertina of frills. The Monets were on holiday. Or, at least, they were until Claude began to work once more.

While in London, Sargent had introduced them to a relation of the Curtises, Mrs Mary Young Hunter, who had invited them to join her in the Palazzo Barbaro, which she had borrowed (Daniel Curtis had died earlier that year). Monet – sixty-eight years old, himself celebrated and rich – fitted easily into the elegantly opulent setting depicted by Sargent a few years before. Even so, for many reasons, he had tried his best not to come. For one, he did not want to leave his garden at Giverny. Although he had worked in the south of France, and even once ventured just over the

border into Italy, Monet preferred the light of his native Normandy and the scenery of the Seine. Another disincentive was that Venice was positively infested with painters. He had firmly but unavailingly resisted the whole idea of the trip. 'No', he had told his friend Octave Mirbeau, 'I will not go Venice.' He was still protesting up to the point of their departure on 8 September 1908 – but Alice had prevailed.

On arrival, his first reaction was that as a subject Venice was impossible. 'It is too beautiful to be painted! It is untranslatable.' No one, he told Alice, had ever managed to render it properly. But before long, he succumbed. By 20 October, just under three weeks into the sojourn, he was already planning his next trip. 'One cannot come to Venice', he wrote to a Florentine acquaintance, 'without wanting to return.'

Around 19 October, he and Alice moved along the canal to the Grand Hôtel Britannia. They were in danger of outstaying their welcome: their hostess had already delayed her planned departure for Provence to keep them company. What had originally been envisaged as a short relaxing break had rapidly changed into a relentless, unremitting daily routine of work (which Monet probably enjoyed much more). During the first month, he began between quarter to eight and eight every morning, and quit in the mid-afternoon. In late September, day breaks in Venice approximately at seven in the morning, and the sun sets around seven in the evening, so Monet was making efficient use of the most vital commodity for an artist who worked as he did *sur le motif*: daylight. Alice fretted that he might exhaust himself. 'At his age,' she wrote to her daughter, 'he ought to take greater care of himself.' On the other hand, she was relieved that he was painting something 'other than the eternal water lilies'.

There was the distinction between what Monet was doing in Venice and what he had done for years before. His later work was generally the result of careful thought and was executed according to a governing concept. Often, he took a motif – perhaps something as apparently nondescript as a row of poplars or haystacks in a field – and methodically studied them at different times of day and under fluctuating light conditions. The resulting series, therefore, had an inner consistency. Arguably, the canvases that made it up amounted to a single, multiple work.

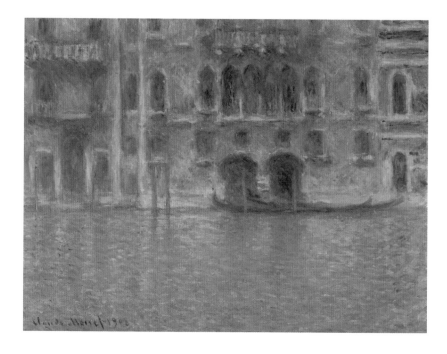

CLAUDE MONET *Palazzo Da Mula*, 1908

What Monet did in Venice was different, as he emphasized when they were finally shown to the public: 'There was not a series among the views, just different motifs repeated one, two, or three times.' He had not planned what he did in advance; indeed, he had not intended to work here at all. He was seduced by the place. To begin with, he barely even chose his subjects. He simply set up his easel on the steps of the Palazzo Barbaro and painted what he saw. The palazzo is on the north side of the canal, just east of the Accademia Bridge (the watergate and steps, where Monet seems to have worked, were the very ones that Manet had depicted twenty-six years before). Straight across the canal, he was confronted by the Palazzo Contarini Dal Zaffo (otherwise known as the Palazzo Contarini Polignac), subject of two pictures. If he shifted his gaze diagonally across the canal, he saw the Palazzo Da Mula, so he painted it twice. A little further away was the Palazzo Dario (subject of four paintings). It was almost as if any fragment of Venice would do. What he was after was not so much any specific struc-

ture or view, but the moist air and light that surrounded them – what he called the 'enveloppe'. Unlike Manet, he made little effort to transmit what it felt like to be at water level in a zone of sparkling ripples and passing boats. What concerned him most was what lay *between* his eyes and the solid buildings of the city – or even the surface of the canal. As a landscape painter who worked – partly at least – outdoors, the weather was at once his subject and a professional problem. Too much wind or rain and it might be impossible to carry on. As it was, fortunately, with the exception of a little rain, conditions were ideal that autumn, as he told the dealer Gaston Bernheim towards the end of November. 'Just a little cold in the morning, but so beautiful that there's no time to worry about it.'

After the move to the Grand Hôtel Britannia, he extended his range of views to include the San Giorgio Maggiore and the Doge's Palace – both seen from the quay in front of San Giorgio and from a gondola in the water off Piazzetta San Marco. But the essential subject did not alter: the moist

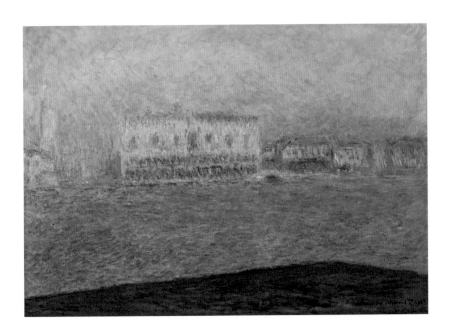

CLAUDE MONET *Doge's Palace seen from San Giorgio Maggiore,* 1908

haze that enveloped the city. In the five pictures of the Doge's Palace seen from San Giorgio Maggiore, the medieval building seems to be dissolving into a misty cloud of pinkish and apricot-coloured light.

The Monets finally departed on 7 December. That day, Monet confessed that his enthusiasm for the place had only grown. 'The moment has now come to leave this unique light. I grow very sad. It is so beautiful. ... What a dreadful shame that I did not come here when I was young and would dare anything! ... The only consolation is the thought of coming back here next year.' But the Monets never did go back. The reasons were first of all practical: on his return to France, he was obliged to finish, review, and select a large array of water-lily pictures for an exhibition in May. After that effort, and the spurt of work in Venice, he was exhausted and did little for a while.

The following year, he contended with a flood that endangered his beloved garden. Then Monet was struck by a much greater disaster. Alice fell ill with a form of leukaemia and died on 19 May 1911. When he recovered from the crushing grief and depression that this caused, the works he turned to were the Venetian paintings that he had brought home three years before. There are thirty-seven of them in all, although some were possibly not even begun when he and Alice departed. And, the Monet scholar Paul Hayes Tucker conjectured, few if any were finished.

This perhaps accounts for the elegiac mood of these pictures. They feel more like meditations on the city than direct transcriptions of experience, worked over in the studio at Giverny by a melancholy widower. Perhaps Monet, if he had come to Venice as a young painter like Manet, would have painted the light and dazzle of a moment on the Grand Canal. But Monet's paintings of the water steps of the Palazzo Barbaro are very different: the waters shimmering but dark, the walls shadowy, and the watergates darkly mysterious like the entrances to caverns. So too – in another way – were the images of the Doge's Palace almost dematerialized in light and haze. As Monet put it, with touching simplicity, these were 'souvenir[s] of such happy days passed with my dear Alice'. But his finished pictures were also permeated by a sense of loss. Visitors to the exhibition at Galerie Bernheim-Jeune in March 1912, where they were shown, might have seen his Venetian *vedute* as examples of that increasingly common theme: death in Venice.

CHAPTER TWENTY-FOUR

MODERNISM ON
THE GRAND CANAL

Of course, not everybody loves, or even likes, Venice. Over the years, there been have plenty of Veneto-phobes, from Edward Gibbon, to whom it famously afforded 'some hours of astonishment and some days of disgust', to D.H. Lawrence ('an abhorrent green, slippery city'). Montesquieu confessed, 'My eyes are very pleased with Venice; my mind and heart are not.' It is often the elusive slippery irrationality of the place that annoys (as perhaps it did Napoleon). In her pair of Italian city portraits, *The Stones of Florence* and *Venice Observed*, Mary McCarthy came down decisively in favour of the Tuscan town. To her, Florence was a proto-New York, hard-headed, clear-cut. Venice on the other hand was a place of illusion, empty facades like stage sets. The rationalist mind, McCarthy noted, 'has always had its doubts about Venice'. Among the many spells the place casts, she goes on, is one 'of peculiar potency: the power to awaken the philistine dozing in the sceptic's breast'. Naturally, this place that had been so venerated by lovers of the antiquated and medieval was anathema to modernizers and modernists alike.

The Futurists certainly loathed Venice – at least officially. In April 1910, a quartet of the group's leaders signed a manifesto entitled *Contro Venezia passatista* (Against Venice mired in the past). This polemic began: 'We repudiate the old Venice, enfeebled and undone by centuries of worldly pleasure, though we too once loved and possessed it in a great nostalgic dream.'

The leaflet then continued to call for a futuristic and powerful city in place of the existing one:

> We want to prepare the birth of an industrial and military Venice that can dominate the Adriatic Sea, that great Italian lake. Let us hasten to fill in its little reeking canals with the ruins from its leprous and crumbling palaces. Let us burn the gondolas, rocking chairs for cretins, and raise to the heavens the imposing geometry of metal bridges and factories plumed with smoke.

On 8 July, the poet Filippo Tommaso Marinetti and the artists Carlo Carrà, Umberto Boccioni, and Luigi Russolo dropped the first batch of these leaflets from the Torre dell'Orlogio in Piazza San Marco opposite the campanile, which had collapsed in 1902 and was being meticulously re-erected exactly as it had been before. In all, 800,000 copies of the Futurist pamphlet were printed. This was followed up by a 'Speech Against the Venetians' by Marinetti at Teatro La Fenice. Though the wording was deliberately provocative, and probably penned by the aggressively self-publicizing Marinetti, many of the sentiments were conventional. As we have seen, there had been calls for canals to be filled up, and for the building of factories and iron bridges, since the mid-nineteenth century.

Afterwards, little attention was paid to the Futurists' demands (although Marinetti claimed, implausibly, that the pigeons were too frightened to return to the piazza for days). From the vantage point of the twenty-first century, it is the Futurists themselves who seem old-fashioned with their enthusiasm for pollution ('factories plumed with smoke') and petrolhead's love of the internal combustion engine.

However, in the years that followed, without filling in the canals or burning the gondolas, the city came to coexist equably with the world's avant-garde. This happened largely because of the evolution of the Biennale d'Arte, the first of which was held in 1893. Doubtless it was no accident that the ninth edition opened on 22 April 1910 – a few days before the Futurists composed their outrageous manifesto. Indeed, the whole affair can be seen as an early example of a Biennale publicity stunt.

That year, Luisa, Marchesa Casati Stampa di Soncino, the estranged wife of a Lombard nobleman, took a palace on the Grand Canal: the Palazzo Venier di Leoni, known as the *palazzo non compiuto*, or the unfinished palace. This building was destined to play a major role in the story of modern art in Venice through much of the twentieth century and into the twenty-first.

The marchesa created an immediate sensation. In part, this was through the décor of her palazzo, which was entirely black and white except for one room in gold, with gold lace curtains and a staircase of verdigris. Accounts of this interior evoke the idiom of contemporary Viennese architects, such as Josef Hofmann and Otto Wagner; art nouveau merging into modernism. It would have made a good setting for Richard Strauss's decadent modernist masterpiece of an opera, *Salome*. The building was a mise en scène, in which the star performer was herself. One visitor described the marchesa appearing, her eyes outlined in black. 'As she advanced to meet us she carried a lily in one hand, with the other she led by a chain a small lioness.' (Actually, this was a pet cheetah, one of the marchesa's most spectacular living accessories.) The writer J. B. Priestley recalled that she ran what almost amounted to a zoo in the garden, including big cats, parrots, peacocks – and albino blackbirds whose feathers could be dyed whatever colour she desired. There was also a pair of hounds, one black and one white, to match the colour scheme.

The British writer Cecil Roberts saw her promenading Piazza San Marco, 'death pale, scarlet cloaked', as 'exotic as an Aubrey Beardsley'. She was accompanied by a servant of colour with one of her cheetahs on a lead (at other times, she led the creature herself on a jewelled leash, while a second servant held blazing torches above her). You can dismiss such behaviour as 'bad theatre' (as one guest did), but performance it clearly was. When she passed down a canal, 'fantastically dressed', with a parrot on one arm and two monkeys held by an attendant, spectators applauded from each bridge.

The marchesa's clothes were astounding to begin with and grew ever more so with time. She was an early adopter of Fortuny gowns, but dropped these when too many others took them up. Mariano (or Marianito) Fortuny (1871–1949) was an artist and designer of textiles, stage sets, and clothes, son of a celebrated Spanish painter, but resident for most of his life in Venice. The first and most famous of all his clothes was the Delphos gown, based

on ancient Greek sculptures such as the Charioteer of Delphi. Its effect was at once classical and liberating; the wearer effectively became a living work of art. The secret lay in the method by which the silk was pleated, rendering the fabric both shimmering and elastic, a technique devised by Fortuny's wife, Henriette Negrin, and patented in 1909. This, then, was an absolutely modern creation, but one that strongly suggested the past. It was not surprising that Fortuny was worn by many creative and free-spirited women of the twentieth century, among them the dancer Isadora Duncan, actress Eleonora Duse, and – later – Peggy Guggenheim. But the marchesa quickly moved on to yet more outrageously unconventional outfits.

There are accounts of her parading in the piazza totally naked except for a fur coat. She quickly got to know Sergei Diaghilev and his associates when they arrived in Venice, and took on Diaghilev's stage designer Léon Bakst as her costumier. Thus she moved her personal style from late art nouveau to the Ballets Russes. As Casati's biographers Scot Ryersson and Michael Yaccarino point out, there is no distinction between her fancy dress and everyday wear. Despite his comparison with Beardsley, Roberts went on to describe the effect of encountering her with her cheetah, costume, and servant as 'pure Tintoretto'. He could just as well have said 'pure Veronese' or 'pure Tiepolo'. One of Bakst's creations was a fantasia on a traditional Arlecchino bianco costume, with oversized white buttons and – at least in a photograph taken of her wearing this outfit around 1913 – a parrot on her wrist in the manner of a Tiepolo portrait. Bakst also depicted her as a sort of Venetian mermaid, wearing a peacock-feather skirt and nothing else, with the lagoon at fiery sunset as a backdrop.

Although spectacular, Luisa's Venetian years were brief. She moved away for much of the First World War, and relinquished the palazzo in 1924. Even so, there was always a great deal about how she acted that was in the spirit of the place: the blending of ordinary life into theatre, love of masks and disguise, and the devotion to flamboyant spectacles, the more extravagant the better (for some parties, she managed to take over the Piazzetta). The marchesa was a hard person to ignore – and also to define. Performer, extreme fashion victim, eccentric attention-seeker. A work of art in herself, she was the subject of innumerable works by others. A selection of the

LEON BAKST *Portrait of Marchesa Luisa Casati*, 1911

artists who portrayed her in one medium or another includes the Futurist Giacomo Balla, Giovanni Boldini, the master of racy turn-of-the-century swagger, Jacob Epstein, Augustus John, and Man Ray. A painting by Alberto Martini portrayed her, red hair piled up like a Mayan headdress, apparently at the moment of transition from human into a butterfly. She was perhaps also metamorphosing from human being to art work, but fifty years before Gilbert and George talked about being 'living sculptures'. As time has gone on, she has been taken more seriously. Designers such as John Galliano, Karl Lagerfeld, and Alexander McQueen have designed clothes in tribute to her; she has frequently been compared to Lady Gaga, who has also paid homage. An opera has been written about her, and there – perhaps more than any other, more prosaic medium – is where she belonged.

Casati's wandering life took her to Paris, St Moritz, Capri, and Rome, before she died in London in 1954, penniless since she had spent her fortune on parties, clothes, and cheetahs. But her greatest days were in Venice.

*

As Margaret Plant observed in her study of Venice in the nineteenth and twentieth centuries, the drastic proposals made by the Futurists in their leaflets and speeches were not as novel as they might seem. What is more, much of this programme was put into action in the following years, but with a crucial difference. Rather than demolishing and rebuilding the historic city, the (eminently practical) decision was made to preserve it as an attraction for upmarket tourism, while developing in areas that elsewhere would be suburbs and outskirts: on the Lido and around the shores of the lagoon.

Little happened during the First World War, but by 1928 when welcoming the world's press to the sixteenth Biennale d'Arte, Count Pietro Orsi, podestà of Venice, was able to point out that, 'Venice has finally solved the question of having an intense industrial life without jeopardizing the safety of the historic centre, by shifting all the equipment outside the lagoon.' Four years later, in 1932, the *Corriere della Sera* recommended a climb to the very point from which the Futurists had dropped their provocative manifestos: the clock tower in Piazza San Marco. From there, in one direction one could see the new, enlarged, and improved bridge across the lagoon, and on the shore the freight and industrial complex at Porto Marghera; while towards the Adriatic, one's gaze fell on the Lido, 'nowadays a model European beach resort'. The newspaper attributed these achievements to 'a pure act of Fascist will'. But in reality Mussolini had much less to do with the transformation of the city than Giuseppe Volpi, count of Misrata (1877–1947). He more than anyone conserved twentieth-century Venice as a destination the attractions of which, apart from those beaches, were cultural.

Although he worked closely with the Fascist regime, Volpi was a more traditional figure: a trader, entrepreneur, politician, and wheeler-dealer who accumulated a huge fortune and, with it, great power. In the 1920s and 1930s, he was plausibly able to present himself as the successor to the doges. One of his collaborators, Piero Foscari, was actually descended from a family that had produced a doge, but Volpi himself was self-made, the son of an engineer. While still in his twenties, he was instrumental in bringing electricity to Venice and the Veneto through his company SADE (Società Adriatica di Elettricità). In modernist fashion, Volpi's empire consisted of organizations known by terse acronyms. He was subsequently one of

the chief promoters of Porto Marghera, and through the company CIGA (Compagnia Italiana Grandi Alberghi), the owner of the largest hotels on the Lido, including the vast Grand Hotel des Bains and even vaster Excelsior. The former was a favourite spot of Diaghilev's. It was there in 1912 that Igor Stravinsky was supposed to have played him an early version of the 'Danse des Adolescents' from *The Rite of Spring* on the piano in the ballroom. And it was in bed at the Grand Hotel des Bains that Diaghilev died in 1929. In the years before the First World War, Bakst made several pictures in a Post-Impressionist manner that brilliantly evoke the life of the beach in front of this celebrated establishment.

In the 1920s and early 1930s, as it had during the eighteenth century, Venice had the reputation of being a frivolous city of parties. This was the spirit in which the composer and socialite Cole Porter and his millionaire wife Linda Lee Thomas approached the place. They came to Venice every summer between 1923 and 1927, first renting Palazzo Barbaro (previously the haunt of Henry James, Claude Monet, and John Singer Sargent); later

LEON BAKST *Bathers on the Lido, Venice, c.* 1909

they took Ca' Rezzonico for $4,000 a month (perhaps $50,000 today), enter-
taining their guests beneath Tiepolo's frescoes with up to fifty gondoliers
serving as waiters and footmen. At one point, Porter imported Leslie 'Hutch'
Hutchinson's jazz band to perform on a floating nightclub on a platform
moored in the lagoon, known to locals as 'Noah's Ark'. This outraged
Diaghilev. A little hot jazz was too much, it seemed, for the impresario who
had staged *The Rite of Spring* (though it did not help that Porter was having
an affair with Boris Kochno, Diaghilev's secretary and sometime lover).

By 1929, Fascist sensibilities were outraged by such seaside fun as this, or
the lines of flappers being taught the Charleston on the sands. Regulations
were promulgated forbidding women from wearing bathing costumes that
revealed their legs above the knees, dancing, playing and listening to music,
or drinking alcohol on the beach. But after protests by hoteliers – and in
the London press – it was agreed not to apply these rules too zealously.

The most visible transformations of Venice were on the Lido and the
shores of the lagoon at Porto Marghera. It was there, as the *Corriere della
Sera* sighed with satisfaction, that the 'splendid spectacle of powerful and
active modernity infiltrates deep into the soul of the old city'. But the greatest
architecture to be created in Venice during the twentieth century was not
built in those places, and was far from bombastic. In the mid-1920s, the
most gifted architect to work in Venice since Baldassare Longhena in the
seventeenth century quietly emerged. But it would be wrong to imagine
that Carlo Scarpa (1906–78) left a monumental mark on the city in the way
that Longhena or Palladio had done. His works are so reticent that many
may not register at all, which was just how he thought it ought to be. 'If
the architecture is any good,' he remarked, 'a person who looks and listens
will feel its good effects without noticing.' Scarpa was Venetian by birth,
and – what is more important – by sensibility. 'Essentially,' he confessed,
'I am a Byzantine.' He was also a modernist. 'It was a real stroke of luck',
he recalled in another lecture, 'to come across the book entitled *Vers une
architecture*, by Le Corbusier, just when I finished art school.' His style is
defined by that paradoxical definition: Byzantine modernist.

Scarpa graduated in 1926. For the next decade, his most notable achieve-
ments were not buildings but objects in a highly Venetian material: glass.

That year, he began designing for the firm M. V. M. Cappellini on Murano; six years later, he became the artistic director of Venini, the leading makers of glass, holding that position for the next decade and a half. The bowls, vases, jars, plates, and other items that he conceived generally had a practical use. However, they are also quite obviously works of art. A dish by Scarpa has the subtlety of an abstract painting: the marks apparently random, but in reality carefully calculated. In addition, a piece of his glass will have depths of colour, translucency or transparency, and elasticity of form that go with the medium. With a small mental adjustment, you can see them as small-scale sculptures – completely modern and utterly Venetian.

Scarpa's career as an architect was delayed – if indeed an architect was what he was (for some reason, he refused to take the professional exam required by the Italian government). He was almost thirty before he produced his first important architectural work, and then it was an adaptation to an existing structure: the Gothic Ca' Foscari, which housed part of the university. Scarpa inserted a new lecture hall in a way that respected the fifteenth-century architecture, while being unashamedly of its time.

This harmonious coexistence with the past – without in any way imitating it – became Scarpa's forte, especially in Venice. Almost everything he did in the city is created within a venerable edifice. One of the most prominently sited, but also easy enough to miss, is the shop for the Olivetti typewriter firm on Piazza San Marco. This masterpiece from 1957–8 is inserted seamlessly into an early sixteenth-century building, the Procuratie Vecchie. Every detail of the interior and facade is conceived with an extreme sensitivity to textures and materials. The floor could be a Dadaist collage of scattered rectangles, but it is also in the spirit of the paving of San Marco. The surfaces of stone, wood, metal, and concrete are treated like so many pieces of precious cloth to be compared and contrasted with one another, again just like the marbles and mosaics encrusting the walls of a medieval church. This was no doubt what Scarpa meant by saying he was 'Byzantine'.

He once confessed, 'I like water, maybe because I'm a Venetian.' Perhaps he was typical of his birthplace in accepting the consequences of living in a semi-aquatic city phlegmatically. Another of his great works was his adaptation to the ground floor and garden of the Fondazione Querini Stampalia.

This abuts a canal, and at certain times is likely to flood. Scarpa not only acknowledged this fact, he exploited it. The director of the museum recalled a conversation he had with the architect at the beginning of the project:

> I asked him to keep the high water outside the palace. ... He told me, looking into my eyes, after a pause: high water will be inside, as it is in the rest of the city. It is just about holding it, controlling it, using it as a bright and reflective material. You'll see the effects of light on the roofs of yellow and purple stucco, it will be wonderful!

And indeed, it is. Although the Querini Stampalia museum contains fine paintings, the greatest work it possesses is Scarpa's.

Although many of Scarpa's influences were architectural, one of his closest affinities was with a painter – Paul Klee – whose work was mainly small and delicate in scale. In a sense, Scarpa collaborated closely with the painter, but not until eight years after Klee's death. He was asked to design a retrospective exhibition of Klee's work for the first postwar Biennale, in 1948. At this point, he made an intimate study of the painter's art, and, in the words of Robert McCarter, 'found in Klee an almost identical temperament to his own'. The parallels were sometimes close. The irregular red tesserae of the floor of Scarpa's Olivetti shop are very like the serried brushstrokes in Klee's picture *Emacht* from 1932.

Coincidentally, Klee himself was in Venice during that year, though it is extremely unlikely that he encountered Scarpa. His visit to Venice was the most fleeting of all the artists chronicled in this book. Klee was there for only a few days in the autumn of 1932. Arriving on 8 October, by the 13th he was already in Padua and looking back on his time in the city. Yet this short visit yielded a couple of paintings done afterwards in his studio, with Venetian associations – as the artist made clear by the titles he gave them. One was *Lagunenstadt* (Lagoon city), which is in its modest, whimsical way one of the most perceptive of all the vistas of this most painted of places. What Klee managed to depict was the overriding impression he had on first arriving: the sheer congested mazelike impenetrability of the urban fabric.

CARLO SCARPA *Interior of the Olivetti shop, Piazza San Marco*, 1958

This was what he described to his wife Lily in a letter written the day after he first stepped outside Stazione Santa Lucia. He found someone who spoke German, who in turn summoned a porter to take him and his luggage to the Albergo Manin & Pilsen by vaporetto ('a horribly funny little steamer'). After 'many stations' – they must have gone down the Grand Canal – and a short walk, they got to the destination. This hotel was located near to Piazza San Marco, but in a particularly bewildering labyrinth of *calle*, bridges, and canals. On his walk the next morning, Klee found 'the main obstacle' was the 'lack of any point of view, making orientation impossible'. He wandered around for hours, 'in this confusion and narrowness'. And that was partly what he represented in his crystalline summary of the city, *Lagunenstadt*. At the bottom in the foreground is a jostling mass of overlapping rectangles and oblongs, then a few higher and more separated trapezoids – no doubt the structures around the piazza, which Klee declared a 'unique creation in stone'. Beyond that, horizonal bands of lighter and darker blue, pink, and lilac rise to a single black stripe – the horizon – and then continue above. So there, in concise geometric summary, was the essence of Venice: a huddle of blocklike human dwellings with water all around and sky above.

Klee's jokey narration disguised the fact that his life, and Lily's, had reached a crisis point. The previous January, the Bauhaus in Dessau, where he had lived and taught since the mid-1920s, was closed after the Nazi party gained control of the local government. In the elections of July 1932, the Nazis emerged as the largest party. At the end of January 1933, three months after Klee's stay in Venice, Hitler became chancellor. Against this darkening background, life in the lagoon struck Klee as carefree. The people were allowed to go about their business and remained 'mentally healthy'. As he walked around, beautiful sights passed by, 'as in a good dream'. Within less than a year, he had been denounced as a 'decadent artist', sacked from his teaching post, and driven to take flight in his native Switzerland.

*

After Mussolini came to power in 1922, Volpi worked closely with the Fascist government, serving as governor of the colony of Tripolitania until 1925 and then as minister of finance from 1925 to 1928. But several scholars, including

PAUL KLEE *Lagunenstadt*, 1932

Stefania Longo, have argued that he was not a true believer in fascism, more a pursuer of a time-honoured Venetian strategy: accommodation with the powers in Rome while avoiding as much as possible more irksome control.

Volpi's true belief was in the development and modernization of Venice, a goal that he saw as identical with his own commercial welfare. He is said to have remarked, 'It is not my fault if my interests happen to meet those of the State.' By the early 1930s, in the worst years of the Depression, the number of visitors coming to the Lido had almost halved since the boom years of the mid-1920s. Something had to be done, for the sake of the hotel business and the city's economy. Volpi, who since 1930 had been the president of the Biennale, may have been the person who came up with an ingenious solution. He certainly supported it strongly. In August 1932, the first International Festival of the Cinema was held in Venice. At Volpi's suggestion, the location was the Lido, which he worried was becoming 'tired'. The films were screened on the terrace of the Hotel Excelsior, owned by Volpi's firm CIGA, where, he enthused, the 'luminous fountains' of the gardens would make a perfect backdrop. The event was such a success that it returned in 1934, and thereafter was held annually.

This was not the first film festival ever to take place, but it was the biggest, the best publicized, and – so far – the longest lasting. Venice, formerly the city of theatres, the *commedia dell'arte*, opera, and theatrical state ceremonies, is an inherently cinematic place. Just as everything in the city is photographable, almost every canal and campo would make a good location.

Consequently, movies set wholly or partially in Venice make up a genre of their own. One appeared shortly after that first festival: *Trouble in Paradise*, released in October 1932 and directed by Ernst Lubitsch. In *Top Hat*, from three years later, the hero, Jerry Travers, played by Fred Astaire pursues the heroine (Ginger Rogers) to the Venice Lido. He and his friend Horace hire a plane to fly down for the weekend, which is an aspect of the plot loosely anchored in reality, since Aeroporto Nicelli, the first commercial airport in Italy, was opened on the northern tip of the Lido in 1926. Rogers remarked in her autobiography that the Venetian set for *Top Hat*, 'However beautiful it may have been [...] was about as Italian as [the Irish-American actor] Pat O'Brien.' But the flimsy art-deco sets, designed by Carroll Clark

and Van Nest Polglase, in fact have an affinity with the buildings that were rising on the Lido, especially the airport and the Palazzo del Cinema di Venezia, which opened in 1937 and was intended as the headquarters for the film festival (this having outgrown the Hotel Excelsior terrace).

Top Hat was shot entirely in Hollywood, and the main Venetian scene on three levels, including dance halls, restaurants, bridges, and canals, was so large that it required two adjoining sound stages at RKO's studio on Gower Street. The 'Big White Set', as these extravaganzas were known, was a hundred metres across. This was a fantasy, but no more so than the nineteenth-century set for *I Due Foscari*. It fed into the notion that Venice was a frivolous place, suitable for fun and romance. In a celebrated sequence, Astaire and Rogers danced in a deserted ballroom to Irving Berlin's song 'Cheek to Cheek' as they visibly, and rhythmically, fell in love. The dress that Rogers wore for this sequence was her own conception, worked out in collaboration with the costume designer Bernard Newman – and fully

Still from the film Top Hat, *1935*

worthy of Marchesa Casati. Rogers stipulated that it was to be a pure light blue, such as you might see in a Monet painting. She reflected, 'It's funny to be discussing colour when you're making a black-and-white film, but the tone had to be harmonious.' It is true, as Venetian painters knew, that colour counts even in monochrome. The water of the canals down which Astaire and Rogers float was dyed black so the camera would see it better. Rogers' dress was to be swathed in ostrich feathers (these alone came to $1,500). Astaire hated this outfit, apparently because he thought it would shed feathers as they danced. The director tried to persuade her to wear something else, but Rogers held her ground. She could imagine how beautifully those feathers would respond as she moved – and she was right.

As David Hockney has said, the cinema is part of the history of pictures. So it is fitting that Venice, city of pictures, should have a place in the story of film. It continued after the war to be the setting for significant movies. We have already considered Luchino Visconti's *Senso* from 1954. David Lean's *Summertime*, from the following year, was a poignant comedy starring Katharine Hepburn and shot in colour entirely on location in Venice. It was Lean's favourite among his own films. This was the first movie to use the city as a huge open-air set – though by no means the last. As we have seen, however, the tradition goes back to the processions and ceremonies of the Renaissance.

The most extraordinary piece of Venetian cinema, considered simply as a series of images, is Visconti's *Death in Venice* of 1971 (based on Thomas Mann's novella). This arguably has deficiencies as a drama, since little happens except that the central character, a composer named Gustav von Aschenbach, falls in love with a beautiful adolescent boy, Tadzio, and so follows him and his family as they trail around the city. Von Aschenbach dies of cholera while watching Tadzio stand in the rippling waters of the Adriatic. There is little dialogue.

Considered as an anthology of pictures, however, it is a masterpiece that refers to many ways in which the city had been depicted before. In the opening sequence to the sound of the 'Adagietto' from Gustav Mahler's *Fifth Symphony*, the little steamer bringing von Aschenbach across the sea emerges from the night into a milky dawn. It is not just a subject from

Still from Luchino Visconti's film Death in Venice, *starring Dirk Bogarde as Gustav von Aschenbach (foreground) and Bjørn Andresen as Tadzio (background),* 1971

Turner; the shot is actually strikingly close to a Turner watercolour from the 1840s – same softly coloured sky, same smear of smoke hanging in the air above the lagoon. As the composer shadows Tadzio and his family around the plague-stricken streets of the old town, they seem more than once to enter an etching by Whistler. At the end, as Tadzio stands in the Adriatic, for a moment the camera is pointed at the sun and the image pixelates, creating a cinematic equivalent of a pointillist painting by Paul Signac.

Visconti, a highly cultivated person, must have been conscious of all these references. But most remarkable of all is his own meticulous, and hugely expensive, recreation of the heyday of the Grand Hotel des Bains in every detail of overstuffed furnishing, jardinière, and parlour palm. It is a setting that would have been instantly recognizable to Diaghilev, Nijinsky, Mann, and all the other patrons of that establishment in the golden age of luxury on the Lido.

CHAPTER TWENTY-FIVE

L'ULTIMA DOGARESSA

One day in 1946, an unfamiliar customer came into the Caffè
Sant'Angelo near San Marco: an American woman accompanied
by a number of Lhasa Apso dogs. The proprietor of the other
Sant'Angelo café near the Rialto had sent her over. She had a name scrawled
on a box of matches: 'Vedova'. This was the name of the most talented young
painter in Venice, Emilio Vedova. A tall, handsome, and heavily bearded
man of twenty-seven, he found it difficult to communicate with the new-
comer. 'She spoke American', he recalled 'if only she had spoken French!
... I could hardly understand a word she said.' But his friend Giuseppe
Santomaso, another young Venetian modernist, realized something was up.

Vedova described how Santomaso 'appeared out of nowhere [...] with
his ears pricked', asking 'Who's that with you?' When Vedova told him
her name, he 'saw a look of amazement, dismay even, come over his face
and he gasped: "Guggenheim? – the big American collector?!"' Perhaps
Santomaso had heard the name Peggy Guggenheim when he travelled to
Paris for his first solo exhibition at the Galerie Rive Gauche in Paris. It
was then, just before the Second World War, that Peggy had begun what
she called 'serious collecting'. In those days, her motto, she claimed, 'was
"buy a picture a day" – and I lived up to it'. By the time she escaped from
occupied France with a new husband, Max Ernst, she took with her a rep-
resentative collection of modern European art: not just Ernst, but Picasso,

Braque, Léger, Klee, the Surrealists. As it turned out, the collection lasted longer than the marriage.

Subsequently, Peggy ran a gallery called Art of This Century in New York and bought some of the most exciting work being made in that city. She not only acquired pictures by Jackson Pollock early, on the advice of Piet Mondrian (Marcel Duchamp was also an adviser), she supported the artist with a small retainer. The result was that when Guggenheim decided to settle in Venice – for the good reason that she loved it more than any other place on Earth – she was the owner of an astonishing array of the best of mid-twentieth-century art. It was understandable that Santomaso was taken aback. The world of the Venetian avant-garde was small enough to fit easily into one café. Now, out of the blue, they were joined by one of the modern art world's great personalities.

Peggy Guggenheim (1898–1979) came from one of the world's wealthiest families (her uncles had at one point controlled the global market in metal). But she was among the 'poor Guggenheims', as she put it, her father having lost much of his fortune and then gone down with the *Titanic*. She did not have unlimited funds for buying art – which perhaps had made her concentrate harder and patronize the new and up-and-coming.

She rapidly made friends with Vedova and Santomaso, despite communication problems ('As they spoke Venetian dialect together, I spent painful hours in their company, not understanding a word they said'). She described Vedova as, 'very young and mad about lovely young girls'. Santomaso she thought 'less tall and rounder' and 'more cultivated'. Through him, she got an invitation to exhibit her collection at the XXIV Biennale, to be held in 1948. Under Giuseppe Volpi's presidency, the event had become a staid, establishment occasion. Klee popped into the 1932 edition, but was not impressed (he preferred Tintoretto at the Accademia 'and especially Giovanni Bellini').

By the late 1930s and early 1940s, there were fewer and fewer nations participating at the Biennale (mainly allies of Italy and Germany and neutral nations). After 1942, it had ceased altogether. So the 1948 edition was a reopening to a new postwar world, welcoming artists and others, such as the Jewish Guggenheim, to which it would once have been closed.

There were notable solo exhibitions within the 1948 Biennale, including displays of work by Klee, Picasso, and Chagall. Modernist and modernist-ish artists were prominent: Braque and Rouault in the French pavilion, while the British played safe by pairing Henry Moore with Turner. To demonstrate how much things had changed, the West German government organized a show of works by the so-called 'degenerate artists' who had been pilloried during the Nazi years.

Like Klee, another of these, the Austrian expressionist Oskar Kokoschka, had a one-room show. He had spent the war in exile in Britain; now his career was on an upswing and he was feeling ebullient. In 1947, Kokoschka told his sister that he had recovered his 'joie de vivre, faith in humanity, and hope for the future'. Perhaps to celebrate the tribute to him at the Biennale, perhaps just for pleasure, he and his wife Olda came to Venice and stayed for seven weeks in the Hotel Regina, on the Grand Canal opposite the Salute. And while he was in the city, he worked.

Kokoschka had painted the city before, on visits with his lover Alma Mahler in 1913 and also several times in the 1920s. Now he began a routine much like Monet's, painting every day from his window at the Europa Britannia Hotel, breaking only for lunch and forays with Olda to the Accademia, the Scuola Grande di San Rocco, and the Frari. He was especially moved by Titian's late *Pietà*. The sheer quantity of boats in his picture of the Punta della Dogana and the Bacino – including several gondolas, vaporetti, and a couple of full-sized liners or car ferries – may be exaggerated. But it expresses the bustle of a city (and world) coming back to life.

Peggy Guggenheim was invited to show her collection in the Greek pavilion, temporarily vacant because that country was embroiled in a civil war. The installation was designed by Carlo Scarpa, and was a momentous display in a momentous year, perhaps the moment in which the Biennale began to transform itself into a carnival of the international cutting-edge (though the metamorphosis took some time). Furthermore, this was the very first time that the work of Pollock – perhaps the single most influential artist of the following decade – was shown in Europe. Venice, far from being a backwater, was moving into the forefront. It was five years, for example, before a work by that epoch-defining artist was seen in London.

OSKAR KOKOSCHKA *Punta della Dogana and the Bacino,* 1947

In 1949, Peggy moved into a permanent Venetian base – the Palazzo Venier dei Leoni, the building once occupied by Marchesa Luisa Casati. Peggy found it perfect for her purposes, partly because, being unfinished, it was not a national monument; it could thus be freely adapted and enlarged to fit her growing art collection – a latitude of which she made full use. From 1951, she opened her collection to the public (and in 1976 she donated the palazzo and its contents to the New York foundation named after her uncle, Solomon R. Guggenheim).

In 1950, there was a one-artist exhibition at the Museo Correr of all of Guggenheim's Pollocks (at that point she still had twenty-three, though had sold or given away a few). The show was held in the grand Ala Napoleonica.

Peggy Guggenheim outside her home, Palazzo Venier dei Leoni, 1948

Peggy was delighted by its success – and by the accolade to an artist whose career she had fostered. She remembered:

> Thousands of people saw this exhibition, as it was in a room through which one had to pass in order to get into the Correr Museum. It was always lit at night, and I remember the extreme joy I had sitting in the Piazza San Marco beholding the Pollocks glowing through the open windows of the Museum, and then going out on the balcony of the gallery to see San Marco in front of me, knowing that the Pollocks were behind me. It seemed to place Pollock historically where he belonged as one of the greatest painters of our time.

What is more, it was appropriate that Pollock should be shown in Venice. Although the abstract expressionist never set foot in the city, or even crossed

the Atlantic, he was – surprisingly though it seems – a remote descendant of sixteenth-century Venetian painters. His teacher, Thomas Hart Benton, was a devout student of El Greco and Tintoretto in particular, to the extent of making preliminary clay models of the figures in his paintings, just as Tintoretto was supposed to have done. Pollock threw off the influence of Benton himself, but retained a fascination with his Venetian predecessors. Harry Jackson, a friend and protégé of Pollock's, discovered this affinity during long nights of beer-drinking and conversation towards the end of the latter's life:

> He talked my goddamn ear off, [he] brought out *Cahiers d'art* and analysed Tintoretto in great detail, explaining the composition of this and that; what he was doing was bringing me pure Tom Benton: Venetian Renaissance to Tom Benton. Tom to Jack, Jack to Harry.

What Pollock derived from El Greco and Tintoretto was, first, a sense of scale; second, an understanding how you could orchestrate a huge, wall-sized painting though swaying, curving, rhythmic forms; and finally, a sense of paint and what it could do. Those twisting, winding forms could be created with a single movement of a loaded brush – and, as we have seen, in the case of Tintoretto often are. In his drip paintings, Pollock took this a step further so that skeins of pigment, flying through the air but controlled by the artist, embody those flickering rhythms.

Not surprisingly, as a native Venetian, Vedova started off with a similar sense of the potential of paint, and also revered Tintoretto. In 1991, he jotted down some thoughts about his great predecessor. They began: 'That/rhythmical staging/syncopated and sanguinary,/molten with energy/inner depths of passion/wrenching emotion'.

By the time Peggy Guggenheim encountered Vedova and began buying his work, he was an abstract painter, as he remained for the rest of his long life. But even as a brilliant teenager, drawing and painting the city around him, he could do extraordinary things with pigment and fully charged brushes. His depiction of the facade of the Baroque church of San Moisè from 1937–8 (overleaf), when he was still in his teens, is a traditional *veduta* in meltdown, halfway between Canaletto and abstract expressionism.

EMILIO VEDOVA *San Moisè*, 1937–8

The fact that the church was still there in the late 1930s for Vedova to paint was the result of the increasing determination that in Venice nothing should change. In the 1870s, it had been proposed to demolish this unloved building. Ruskin had vilified it ('one of the basest examples of the basest school of the Renaissance'). Some in Venice agreed. Ruskin's ally Count Alvise Zorzi thought it a 'mad fantasy of the epoch of decadent architecture'. But nonetheless, Zorzi defended the church's right to exist, adding a note of the bizarre to the texture of the city.

*

In 1951, a young architect from Udine named Angelo Masieri and his wife commissioned Frank Lloyd Wright to design a replacement for the decrepit and undistinguished residence they owned just off the Grand Canal. This small, nondescript building was next to the huge late-sixteenth-century Palazzo Balbi, on the serpentine bend of the Grand Canal between San Marco and Rialto. The commission was a boldly ambitious idea, Wright then in his mid-eighties, was one of the most celebrated architects in the world. The couple travelled to the United States to discuss the plan further, and while they were there were involved in a car accident. Angelo, aged only thirty-one, was killed, so the scheme for a house turned into a memorial.

Wright came up with an intriguing conception in his idiosyncratic modernist idiom, with an added Venetian flavour and a slight art-nouveau air. It featured a stack of projecting boxlike balconies and tall, narrow buttresses. He explained his ideas when the plans were submitted to the planning authorities in March 1954:

> Venice does not float upon the water like a gondola but rests
> upon the silt at the bottom of the sea. In the little building I have
> designed slender marble shafts, firmly fixed upon concrete piles
> (two to each) in the silt, [that] rise from the water as do reeds or
> rice or any water plants.

This was, he emphasized, 'Venetian as Venetian can be'; however, it was 'not imitation but interpretation of Venice'. To judge from the drawings, the effect

was lively, even busy, and would have had an impact out of proportion to its small scale. Wright's design would have upstaged the Palazzo Balbi, its far larger – but slightly bland – neighbour. Everyone travelling up the Grand Canal would have noticed it, which must have been Wright's intention. He was, after all, among the most imperious members of a profession known throughout history for its mania for control.

The response at the time was firmly traditional. Nothing should change. Eventually, the project was given to Scarpa, an ex-colleague of Masieri's. Probably with a heavy heart, because he revered Wright, Scarpa left the exterior walls as they were and reconstructed the rooms within. The result is so unobtrusive that if you did not know the story, you would not notice it at all. Some much less distinguished modernist buildings were put up in the 1950s and 1960s, while designs by Wright and Le Corbusier were turned down. On the whole, however, from now on innovation in Venice was indoors, behind the ancient facades. There, some of the most flamboyantly, outrageously, creative works in the world were increasingly to be seen – although not by those passing along the streets and canals outside.

*

As the Biennale d'Arte grew steadily bigger and more international, ineluctably it became more political. For a while in the 1950s and early 1960s, this led to a tussle between realism – espoused by the Soviet bloc – and abstraction. But in 1964 this artistic cold war was abruptly replaced by an entirely different split, between the old world and a new consumerist order – or to put it another way, the United States against the rest.

This became apparent at the XXXII Biennale in 1964 when a thirty-nine-year-old American named Robert Rauschenberg was awarded one of the *gran premi* (grand prizes): the Golden Lion for painting. He was the youngest artist and the first American to win the coveted award. This event was followed by an astonishing furore. *L'Osservatore Romano*, the Vatican newspaper, lamented 'the total and general defeat of culture' that had occurred. The shock was felt especially keenly in Paris, where the newspaper *Combat* described Rauschenberg's victory as 'an offense to the dignity of artistic creation'. The cover of the French magazine *Arts* was emblazoned

ROBERT RAUSCHENBERG *Buffalo II*, 1964

'Venice Colonized by American', with further coverage under the headline 'In Venice, America Proclaims the End of the School of Paris and Launches Pop Art to Colonize Europe'.

Rauschenberg's prize was widely seen as the end of the era in which Paris was the capital of the arts. As is often the case with dramatic transformations, this change had been preceded by slow shifts of the underlying tectonic plates. Ever since the initial appearance of Pollock at the Venice Biennales of 1948 and 1950, European artists had been excited by developments in New York. The attention of the young and avant-garde had already switched from Paris to the other side of the Atlantic. Rauschenberg's prize merely highlighted an event that had already occurred. That is not to say, however, that the suspicions of conspiracy harboured by various European writers were completely unfounded.

There have been accusations that the CIA was manipulating events behind the scenes. It was suspected that the presence of an American, Sam Hunter, on the jury was the result of machinations – although in retrospect, the choice does not seem unreasonable. However, it was true that the United States had made an unusual effort that year. It was decided to exhibit work by a cohort of new stars from New York: Rauschenberg, Jasper Johns, Morris Louis, and Kenneth Noland, who appeared under the heading 'Four Germinal Painters', plus John Chamberlain, Jim Dine, Claes Oldenburg, and Frank Stella, dubbed 'Four Younger Artists'. Altogether, this added up to a large, impressive display of the newest manifestations of American art. This was in line with US government policy as articulated in a magazine article by the late President Kennedy, assassinated the previous year. Kennedy had noted that, 'the arts incarnate the creativity of a free society'. It was neatly apt that an image of Kennedy from one of his debates with Richard Nixon during the presidential election of 1960 featured prominently in a number of Rauschenberg's works exhibited in Venice, including the silk-screen painting *Buffalo II*. A totalitarian society, Kennedy conceded, could promote great works from its history, but, he went on, 'art means more than the resuscitation of the past: it means the free and unconfined search for new ways of expressing the experience of the present and the vision of the future'. This is 'the creativity of a free society'.

Thus showcasing the audacious experimentation of New York artists in Venice made excellent sense. It was not, however, solely an American scheme. Research by Laurie Monaghan revealed that the commissioner of the American pavilion, Alan Solomon, was urged on by officials of the Venice Biennale. The latter were particularly keen that Rauschenberg and Johns should be included.

The American presence grew unprecedentedly large, physically as well as artistically. All eight of the selected artists tended to make extremely sizable works. Consequently it was decided to divide the exhibition in two. Only the 'colour field' abstract painters Louis and Noland would be shown in the pavilion, the rest being displayed in the recently vacated premises of the US Consulate: the Casa Artom, a nineteenth-century palace on the Grand Canal next door to Peggy Guggenheim's Palazzo Venier dei Leoni. This solution had the added benefit of creating a temporary zone for modern art. Visitors to the Guggenheim Collection would find themselves next door to a large array of the latest, most innovative American art. The Biennale had thus begun to expand over the city (and has continued to do so ever since).

However, having initially been enthusiastic about the idea of the additional exhibition at the Casa Artom, Biennale officials suddenly insisted that only artists exhibited in the Giardini, where the permanent national pavilions were located, could be eligible for a prize. Intriguingly, this suggests the Italians had become worried about the repercussions if the rules were not followed strictly (not without reason, there were complaints in the French press that the Americans had cheated by having an extra venue). On the other hand, some people on the Italian side – perhaps the Ministry of Culture – wanted an American to win. The US Embassy in Rome, which got involved in the negotiations, noted that Rauschenberg was 'considered eminently eligible for [the] grand prize'. Eventually, one Rauschenberg work was moved to the American pavilion (plus a Johns, in case he won), but the president of the jury had threatened to resign if the prize were given on the basis of a single work, so three more were hastily moved across Venice by boat on 1 June.

Why should the Italian authorities have wanted an American to win? There was anxiety that if the Americans continued to be overlooked, they

might stop participating. But there was also, Solomon noted, an 'entirely altruistic' desire for an American, especially Rauschenberg, to win. This was perhaps because what he was doing in the silk-screen paintings shown at Venice was close to the interests of younger artists in Italy, Britain, and indeed Paris. In France, the Nouveaux Réalistes had very similar interests to their contemporaries across the Atlantic. Their champion, the critic Pierre Restany, recalled: 'They were fascinated by postwar urban culture, the media, the new technology, the consumer society, the start of the space era.' This roster of contemporary preoccupations was closely matched by Rauschenberg's silk-screens, with their intuitively combined images from magazines and other media, in which a space-traveller dangling from a parachute might be juxtaposed with a street sign or the president. There was, according to Restany, also a big difference. 'In America, that was much more widely regarded as *the* postwar culture. In Paris, things were much more fragmented. There was a lot of opposition.' It was the same in Italy, where Mimmo Rotella was associated with the Nouveaux Réalistes and showed at the 1964 Biennale (but was unable to attend in person as he was temporarily in prison).

The award to Rauschenberg was therefore perhaps not so much a victory for Americanization, more as the breakthrough moment for a new generation with a fresh sensibility. It was also a clear sign that the Biennale was to be a truly international affair. In both respects, it was a portent of things to come.

So too was Rauschenberg's own reaction. He sent a message to his studio in New York, asking for all the silk screens that he had been using – Kennedy, the spaceman with a parachute, the street signs – to be destroyed. It was a way of dramatizing, even to himself, his intention not to repeat himself. This work had been spectacularly successful. So he would never make anything like it again. Looking back, many years later, he recalled, 'As long as I could walk, I didn't want any crutches. No crutches in the house!' This, too, was an indication of the radical novelty that was to follow.

Two years later, at the XXXIII Biennale in 1966, there was a similar controversy about the prominence of works by Roy Lichtenstein – who was much more truly a pop artist than Rauschenberg – in the American pavilion. But a more gripping art drama played out a few yards away on the lawn

outside the Italian pavilion (flanked by the Dutch and the Finnish ones). At this strategic spot, a nodal point of the Giardini past which every visitor was bound to pass, Yayoi Kusama had positioned an utterly unorthodox work entitled *Narcissus Garden*. This consisted of 1,500 mass-produced plastic silver globes, plus, during the opening week, the artist herself. Two adjacent signs read 'NARCISSUS GARDEN, KUSAMA' and 'YOUR NARCISSIUM [by which she meant 'narcissism'] FOR SALE'. Dressed in a golden kimono, Kusama offered the mirror-surfaced spheres for sale to passers-by for 1,200 lire or $2 each. A person gazing at any one of these identical objects would, of course, see their own features reflected back (together with a patch of sky and the surrounding Giardini).

Narcissus Garden was simultaneously a set of sculptural objects and a piece of performance art that involved both artist and the public. Earlier in the year, Kusama had declared her intention to 'work very hard to be internationally active in an avant-garde manner'. This was something

Yayoi Kusama with Narcissus Garden, *Giardini, Venice*, 1966

that she certainly achieved with *Narcissus Garden*. It was not true, as is sometimes claimed, that this was a piece of guerrilla art, inserted into the Biennale without authorization. She had permission, obtained through her Italian gallery, and financial backing from her friend and fellow artist Lucio Fontana. What shocked the authorities, she later explained, was her act of selling the mirror balls on the site, 'as if I were selling hot dogs or ice cream cones'. The police were summoned and asked her to stop, which she did – but not before numerous photographs had been taken. It made an excellent news story and was also a sharp parody of the art business in which works are sold – arguably at least – to enhance and reflect the collector's sense of self. It played into their narcissism – and also, the artist seemed to acknowledge, her own.

This was also a wonderfully international work. In aggregate, the balls had a Zen effect: a cloud of ego bubbles clustered together, each distinct while being absolutely indistinguishable from the rest, all registering the surrounding world from a slightly divergent position. Their glassy, reflective surfaces fitted easily into the Venetian context. In her kimono, Kusama herself acted the part of an exotic Far Easterner (in a later photo shoot, she reclined amongst the balls in a red jumpsuit like an avant-garde Bond girl). But *Narcissus Garden* was quite as much an import from the West. In 1966, Kusama had been living and working in New York for a decade. She was the friend and contemporary of American artists such as Donald Judd and Eva Hesse. In the jargon of the Manhattan cutting edge, this was a 'happening'. It was not the first to occur at the Biennale – that record belonged the Futurists, more than fifty years before. But in its emphasis on the physical presence of the artist herself, and in its critical focus on the economics (and hence politics) of art, it was a harbinger of things to come.

The opening of the next Biennale coincided with the wave of radical demonstations that engulfed many countries throughout the world in the early months of 1968. There were protests and sit-ins at many Italian universities in May (a movement that came to be called 'Sessantotto', or 'Sixty-eight'). In Italy, as in France, this was a revolt aimed at capitalism, consumerism, and traditional institutions. Since the Biennale stood for all three, it was unlikely to escape.

There were tensions before the opening, then the position escalated after a heavy-handed response to a demonstration in Piazza San Marco in which the participants were met by police in full riot gear. There followed a widespread outcry in which, for a while, art was quite literally replaced by slogans. The French and Swedish pavilions had notices reading '*Chiuso*' (closed) placed outside with, in the latter case, the words '*la Biennale è morta!*' (the Biennale is dead) added. In the Italian pavilion, Gastone Novelli turned one of his canvases to the wall and wrote on the reverse: 'The Biennale is fascist!' But when the police were withdrawn, the outrage subsided and the Biennale continued more or less as usual. Bridget Riley won one of the grand prizes, but these were the last to be awarded for many years.

It was decided that the institution was, quite literally, fascist since its current constitution dated back to 1930, when control had been transferred from Venice's city council to Mussolini's state. In 1973, the Italian parliament passed an act giving the institution a much more democratic structure, with representatives of local organizations and trade unions among the nineteen members of the new board. The following year, the most radical Biennale of all took place – or rather, as far as the visual arts were concerned, did not. In the aftermath of the Chilean coup d'état and violent overthrow of the government of Salvador Allende, the president of the Biennale, Carlo Ripa di Meana, decided the international art exhibition should not take place at all (there were musical and theatrical events concerning Chile in the autumn). Some think that this was an exemplary example of an artistic institution engaging in political struggle. Alternatively, it might be seen as the complete erasure of art by ideology.

In 1976, the Biennale returned, but changed in mood. The most memorable and radical work on show was a highly personal meditation on conflict and the artist's own biography. You might say Joseph Beuys's *Strassenbahnhaltestelle* (Tramstop) sculpted time. The central element was a cast of a monument in Beuys's native city of Kleves beside which, long ago as a child – before Hitler came to power, before the war in which he had fought – he had waited for trams. This public sculpture consisted of a long seventeenth-century culverin, or artillery piece, mounted upright with a figure of Cupid in its mouth to represent the victory of peace over war.

Beuys exhibited a cast of the cannon but replaced the god of love with an adult male head, at once anguished and martial. This implied what had happened in mid-twentieth-century Europe: peace vanished and instead there was violence, suffering, and death.

Beside the column, Beuys placed empty cases of mortar bombs, a tram-rail, and a pile of earth and rubble. He also had a twenty-five-metre hole dug into the ground beneath the German pavilion, thus making a physical link with the history of Venice. The detritus from this hole included shards of pottery and fragments of masonry; a human skull was also part of the display. It was suggested that some of this rubble came from the wreckage of the campanile of San Marco, which collapsed in 1902, but more probably it was remnants of the neighbourhood of Sant'Antonio – destroyed long ago in the aftermath of another war fought by Napoleon – which lies beneath the Giardini.

The *Tramstop* has been exhibited in various places since 1976, but Beuys stipulated that in every other location it should be shown dismantled and laid on the floor. The upright column and deep delving into the past existed only in Venice. They were a sombre reminder that history is all around, beneath our feet – and has consequences. It was an apt reminder of the period in Italy that followed the radicalism of 1968. The 1970s were dubbed the 'years of lead': the era of bullets.

<p style="text-align:center">*</p>

In 1978, on the occasion of her eightieth birthday, Peggy Guggenheim was greeted, as she alighted from her gondola, by a banner proclaiming her the 'Ultima Dogaressa' – the last dogesse – of Venice. It was a fitting title. Not only did she live in a splendid palazzo on the Grand Canal, but she excelled in the ancient Venetian role of patronage and art-collecting.

Just over a year later, on 23 December 1979, Guggenheim died and her ashes were placed even more suitably – in a corner of the sculpture garden of her house, the Palazzo Venier dei Leoni. Long before her death, she had given Venice something that it had never had before: a truly great collection of modern art. More than anyone else, she was instrumental in finding the city a new role as international metropolis of the avant-garde.

COLLIDING BEAUTIFULLY: PAST, PRESENT, AND FUTURE MEET ON THE LAGOON

In 2019, the Irish-born artist Sean Scully erected a high stack of richly coloured felt in the crossing of the nave and transept of San Giorgio Maggiore, directly beneath the cupola. It looked like a spaceship (or perhaps a time machine) from the twenty-first century that had landed in the sixteenth. And in that respect, it was typical of the kind of meeting that takes place in contemporary Venice.

As we have noted before, this is perhaps the largest intact old town in the world: a dense mass of medieval, Renaissance, and eighteenth-century structures in which quite often you are looking at a view that Canaletto or even Carpaccio would have known. Yet, strangely, more and more, this is a spot in which you are likely to bump into the very new. And even more unexpectedly, it is often a very good fit.

Scully noted how 'recent paintings really flourish in those dark, semi-lit churches because they have the chance to release all their secrets *slowly*. Whereas if you point light at paintings, they get blasted. We didn't really think about the lighting, we just let it be.' At San Giorgio, he continued: 'This thing that was not particularly illuminated at all looked almost hallucinatory when you walked into the church. It looked as if it had been lit up by the Virgin Mary herself. It was quite amazing. The felt simply *sucked* all the light that was in the church unto itself.' So in this case a four-hundred-year-old building turned out to be an ideal place in which to see a new work

of art (while the latter had an intriguing effect on the former). But Scully felt this was just what might have been expected:

> Contemporary art collides beautifully with sacred spaces because, regardless of the disobedience of artists, art is still an attempt to capture our spirit – our better angels. Churches are always going to be receptive to that. Against the ideologues who are trying to ruin the world, we are pushing back.

<div align="center">*</div>

Rather than thinking of the city as a mass of old buildings, made up of ancient stones, timbers, and bits of painted cloth, you could regard it as a huge, three-dimensional repository of memory. The churches, palaces, and streets hold innumerable recollections – historical, cultural, and personal. For that reason, it was an extremely fitting setting for the eccentric, perhaps mildly unhinged, figure of Giulio Delminio Camillo who flitted through Venice in the mid-sixteenth century, a friend of Sansovino, Serlio, Lotto, and Titian. Camillo (*c.* 1480/5–1544) was a philosopher, logician, poet, and projector of an extraordinary idea that he described in a short book entitled *L'idea del theatro*. In this, he proposed that all human knowledge could be organized in the form of an ancient Roman theatre, with a semi-circular ring of seats around a stage. But he reversed the relationship between the two, so that the spectator looked from the centre up at ranks of images arranged in ascending order. Essentially, he proposed that the whole of the universe, and everything in it, could be represented as a series of pictures.

Of course, it turned out to be a disappointment. Yet, the ideas behind his theatre, though elusive and even slightly crazy, retain a powerful attraction. It is close to Proust's discovery that a sight, sound, or sensation can trigger memory – and, with it, deep comprehension. The name of Venice reverberates through his masterpiece, *À la recherche du temps perdu* (In search of lost time) – standing for beauty and desire, both anticipated and actually experienced. One of the most crucial moments of the vast novel – the point

SEAN SCULLY *Opulent Ascension, installation in San Giorgio Maggiore,* 2019

BILL VIOLA *Ocean Without a Shore, installation in San Gallo,* 2007

at which time, memory, and bliss are indeed regained – concerns San Marco. The central character trips on some uneven paving stones and at once his mind is flooded with 'a dazzling and indistinct vision'. This seemed to say to him, 'seize me if you can and try to solve the riddle of happiness which I set you'. Then 'almost immediately', he recognizes this spectre: it was Venice. He has been reminded of the sensation of 'standing on two uneven stones in the baptistery of St Mark's in Venice' (a place to which Proust was led by his reading of Ruskin). This is the key, and memory is unlocked.

The historian Frances A. Yates revisited Camillo's ideas in a celebrated and influential book, *The Theatre of Memory* of 1966. And in the 1970s and 1980s, among the most avid readers of Yates's book were the early exponents of computerized information storage and access. One of these was Bill Viola, a pioneer video artist. 'As we take the first steps into data space,' he wrote in 1982, 'we discover that there have been many previous occupants. Artists have been there before. Giulio Camillo's Memory Theatre ... is one example.' It was in Venice, in the American pavilion of 1995, that I first

saw Viola's art. He was back again in 2007 with an installation in the little sixteenth-century church of San Gallo. This, like many buildings in Venice, is older than it looks. It was founded in the sixteenth century but rebuilt in 1703. The facade looks like a small classical gateway, and when you step inside, the three marble altarpieces – one on the end wall, and one each on the side walls, facing one another – look like that too: grand doorways above high steps. And that was how Viola saw them when he first came to the place: as three imposing points of entry and exit.

It struck him that, in early Christianity, altars were places where the dead reside. Saints and martyrs were buried underneath them, worshippers hoped for salvation around them. If there are no actual bones inside, altars often have pictures of people who lived and died long ago placed above them. In place of these paintings, Viola put three plasma screens. On each of these, a series of figures walked forward towards the portal of the picture frame. At first, he or she was distant, fuzzy, and monochrome. Then the person passed through a sheet of water, as smooth and clear as glass, and emerged in sharp focus and full colour. Viola used two pieces of technology that were innovative at the time. One was a 'wall of water' flowing from a laser-cut, razor-edged slit so as to form a surface as smooth as a mirror or a picture plane. The other was a system that enabled him to align a high-definition camera with one from a twenty-five-year-old surveillance system.

Like Alice going through the looking glass, the people on Viola's screens seemed to make a transition from one world to another. He was concerned with the 'fragility' of human existence. 'The border between life and death is not a hard wall. It's not to be opened with a lock and key. It's very fragile, very tenuous, you just cross it like that!' All over Venice, you can turn off a shopping street or a square, pass a threshold, and encounter a picture made by someone who died hundreds of years ago, such as Giovanni Bellini. If the painter used living models to pose for his holy figures, we are contemplating faces and bodies from half a millennium ago. Because we are used to doing so, this does not seem as remarkable as it really is. But Viola brought out this latent weirdness. He showed us how close we are in these places to the past. The barrier between us and the dead is a thin, permeable membrane. It is not hard to penetrate. In Venice, it can happen all the time, with ease.

Not all memories are good. The list of materials for Marina Abramović's *Balkan Baroque* in 1997 was not a conventional catalogue of pigments, canvas, or paper. It consisted of cow bones, copper sinks, tub filled with black water, bucket, soap, metal brush, and dress stained with blood. Furthermore, it omits one absolutely crucial ingredient: the artist herself.

This was a time of war between the states that had formerly made up Yugoslavia. Abramović's work was itself a refugee within the Biennale. At first, she had proposed to present it in the Serbian pavilion (she originally came from Belgrade), then in the Montenegrin one. But when those two nations discovered what she had in mind, they turned down the offer. Eventually, she found a sanctuary in a semi-basement area in the ex-Italian pavilion, which is now an international zone controlled by the curator of each Biennale. No other artist wanted this slightly oppressive, underground space. But it turned out to be ideal for Abramović's purpose.

MARINA ABRAMOVIC *Balkan Baroque*, 1997

There she sat for hours on end on a heap of bleeding bones, singing, weeping, and trying to wash them. But the more she attempted to cleanse these broken body parts, the more stained with blood she became. When she finished cleaning one bone and put it down, there was no clean cloth to use for the next. So gore and fragments of meat and ligament were transferred to her white overall, which became steadily filthier as time went on. Meanwhile, the smell in the gallery grew stronger. There is often an element of suffering in Abramović's work for her, the artist; in this case, it was the increasingly terrible stench.

So powerful was the impression that her performance made that Abramović won the main prize of the Biennale that year, the Golden Lion. This was a work, however, for which, to paraphrase the title of one of Abramović's most celebrated pieces, the artist had to be present. I remember wandering through that semi-cellar of a gallery at one of the times when she was not performing. The bones, screens, and smell were all there, but without her, it was like walking through a stage set after the actors had departed.

*

When he first arrived in Venice one cold December night in the 1970s, the Russian-born American poet Joseph Brodsky encountered a certain smell as he stepped out of the station. It was one that he had associated with happiness since his boyhood beside the Baltic: freezing seaweed. Not everybody likes the odours of Venice. It used to be a common complaint, especially among Anglo-Saxon travellers, that the city reeked of drains.

Personally, I have almost never noticed any such stink, perhaps because I have never paid a visit in midsummer. But I did once sniff something as evocative to me as cold seaweed was to Brodsky. On walking into an exhibition of work by Anselm Kiefer at the Museo Correr in 1997, I detected a delightful aroma of linseed oil. Kiefer's paintings were so thickly encrusted, and some so recently finished, that the whole gallery smelled like an artist's studio. It was perfectly appropriate to the place. As earlier chapters of this book have underlined, the medium of oil paint on canvas is Venice's greatest gift to the world. It comes not from Florence but from this city, and it is from its great artists – Titian, Tintoretto, Veronese – that the main

tradition of European painting descends. We have seen how Rubens, Van Dyck, and Velázquez learnt from them. That is still true of twentieth- and twenty-first-century painters such as Kiefer, Jackson Pollock, Cy Twombly, Gerhard Richter, and Lucian Freud. Lucian *loved* paint itself, even liking the smell of linseed oil whenever he encountered it because it reminded him of paint. His studio was a cave of pigment, the walls smeared with it, producing an effect like a Pollock painting or a Twombly. Tumbled tubes of paint lay, two or three deep, on the tops of trolleys. And, of all his predecessors, Titian was his favourite.

In a way, Titian introduced me to Lucian. In 1995, I wrote an essay about Venice and painting. The nub of what I was arguing was contained in these two sentences: 'Flesh, as Willem de Kooning famously observed, is the reason why oil paint was invented. And for practical purposes, this invention took place in Venice.' I elaborated this point, discussing Giorgione and (especially) Titian. The latter, I claimed, 'was at once the creator of some of the most sensuous paintings in art, and also some of the most moving images of suffering and death'. Then I added a more recent example: 'This emphasis on the imperfect fleshiness of flesh continues in the work of a contemporary painter such as Lucian Freud.' Lucian read this, was pleased, and sent me a postcard. We got to know one another, and so eventually a decade later, a portrait of me by him hung in another exhibition at the Museo Correr.

Kiefer returned in 2022 and took over the Sala dello Scrutinio, a huge chamber of the Doge's Palace, next to the Sala del Maggior Consiglio. Beneath a carved ceiling probably designed by Cristoforo Sorte (who once observed Tintoretto in this very building, working with amazing 'boldness and skill, speed and promptness'), around the walls, Kiefer's pictures hung over late-sixteenth-century canvas depicting such subjects as the Battle of Lepanto. Kiefer's works took as their motto a remark by Andrea Emo (1901–83), a philosopher who came from an old Venetian family. 'Questi scritti, quando verranno bruciati, daranno finalmente un po' di luce', or 'These writings, when they are burned, will finally give some light.'

The theme of Kiefer's *Venice Cycle* was elemental as well as historical: transformation through destruction by warfare, fire, and flood. This has

ANSELM KIEFER *Venice Cycle, installed in Sala dello Scrutinio, Doge's Palace,* 2022

indeed been the history of the city, which began humbly as a few settlements clinging to islets of silt in the lagoon, then ballooned to huge wealth, power, and cultural prestige. Venice was crushed politically and economically by the armies of Napoleon, but – as we have seen – it found newer roles.

At the end of the twentieth century and the beginning of the twenty-first, the Venice Biennale became the greatest art event in the world. It is still getting bigger, an ever-growing archipelago of shows: official and unofficial, national and international, large and small, spilling out of the main sites, into churches and palazzi all over the city and off into the lagoon. There are times when the experience seems downright purgatorial. In 2003, the temperature climbed to 40 °C and it seemed possible that the milling assembly of dealers, curators, artists, critics, publicists, collectors, and hangers-on

might melt into the canals like so many gelati. Or else, as it was in Mann's *Death in Venice*, all this decadence might be stricken by a plague.

At the same time, the museums devoted to modern art have proliferated. Over the years, Peggy Guggenheim's collection and the gallery of modern art housed in the Ca' Pesaro – a fabulous baroque palace by Longhena – have been joined by a series of newer institutions. The French billionaire François Pinault began by taking over the Palazzo Grassi on the Grand Canal for revolving displays of his huge array of new art. Then he expanded into the old customs buildings on the Punta della Dogana, which were remodelled by Tadao Ando to make an enormous additional space. The Fondazione Prada followed in 2011, occupying another imposing palazzo on the Grand Canal. Finally – for now, at least – the Indian-British artist Anish Kapoor, who had previously moved to Venice – took over the Palazzo Manfrin on the Cannaregio Canal (where Byron was once beguiled by a Giorgione). This atmospherically crumbly building is now the location of the Kapoor Foundation, with a permanent collection of his work plus temporary displays.

So, at present, Venice has six large institutions devoted to exhibiting modern and contemporary art – a large number for any city. But that does not include the many structures and museums that display such works during the Biennale, which now include the Accademia and Correr galleries, the Palazzo Grimani at Santa Maria Formosa, many churches, the Doge's Palace, most of the external and internal spaces of the Arsenale, and a considerable area of the first floor of the Procuratie Vecchie (where Jacopo Sansovino and Lorenzo Lotto once lived). Taking all those into account, you might well conclude that the business of Venice is now new art.

Meanwhile, the sheer number of visitors to the city has increased and increased. Fittingly, it was a performance that dramatized what was happening. On 15 July 1989, around two hundred thousand fans crammed into the centre of the city to watch and listen to the band Pink Floyd. The concert was held on the date of the Festa del Redentore, but the result seemed more like a modern parody of the traditional festival. The musicians performed on a huge stage floating in the basin of San Marco between San Giorgio and the Doge's Palace (precisely the arrangement that Alvise Cornaro had suggested in the mid-sixteenth century). But the volume of visitors was grotesquely

out of proportion with the setting. The Italian army eventually had to be called in to help clear up the three hundred tonnes of rubbish left behind by the audience, including five hundred cubic metres of tins and empty bottles. This event was described, with some journalistic hyperbole, as the most brutal invasion that Venice had suffered since Napoleon's. Certainly, the event increased a new anxiety: could this venerable metropolis sustain or even survive the vast mass of people who now came to visit it?

Yet somehow, at least so far, the place has managed to survive. Even when the queue to enter San Marco snakes away into the distance, and there is barely space to move on the main routes from the station to the Rialto and the piazza, still it usually seems possible to find quiet churches, even whole neighbourhoods, that are almost empty. The maze of streets has an extraordinary capacity to absorb people.

Similarly, it is impossible to claim that all, or even most, of the art on show every other year is anything but dire. Sometimes the Biennale feels like another inundation of rubbish. 'Such a terrible thing to happen to Venice!', as a fastidious conservative critic of my acquaintance once said. But I do not agree: there are always magnificent sights among the dross.

Nor can it be true that there was once an age in which everything was wonderful from which the present is a disastrous decline. The city of Titian, Giorgione, and Tintoretto certainly had its downside, afflicted as it was by war, fire, flood, poverty, and epidemic diseases regularly killing a large portion of the population, and the Inquisition. The truth is that there never are golden ages; they only seem so because we see them in terms of the pictures they produced. Who knows, perhaps we are living in an age of masterpieces right now, without noticing.

Paula Rego was an artist who produced great works in front of our eyes. And rightly she was at the heart of the Biennale of 2022 (she died two months after the opening). This was the first time that women artists constituted a large majority of those shown in the main exhibition – thus perhaps beginning to right the neglect suffered in the past by Giulia Lama and many others. The centrepiece of Rego's gallery was *Oratorio* of 2009, which was – of all Venetian things – an altarpiece. But, though it drew on Rego's upbringing in Catholic Portugal, this was far from a conventionally

443

PAULA REGO *Oratorio, 2009, displayed in the International Pavilion, Venice Biennale, 2022*

religious work. It took the form of an open cupboard, filled with pictures and soft sculptures evoking the surrender by mothers of illegitimate infants to foundling hospitals. *Oratorio* was filled with the loss, grief, and suffering of a martyrdom or crucifixion, but with a secular, feminist message. It demonstrated how in Venice things have a way of changing completely while remaining somehow just the same.

<p style="text-align:center">*</p>

A stroll around Venice can offer virtual travel in space as well as time. It always has done. Anton Kolb's great view of 1500 depicted ships arriving from all points of the compass, and the routes along which goods were transported inland and over the Alps. People, goods, ideas, and fashion all came here, and sometimes were changed by the experience.

In 2003, in collaboration with the architect David Adjaye, the painter Chris Ofili transformed the British pavilion into a microcosm of the Tropics. Inside, like a forest in a hot place, it was both dark and light. The central space – floors, walls, everything – was black, except for the pictures and the ceiling. Above your head, the skylight that normally lit the room had been replaced by a jigsaw of jagged, coloured glass shards: red, black, and green. Through these, the sun filtered down as if in a grove of palms or banana leaves. On one side of the pavilion there was a room that was entirely red, even the paintings (mostly); on the other, one completely green. Ofili imagined going into the pavilion as being like entering the paintings themselves: 'Maybe if one could climb into this space in this thin skin of

View of Chris Ofili's exhibition in the British Pavilion, Venice Biennale, 2003

PIPILOTTI RIST *Homo Sapiens Sapiens, installation in Chiesa di San Stae,* 2005

paint, you would be surrounded only by red, black and green – the light around you would be only red, black and green.' Stepping into the galleries did indeed alter the viewer's state of mind. There was an analogy with the immediate mood-changing transition caused by walking from the piazza through the doors of San Marco. The blues, greys, and golds of that interior are different from Ofili's red, black, and green, admittedly, but the glitter and richly coloured gloom are the same.

<p style="text-align:center">*</p>

Venice, we began by noting, is a place where things blend together. Sculpture and architecture tend to turn into painting. Now, after considering five hundred years of Venetian history, we can understand something else: how past and present coexist and interact here, each illuminated by the other.

Few times and places were better to appreciate this point than when lounging on the floor of the eighteenth-century church of San Stae in the summer of 2005, cushioned on couches specially designed by the artist Pipilotti Rist and gazing upwards at her remarkable work *Homo Sapiens Sapiens*. San Stae (a typical soft Venetian remodelling of the name Sant'Eustachio) is a noble Palladian building with some good pictures, including an early Tiepolo and an even better Piazzetta. To these, Rist made a spectacular addition. That year, she was one of the artists representing her native Switzerland at the Biennale, but instead of exhibiting in the Swiss pavilion at the Giardini, she decided to make the whole of San Stae her viewing space.

Rist's unusual first name, by the way, is her own creation, an amalgam of 'Charlotte', one of her given names, and Pippi Longstocking, the central character of her favourite books. Her medium and the way she presented it are just as self-invented. Beginning in the 1980s, she developed her own idiom: a collage of moving images, with musical accompaniment, that might be compared to a Rauschenberg on film – except that these pictures were all her own. The other comparison that she invoked was, of course, with the ceiling paintings of Tiepolo, Veronese, and Tintoretto. When we look up at these, we take it for granted that complicated biblical and mythological narratives, involving flying bodies and naked limbs, should take place

above our heads. What Rist offered was much the same experience, but with a twist. The story that she told was of an alternative Garden of Eden, with two naked Eves – named Peppermint and Amber – and no Adam. For her, she remarked, woman was the norm and man the exception. It is not surprising that *Homo Sapiens Sapiens* was closed after a few months by the ecclesiastical authorities, allegedly for technical reasons. This Eden was far from being theologically orthodox.

*

In the medium of art, it is possible to record sensations and feelings that no words could preserve. That at any rate was the belief of the British painter Howard Hodgkin, who had his moment of Venetian fame in 1984. Not since Rauschenberg's appearance in 1964, the critic Robert Hughes wrote, 'has a show by a single painter so hogged the attention of visitors or looked so effortlessly superior to everything else on view by living artists'. Hodgkin also continued a couple of traditions. With *In Bed in Venice* from 1984–8, he added to the rare genre of Venetian bedrooms (to which Turner's watercolour of his hotel room and Klee's *Small Room in Venice* also belong).

Hodgkin was also the most recent painter to produce cityscapes that are at once completely personal and recognizably Venetian. What he depicted, however, was more elusive than the subjects of Canaletto or even Turner. In *Venice Evening* from 1984–5, there is almost nothing to be seen, just dark rippling water with, beyond it in the distance, a few indistinct shapes looming on the horizon in the afterglow of sunset. It is as much a sensation as a sight, a mood, a feeling of waves lapping in the glowing gloom. But perhaps it is best to end this book with *Venice Sunset* of 1989 – another to join the uncountable twilit, crepuscular, and daybreak scenes, many splendid, that have been painted in this, the city of pictures.

HOWARD HODGKIN *Venice Sunset*, 1989

Notes

Introduction
9 'Polo replies: "Every time I describe a city"': Calvino, p. 78
12 '[Banksy] explained the meaning of his picture': Hannah Ellis-Petersen, 'Banksy uses Steve Jobs artwork to highlight refugee crisis': *Guardian*, 11 December 2015
12 'On Monday, 1 November 1610': Chaney and Wilks, p. 179
13 'This verdict': James 1909, p. 1

Chapter One
15 'It was from a book dealer': Chambers and Pullan, p. 373; following quotations from Kolb's petition, ibid.
24 'In 1581, in a pioneering guidebook': Fortini Brown 2004, p. 189
25 'He argued that this structure': Ruskin 1851–3, Vol. 1, p. 31
27 'Eduardo Arslan, an authority': Arslan, p. 83
28 'After analysis of the composition of the various bronze alloys': Scarfi, p. 109

The miracle depicted in the *Procession in the Piazza San Marco* is narrated in Fortini Brown 1988, pp. 142–50.

Chapter Two
37 'The motion passed by the Senate was effusive': Fortini Brown 1988, p. 273
38 'Whether coincidentally or not': Campbell and Chong, p. 107
38 'A few years later, a chronicler named': ibid., pp. 106, 108
40 'On 7 February 1506': Dürer, p. 6
41 'Bellini also candidly expressed his admiration': Sturge Moore, p. 192
45 'Gentile inherited Jacopo's drawings': Fortini Brown 1997, p. 118
45 'An obscene poem by Bartolomeo Fuscus': Fletcher, pp. 173–4
48 'When Gentile died in 1507, Marin Sanudo': Goffen 1989, p. 269
49 'This was despite the fact that Bellini': Cartwright, p. 342
49 'When Vianello next caught up with him': ibid., p. 343; following quotations, ibid., p. 344
50 'But he agreed to paint it': ibid., p. 347

Fortini Brown 1997 analyses the frescoes of the Mascoli Chapel. Maze gives an account of the facts concerning Giovanni Bellini's birthdate and family relations (plus an unorthodox conclusion). The differences between Bellini's and Mantegna's Agony in the Garden pictures are discussed by Jill Dunkerton and Babette Harweig in Campbell et al (eds).

Chapter Three
51 'A few days earlier': Dürer, pp. 3–5
51 'On 8 September': ibid., p. 21
54 'I have sold all my pictures': ibid., p. 8
54 'One smart person met another': Glaeser, p. 19

55 'I have to paint a picture for the Germans': Dürer, p. 4
57 'Years later, Lorenzo Lotto': Chambers and Pullan, p. 438
58 'In Baldassare Castiglione's *Book of the Courtier*': Facchinetti and Galansino 2016, p. 21
58 'heads and figures that Vasari described': Vasari, p. 643
59 'Tom Nichols has suggested': Nichols 2021, p. 39
61 '*The Book of the Courtier* explained': Facchinetti and Galansino 2016, p. 21
61 'Jaynie Anderson has pointed': Anderson, pp. 44–8
62 'In 2019, an inscription was discovered': Anderson et al, p. 192
63 'Admittedly, it can never have been easy reading': Colonna, p. ix
64–5 'In the book, it is argued': Facchinetti and Galansino 2016, p. 75
65 'Apparently, Giorgione "painted"': Pardo, p. 367
67 'Just over a month later': Facchinetti and Galansino 2016, p. 20

Dürer's stay in Venice was a focus of an exhibition at the National Gallery, London, and catalogue edited by Foister and van den Brink. Dal Pozzolo deciphered the name of the original owner of *Laura*. Anderson and Pignatti reprint the original documents concerning Giorgione, with the exception of the post-mortem inventory discovered by Segre (with a dissenting view about his surname from Puppi) and the inscription in the copy of Dante (Anderson et al). Marzo Magno gives an overview of the early Venetian publishing industry. Godwin's introduction to Colonna provides a summary of what is known of the author and his strange masterpiece.

Chapter Four
69 'It began with a declaration of self-belief': Hale, pp. 121–2
70 'According to Ludovico Dolce's *Dialogo della pittura*': Carlo Corsato (ed.) 2019 (2), p. 154
70 'An anonymous seventeenth-century life': Pignatti, p. 175 (my translation)
72 'Vasari, who greatly admired': Vasari, Vol. 2, p. 782
74 'He presented his proposal to the doge': Hale, pp. 121–2
79 'Noting Giorgione's *Tempesta*': Anonimo, p. 123; following quotation, ibid., p. 93
82 'To no avail, the government lamented': Trentmann, p. 37
82 'Many years later, the writer Pietro Aretino': Carlo Corsato (ed.) 2019 (2), p. 139

Mazzotta identifies the National Gallery portrait of a man as Gerolamo

Barbarigo. For *Sacred and Profane Love* and its possible relation to the marriage of Niccolò Aurelio, I refer to Goffen 1997 and Howard 2013. Elisabetta Condulmer's possessions are described in Fortini Brown 2004. There is an account of the commission of the *Assunta* in Goffen 1986.

Chapter Five
88 'According to Dolce': Carlo Corsato (ed.) 2019 (2), pp. 156–9
91 'Bordone darkly suggested': Vasari, Vol. 2, p. 799
91 'On 29 May 1520': Hale, p. 188
92 'But in Titian': Hale, p. 184
92 '"Exhort him to do what he has promised"': Goffen 2002, p. 286
For Tebaldi's negotiations with Titian over the St Sebastian, see ibid., pp. 286–90, and Hale, pp. 189–91
103 'They asked to be allowed to pay': Humfrey 1988, p. 104
103 'It was a blow to the head very much': Saccardo, p. 407
103–4 'In a letter published in 1537': Vasari et al, pp. 115–16
104 'It was left to the twentieth-century art historian': Hope et al, p. 17
104 'The latter is described': Roskill, p. 86

Hale gives a narrative of Titian's relations with Alfonso d'Este. I have followed Goffen's ideas in *Renaissance Rivals* about the St Sebastian and Titian's rivalry with Michelangelo (and Raphael). On Charles V's reaction to the *Tribute Money*, see Hale. There is an account of Alfonso d'Este's *camerini* and the pictures that hung there in Hope et al. On the *Pesaro Altarpiece*, I have depended on Goffen 1986.

Chapter Six
106 'Asked the reason for the ruination': Boucher, Vol. 1, pp. 199–200
108 'For his part, though he complained': Howard 1975, p. 21
112 'Deborah Howard, doyenne of historians of Venetian architecture': ibid., p. 35
112 'According to Sansovino's son': Davis, p. 398
114 'Expecting Michelangelo to do anyone else any good': Gayford 2013, p. 316
114 'On 5 August 1527, the painter Lorenzo Lotto': Boucher, Vol. 1, p. 37
114–15 'But he stopped en route in Venice,': Vasari, Vol. 2, p. 813
115–17 'But despite an "excellent dinner"': Cellini, p. 144
117 'This was because he had "taken into the service"': Howard 1973, p. 516
118 'That was why a later writer, Giovanni Paolo Lomazzo': Peter Hicks and Vaughan Hart (eds), *Sebastiano Serlio on Architecture*, Vol. 2, New Haven and London, 1996, p. xviii

Boucher, Vol. 1, gives a narrative
of Sansovino's life and transcription
of his interrogation. The architect's
interventions around the Piazza San
Marco are analysed in Howard 1975.
Davis drew attention to Francesco
Sansovino's account of the Loggetta
and its iconography. Dinsmoor and
Howard 1973 describe Serlio's life and
his innovative books on architecture.
Titian's *Presentation* is analysed by
Rosand 1982. Titian and Serlio's
discussion is in Brucioli. Gould
suggested the connection between
Serlio and Venetian painting (though
not the parallels between Serlio's plates
and the painting that I suggest here).

Chapter Seven

124 'The altarpiece has been described
as': Dal Pozzolo and Falomir (eds) 2018,
p. 302
124 'The artist waived a further 35
ducats': Humfrey 1997, p. 180
124 'In his punctiliously methodical
way': ibid.
124 'On 13 May 1542': Dal Pozzolo and
Falomir (eds) 2018, p. 310
127 'When he returned to Venice in
1525': ibid., p. 52
127 'His mind, as he wrote in 1529,':
ibid., p. 55
127 'When he left Venice once more':
Humfrey 1997, p. 179
128 '"A close analysis", Poli writes,
"reveals"': Dal Pozzolo and Falomir (eds)
2018, p. 116
128 'The second jotting': Lotto, p. 288
129 'The last wishes he expresses':
Humfrey 1997, p. 181
129 '"To your disgrace"': quoted in
Facchinetti and Galansino 2014, p. 76
130 'As the scholar Giorgio Padoan
noted': Biadene (ed.), p. 50
131 'His sitter was not in Bologna': ibid.,
pp. 49–50; following quotations from
this letter.
132 'For example, on 15 February 1541':
Lotto, p. 288; following quotations on
pp. 132–3, ibid., pp. 172, 128
134 'He described the subject':
<https://cavallinitoveronese.co.uk/
general/view_artist/69>
134 'Lotto, "a very devout man"': ibid.
136–7 'Regarding the drawings of the
covers': Galis, p. 364
139 'But Peter Humfry': Humfry 1997,
p. 114
139 'Vasari wrote that by this stage':
Vasari, Vol. 1, p. 948

Dal Pozzolo and Falomir (eds) 2018
is full of fascinating research on Lotto.
On the altarpiece of The *Alms of Saint
Antoninus of Florence*, see pp. 301–4;
and on the *Triple Portrait of a Goldsmith*,
see pp. 292–4. I also referred frequently
to Humfrey 1997. Titian's letter about

Cornelia is translated by Padoan (see
note to p. 130 above), and the incident
of her portrait is recounted by Hale.
Fra Agostino da Genova's sermon is
described in Martin.

Chapter Eight

141 'According to one of the friars':
Hope, pp. 99–100
142 'The first is vividly evoked in a letter':
Vasari et al, pp. 107–12
143 'The painter's household was much
smaller': Schulz 1982, p. 80
143 'In Schulz's words': ibid., p. 82
144 'The duke of Urbino's agent': Hale,
p. 607
144 'Titian replied': Hope, p. 118
144 'When he visited Parma in 1530':
ibid., p. 266
145 'Its author, Antonio Persio':
Hope, p. 170
145 'There is an account of his methods':
ibid., pp. 163–4
147 'Giorgio Vasari visited the artist':
Vasari, Vol. 2, p. 798
148 'Upon receiving an unexpected tax
demand': Hale, p. 693
148 'When a young Florentine writer
and humanist': ibid., pp. 598–9
148 'Niccolò Stoppio': ibid., p. 644
149–50 'Titian and he are like two
gluttons': Hope p. 160
151 'John Pope-Hennessy': Jansen, p. 5
152 'The great man': Hale, p. 692
154 'On 1 March 1575, the papal
nuncio': Corsato, p. 109, note 36
155 '"Titian's trembling hand"': Hale,
p. 702; following quotations, ibid.,
pp. 702–3

The question of Titian's 'late style'
has been discussed by many authors,
including Hope and Nichols 2013.
The question of the *Pietà* and Titian's
tomb is discussed by Nichols 2013.

Chapter Nine

158 'Paolo Veronese once jotted an
aspiration': Salomon, p. 115
158 'In his paintings': Salomon (ed. and
trans.), p. 48
159 'A monk from the monastery':
Hanson, p. 32
163 'He "would at first place"': Salomon,
p. 78
165 'Veronese was a fluent': ibid.,
pp. 78–9
165 '"Paolo greeted him with due
reverence"': Salomon (ed. and trans.),
p. 178
166 'He dressed': Salomon (ed. and
trans.), p. 181; following quotation, ibid.,
p. 182
167 'Asked who was present at the
Last Supper': this and following
quotations are from Crawford, pp. 29–34
(translation by Charles Yriarte)
173 'Emily Wilbourne': Wilbourne, p. 35

173 'As the scholar Peter Jordan noted':
Jordan 2010, p. 223
174 'Pavoni described how Isabella':
MacNeil, p. 198
174 'Next, she went through': ibid., p. 199
176 'Archbishop Borromeo received a
letter': Jordan 2014, p. 178
176 'The Inquisitor asked Veronese' and
following quotations: Crawford, pp. 29–34

Veronese's early life is described
in Salomon. An account of Peter
Greenaway's installation at San Giorgio
Maggiore can be found in Smith,
Stoppani, and on the website <https://
www.factum-arte.com/pag/102/peter-
greenaway-on-veronese-s-wedding-at-
cana>. The context and *dramatis personae*
of Veronese's interrogation have been
analysed by Grasman. Isabella Andreini's
performance is discussed by MacNeil,
and the contest between I Gelosi and
Cardinal Borromeo is described in
Jordan 2014. The frescoes at Trausnitz are
evaluated by Maxwell.

Chapter Ten

178 'In 1816, a Colonel Isaac A. Coles':
Isaac A. Coles's account of a conversation
with Thomas Jefferson, <https://
founders.archives.gov/documents/
Jefferson/03-09-02-0336>
178 'Palladio is, as the art historian James
Ackerman': Ackerman, p. 19
180 'Palladio felt that these added':
Ackerman, p. 65
182 'Palladio described Trissino':
Beltramini, p. 29
182 '"Trissino, realizing that Palladio"':
ibid., p. 28
184 'Most other arts including painting':
Barbaro, p. 14
184 'Deborah Howard has recounted':
Howard 2011, p. 134ff
186 'Howard analysed the hazards': ibid.,
p. 156
187 'Most Venetians, however, probably
agreed': Fortini Brown 1997, p. 273
187 'Cities, she argued': Jacobs, p. 433
188 'But as Howard argues, da Ponte':
Howard 2011, p. 164; following
quotation, ibid., p. 161
189 'Ackerman described this
archaeological romance': Ackerman, p. 182
190 'Because it enjoys, the most lovely
views': Palladio, p. 94; following
quotation, ibid.
191 'In 1609, the new doge': Savoy, p. 211
193 '"Why", he asked the senators':
Howard 2011, p. 100
196 'He was a great artist, as Ackerman
put': Ackerman, p. 184

Beltramini 2012 contains an account of
Palladio's early life. On the designs of the
new Rialto bridge and Il Redentore, I am
indebted to Howard 2011. On Henri III's
stay in Venice, I followed Korsch.

Chapter Eleven

197 "'I have observed in M. Giacomo Tentoreto': Sorte (my translation); following quotation, ibid.
197 'The art historian Tom Nichols': Nichols 1999, pp. 206–7
200 'In an application to the Senate': Falomir (ed.), p. 434 (my translation)
200 'His seventeenth-century biographer Carlo Ridolfi': Carlo Corsato (ed.) 2019 (I), p. 230
200 'Giorgio Vasari, however, published': Vasari, Vol. 2, pp. 513–14
201 'The records of the *scuola*': Nichols 1999, p. 153–4
203 'Ridolfi relates a story': Carlo Corsato (ed.) 2019 (I), p. 76
203 'Afterwards, Michelangelo, speaking privately': Vasari, Vol. 2, p. 791
204 'Paris Bordone': Vasari, Vol. 2, p. 799
206 'The writer wrote him a letter': Aretino 2019, p. 53; following quotation, ibid., p. 58
206 'Doménikos Theotokópoulos, a young Cretan painter': Carlo Corsato (ed.) 2019 (I), p. 50
207 'Calmo applauded this fiery little person': Carlo Corsato (ed.) 2019 (I), pp. 60–1
207 'Ridolfi describes a solitary, driven artist': Carlo Corsato (ed.) 2019 (I), p. 234; following quotations, ibid., pp. 80, 234–5
209 'She was then was about': Savage, p. 15; following quotation, ibid., p. 16
210 'Ridolfi relates that': Carlo Corsato (ed.) 2019 (I), p. 80; following quotations, ibid.
213 'But, as Nichols argues': Nichols 1999, p. 176

For an assessment of Marietta Tintoretto and her sole surviving drawing, see Hughes.

Chapter Twelve

216 'In a text written after the architect's death': Summerson, p. 4
217 "'Friday the first of August 1614'": Worsley, p. 225
217 "'this secret Scamozzi being purblind'": ibid.
219 'This accords with Jones's own conclusion': Harris and Higgott, p. 56
220 'Henry Wotton (1568–1639) was three times': Wilks and Chaney, p. 179
222 'He dedicated it': Brown 1982, p. 78 (my translation)
224 "'When it comes to fine pictures'": Magurn, p. 322
225 'Justus Sustermans (1597–1681), the Flemish painter': quoted in Maximilian Rooses, *Rubens*, trans. by Harold Child, London, 1904, Vol. I, p. 103
226 'These are not precise imitations': Keith, p. 82
228 'Velázquez's biographer': Palomino, p. 76

229 'Thus Tintoretto's painterly brilliance': Sohm 1991, p. 103; following quotations, ibid., pp. 103 and 152
229 'He noted the way that works': Fortini Brown 2009, p. 66
230 'According to Palomino': Palomino, p. 76
231 'The description that Boschini gave of him': Brown 1988, p. 289
231 'When it came to painting, the great Spaniard': Washburn, p. 120

On the Banqueting House and Rubens's dependence on Venetian predecessors, see Donovan. Van Dyck's copying of Titian is chronicled in Christopher Brown's study of the artist; Velázquez's journeys to Italy are detailed by Jonathan Brown. For my account of Boschini's writings, I drew on Sohm 1991.

Chapter Thirteen

233 'As he explained to the Senate': Hopkins, p. 451; following quotations, ibid.
236 "'Comedies (& other plays)'": Evelyn, p. 191; following quotations, ibid.
237 "'The curtain having disappeared'": Rosand 2007, pp. 70–1
238 'Evelyn's contemporary Inigo Jones': Peacock, p. 48
238 'In the preface, a new figure emerged': Rosand 2007, p. 104
239 'The preface made a bold claim': Rosand 2007, p. 104; following quotations, ibid.
240 'In the words of an anonymous account': Larson, p. 450
243 "'The Seanes chang'd 13 times'": Evelyn, p. 191
243 'At that date': Rosand 2007, p. 414 (my translation)

The fundamental work on opera in Venice during the seventeenth century is Rosand 2007. Zanetti the Elder's caricatures are described in the online catalogues of Royal Collection and Fondazione Cini.

Chapter Fourteen

247 'When Folkes met her': McGeary, p. 118; following quotations, ibid.
248 'In 1721, she complained': Oberer, p. 118
248 'When Lady Mary Wortley Montagu': Montagu, pp. 174–5
248 'Folkes found himself in her studio': McGeary, p. 118
249 'During his studio visit, Folkes also saw' and following quotations: ibid.
249 'as Bernardina Sani wrote': Sani, p. 81
250 'Cole wished, he wrote': Oberer, p. 220
250 'In a series of letters': ibid., p. 53
250 'She had been delayed': ibid., p. 55
250 'At that point, she showed signs': ibid., p. 56
251 'She tactfully turned down an amorous declaration': ibid., p. 221

251 'On 27 September 1705': Oberer, p. 60
251 'Apart from Rosalba herself,': McGeary, p. 118
252 'He wrote to the comtesse de Caylus': Cheney, p. 225; following quotations, ibid., p. 226
253 "'It is true that she is as ugly as'": Gaze, p. 820
253 'Looking at the picture': Binion, p. 144
254 'Conti noted': ibid.
254 'In the poem': Cheney, p. 243; following quotations, ibid.
254 'Luisa Bergalli, a Venetian writer': Cheney, p. 226
256 'Piazzetta was so notoriously slow': Binion, p. 153
256 'Piazzetta, Binion observed, "felt more at ease"': ibid., p. 144
257 'In 1736, the Swedish connoisseur Count Tessin': ibid.
257 'Albrizzi remembered that': Ruggeri, p. 91
258 'It was as "the grand master of light and shadow"': Binion, p. 140
258 'Algarotti added a crucial point': Algarotti, p. 236

Oberer's monograph is the most substantial study of Carriera. McGeary published Folkes's account of his visit. Cheney has undertaken a pioneering investigation of Lama's personality, career, and poetry. On life drawing, Lama, and Piazzetta, see Whistler.

Chapter Fifteen

260 'At the exhibition of 1725': Links, p. 8
263 'According to Zanetti the Younger, he said': Beddington 2006, p. 9
266 'In his correspondence with Conti': Links, p. 37
266 'Marchesini - an acute observer': ibid.
266 "'He paints on the spot'": ibid.
267 'Steadman points out': Steadman, p. 107
267 'This perhaps is what Zanetti meant': Beddington 2010, p. 28
269 'By means of this "artificial eye"': Algarotti, pp. 61–2
271 'NOTICE FOR THE LOVERS OF FINE ARTS': Beddington 2006, p. 127
272 'The architect James Adam wrote': Haskell, p. 310
272 'Adam could not stand': ibid., p. 302
273 "'I have (in imagination) attended'": Francis Russell, quoted in Beddington 2006, p. 39
274 'On 25 July 1749, he placed': Beddington 2006, p. 14
274 'Strolling in the Piazza San Marco': Links, p. 195
275 'Vertue noted his "reservedness"': George Vertue's note from June 1749, quoted in Hilda Finberg, *Canaletto in England*, Oxford, 1921, p. 29
275 'A rare inscription on a drawing': Beddington 2010, p. 72

Chapter Sixteen

276 ' "I have often heard Signor Tiepolo"': Haskell, p. 253, note 2; following quotations, ibid.

281 'On 21 December 1739, the confraternity's minutes': Levey, p. 111

281 'borne along': Levey, p. 106

283 'Sophie Bostock, who discovered': Bostock, p. 48

284 'As a rising artist in 1736': Alpers and Baxandall, p. 23

284 'Zanetti the Younger wrote': Calasso, p. 5

285 'The art historians Svetlana Alpers and Michael Baxandall': Alpers and Baxandall, p. 21

286 ' "The youngest princess"': Goethe, p. 93

286 'They pick out the white bull terrier': Alpers and Baxandall, pp. 31–2

289 'Zanetti commended': Royal Collection Trust catalogue, <https://www.rct.uk/collection/807843-d>

289 'The French dealer and collector': ibid.

289 'Alpers and Baxandall imagined': Alpers and Baxandall, pp. 88, 84

291 ' "The sunshine raised the local colours"': Goethe, p. 94

Chapter Seventeen

292 'At one point, Caravaggio': Calasso, p. 21

294 ' "In Venice, at that time"': Da Ponte, p. 44; following quotation, ibid.

295 'As James Johnson explains': Johnson, p. 153–4

296 ' "Masks, which in our country"': Goethe, pp. 101–2

297 ' "Longhi, tu che la mia musa"': Sohm 1982, p. 259

298 'At one point in the 1770s': Da Ponte, p. 33

299 'In the preface to an edition of his works': Johnson, p. 157

299 'He claimed it would': Gozzi, p. 4

300 'The Swiss-French writer Madame de Staël': Staël, p. 116

301 'In his study of this picture': Spieth, p. 188; following quotations, ibid.

305 ' "One may imagine"': Byam Shaw, p. 59

Chapter Eighteen

308 ' "Some three years ago"': Byron 1976 (1), p. 129

308 ' "I am going out"': ibid., p. 145

308–9 'He also confessed': ibid., p. 203

309 ' "It has not disappointed me"': ibid., p. 129

309 'To Byron, Venice may have been': Byron 1818 (1), verse XVIII

310 'In June 1814': Laven, p. 7; following quotation, ibid.

310 'He was bound to Napoleon': MacCarthy, p. vii

310 'In 1821, a newspaper': ibid., p. ix

311 'His only regret was': Byron, 1976 (1), p. 132

311 'He positively preferred its lack': ibid., p. 133

311 'He announced: "I shall tolerate"': Madden, p. 303

311–12 'Napoleon, Robert Holland has written': Holland, p. 60

313 'In the meantime, Napoleon had issued': Saltzman, p. 135

314 'He reflects that, "Our French friends"': Nievo, p. 440

316 'The prosecutor declared: "Napoleon"': The Times, 23 December 2003

316 'Daru began by noting': Plant, p. 88

317 'A lengthy critique': Quarterly Review, Vol. 31 (1825), p. 421

319 ' "I mean to write a tragedy"': Byron 1976 (1), p. 174

319–20 ' "I have a box"': ibid., p. 160

320 'In February 1818': Byron 1976 (2), p. 13

322 ' "I stood in Venice"': Byron 1818 (1), Verse I

324 'He wrote to his brother,': Gilchrist, p. 189; following quotations, ibid.

324 ' "I had my foot upon the spot"': Dickens, p. 81

325 ' "a sea Cybele, fresh from ocean"': Byron 1818 (1), Verse II

325 'Turner, he writes': Warrell, p. 16

Laven adds interesting information about French (and British) anti-Venetian prejudices.

Chapter Nineteen

327 ' "like a picture by Giorgione"': Byron 1818 (2), Verse XV

328 ' "St. Mark's - and indeed Venice"': Byron 1976 (1), p. 133

328 ' "I know nothing of painting"': ibid., p. 213

328 ' "That Picture (howsoever fine the rest)"': Byron 1818 (2), Verse XII

330 'The great painter had depicted himself': Anderson, p. 248

330 'The poet was known': MacCarthy, p. 332

330 ' "in a few evenings we arranged our affairs"': ibid.

330 'According to Byron's friend': ibid.

331 ' "Love in full life and length"': Byron 1818 (2), Verse XIII

331 'According to Musset's friend': Cochrane, p. 153

332 'To him, it looked like a "strange jumble"': Hamilton, p. 268

334 ' "A great many persons spend"': Balzac, unpaginated

334 'But Nature doth not die': Byron 1818 (1), Verse III

335 'On the back': Warrell, p. 138

336 'As Warrell notes, "the eye scans" and following quotations, ibid.

340 'The almost completed bridge': quoted on <https://sublimesites.co/2014/03/15/ruskin-drawings-at-kings-college-cambridge-2-window-in-the-ca-foscari-venice-2/>

340 ' "My Venice"': Ruskin 1885, p. 295

340 ' "Many-coloured mists are floating"': Hamilton, p. 270

340 'Even so, Ruskin reflected': Ruskin 1885, p. 295

Chapter Twenty

341 'On that day, he had been': Unrau, p. 29; following quotations, ibid.

342 'He had scarcely arrived in Venice': ibid., p. 19

342 'The Morning Chronicle reported': 'The first air bomb: Venice, 15 July 1849'

345 'The Stones of Venice has been described': Unrau, p. 13

345 ' "Great nations write their autobiographies"': Ruskin 1877, p. 1

346 'William Morris wrote that': preface to The Nature of Gothic, 1892

347 ' "The moral, or immoral, elements"': Ruskin 1851–3, Vol. 3, p. 38

347 'First, he asks his readers': ibid., p. 6

348 'This was the initial Renaissance mistake': ibid., p. 17

349 ' "She was not supremely distinguished"': ibid., p. 5

351 'In his autobiography, Praeterita': Ruskin 1885, p. 348

352 ' "Professing the most servile"': Ruskin 1843–60, Vol. 1, p. 215

352 ' "The greatest thing a human soul"': Ruskin 1843–60, Vol. 3, p. 333

352 'In September 1845, he was "before the Casa d'Oro"': Ruskin, 23 September 1845, <https://www.lancaster.ac.uk/fass/ruskin/eSoV/texts/vol08/vol08p243.html>

Hewison 2009 is the most magisterial study of Ruskin's despairing romance with the city.

Chapter Twenty-One

355 ' "I decided to have the large room"': Barker, p. 7

356 'Bertha Goldweg': ibid., p. 286

357 'Wagner mused in his autobiography': Barker, p. 22; following quotations, ibid.

357 'Wagner had to admit': ibid., p. 23

358 'After "four externally dreary days there"': ibid.

359 'To Carlo Leoni': Sorba, p. 433

362 ' "he teaches with the inspiration"': quoted in Witemeyer, Chapter 2

363 'Even in the Scuola Grande di San Rocco': Eliot, p. 204

363 'Eliot was struck by her "calm, grand beauty"': ibid., p. 205

364 ' "For a thoroughly rapt expression"': ibid.

364 'In the Sala del Maggior Consiglio': ibid., p. 201

367 'Ruskin realized that, "with much consternation"': Modern Painters, Vol. 5, Preface

367 ' "One day when I was working"': Hewison 1976, p. 124

367 'In a letter to a friend': ibid., p. 125

368 'It was "as if I were hearing a Beethoven symphony"': Barker, p. 275; following quotations, ibid.
368 'As Alex Ross explains': Ross, p. 68
370 'The coffin, "bronzed in three shades"': Barker, p. 94

Chapter Twenty-Two
371 'One day in the autumn of 1874': Wilson-Bareau, p. 172
372 'A few years later, the Anglo-American author': James 1909, pp. 12–13
373 '"To be a young American painter unperplexed"': James 1909, p. 54
374 'It was "devilishly hard", he complained': Wilson-Bareau, p. 172; all quotations from Toché on Manet, ibid., pp. 374–5
p.375 'It was moonlight, and the waters': Dorment and MacDonald, p. 198
376 '"a sort of Opera Comique country"': Dorment and MacDonald, p. 187
376 'In December, Whistler reported': ibid.
377 '"The work I do is lovely"': Grieve, p. 28
377 'An art critic named Frank Wedmore': Dorment and MacDonald, p. 194
378 'Whistler "would load his gondola"': ibid., p. 195
378 'In the spring of 1880, he wrote': Dorment and MacDonald, p. 187
379 'Pierre-Auguste Renoir wrote': White, p. 343
379 '"I love the sun and the reflections"': <https://www.christies.com/en/lot/lot-5075610>
381 'She confessed that she was': Bunney, p. 10
381 'Eliot recalled': ibid., p. 13
381 'But although he remembered': ibid., pp. 14–15
382 '"I can't write this morning"': Ruskin 1872, p. 328
383 'Ruskin wrote an introduction': Unrau, p. 192
384 'Why, he demanded': Plant, p. 209

Camillo Tonini's essay in the catalogue for the exhibition *Manet: ritorno a Venezia* was the origin of information about the painter's stay in Venice.

Chapter Twenty-Three
386 'Whistler felt that': MacDonald, p. 23
387 'The Sargent scholar Richard Ormond': Kilmurray and Ormond (eds), p. 152
387 '"I can't help thinking"': ibid.
387 'The *portego*, or central hall, for example': James 2013, p. 11; following quotations, ibid.
388–9 'When the narrator of *The Aspern Papers*': ibid., p. 7
389 'By 1897, he had come to regard his work': James 1956, p. 258
389 '"It was a bit of a caricature"': Sturgis, p. 237
390 '"It just isn't worth battling"': Upstone, p. 41

391 'On this occasion, he decided': Sturgis, p. 321
391 'This man was': ibid., p. 290
392 'By his own account, it was mostly': Upstone, p. 42
392–3 '"From 9 to 4 it is the uninterrupted pleasure"': Upstone, pp. 39–40
393 'Sickert confessed to Blanche': Upstone, p. 47
393 '"I regret too late that I painted"': ibid.
395 '"No", he had told his friend Octave Mirbeau': Tucker (ed.), p. 52
395 '"One cannot come to Venice", he wrote': ibid., p. 50
395 'Alice fretted that he might exhaust': ibid., p. 53
397 '"Just a little cold in the morning"': ibid.
398 '"The moment has now come to leave"': ibid., p. 54
398 'As Monet put it': ibid., p. 57

Chapter Twenty-Four
399 'The rationalist mind, McCarthy noted': McCarthy, p. 173
399 '"We repudiate the old Venice, enfeebled"': Rainey et al, p. 67
400 '"We want to prepare the birth"': ibid., p. 68
401 '"As she advanced to meet us"': Ryersson and Yaccarino, p. 52
402 'Despite his comparison with Beardsley': ibid.
404 '"Venice has finally solved"': Longo, p. 85
404 'one's gaze fell on the Lido': ibid., p. 87
406 'It was there, as the *Corriere della Sera*': ibid.
406 '"If the architecture is any good"': Dal Co and Mazzariol, p. 286
406 '"It was a real stroke of luck"': ibid., p. 283
407 'He once confessed, "I like water"': Dodds, p. 35
409 '"I asked him to keep the high water outside"': Barba and De La Quintana, unpaginated
409 'in the words of Robert McCarter': McCarter, pp. 76–7
410 'On his walk the next morning, Klee': Klee, p. 1190; following quotations from Klee's letters to Lily, ibid., pp. 1190–1 (my translation)
412 'Rogers remarked in her autobiography': Brookins, unpaginated
414 'She reflected, "It's funny to be discussing colour"': ibid.

Longo filled in more detail about Giuseppe Volpi.

Chapter Twenty-Five
416 '"She spoke American", he recalled': Vedova, unpaginated
417 '"As they spoke Venetian dialect together"': ibid., p. 325

417 'Klee popped into the 1932 edition': Klee, p. 1190
420 '"Thousands of people saw this exhibition"': Guggenheim, p. 336
421 '"He talked my goddamn ear off"': Naifeh and Smith, p. 564
421 'That/rhythmical staging': Vedova, unpaginated
423 'Ruskin had vilified it': Ruskin 1851–3, p. 124
423 'Ruskin's ally Count Alvise Zorzi': Plant, p. 187
423 '"Venice does not float upon the water"': Ainsworth, p. 101
424 *L'Osservatore Romano*, the Vatican newspaper, lamented': Arnold, unpaginated; following quotation, ibid.
424–6 'The cover of the French magazine *Arts*': Monaghan, p. 99
426 'Kennedy had noted that': Monaghan, p. 32; following quotations from Kennedy's speech, ibid.
427 'The US Embassy in Rome': ibid., p. 27
428 'But there was also, Solomon noted': ibid., p. 84
428 'Their champion, the critic Pierre Restany' and following quotation: interview with the author, 2003
428 'Looking back, many years later': interview with the author, 1997
429 'Earlier in the year, Kusama': Hoptman, p. 34
430 'What shocked the authorities': ibid., p. 58

Chapter Twenty-Six
433 'Scully noted how "recent paintings"' and following quotations: interview with the author, 2022
436 '"As we take the first steps into"': Viola, p. 106
437 'The border between life and death"': Bill Viola, Tate Shots, 2007, <https://www.youtube.com/watch?v=cg1yxEW-ZFE>
440 '"Flesh, as Willem de Kooning famously observed"': Gayford 1995, p. 30; following quotations, ibid, p. 33.
445–7 'Ofili imagined going': Coleman et al, interview with Thelma Golden, unpaginated

Select Bibliography

James Ackerman, *Palladio*, Harmondsworth, 1966

Troy M. Ainsworth, 'Modernism Contested: Frank Lloyd Wright in Venice and the Masieri Memorial Debate', PhD thesis, Texas Tech University, 2005

Francesco Algarotti, *An Essay on Painting*, English translation, London, 1764

Svetlana Alpers and Michael Baxandall, *Tiepolo and the Pictorial Intelligence*, New Haven and London, 1994

Jaynie Anderson, *Giorgione: The Painter of Poetic Brevity*, Paris and New York, 1997

Jaynie Anderson et al, 'Giorgione in Sydney', *Burlington Magazine*, Vol. 161, No. 1399 (2019), pp. 190–9

Anonimo [Marcantonio Michiel], *The Anonimo Notes on Pictures and Works of Art in Italy made by an Anonymous Writer in the Sixteenth Century*, ed. George Williamson, trans. Paolo Mussi, London, 1903

Pietro Aretino, *Selected Letters*, trans. George Bull, Harmondsworth, 1976

Pietro Aretino, 'Letters to Jacopo Tintore', in Giorgio Vasari et al, *Lives of Tintoretto*, Los Angeles, 2019

Katharine Arnold, lot essay on Robert Rauschenberg's *Transom*, https://www.christies.com/en/lot/lot-6059892

Honoré de Balzac, *Massimilla Doni*, trans. Clara Bell, and James Waring, Project Gutenburg e-book, 2010

José Juan Barba and Paloma De La Quintana, 'The Architecture of Details: Palazzo Querini Stampalia by Carlo Scarpa', 2016, https://www.metalocus.es/en/news/architecture-details-palazzo-querini-stampalia-carlo-scarpa

Daniele Barbaro, *Daniele Barbaro's Vitruvius of 1567*, trans. Kim Williams, Cham, 2019

John Barker, *Wagner and Venice*, Rochester, New York, 2008

Charles Beddington, *Canaletto in England*, exh. cat., New Haven and London, 2006

Charles Beddington, *Venice: Canaletto and His Rivals*, exh. cat., London, 2010

Guido Beltramini, *The Private Palladio*, Oslo, 2012

Guido Beltramini and Howard Burns, *Palladio*, exh. cat., London, 2009

Susanna Biadene (ed.), *Titian: Prince of Painters*, exh. cat., Venice and Washington, 1990

Alice Binion, 'The Piazzetta Paradox', in Jane Martineau and Andrew Robison (eds), *The Glory of Venice: Art in the Eighteenth Century*, exh. cat., New Haven and London, 1994

Sophie Bostock, 'The Pictorial Wit of Domenico Tiepolo', PhD thesis, University of Warwick, 2009

Bruce Boucher, *The Sculpture of Jacopo Sansovino*, New Haven and London, 1991 (2 vols)

Laurie Brookins, 'Story of a Dress: "Top Hat"', https://www.screenchic.com/post/story-of-a-dress-top-hat

Christopher Brown, *Van Dyck*, Oxford, 1982

Jonathan Brown, *Velázquez: Painter and Courtier*, New Haven and London, 1988

Antonio Brucioli, *Dialogi di Antonio Brucioli Della naturale philosophia: Libro terzo*, Venice, 1537

Sarah Bunney, 'Mr and Mrs Cross with the Artist John Wharlton Bunney in Venice, June 1880', *George Eliot Review*, No. 42 (2011)

James Byam Shaw, *The Drawings of Domenico Tiepolo*, London, 1962

Lord George Gordon Byron, *Childe Harold's Pilgrimage: Canto the Fourth*, London, 1818 (1)

Lord George Gordon Byron, *Beppo: A Venetian Story*, London, 1818 (2)

Lord George Gordon Byron, *Selected Letters and Journals: Vol. 5, So Late into the Night, 1816–1817*, ed. Leslie A. Marchand, London, 1976 (1)

Lord George Gordon Byron, *Selected Letters and Journals: Vol. 6, The Flesh is Frail, 1818–1819*, ed. Leslie A. Marchand, London, 1976 (2)

Roberto Calasso, *Tiepolo Pink*, London, 2010

Italo Calvino, *Invisible Cities*, trans. William Weaver, London, 1997

Caroline Campbell and Alan Chong, *Bellini and the East*, exh. cat., London, 2005

Caroline Campbell et al (eds), *Mantegna and Bellini: A Renaissance Family*, exh. cat., New Haven and London, 2018

Julia Cartwright, *Isabella d'Este, Marchioness of Mantua: A Study of the Renaissance*, New York and London, 1903

Baldassare Castiglione, *The Book of the Courtier*, trans. George Bull, Harmondsworth, 1976

Benvenuto Cellini, *Autobiography*, trans. George Bull, London, 1966

David Chambers and Brian Pullan, *Venice: A Documentary History, 1450–1630*, Oxford, 1992

Edward Chaney and Timothy Wilks, *The Jacobean Grand Tour: Early Stuart Travellers in Europe*, New York, 2014

Liana De Girolami Cheney, 'Giulia Lama: A Luminous Painter and a Tenebrist Poet', *Artibus et Historiae*, Vol. 38, No. 75 (2017), pp. 225–52

Peter Cochrane, *Byron's European Impact*, Cambridge, 2015

Beth Coleman et al, *Chris Ofili: Within Reach*, London, 2003

Francesco Colonna, *Hypnerotomachia Poliphili*, trans. Joscelyn Godwin, London, 2005

Isaac A. Coles, *Account of a Conversation with Thomas Jefferson*, https://founders.archives.gov/documents/Jefferson/03-09-02-0336

Carlo Corsato, 'Public Piety and Private Devotion: The Altar of the Cross, Titian ad the Scuola della Passione at the Frari', in Carlo Corsato and Howard Deborah (eds), *Santa Maria Gloriosa dei Frari: Immagini di Devozione, Spazi della Fede, Devotional Spaces, Images of Piety*, Padua, 2015, pp. 101–16

Carlo Corsato (ed.), *Lives of Tintoretto*, Los Angeles, 2019 (1)

Carlo Corsato (ed.), *Lives of Titian*, London, 2019 (2)

Francis Marion Crawford, *Salve Venetia: Gleanings from Venetian History*, Vol. 2, New York, 1905

Francesco Dal Co and Giuseppe Mazzariol, *Carlo Scarpa: The Complete Works*, London, 1986

Enrico Maria Dal Pozzolo, 'Ipotesi per un esordio', in *Giorgione*, exh. cat., Castelfranco Veneto, 2009

Enrico Maria Dal Pozzolo, 'Il problema della committenza della "Laura" di Giorgione: una revision paleografica e un'ipotesi aperta', *Jahrbuch des Kunsthistorischen Museums Wien*, No. 17/18 (2016), pp. 45–57

Enrico Maria Dal Pozzolo and Miguel Falomir (eds), *Lorenzo Lotto Portraits*, exh. cat., London and Madrid, 2018

Lorenzo Da Ponte, *Memoirs of Lorenzo Da Ponte*, trans. L. A. Shepard, London, 1929

Charles Davis, 'Jacopo Sansovino's Loggetta in San Marco and Two Problems in Iconography', *Mitteilungen des Kunsthistorischen Institutes in Florenz*, No. 29 (1985), pp. 396–400

Charles Dickens, *Pictures from Italy*, ed. Kate Flint, London, 1998

William Bell Dinsmoor, 'The Literary Remains of Sebastiano Serlio', *Art Bulletin*, Vol. 24, No. 1 (1942), pp. 55–91

George Dodds, 'Directing Vision in the Landscapes and Gardens of Carlo Scarpa', *Journal of Architectural Education*, Vol. 57, No. 3 (2006)

Fiona Donovan, *Rubens and England*, New Haven and London, 2004

Richard Dorment and Margaret MacDonald, *Whistler*, exh. cat., London, 1994

Albrecht Dürer, *Dürer's Record of Journeys to Venice and the Low Countries*, Mineola, New York, 1995

Robert Echols and Frederick Ilchman (eds), *Tintoretto: Artist of Renaissance Venice*, New Haven and London, 2019

George Eliot, 'Recollections of Italy 1860', in J. W. Cross (ed.), *The Works of George Eliot*, Vol. 2, pp. 140–211

John Evelyn, *Memoirs of John Evelyn*, ed. W. Bray, Vol. 1, London, 1819

Simone Facchinetti and Arturo Galansino, *Giovanni Battista Moroni*, exh. cat., London, 2014

Simone Facchinetti and Arturo Galansino, *In the Age of Giorgione*, exh. cat., London, 2016

Miguel Falomir (ed.), *Tintoretto*, exh. cat., Madrid, 2007

Jennifer Fletcher, 'Some Venetian 15th Century Painters and Their Responses to the Antique', in Gustavo Traversari (ed.), *Venezia e l'archeologia*, Venice, 1989

Susan Foister and Peter van den Brink (eds), *Dürer's Journeys: Travels of a Renaissance Artist*, exh. cat., London, 2021

Patricia Fortini Brown, *Venetian Narrative Painting in the Age of Carpaccio*, New Haven and London, 1988

Patricia Fortini Brown, *Venice and Antiquity: The Venetian Sense of the Past*, New Haven and London, 1997

Patricia Fortini Brown, *Private Lives in Renaissance Venice: Art, Architecture, and the Family*, New Haven and London, 2004

Patricia Fortini Brown, 'Where the Money Flows' in Frederick Ilchman (ed.), *Titian, Tintoretto, Veronese*, exh. cat., Boston, 2009

David Freedberg, 'Rubens and Titian: Art and Politics', *Titian and Rubens: Power, Politics, and Style*, exh. cat., Boston, 1998

Diana Galis, 'Concealed Wisdom: Renaissance Hieroglyphic and Lorenzo Lotto's Bergamo Intarsie', *Art Bulletin*, Vol. 62, No. 3 (1980), pp. 363–75

Martin Gayford, 'A Grand Tradition', *Modern Painters*, Vol. 8, No. 3 (1995)

Martin Gayford, *Michelangelo: His Epic Life*, London, 2013

Delia Gaze, *Dictionary of Women Artists*, Vol. 2, London, 1997

Alexander Gilchrist, *The Life of William Etty R.A.*, Vol. 1, London, 1855

Edward Glaeser, *Triumph of the City*, London, 2011

Johann Wolfgang von Goethe, *Italian Journey*, trans. Elizabeth Mayer and W. H. Auden, Harmondsworth, 1982

Rona Goffen, *Piety and Patronage in Renaissance Venice: Bellini, Titian, and the Franciscans*, New Haven and London, 1986

Rona Goffen, *Giovanni Bellini*, New Haven and London, 1989

Rona Goffen, *Titian's Women*, New Haven and London, 1997

Rona Goffen, *Renaissance Rivals: Michelangelo, Leonardo, Raphael and Titian*, New Haven and London, 2002

Cecil Gould, 'Serlio and Venetian Painting', *Journal of the Warburg and Courtauld Institutes*, Vol. 25, No. 1/2 (1962), pp. 56–64

Carlo Gozzi, *Five Tales for the Theatre*, trans. Albert Bermel and Ted Emery, Chicago, 1989

Edward Grasman, 'On Closer Inspection: the Interrogation of Paolo', *Artibus et Historiae*, Vol. 30, No. 59 (2009), pp. 125–34

Alastair Grieve, *Whistler's Venice*, New Haven and London, 2000

Peggy Guggenheim, *Out of this Century: Confessions of an Art Addict*, London, 1960, republished 2005

Sheila Hale, *Titian: His Life*, London, 2012

James Hamilton, *Turner: A Life*, London, 1997

Kate H. Hanson, 'The Language of the Banquet: Paolo Veronese's Wedding at Cana', *InVisible Culture*, No. 14, 2010

John Harris and Gordon Higgott, *Inigo Jones: Complete Architectural Drawings*, exh. cat., London, 1989

Francis Haskell, *Patrons and Painters: Art and Society in Baroque Italy*, New Haven and London, 1980

Robert Hewison, *John Ruskin: The Argument of the Eye*, London, 1976

Robert Hewison, *Ruskin on Venice: The Paradise of Cities*, New Haven and London, 2009

Robert Holland, *The Warm South: How the Mediterranean Shaped the British Imagination*, London, 2018

Hugh Honour and John Fleming, *The Venetian Hours of Henry James, Whistler and Sargent*, London, 1991

Charles Hope, *Titian*, London, 1980

Charles Hope et al, *Titian*, exh. cat., London, 2003

Andrew Hopkins, 'Plans and Planning for S. Maria della Salute, Venice', *Art Bulletin*, Vol. 79, No. 3 (1997), pp. 440–65

Laura Hoptman, 'Yayoi Kusama: A Reckoning', in *Yayoi Kusama*, London, 2000, pp. 32–83

Deborah Howard, 'Sebastiano Serlio's Venetian Copyrights', *Burlington Magazine*, Vol. 115, No. 845 (1973), pp. 512–16

Deborah Howard, *Jacopo Sansovino: Architecture and Patronage in Renaissance Venice*, New Haven and London, 1975

Deborah Howard, *Venice and the East: The Impact of the Islamic World on Venetian Architecture 1100–1500*, New Haven and London, 2000

Deborah Howard, *The Architectural History of Venice*, rev. ed., New Haven and London, 2004

Deborah Howard, *Venice Disputed: Marc'Antonio Barbaro and Venetian Architecture, 1550–1600*, New Haven and London, 2011

Deborah Howard, 'Contextualising Titian's Sacred and Profane Love: The Cultural World of the Venetian Chancery in the Early Sixteenth Century', *Artibus et Historiae*, Vol. 34, No. 67 (2013), pp. 185–99

Deborah Howard and Henrietta McBurney, *The Image of Venice: Fialetti's View and Sir Henry Wotton*, London, 2014

Rebecca Ann Hughes, 'The lost paintings of Marietta Robusti are a maddening Renaissance mystery', *Apollo*, 28 April 2021

Peter Humfrey, 'Competitive Devotions: The Venetian Scuole Piccole as Donors of Altarpieces in the Years around 1500', *Art Bulletin*, Vol. 70, No. 3 (1988), pp. 401–23

Peter Humfrey, *Lorenzo Lotto*, New Haven and London, 1997

Jane Jacobs, *The Death and Life of Great American Cities*, New York, 1961

David Jaffé and Elizabeth McGrath, *Rubens: A Master in the Making*, exh. cat., London, 2005

Dirk Jacob Jansen, *Jacopo Strada and Cultural Patronage at The Imperial Court* (2 vols), Leiden, 2019

Henry James, *Italian Hours*, London and Boston, 1909

Henry James, *The Painter's Eye: Notes and Essays on the Pictorial Arts*, ed. John Sweeney, London, 1956

Henry James, *The Aspern Papers and Other Stories*, ed. Adrian Poole, Oxford, 2013

Paul Joannides, *Titian to 1518: The Assumption of Genius*, New Haven and London, 2002

James H. Johnson, *Venice Incognito: Masks in the Serene Republic*, Berkeley, London, and Los Angeles, 2017

Peter Jordan, 'In Search of Pantalone and the Origins of the Commedia dell'Arte', *Revue Internationale de Philosophie*, Vol. 64, No. 252(2) (2010), pp. 207–32

Peter Jordan, *The Venetian Origins of the Commedia dell'Arte*, Abingdon, 2014

Larry Keith, 'Velázquez's Painting Technique', *Velázquez*, exh. cat., London, 2006, pp. 70–89

Susanne Keegan, *The Eye of God: A Life of Oskar Kokoschka*, London, 1999

Elaine Kilmurray and Richard Ormond (eds), *John Singer Sargent*, exh. cat., London, 1998

Paul Klee, *Briefe an die Familie*, Vol. 2, Cologne, 1979

Evelyn Korsch, *Diplomatic Gifts on Henri III's Visit to Venice in 1574*, Rhode Island, 2007

David Landau and Peter Parshall, *The Renaissance Print 1470–1550*, New Haven and London, 1994

Orville Larson, 'Giacomo Torelli, Sir Philip Skippon, and Stage Machinery for the Venetian Opera', *Theatre Journal*, Vol. 32, No. 4 (1980), pp. 448–57

David Laven, 'Lord Byron, Count Daru, and anglophone myths of Venice in the nineteenth century', *MDCCC 1800*, No. 1 (2012), pp. 5–32

Michael Levey, *Giambattista Tiepolo: His Life and Art*, New Haven and London, 1994

J. G. Links, *Canaletto*, London, 1982

Stefania Longo, 'Culture, tourism and Fascism in Venice 1919–1945', PhD thesis, University College London, 2004

Lorenzo Lotto, *Il libro di spese diverse*, ed. Francesco De Carolis, Trieste, 2017

Christoph Lüthy, 'Hockney's Secret Knowledge, Vanvitelli's Camera Obscura', *Early Science and Medicine*, Vol. 10, No. 2 (2005), pp. 315–39

Fiona MacCarthy, *Byron: Life and Legend*, London, 2002

Margaret MacDonald, *Palaces in the Night: Whistler in Venice*, Berkeley, 2001

Thomas McGeary, 'British Grand Tourists visit Rosalba Carriera, 1732–1741: New documents', *British Art Journal*, Vol. 15, No. 1 (2014), pp. 117–19

Anne MacNeil, 'The Divine Madness of Isabella Andreini', *Journal of the Royal Musical Association*, Vol. 120, No. 2 (1995), pp. 195–215

Robert McCarter, *Carlo Scarpa*, London, 2013

Mary McCarthy, *The Stones of Florence and Venice Observed*, Harmondsworth, 1972

Thomas F. Madden, *Venice: A New History*, London, 2012

R. S. Magurn, *The Letters of Peter Paul Rubens*, Cambridge, Mass., 1955

John Jeffries Martin, *Venice's Hidden Enemies: Italian Heretics in a Renaissance City*, Baltimore, 2003

Alessandro Marzo Magno, *Bound in Venice*, trans. Gregory Conti, New York, 2013

Susan Maxwell, 'A Marriage Commemorated in the Stairway of Fools', *Sixteenth Century Journal*, Vol. 36, No. 3 (2005), pp. 717–41

Daniel Wallace Maze, 'Giovanni Bellini: Birth, Parentage, and Independence', *Renaissance Quarterly*, Vol. 66, No. 3 (2013), pp. 783–823

Antonio Mazzotta, 'A 'gentiluomo da Ca' Barbarigo' by Titian in the National Gallery, London', *Burlington Magazine*, Vol. 154, No. 1306 (2012), pp. 12–19

Laurie Monaghan, 'The New Frontier goes to Venice: Robert Rauschenberg and the XXXII Venice Biennale', thesis, University of British Columbia, Vancouver, 1985

Lady Mary Wortley Montagu, *Selected Letters of Lady Mary Wortley Montagu*, ed. Robert Halsband, London, 1970

Steven Naifeh and Gregory White Smith, *Jackson Pollock: An American Saga*, New York, 1990

Tom Nichols, *Tintoretto: Tradition and Identity*, London, 1999

Tom Nichols, *Titian and the End of the Venetian Renaissance*, London, 2013

Tom Nichols, *Giorgione's Ambiguity*, London, 2021

Ippolito Nievo, *Confessions of an Italian*, trans. Frederika Randall, London, 2014

Angela Oberer, *The Life and Work of Rosalba Carriera (1673–1757): The Queen of Pastel*, Amsterdam, 2020

Andrea Palladio, *The Four Books of Architecture*, trans. R. Tavernor and R. Schofield, Cambridge, Mass., 1997

Antonio Palomino, 'Life of Velázquez', in *Lives of Velázquez*, Los Angeles, 2018

Mary Pardo, 'Paolo Pino's "Dialogo Di Pittura": A Translation with Commentary', PhD thesis, University of Pittsburgh, 1984

John Peacock, *The Stage Designs of Inigo Jones: The European Context*, Cambridge and New York, 1995

Terisio Pignatti, *Giorgione: Complete Edition*, London, 1971

Margaret Plant, *Venice Fragile City: After the Republic 1797–1997*, New Haven and London, 2003

Lionello Puppi, 'Il cognomen di Giorgione è Barbarella', *Corriere del Veneto*, 14 October 2011

Lawrence Rainey et al, *Futurism: An Anthology*, New Haven and London, 2009

David Rosand, 'Theater and Structure in the Art of Paolo Veronese', *Art Bulletin*, Vol. 55, No. 2 (1973), pp. 217–39

David Rosand, *Painting In Cinquecento Venice: Titian Veronese Tintoretto*, New Haven and London, 1982

Ellen Rosand, *Opera in Seventeenth-Century Venice: The Creation of a Genre*, Berkeley and Los Angeles, 2007

Mark Roskill, *Dolce's Aretino and Venetian Art Theory of the Cinquecento*, New York, 1968

Alex Ross, *Wagnerism: Art and Politics in the Shadow of Music*, New York, 2020

Ugo Ruggeri, 'The Drawings of Giambattista Piazzetta', in *Masterpieces of Eighteenth Century Venetian Drawing*, exh. cat., Brussels, 1983

John Ruskin, *Modern Painters*, 5 vols, London, 1843–60

John Ruskin, *The Stones of Venice*, 3 vols, London, 1851–3

John Ruskin, *Fors Clavigera, Vol. 2: Letters to the Workmen and Labourers of Great Britain*, London, 1872

John Ruskin, *St Mark's Rest: The History of Venice*, Kent, 1877

John Ruskin, *Praeterita*, Kent, 1885

Scot Ryersson and Michael Yaccarino, *Infinite Variety: The Life and Legend of the Marchesa Casati*, New York, 1999

G. Saccardo, 'Due avventure tragiche e una abitazione di Tiziano in Venezia', *Archivio Veneto*, 1888, 35:403f

Xavier F. Salomon, *Veronese*, exh. cat., London, 2014

Xavier F. Salomon (ed. and trans.), *Lives of Veronese*, London, 2015

Cynthia Saltzman, *Napoleon's Plunder and the Theft of Veronese's Feast*, London, 2021

Bernardina Sani, 'Rosalba Carriera's "Young Lady with a Parrot"', *Art Institute of Chicago Museum Studies*, Vol. 17, No. 1 (1991), pp. 74–87

Alicia J. Savage, 'Marietta Robusti, La Tintoretta: A Critical Discussion of a Venetian Pittrice', MA thesis, Texas Christian University, 2018

Daniel Savoy, 'Palladio and the Water-oriented Scenography of Venice', *Journal of the Society of Architectural Historians*, Vol. 71, No. 2 (2012), pp. 204–25

Bianca Maria Scarfi, 'The Bronze Lion of St Mark', in Bianca Maria Scarfi (ed.), *The Lion of Venice: Studies and Research on the Bronze Statue in the Piazzetta*, Munich, 1990

Juergen Schulz, 'Jacopo de' Barbari's View of Venice: Map Making, City Views, and Moralized Geography before the Year 1500', *Art Bulletin*, Vol. 60, No. 3 (1978), pp. 425–74

Juergen Schulz, 'The Houses of Titian, Aretino, and Sansovino', in David Rosand (ed.), *Titian, His World and His Legacy*, New York and Guildford, 1982

Renata Segre, 'A rare document on Giorgione', *Burlington Magazine*, Vol. 135, No. 1299 (2011), pp. 383–6

Sebastiano Serlio, *The Five Books of Architecture*, trans. Robert Peake, London, 1611 (reprinted New York, 1983)

Roberta Smith, 'In Venice, Peter Greenaway Takes Veronese's Figures Out to Play', *New York Times*, 21 June 2009

Michael Snodin and Michael Llewellyn, *Baroque: Style in the Age of Magnificence, 1620–1800*, exh. cat., London, 2009

Philip Sohm, 'Pietro Longhi and Carlo Goldoni: Relations between Painting and Theater', *Zeitschrift für Kunstgeschichte*, Vol. 45. No. 3 (1982) pp. 256–73

Philip Sohm, *Pittoresco: Marco Boschini, his Critics, and their Critiques of Painterly Brushwork in Seventeenth- and Eighteenth-Century Italy*, Cambridge, 1991

Carlotta Sorba, 'Ernani Hats: Italian Opera as a Repertoire of Political Symbols during the Risorgimento', in Jane Fulcher (ed.), *The Oxford*

Handbook of the New Cultural History of Music, Oxford and New York, 2011

Cristoforo Sorte, *Osservazioni Nella Pittura*, Venice, 1580

Darius A. Spieth, 'Giandomenico Tiepolo's "Il Mondo Nuovo": Peep Shows and the "Politics of Nostalgia"', *Art Bulletin*, Vol. 92, No. 3 (2010), pp. 188–210

Germaine de Staël, *Corinne: or, Italy*, Vol. 1, London, 1894

Philip Steadman, 'Canaletto's Camera', in Martin Gayford, Martin Kemp, and Jane Munro (eds), *Hockney's Eye: The Art and Technology of Depiction*, London, 2022

Teresa Stoppani, 'After the First Miracle: Greenaway On 'Veronese', *Log*, No. 18 (2010), pp. 59–64

T. Sturge Moore, *Albert Dürer*, London, 1905

Matthew Sturgis, *Walter Sickert: A Life*, London, 2005

John Summerson, *Inigo Jones*, Harmondsworth, 1966

Manfredo Tafuri, *Venice and the Renaissance*, Cambridge, Mass., 1995

Camillo Tonini, 'Édouard Manet: settembre a Venezia, 1853 e 1874', in Stéphane Guegan, (ed.), *Manet: Ritorno a Venezia*, exh. cat., Venice, 2013

Frank Trentmann, *Empire of Things: How We Became a World of Consumers, from the Fifteenth Century to the Twenty-First*, London, 2016

Paul Hayes Tucker (ed.), *Monet in the Twentieth Century*, New Haven and London, 1999

John Unrau, *Ruskin and St Mark's*, London, 1984

Robert Upstone, *Sickert in Venice*, London, 2009

Giorgio Vasari, *Lives of the Most Eminent Painters, Sculptors and Architects*, 2 vols., trans. Gaston du C. De Vere, London, 1912, reprinted 1996

Emilio Vedova, *Pagine di diario*, Milan, 1961, quoted https://www.fondazionevedova.org/1941-1950

Bill Viola, *Reasons for Knocking at an Empty House*, ed. Robert Violette, Cambridge, Mass., 1995, pp. 121–35

Emelyn W. Washburn, *The Spanish Masters: An Outline of the History of Painting in Spain*, New York, 1884

Catherine Whistler, 'Life Drawing in Venice from Titian to Tiepolo', *Master Drawings*, Vol. 42, No. 4 (2004), pp. 370–96

Barbara Ehrlich White, 'Renoir's Trip to Italy', *Art Bulletin*, Vol. 51, No. 4 (1969), pp. 333–51

Emily Wilbourne, *Seventeenth-Century Opera and the Sound of the Commedia dell'Arte*, Chicago, 2016

Juliet Wilson-Bareau, *Manet By Himself*, Boston, 1991

Hugh Witemeyer, *George Eliot and the Visual Arts*, New Haven, 1979

Giles Worsley, 'Scamozzi's influence on English seventeenth-century architecture', *Annali di Architettura*, No. 18–19 (2007), pp. 225–33

Picture Credits

Dimensions are given in centimetres followed by inches, height before width

2 Oil on canvas, 147.7 × 199.4 (58³/₁₆ × 78⁹/₁₆). National Gallery, London. Photo National Gallery, London/Scala, Florence. 7 Photo coffe71/123rf.com. 8 Chromogenic print, 182 × 230.5 (71¹¹/₁₆ × 90¾). © Thomas Struth. 13 Photo Sally Nicholls. 16–17, 20, 21 Woodcut from six blocks on six sheets of paper, 132.7 × 277.5 (52¼ × 109¼). The John R. Van Derlip Fund, Minneapolis Institute of Art. 23 Oil on canvas, 319 × 392 (125⅝ × 154⅜). Scuola Grande di San Marco, Venice. 26 Photo gameover/123rf.com. 27 Photo donyanedomam/123rf.com. 29 Photo © Marcus Scott-parkin/Dreamstime.com. 32–3 Tempera and oil on canvas, 373 × 745 (146⅞ × 293³/₁₆). Gallerie dell'Accademia, Venice. Photo Cameraphoto/Scala, Florence. 35 Tempera on panel, 230 × 180 (90⁹/₁₆ × 70⅞). Church of San Pantalon, Venice. Photo Cameraphoto/Scala, Florence. 36 Mosaic. Cappella dei Mascoli, Basilica di San Marco, Venice. Photo Cameraphoto/Scala, Florence. 39 Pen and ink with watercolour and gold on paper, 18.2 × 14 (7³/₁₆ × 5⁹/₁₆). Isabella Stewart Gardner Museum, Boston, Massachusetts. PhotIsabella Stewart Gardner Museum/Bridgeman Images. 42 Oil on panel, 58 × 107 (22⅞ × 42³/₁₆). Gallerie dell'Accademia, Venice. Photo Scala, Florence. 43 Tempera on panel, 62.9 × 80 (24¹³/₁₆ × 31½). National Gallery, London. Photo National Gallery, London/Scala, Florence. 44 Tempera on panel, 81.3 × 127 (32¹/₁₆ × 50). National Gallery, London. Photo National Gallery, London/Scala, Florence. 47 Oil on panel, 471 × 258 (185⁷/₁₆ × 101⅝). Gallerie dell'Accademia, Venice. Photo Cameraphoto/Scala, Florence. 53 Tempera on canvas, 371 × 392 (146⅛ × 154⅜). Gallerie dell'Accademia, Venice. Photo Scala, Florence. 56 Oil on canvas, 41 × 34 (16³/₁₆ × 13⁷/₁₆). Kunsthistorisches Museum, Vienna. 57l Grey ink, heightened with white, on blue paper, 38.1 × 22.3 (15 × 8¹³/₁₆). Kupferstichkabinett, Berlin. Photo Scala, Florence/bpk, Bildagentur für Kunst, Kultur und Geschichte, Berlin. 57r Detached fresco, 243 × 140 (95¹¹/₁₆ × 55⅛). Gallerie dell'Accademia, Venice. Photo Scala, Florence – courtesy of the Ministero Beni e Att. Culturali e del Turismo. 60 Oil on canvas, 52 × 43.4 (20½ × 17⅛). Herzog Anton Ulrich Museum, Braunschweig. Photo Scala, Florence/bpk, Bildagentur für Kunst, Kultur und Geschichte, Berlin. 64 Printed book with woodcut illustrations, 29.5 × 22 (11⅝ × 8¹¹/₁₆). Metropolitan Museum of Art, New York. 65 Oil on canvas, 108.5 × 175 (42¾ × 68¹¹/₁₆). Gemäldegalerie Alte Meister, Staatliche Kunstsammlungen, Dresden. Photo Scala, Florence/bpk, Bildagentur für Kunst, Kultur und Geschichte, Berlin. 66 Oil on canvas, 200 × 156 (78¾ × 61⁷/₁₆). San Giovanni Crisostomo, Venice. Photo Scala, Florence. 71 Oil on canvas, 105 × 136 (41⅜ × 53⅝). Musée du Louvre, Paris. Photo RMN-Grand Palais (musée du Louvre)/Michel Urtado. 72 Oil on canvas, 81.2 × 66.3 (32 × 26⅛). National Gallery, London. Photo National Gallery/Scala, Florence. 76–7 Oil on canvas, 118 × 279 (46⅜ × 109⅞). Galleria Borghese, Rome. Photo Scala, Florence. 78 Printed book with woodcut illustrations, 29.5 × 22 (11⅝ × 8¹¹/₁₆). Metropolitan Museum of Art, New York. 80 Oil on panel, 48 × 41.8 (18¹⁵/₁₆ × 16½). Kunsthistorisches Museum, Vienna. Photo Fine Art Images/Heritage Images/Scala, Florence. 81 Oil on panel, 115 × 89 (45⁵/₁₆ × 35¹/₁₆). Musei Capitolini, Rome. Photo Ian Dagnall Computing/Alamy Stock Photo. 84 Photo Mark E. Smith/Scala, Florence. 87 Oil on panel, 690 × 360 (271¹¹/₁₆ × 141¾). Santa Maria Gloriosa dei Frari, Venice. Photo Scala, Florence. 93 Oil on canvas, 170 × 65 (66¹⁵/₁₆ × 25⅝). Santi Nazaro e Celso, Brescia. Photo Scala, Florence. 96 Oil on canvas, 488 × 269 (192³/₁₆ × 105¹⁵/₁₆). Santa Maria Gloriosa dei Frari, Venice. Photo Scala, Florence. 99 Oil on canvas, 176.5 × 191 (69½ × 75¼). National Gallery, London. Photo National Gallery/Scala, Florence. 100 Oil on canvas, 175 × 193 (68¹⁵/₁₆ × 76). Museo del Prado, Madrid. 105 Engraving, 40.1 × 27.2 (15¹³/₁₆ × 10¹¹/₁₆). Metropolitan Museum of Art, New York. 107 Oil on canvas, 70 × 65.5 (25⁹/₁₆ × 25¹³/₁₆). Galleria degli Uffizi, Florence. Photo Scala, Florence. 111 Photo rudiernst/123rf.com. 112 Engraving, 19 × 26.5 (7½ × 10⁷/₁₆). Rijksmuseum, Amsterdam. 113 Photo zatletic/123rf.com. 116 Oil on canvas, 133.6 × 103.2 (52⅝ × 40¹¹/₁₆). Samuel H. Kress Collection, National Gallery of Art, Washington, D.C. 119 Oil on canvas, 335 × 775 (131¹⁵/₁₆ × 305⅛). Gallerie dell'Accademia, Venice. Photo Scala, Florence – courtesy of the

Ministero Beni e Att. Culturali e del Turismo. 120 Printed book with woodcut illustrations. National Library of Poland, Warsaw. 121 Oil on canvas, 335 × 775 (131¹⁵/₁₆ × 305⅛). Gallerie dell'Accademia, Venice. Photo Scala, Florence – courtesy of the Ministero Beni e Att. Culturali e del Turismo. 125 Oil on panel, 332 × 235 (130¾ × 92⅞). Santi Giovanni e Paolo, Venice. 126 Oil on canvas, 89.9 × 69.4 (35⅜ × 27⁵/₁₆). Harvard Art Museums/Fogg Museum, Gift of Edward W. Forbes in memory of Alice F. Cary. Photo © President and Fellows of Harvard College. 128 Oil on panel, 332 × 235 (130¾ × 9⁹/₁₆). Santi Giovanni e Paolo, Venice. 130 Oil on canvas, 125 × 99 (49¼ × 39). Museo del Prado, Madrid. 133 Oil on canvas, 52 × 79 (20½ × 31⅛). Kunsthistorisches Museum, Vienna. 137 Oil on wood, 243 × 237 (95¹¹/₁₆ × 93¾). Pinacoteca Civica, Jesi. Photo A. De Gregorio/De Agostini/Getty Images. 140 Oil on canvas, 96 × 75 (37¹³/₁₆ × 29⁹/₁₆). Gemäldegalerie, Staatliche Museen zu Berlin. 146 Oil on canvas, 212 × 207 (83½ × 81½). Archbishop's Gallery, Kromeriz, Czech Republic. Photo Artothek/Bridgeman Images. 149 Oil on canvas, 119 × 97 (46⅞ × 38¼). Hermitage, St. Petersburg. Photo Peter Barritt/Alamy Stock Photo. 150 Oil on canvas, 126 × 95.5 (49⅝ × 37⅝). Kunsthistorisches Museum, Vienna. 153 Oil on canvas, 353 × 347 (139 × 136⅝). Gallerie dell'Accademia, Venice. Photo Scala, Florence. 154 Oil on canvas, 353 × 347 (139 × 136⅝). Gallerie dell'Accademia, Venice. Photo Scala, Florence – courtesy of the Ministero Beni e Att. Culturali e del Turismo. 157 Oil on canvas, 353 × 347 (139 × 136⅝). Gallerie dell'Accademia, Venice. Photo Scala, Florence – courtesy of the Ministero Beni e Att. Culturali e del Turismo. 160–1, 162, 165 Oil on canvas, 677 × 994 (266⁹/₁₆ × 391⅜). Musée du Louvre, Paris. 167, 168–9 Oil on canvas, 560 × 1309 (220½ × 515⅜). Gallerie dell'Accademia, Venice. Photo Scala, Florence – courtesy of the Ministero Beni e Att. Culturali e del Turismo. 170 Fresco. Villa Barbaro, Maser. Photo Scala, Florence. 171 Fresco. Villa Barbaro, Maser. Photo Mondadori Portfolio/Getty Images. 109.5 × 90.5 (43⅛ × 35¹¹/₁₆). Kunsthistorisches Museum, Vienna. 179 Photo mazzur/123rf.com. 180 Oil on canvas, 121 × 105.5 (47¹¹/₁₆ × 41⁹/₁₆). Rijksmuseum, Amsterdam. 186 Oil on canvas, 90.5 × 130 (35¹¹/₁₆ × 51³/₁₆). Royal Collection Trust/© His Majesty King Charles III 2023. 189 Photo mauritius images GmbH/Alamy Stock Photo. 191 Photo © Dudlajzov/Dreamstime.com. 192 Oil on canvas, 400 × 810 (157½ × 318⅞). Sala dele Quattro Porte, Palazzo Ducale, Venice. Photo Mondadori Portfolio/Getty Images. 194 Photo © Viktor Karasev/Dreamstime.com. 195 Oil on canvas, 115 × 205 (45⁵/₁₆ × 80¾). Museo Correr, Venice. Photo Mondadori Portfolio/Getty Images. 196 Photo Bildarchiv Monheim GmbH/Alamy Stock Photo. 199 Oil on canvas, 538 × 455 (211¹³/₁₆ × 179³/₁₆). Scuola Grande di San Rocco, Venice. Photo Scala, Florence. 204 Oil on canvas, 45.1 × 38.1 (17¾ × 15). Gift of Marion R. Ascoli and the Marion R. and Max Ascoli Fund in honor of Lessing Rosenwald, 1983, Philadelphia Museum of Art. 205 Oil on canvas, 416 × 544 (163¹³/₁₆ × 214³/₁₆). Gallerie dell'Accademia, Venice. Photo Scala, Florence – courtesy of the Ministero Beni e Att. Culturali e del Turismo. 208 Chalk on paper, 39 × 28 (15⅜ × 11¹/₁₆). Private Collection. Photo Christie's Images/Bridgeman Images. 211, 212 Oil on canvas, 542 × 455 (213⁷/₁₆ × 179³/₁₆). Scuola Grande di San Rocco, Venice. Photo Mondadori Portfolio/Getty Images. 214–15 Oil on canvas, 536 × 1127 (211¹/₁₆ × 443¾). Scuola Grande di San Rocco, Venice. Photo Scala, Florence. 218 Photo John Michaels/Alamy Stock Photo. 221 Photo Mike Booth/Alamy Stock Photo. 223 Oil on canvas, 124.5 × 100.6 (49 × 39⅝). Metropolitan Museum of Art, New York. 224 Oil on canvas, 124 × 165 (48⅞ × 65). Kunsthistorisches Museum, Vienna. 227 Oil on canvas, 238 × 184.5 (93¾ × 72¹¹/₁₆). Museo del Prado, Madrid. 234 From Marco Boschini, *Il Gran teatro del pitture, e prospettive de Venezia …*, Venice, 1720. British Library, London. 235 Photo Stefano Ravera/Alamy Stock Photo. 237 Photo Secchi Smith. © Teatro San Cassiano Ltd. 238 From *Apparati Scenici per il Teatro Nuovissimo dell'Opera Pubblica di Venezia*, 1644. Museo Correr, Venice. Photo A. Dagli Orti/De Agostini/Getty Images. 242 Ceiling painting consisting of forty-four separate canvases. San Pantalon, Venice. Photo Cameraphoto/Scala, Florence. 244l Pen and ink over lead on paper, 21.9 × 19.6 (8⅝ × 7¾). Royal Collection Trust/© His Majesty King Charles III 2023. 244r Pen and ink on paper,

5.9 × 15.4 (10¼ × 6⅛). Royal Collection Trust/© His Majesty
King Charles III 2023. 245 Pastel on paper, 44.5 × 33.5
17⁹⁄₁₆ × 13¼). Gemäldegalerie Alte Meister, Staatliche
Kunstsammlungen Dresden. Photo Hans Peter Klut/Elke Estel.
249l Pastel on paper, laid down on canvas, 56.5 × 42.9 (22¼ × 16⅞).
Metropolitan Museum of Art, New York. 249r Pastel on laid
paper, mounted on laminated paper board, 60 × 50 (23⅜ × 19¹⁄₁₆).
Art Institute of Chicago. 252 Oil on canvas, 69.4 × 55.5
27⅜ × 21⅞). Museo Nacional Thyssen-Bornemisza, Madrid. 255
Oil on canvas, 59 × 40 (23¼ × 15¾). Ca' Rezzonico, Museo del
Settecento Veneziano, Venice. Photo F. Ferruzzi/De Agostini/
Getty Images. 257l Pencil on paper. Museo Correr, Venice. 257r
Charcoal on paper heightened with white chalk, 39.5 × 31.6
15⁵⁄₁₆ × 12⁷⁄₁₆). National Gallery of Art, Washington, D.C. 259 Oil
on canvas, 367 × 200 (144½ × 78¾). Santa Maria della Fava, Venice.
Photo Scala, Florence. 261 Oil on canvas, 147.7 × 199.4
58³⁄₁₆ × 78¹⁄₁₆). National Gallery, London. Photo National Gallery,
London/Scala, Florence. 262 Pen and ink, wash, over chalk,
20.3 × 19.1 (8 × 7⁹⁄₁₆). J. Paul Getty Museum, Los Angeles, 88.
GA.1. 264 Pen and ink on paper, 14 × 20.2 (5⁹⁄₁₆ × 8). Ashmolean
Museum, Oxford. Photo Ashmolean Museum/Mary Evans. 265
Oil on canvas, 91.4 × 135.8 (36 × 53½). Pinacoteca Agnelli, Turin.
268 Pencil and pen and ink on paper, 23.5 × 17.5 (9¼ × 6¹⁵⁄₁₆).
Gallerie dell'Accademia, Gabinetto dei Disegni e Stampe. Photo
Mondadori Portfolio/Getty Images. 269 Oil on canvas, 46.9 × 78.7
(18½ × 31). Woburn Abbey Collection. Photo © His Grace the
Duke of Bedford and the Trustees of the Bedford Estates. 275
Etching, 38.4 × 54.3 (10¹¹⁄₁₆ × 16⅞). Metropolitan Museum of Art,
New York. 277 Etching on laid paper, 22.5 × 18.2 (8⅞ × 7³⁄₁₆).
Cooper Hewitt, Smithsonian Design Museum, New York. 279
Fresco, 1200 × 450 (472½ × 177³⁄₁₆), I Gesuati, Venice. Photo Scala,
Florence. 282 Oil on canvas, 533 × 432 (209⅞ × 170¾). Scuola
Grande dei Carmini, Venice. Photo Scala, Florence. 287 Oil on
canvas, 236.2 × 474.9 (93 × 187). National Gallery, London. Photo
National Gallery, London/Scala, Florence. 288 Etching,
34.4 × 23.7 (13⁹⁄₁₆ × 9⅜). Metropolitan Museum of Art, New York.
290 Photo Mark E. Smith/Scala, Florence. 293 Oil on canvas,
108 × 208 (42¹¹⁄₁₆ × 81⁹⁄₁₆). Ca' Rezzonico, Museo del Settecento
Veneziano, Venice. Photo Scala, Florence. 296 Oil on canvas,
127 × 144 (50 × 56¾). Casa Goldoni, Venice. Photo DeAgostini
Picture Library/Scala, Florence. 297 Oil on canvas, 62 × 50
(24⁷⁄₁₆ × 19¹¹⁄₁₆). Ca' Rezzonico, Museo del Settecento Veneziano,
Venice. Photo Scala, Florence. 302–3 Fresco, 205 × 525
(80¾ × 206¾). Ca' Rezzonico, Museo del Settecento Veneziano,
Venice. Photo Mondadori Portfolio/Getty Images. 304 Detail
from ceiling in Ca' Rezzonico, 1797. Fresco. Ca' Rezzonico, Museo
del Settecento Veneziano, Venice. Photo Roberto Serra-Iguana
Press/Getty Images. 306 Ink and wash over chalk on paper,
29.2 × 40.6 (11½ × 16). Nelson-Atkins Museum of Art, Kansas
City, Missouri. 307 Pen and ink with wash over charcoal on laid
paper, 35.1 × 46.7 (13¹³⁄₁₆ × 18⅜). National Gallery of Art,
Washington, D.C. 309 Wood engraving with letter press,
11.6 × 15.5 (4⅝ × 6⅛). British Museum, London. Photo Trustees
of the British Museum, London. 312 Oil on canvas, 65 × 85
(25⅝ × 33½). Museo Correr, Venice. Photo by Fine Art images/
Heritage Images/Getty Images. 314 Aquatint. Private Collection.
Photo The Stapleton Collection/Bridgeman Images. 315 Oil on
canvas, 65 × 90 (25⅝ × 35⁷⁄₁₆). Musée de l'Histoire de France,
Château de Versailles. Photo by Fine Art images/Heritage
Images/Getty Images. 317 Oil on canvas, 121 × 167.5 (47⅝ × 66). Gallery of
Modern Art, Glasgow. Photo Scala, Florence – courtesy of the
Ministero Beni e Att. Culturali e del Turismo. 323 Oil on canvas,
80 × 50.8 (31½ × 20). York Art Gallery, York Museums Trust. 326
Watercolour on paper, 22.3 × 28.7 (8¹³⁄₁₆ × 11³⁄₁₆). Tate Britain.
Photo Tate. 329 Oil on canvas, 83 × 73 (32¹¹⁄₁₆ × 28¾). Gallerie
dell'Accademia, Venice. Photo Tate. 333 Oil on canvas, 88 × 121
(34¹¹⁄₁₆ × 47¹¹⁄₁₆). Colección AMALITA, Ciudad Autónoma de
Buenos Aires. Photo Vidimages/Alamy Stock Photo. 336
Watercolour and bodycolour on paper, 23 × 30.2 (9¹⁄₁₆ × 11¹⁵⁄₁₆).
Tate Britain. Photo Tate. 337 Graphite, watercolour, and

bodycolour on paper, 19.8 × 28.2 (7¹³⁄₁₆ × 11⅛). Tate Britain. Photo
Tate. 339 Photo DEA/Biblioteca Ambrosiana/Getty Images. 343
Oil on canvas, 252 × 357 (99¼ × 140⅝). Querini Stampalia
Foundation, Venice. Photo Mondadori Portfolio/Getty Images.
344 Oil on canvas, 25 × 43 (9⅞ × 16¹⁵⁄₁₆). Museo Correr, Venice.
Photo Cameraphoto/Scala, Venice. 349 Watercolour, touched
with white on purple paper, 28 × 22.2 (11¹¹⁄₁₆ × 8¾). British
Museum, London. Photo Trustees of the British Museum,
London. 350 Pencil and watercolour, 33 × 47.6
(13 × 18¾). Ruskin Foundation (RF 1590), Ruskin Library,
Lancaster University. Photo The Ruskin, Lancaster University. 353
Oil on canvas, 99.5 × 162 (39³⁄₁₆ × 63¹³⁄₁₆). Museo Correr, Venice.
Photo Cameraphoto/Scala, Florence. 356 Oil on canvas, 61 × 78
(24¹⁄₁₆ × 30¾). Ca' Pesaro Galleria d'Arte Moderna, Venice, Italy.
Photo O. Bohm/DEA/Getty Images. 359 Engraving Photo
Gianni Dagli Orti/Shutterstock. 360 Oil on canvas, 110 × 88
(43⁵⁄₁₆ × 34¹¹⁄₁₆). Pinoteca de Brera, Milan. 361 TCD/Prod.DB/
Alamy Stock Photo. 365 Oil on panel, 214 × 85 (84⁵⁄₁₆ × 33½).
Santa Maria Formosa, Venice. Photo Cameraphoto/Scala,
Florence. 366 Oil on canvas, 250 × 180 (98⁷⁄₁₆ × 70⅞). Palazzo
Ducale, Venice. Photo Scala, Florence. 373 Oil on canvas,
57.5 × 47.9 (22⁵⁄₁₆ × 18¾). Private collection. Photo Leemage/
Corbis/Getty Images. 377 Etching and drypoint on paper,
23.7 × 30.4 (9¼ × 11¹⁵⁄₁₆). Metropolitan Museum of Art, New York.
378 Pastel on wove paper, 15.9 × 25.4 (6¼ × 10). Gift of George
D. Pratt, Mead Art Museum, Amherst College, Massachusetts.
Photo Mead Art Museum/Bridgeman Images. 379 Oil on canvas,
45.4 × 60 (17⅞ × 23 ⅝). Kreeger Museum, Washington, D.C.
Photo Artefact/Alamy Stock Photo. 380 Oil on canvas,
144.7 × 226 (57 × 89). Collection of the Guild of St George,
Museums Sheffield. 383 Oil on canvas, 96 × 136.5 (37¹³⁄₁₆ × 53¾).
Galleria Internazionale d'Arte Moderna di Ca' Pesaro, Venice.
Photo M. Carrieri/DEA/Getty Images. 386 Oil on canvas,
64.8 × 30.7 (25⁹⁄₁₆ × 31¹¹⁄₁₆). Royal Academy of Arts, London.
Photo Heinrich Zinram Photography Archive/Bridgeman
Images. 388 Oil on canvas, 48.4 × 60.8 (19¹⁄₁₆ × 23¹⁵⁄₁₆). Clark Art
Institute, 1955.580. 391 Oil on canvas, 61 × 50.8 (24 × 20).
National Galleries Scotland. 392 Oil on canvas, 45.7 × 57.2
(18 × 22½). Museum of Fine Arts, Boston, Massachusetts. Photo
MFA, w/Scala, Florence. 394 Musée Marmottan Monet, Paris.
Photo Bridgeman Images. 396 Oil on canvas, 61.4 × 80.5
(24³⁄₁₆ × 31¹¹⁄₁₆). National Gallery of Art, Washington, D.C. 397
Oil on canvas, 65.4 × 92.7 (25¾ × 36½). Metropolitan Museum of
Art, New York. Photo Art Resource/Scala, Florence. 403 Oil on
canvas, 85.5 × 76 (33¹¹⁄₁₆ × 29¹⁵⁄₁₆). Private Collection. 405 Oil on
canvas, 93 × 43 (36⅝ × 16¹⁵⁄₁₆). Belgazprombank corporate
collection. 408 Photo Mark E. Smith/Scala, Florence. 411
Watercolour and pen on paper mounted on cardboard, 48.5 × 29
(19⅛ × 11⁷⁄₁₆). Sammlung Rosengart, Luzern. Photo akg-images.
413 Everett Collection Inc/Alamy Stock Photo. 415 Photofest.
419 Oil on canvas, 65 × 90 (25⅝ × 35⁷⁄₁₆). Private Collection. ©
Foundation Oskar Kokoschka/DACS 2023. 420 SuperStock/
Alamy Stock Photo. 422 Oil and acrylic on canvas, 50 × 53
(19¹¹⁄₁₆ × 20⅞).© Fondazione Emilio e Annabianca Vedova,
Venice. Photo Vittoria Pavan. 425 Oil and silkscreen ink on
canvas, 243.8 × 183.8 (96 × 72¾). Private Collection. Photo
Christies Images/Bridgeman Images. © Robert Rauschenberg
Foundation/VAGA at ARS, NY and DACS, London 2023. 429
Copyright YAYOI KUSAMA. 435 © Sean Scully. 436 Video/
sound installation, Color high-definition video triptych, two
65-inch flat panel screens, one 103-inch screen mounted
vertically on architectural elements on three walls; six
loudspeakers (three pairs, stereo sound). Photo Thierry Bal,
courtesy Bill Viola Studio. 438 Performance four days, six hours,
XLVII Biennale Venice, June, 1997. Courtesy of the Marina
Abramović Archives. © Marina Abramović/DACS 2023. 441
Photo Georges Poncet/Atelier Anselm Kiefer, Paris. © Anselm
Kiefer. 444 Wood cabinet with side panels comprising eight
paintings (conte pencil on paper) and eight figures, 67 × 101.3
(26⅜ × 39⅞). © Paula Rego. 445 Photo Cameraphoto/Scala,
Florence. © Chris Ofili. 446 Photo Heiner H. Schmidt Jr.
Courtesy the artist, Hauser & Wirth and Luhring Augustine.
© Pipilotti Rist. All Rights Reserved, DACS 2023. 449 Oil
on wood, 26 × 30 (10¼ × 11⅞). ArtImage/© The Estate of
Howard Hodgkin. All rights reserved, DACS 2023.

Acknowledgments

To say that this has been a lengthy project is a drastic understatement. It is no exaggeration to say that it has been gestating for much of my life. In the process, I have incurred many debts, among them to Michael Hirst, who once taught me about Venetian painting, and Karen Wright, whose inspirational journalist trips under the auspices of *Modern Painters* magazine first made me a Venice Biennale aficionado.

Lucian Freud's profound admiration for Titian revealed how important old master painting could be to living artists. David Hockney has taught me much about the history of pictures, including the crucial point that if a work still matters to us, it still counts as contemporary art. I am greatly indebted to Sean Scully, not only for his insights into exhibiting in San Giorgio Maggiore, but also for providing a chapter title.

I am equally obligated to many books and articles that affected my thinking and – in a different way from travel – changed my life. The most thorough studies of the *View of Venice* of 1500, and also of the intriguing question of Titian's houses, are by Juergen Schulz. Deborah Howard's *Venice and the East* brought about a paradigm shift in my understanding of the influence that Middle Eastern and Islamic architecture had on the Venetians.

I bought Charles Hope's book on Titian when it was published in 1980, and I have read it time and again since, setting me on a lifetime's reflection on that artist. The most thoughtfully sensitive overview of Titian's early career is by Paul Joannides, and the most comprehensive account of his life is Sheila Hale's. My thoughts on Titian's 'late style' have also been informed by conversations with contemporary painters, including Frank Bowling and Freud. Tom Nichols' *Tintoretto: Tradition and Identity* is full of insights, several of which I have borrowed; similarly, I have learned much on Tintoretto from Robert Echols and Frederick Ilchman. Xavier Saloman's writings reveal much about Veronese to me.

Michael Levey's monograph on Giambattista Tiepolo was the starting point for my exploration of that great artist (on an early visit to Venice, I was awed to see Levey examining a Tiepolo fresco through binoculars). Later, I found Svetlana Alpers and Michael Baxandall immensely stimulating. Robert Calasso's reflections set me thinking in other ways about what makes this artist so elusive and at the same time so delightful.

James H. Johnson's *Venice Incognito* taught me a great deal about the Ridotto, eighteenth-century Venetian theatre, the etiquette of mask-wearing, and also the grimmer connections between Giandomenico Tiepolo's drawings and the brutality of life under French occupation.

Fiona MacCarthy's life of Byron fuelled my curiosity about the poet's relationship with Napoleon. On Turner in Venice, Ian Warrell's writings were the most erudite and enthusiastic of companions. Long ago, I bought John Unrau's study of Ruskin and San Marco. Margaret Plant's study of Venice since the fall of the Republic, packed with fascinating information, opened up vistas of nineteenth- and twentieth-century Venetian history. She was my informant on the short-lived Republic of 1848–9 and on the pictures by Nani and Caffi. Her book also drew my attention to Giovanni Busetto-Fisola's development project and Luigi Querena's paintings.

Alex Ross got me started on the theme of Wagner in Venice, and John Barker's study revealed the colours and leitmotifs of the composer's time in La Serenissima. I drew on the rich information about Whistler's Venetian period in Richard Dorment and Margaret MacDonald's Tate catalogue, while Alastair Grieve's research allows one to accompany that painter through the city canal by canal.

Hugh Honour and John Fleming's study of Whistler, James, and Sargent in Venice brilliantly evokes the social and literary ambiance of expatriate life, as does Matthew Sturgis's biography of Sickert. I derived a mass of information from the latter, while Robert Upstone's show and catalogue made the full fascination of the artist's stays in the city clear to me. Paul Hayes Tucker was my principal source for Monet in Venice, in an essay from the catalogue to *Monet in the Twentieth Century*, another hugely eye-opening exhibition for me. Other debts, too many to mention here, are cited in the notes.

During the writing process (which was interrupted while I worked on two other books), my son Tom read through many early drafts, making innumerable valuable comments and suggestions. While the text was gestating, my wife Josephine and I stayed in the city for long periods, encouraged and assisted by David Landau and Rosi Kahane, Chris and Anna Wayman, and Charles and Mary Avery.

Sophy Thompson at Thames & Hudson has been unfailingly patient and supportive. Once again, Andrew Brown has proved an impeccable, perceptive, and efficient editor and designer, and Sally Nichols, an immensely resourceful picture editor. A number of friends generously agreed to read sections of the text in draft, offering expert observations. For undertaking this task, I am hugely grateful to Xavier Bray, Richard Calvocoressi, Paul Joannides, Jane Munro, Jeremy Musson, Philip Steadman, and Ian Warrell.

Index

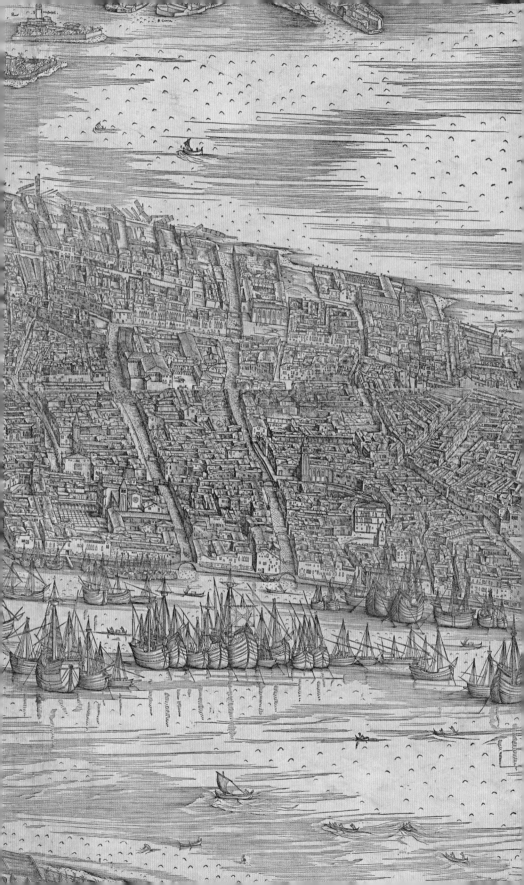

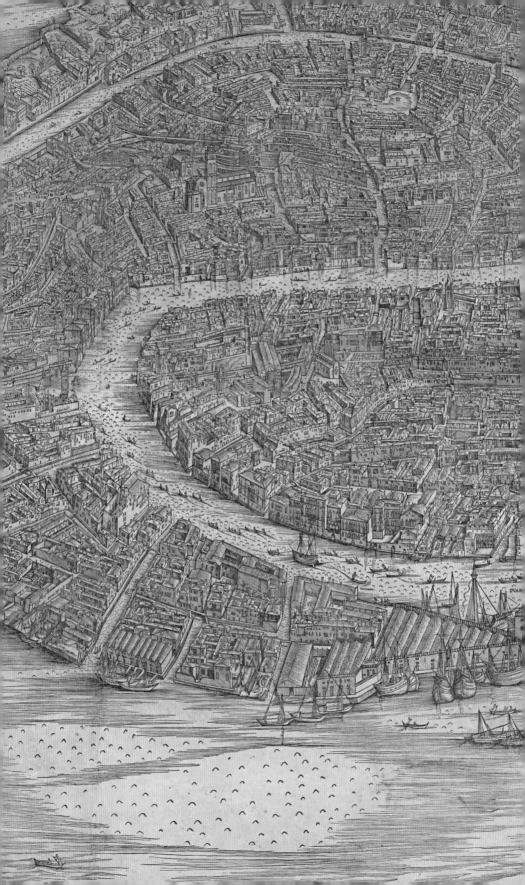